PHOTOGRAPHY
CINEMA

MEMORY

PHOTOGRAPHY
CINEMA
The Crystal Image of Time
MEMORY

Damian Sutton

University of Minnesota Press
Minneapolis
London

Published by the University of Minnesota Press
111 Third Avenue South, Suite 290
Minneapolis, MN 55401-2520
http://www.upress.umn.edu

Library of Congress Cataloging-in-Publication Data

Sutton, Damian.
 Photography, cinema, memory : the crystal image of time /
Damian Sutton.
 p. cm.
 Includes bibliographical references and index.
 ISBN 978-0-8166-4738-5 (hc : alk. paper) — ISBN 978-0-8166-4739-2
(pb : alk. paper)
 1. Photography, Artistic. 2. Photography—Philosophy.
3. Cinematography. I. Title.
 TR183.S88 2009
 778.5'3—dc22
 2009006995

Printed in the United States of America on acid-free paper

The University of Minnesota is an equal-opportunity educator and employer.

18 17 16 15 14 13 12 11 10 09 10 9 8 7 6 5 4 3 2 1

For my mother and father,
whose support has been unbending and without question.

CONTENTS

PREFACE

As critics we imagine that we look upon photography with open eyes, distanced from the visual culture in which the photographic image is still the prime molarity. We forget that there is an abstract machine of culture in which we are an essential part—as photographers, writers, critics, artists, family members. We neglect to look for the ways in which photography as an idea is instrumental to the ways that we live and act, the ways that we see and represent ourselves and others.

My first idea was simply to investigate the relationship that photography had with cinema. I realized this was too simplistic when I started to look at films and photographs that had long been able to do in images what I found difficult to express in words. At that time I was reading a lot of Roland Barthes, and my writing and my thinking had taken on a circular, debilitating self-consciousness that his extraordinary work often provokes. My project became something of a quest to figure out why photography theory in particular had stalled at the moment of Barthes's most famous work on the photograph, *Camera Lucida*. But that revelation would come only after I had found a new way of understanding the photographic image. I had two extraordinary realizations. I found my interest was taking me further away from the study of film and closer to an understanding of the photographic in general and the photograph in particular. At the same time, it was becoming increasingly clear to me that perhaps the best way to understand photography and the photograph was to do so through the lens of cinema.

But what does it mean to *understand* the photograph? This question

lies behind much of the work done to inform this book, and I'm still not exactly sure. What quickly became the driving force behind the project was a need to appreciate, with more complexity than I felt entirely comfortable with at the time, the nature of time in photography, especially in our experience of it. I was still being influenced by Barthes, and also Walter Benjamin and André Bazin, each of whom have contributed so much to photography criticism—all the more remarkable because of the brevity of some of their writings. The shadows cast by these figures seemed to me extraordinarily long, and their appreciation of photography has coalesced into particular ideas of the Photograph as an emphatic image presenting the impossible conflation of past and future, near and far, subject and object. I needed a different way of seeing the photograph, a way that would allow me to peel back the surface of the image, to reveal the world of images seen beyond it, to discard the paper print (or the filmstrip) and deal with photography as something all around us, permeating visual culture and acting as the imprint of life itself in a manner that defies metaphor. Happily, at that time Bill Marshall, my tutor at Southampton and Glasgow, said something like "I think you might find Deleuze quite satisfying." To be honest, I cannot remember if that's exactly what he said. Funny . . . I have a better memory of the moment when I asked if I would be okay to study for a PhD, and he said, perhaps with trepidation, "Sure, and we'd love to have you." Nevertheless, the moment when I was introduced to Gilles Deleuze has lived with the project ever since.

The project has seen the fortunes of Deleuzian analysis rise and fall, intensify and recede into the shadows. When I started, Deleuze had only recently died, bringing himself to death rather than waiting for his emphysema to claim him. The effect of this was profound even to the novice reader, whose growing interest was satisfied by the inevitable collection of critical texts, readers, and primers that ensued. My project has seen the ten-year anniversary of his death as well as anniversaries of some of his key texts, most significantly the twenty-year anniversary of *The Time-Image,* which has been so instrumental to my own work. Luckily, the growth of Deleuzian literature has allowed for a rich and vibrant discourse that exploits his work but often takes him to task, and it has been my pleasure to be involved in some of this discourse, either informally through the debates in a forum such as film-philosophy.com

or more formally through writing for others when they have been kind enough to ask me.

Even at this late stage, I find it difficult to put into a few short sentences the philosophical approach to photography that I have developed from Gilles Deleuze. I turned my attention to Deleuze because of how his treatment of time in cinema relied so heavily on the cinematic— really, the photographic—image from which cinema is constituted. His thesis, that a different kind of cinema grows from a resistance to classical systems of narration and monstration and by growing gives us a glimpse of the pure time within which we live, is uncompromisingly brilliant. I find myself forgiving his auteurism, his adherence to the canon of works that a director produces. Furthermore, I find myself forgiving his tendency to forget that cinema is a petrochemical, industrial process that involves vast numbers of creative people who are poorly served by film criticism that reduces their output to "Welles," "Kubrick," or "Antonioni." I can even forgive Deleuze's adherence, in those first few pages of *The Movement-Image,* to the Bazinian idea of the photograph as the immobile entity from which cinema is constituted. This is because his idea of the time-image is so instrumental in appreciating the complex relationship we have with the photograph and photography. Its glimpse of pure time—which Henri Bergson called duration *(durée)*—relies on its dislocation from cinema style and construction that was built on the fixed image but that was a closing down, a veiling, of the still image's own relationship with time. In recognizing the pure optical situation, the opsign, Deleuze gives us a philosophy capable of understanding the photograph but also explaining why we need to understand it. Later the dicisign reveals for us the strange relationship we have with the photographic image as a collection of glances and gazes: some outward to the future, some inward to the past, some returned to us with blinding intensity.

Not every photograph is a time-image, and it quickly becomes apparent to any study that photography can be organized into various types of image, a taxonomy of images much like the one that Deleuze draws of cinema. This book attempts to do this for photography, even though it has a large enough task just to establish the credentials for the photographic time-image itself. As this project grew, especially in the years since 2002, I found myself looking more and more at the substance

of photography and, by extension, reexamining the nature of the differences that are so often seen as lying between cinema and the photograph. To paraphrase Deleuze and Félix Guattari, cinema and photography are badly explained by the binary organization that sees them as representing mobility and immobility, life and death. If the cinema of Alain Resnais, Chris Marker, Andy Warhol, and others, as well as the photography of Helen Levitt, Nan Goldin, and Cindy Sherman, demonstrates anything, it is that the substance of photography is continuous, though stretched and formed by culture into the shapes of cinema and the photograph. Cinema and photography, I will show, are ideas used to create objects from a monadic, folding continuum of the photographic, and we should really be surprised that they are seen as so different. From this position I became interested in Deleuze's work with Guattari, especially that focused on becoming, and later immanence. This informs my approach to memory and time, particularly in the context of digital photography and the "planetization," as we shall see, of photographic culture through the Internet. At heart is a realization that to understand the photographic image is to understand the glimpse of immanence it so often affords us.

I begin by introducing the *event* of photography and its relationship to cinema as one of the motifs by which studies of both are written. The event, as a division of before and after that creates subjects and subjectivity, is the essential notion through which we humanize time. The first chapter is also a reconciliation with the event of Deleuze, and I discuss some concerns we might have in embarking on a self-consciously Deleuzian analysis. Nevertheless, this is a book about photography, cinema, time (and memory, too), and whenever Deleuze is introduced into the discussion he is always told to "make yourself useful."

I need to let you get on and read the book, so it is time to raise a vote of thanks. During a ten-year project I have been fortunate to have productive, exciting, and rewarding relationships with many good people who, no matter how briefly or slightly, have had a welcome impact on the work. The project started with help from the Arts and Humanities Research Board (now Council), which should be rightly thanked. My appreciation goes to the staff at the School of Modern Languages, Southampton University, and especially to the staff of the Department of French at the University of Glasgow. I also express my warm thanks

to colleagues in the Department of Historical and Critical Studies, Glasgow School of Art, especially Jane Allan, who provided timely and effective support when needed. I cannot commit this project to print without thanking Doug Armato, Niamh Doheny, Philip Drake, David Martin-Jones, Gene McSweeney, Ken Neil, Benjamin Noys, John Rajchman, Karen Randall, D. N. Rodowick, Nancy Sauro, Sarah Street, and Liz Wells. Professor Bill Marshall was my supervisor and continues to be an excellent mentor and supporter, constantly working on redefinitions of the term "tough love." Finally, I thank my partner, Karen Wenell, who is just brilliant.

1 CINEMA AND THE EVENT OF PHOTOGRAPHY

> The fact is that the new spiritual automatism and the new psychological
> automata depend on an aesthetic before depending on technology.
>
> —Gilles Deleuze, *Cinema 2: The Time-Image*

The Convergent Image

Vidocq was not released in the United States, United Kingdom, or
Australia. Amid speculation surrounding the development of digital
technology in the production of mainstream cinema, the first film to be
made entirely on high-definition digital video (using a Sony/Panavision
CineAlta, serial number 000001) slipped by virtually unannounced.[1]
Vidocq (France, dir. Pitof, RF2K/Studio Canal/TF1, 2001) had a mixed
critical reception in cinemas and on home video that suggested some-
thing else was amiss. Audiences found it difficult to relate to the jux-
taposition of the grand vistas of Paris with the extreme close-ups that
video allows and that the film uses liberally. It is disconcerting to view
the Paris of 1830 through an MTV aesthetic. Although avant-garde
filmmakers might be expected to experiment with the different tech-
nologies in hand, the pressures on the producers of *Vidocq* to deliver
images equivalent to 35mm can be sensed in every cut of the film. The
coming of digital cinema was certainly an event felt in *Vidocq*, but felt in
a manner similar to any technological innovation: the vanguard of any
new technology is always clattering frenetically against the redoubt of
the old. There is another reason to take note of *Vidocq*'s inky images of
Paris during Les Trois Glorieuses: reference photographs—particularly
aerial daguerreotypes of pre-Haussmann Paris—commanded not only
Vidocq's detail but the look of the film. *Vidocq* makes no attempt at
the verisimilitude normally expected of the historical epic; instead,
the final result often looks like a daguerreotype that moves. Similarly,
Vidocq's adversary, the Alchemist, wears a mirrored mask that reflects

1

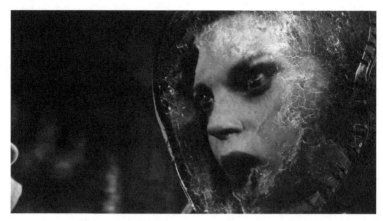

Vidocq (France, dir. Pitof, RF2K / Studio Canal / TF1, 2001)

the tormented faces of his victims. (Photography, in its early years, had the aura of alchemy.) When the Alchemist is destroyed, the faces of previous victims are visible once more. Like Oliver Wendell Holmes's famous description of early photography, invoking the daguerreotype's own reflective surface, the Alchemist's mask really is "a mirror with a memory."[2]

Vidocq's unification of the very beginning of photography with its contemporary, digital life exemplifies the trajectory that photography (and cinema) has taken, culminating in a unifying aesthetic of what many call convergence. In convergence, sometimes the technology alters practice, gives it a jolt, such as in the advent of mobile telecommunications and the Internet, which has dramatically affected where, how, and with whom we communicate. At other times it is the practice that subsumes the new technology and that, despite academic protests to the contrary, is what has happened in photography and cinema. Where digital culture once presented us with "mixed, layered, and heterogeneous audiovisual images in a nonlinear space and time," a set of optimistic possibilities, as D. N. Rodowick has suggested, the forces of visual culture have taken these malleable forms and wrought them back into a homogeneous, linear image.[3] Rodowick, for example, acknowledges the "technological criteria" of digital cinema as being those of a "perceptual realism," and in particular, the photographic.[4] His argument is

influenced by John Belton, who has described the reaction to the pro-
posed digital revolution from critics complaining that the feel of 35mm
cinema is lost.[5] There has undoubtedly been a huge technological event
due to the radical change that the new media has effected on social life
and visual culture, but its political and artistic potential is always in
danger of being lost.

The onset of digital means continues to exercise academics. For
well over a decade, the arrival of digital has been treated as an event
just happening, changing, or about to change everything we expect.
Perhaps the best reflection of this critical slow burn is in the work of
Lev Manovich. Manovich wrote, for the 1996 exhibition catalogue
Photography after Photography, that the digital image in cinema and
photography is "paradoxical; radically breaking with older modes of
visual representation while at the same time reinforcing these modes."[6]
At the time, Manovich's argument was based on the lack of radical
change that the digital revolution had provoked. Such an unfashion-
able view of new technology was never going to sit well with those who
continue to see the new media as either a real revolution, a "panacea
for the ills of the present," or as the (no less fetishized) cataclysm of
the breaking of photography's privileged link with reality.[7] A few years
later Manovich's argument had altered. In a much quoted passage, he
suggests that cinema's relationship to reality (or should that read "pho-
tography's"?) and the powers that it harnessed were only "an isolated
accident in the history of visual representation . . . No longer a kino-eye,
but a kino-brush."[8]

Or rather, a return to the kino-brush. The extraordinary desire
for the use of digital technologies to be seen as a fundamental event
has been doubly met—the arrival of digital not only is a life-changing
technological intervention but returns us to a natural state of affairs in
which poetics, represented by painting, is the predominant regime. Yet
one cannot simply dismiss 160 years of belief in the idea of photographic
evidence as a mere blip in art history. Furthermore, if digital technolo-
gies in image culture are indeed a return to the poetic regime, what
was gained (and what was lost) from photography? Why and how did
photography constitute an event of art history? What Manovich's state-
ment does support is the argument that the technology at art's disposal
is not as important as the belief invested in what it can do. Technology

cannot enforce change on a societal level, but it can provide the potential or precarious possibility of change. Radical technological change is not nearly so significant as the radical change of ideas that accompanies or provokes it. Technological change, such as the arrival of digital technology, if it does nothing else, provides a dividing point between the situation of ideas before and after, an event that might take moments to inspire or years to detect that it ever happened.

This effect of the technological event suggests that the interface, or struggle, between old and new is in more than just the image; it is also in time. Just as the producers of *Vidocq* found themselves under pressure to produce a cinematic image, so the film struggles with the dominant cinematic time of an exasperated "neoclassicism."[9] The regime of poetics is not limited to the visual but is the establishment of a knowledge and order of the temporal that relates to the workplace, the home, the government, the space of art. Cinema and photography have come to be intimately associated with time—the cinema with time in passing, the photograph with the lost moment. Individually, but more so when they reference each other, they have a particular relationship with our common concept of memory and death. One only has to see in movies the use of Super 8, black-and-white prints, or the snapshot to appreciate an axiomatic relationship with memory thrown into sharp relief by professional production techniques. The fact that digital convergence allows different analog formats to be treated as the same image data suggests once more that it is the poetic regime, rather than a technological one, that organizes the popular conception of time and memory. This effect can be easily demonstrated. New mobile technologies emphasize co-presence in society, while digital imaging technologies wipe out the cinematic cut in favor of split screen in cinema and television. The examplar of this, *Timecode* (USA, dir. Mike Figgis, Red Mullet, dist. Columbia, 2000), elaborates the new regime of time that is forced by mobile technologies. With lover's trysts and quarrels filmed simultaneously and rendered in split screen, we are made aware not only of the splitting of our attention but also of the heightened sense of co-presence. An old Hollywood gag, split screen was once used to portray frothy romantic telephone conversations or the thrilling approach of a stalker. In the last decade, multiscreen cinema and television have become the signifier of a world in which it is guaranteed that everything

happens in a singular and homogeneous time, whether separated by a thousand miles or a few inches. "Time becomes spatialized," Manovich notes, "distributed over the surface of the screen."[10] Even in the split-screen slow-mos of contemporary film and television, such outward images of heterogeneity hide the triumph of modernity's unified temporal regime. But if mobile technologies, discussed in more depth in chapter 7, are yet to be seen as a challenge to the regime of time put in place by photography and cinema, then that regime must be understood. This, essentially, is the task before us.

In modernity our ideas of time have coalesced around particular concepts of the moment. Photography's division of time and space has been instrumental to this, ceded eventually to cinema, which became the archetypal classification of the event. In the cinema's frame-by-frame analysis, the moment was identified, frozen, and reproduced in series. The first 50 years of cinema, and 110 years of photography, represented the establishment of a particular idea of time and space that had its roots in both the rational empiricism of science and the regime of poetics. Cinema's modernism was in the ossification of a particular schema of time, organized around the moment, that only catastrophe could break.

This is the subject of one of the more influential ideas to approach cinema and time. Gilles Deleuze's conception of the *movement-image,* the relation of the image to time and space purified, is what we might call classical narration.[11] Out of the ruins of postwar Europe, cinema developed a new schema that promised the destruction of the old. The

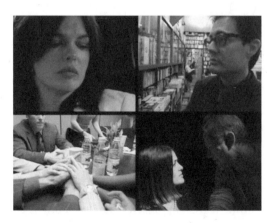

Timecode (USA, dir. Mike Figgis, Red Mullet, dist. Columbia, 2000)

time of this cinema was fractured and fragmented, reflecting the cinema-industrial ruins of the countries out of which it emanated, France and Italy, yet it always ran alongside the former model of movement and time, and they rely still on each other. As Alain Badiou suggested, the "dominant forms of non-art are immanent to art itself, and make up part of its intelligibility."[12] For Deleuze, this new time of cinema was expressed in the *time-image,* a cinema often made by filmmakers conscious of their difference from the mainstream.[13] In its reliance on a break from the classical mode, the time-image can be found in cinema that has developed in opposition to the seat of that mode in Hollywood, though the two are not always mutually exclusive. The time-image is an example of when the accepted knowledge and opinion on time and memory is broken apart, ready to be appreciated anew. The photography historian David Campany, in his luxurious survey of cinema and photography, writes that Deleuze offers an extraordinarily rich framework for thinking about film's "protean form that makes photography seem impoverished by contrast. [Yet] the time and movement of photography deserve an analysis every bit as sophisticated as those extended to film."[14] The task before us is to take up Campany's challenge, since we will discover that Deleuze's time-image is an event of cinema and *thus* an event of photography. Seen from such a perspective, this book is about what happened to time in photography before and after cinema, especially during cinema's unstoppable development. It is more than a book about the situations that arise from the crossover of cinema and photography; it is a taxonomy that sees cinema as an event of photography.

The Event of Photography

Photography as an idea is rigidly organized around particular objects and practices, and the Photograph emerges as a kind of mythological or historical unity in photography history.[15] Just as the history of cinema is oriented around the purification of the cinema model (the Lumières' status as inventors is tied to cinema's first public performance, for example), so the history of photography is oriented around its purification as a technology of the event of seeing. For Georges Didi-Huberman, in his work about the nineteenth-century director of the Saltpêtrière asylum Jean-Martin Charcot, photography was a technology ideally suited

to the practice of medical observation—*to see* as a reflexive activity hidden in the moment of revelation.

> [The act of observation is manifest in a] certainty, which, in the always intersubjective moment of sight, emerges only as a theft, and as anticipated; this is to say that it also denies the time that engenders it, denies memory and threat, inventing itself as a victory over time. . . . *It invents itself an instantaneity and efficiency of seeing,* although seeing has a terrible duration, a single moment of hesitation in efficiency.[16]

As the *pose* of photography, this efficiency of seeing was as instrumental in the observational photographs of the Paris asylum as it was in any other institution, or even in the newly opened portrait studios in France, Great Britain, and the United States. The commonality of all photography was the moment of taking, and the pose, as photographic exposure and as comportment of the body, became the archetypal or "mother-temporality" of photography.[17] Even as technology in the nineteenth century decreased exposure times to a fraction of a second and hurried photography toward the *instant* and then cinema, the legacy of that moment of hesitation—the Kodak moment and the decisive moment—still remains. This is our first example of a different understanding of a photographic event. It is not a radical change in technology but the event of the Photograph, the real event around which photography history is written.

A common understanding of an event is a change or a radical break or an occurrence designed to provoke one of these. Indeed, if such an event does not cause radical change it is seen as a failure. This is why inventions tend to be adaptable to the notion of the event. The history of invention is an archaeology of moments of significant change. Thus the introduction of sound in cinema theaters becomes an event, understandably, as does the development of the 35mm still camera (photography as an event of cinema, as it were, since it used motion picture stock). The very identification or naming of the event gives it significance. Furthermore, the naming is an archaeology of photography, since events are latent images of change that are occurring all the time but that need to be developed or otherwise brought to clarity.

For example, in the field of institutional theory such events are seen as "jolts," since they reconfigure the practices of the marketplace for both consumer and manufacturer.[18] It is as a jolt that the onset of digital

photography was experienced, but the *delay* with which it occurred ensured that many of the stories of the jolt—such as the manipulation of high-profile press images or those referring to the dominance of worldwide camera sales by manufacturers of cell phones—emerged long after the industries of journalism and domestic photography, as well as artists, had come to treat digitization as routine. In the example of the photographic industry the process of naming the event can be brought into focus, not least because the originally proposed technological event of the first electronic camera—the 1981 Sony Mavica—is usurped in significance by another, the intervention of the Internet in the mid-1990s. Where the manufacturing and print-finishing industry had invested in photography as the preservation of love and memory enshrined in high-quality print images, the Internet, the personal computer, and the cell phone offered photography as an ephemeral activity centered on the sharing of images that could be deleted without conscience. Even so, the industry has moved to "tame" this change.

Kamal Munir, in his short study of the adoption of digital photography, stresses the central importance of the written and verbal exchanges that constitute the "theorization" of the event. Whether it is in the attempts by Kodak to publicly discredit the Mavica or, we might add, in the enormous style industry that surrounds consumer electronics, the industry as a whole can be seen as one looking for the event in order to orient their response around it. In this respect, designers and entrepreneurs might act as early warning systems, even to the extent that chic radical design can constitute the technological and theorized event around which the industry can plan fiscal policy and corporate growth. Munir uses Bruno Latour's concept of the black box to suggest that it is not the technology that achieves the change but the jostling for position to harness or depose it.[19] The extraordinary complexity of various elements and layers of the black box—technology, industry, academy, user—act as a whole. It is in the interest of particular elements that the whole never changes, so Kodak and other manufacturers moved quickly to present the traditions of photography as desirable, or at least as desirable as the new capabilities of digital photography. We see advertisements reminding us of the security of having paper portraits of our loved ones, while other companies emphasize the importance of sharing. The process is one of interest and surveillance:

Interested groups may therefore be kept in line as, moving through a series of translations, they end up being trapped by a completely new element that is itself so strongly tied that nothing can break it up. Without exactly understanding how it all happened, people start placing transcontinental phone calls, taking photographs.[20]

Each new element is treated in the public sphere as intrinsic to photography, so the whole process of change is ultimately accepted as essential. To *prevent* uncontrollable change to the industry, photography's interested groups successfully reacquainted users with the traditional notions of photography—especially the mother-temporality of the pose. Through theorization, older manufacturers such as Kodak were able to delay the introduction of new technologies long enough to develop their own response (inkjet papers, home printers, and so on), even while incoming manufacturers such as Hewlett-Packard, Nokia, and others promoted photography as a practice of connectivity. As an industry, the new practices were seamlessly incorporated into the traditions of photography in order to manage the event as a jolt rather than as a catastrophe.

The picture of capitalism incorporating the technological event into its program is a dark one. However, the notion of the event as latent, waiting to be developed, should not be lost, since it can also be the spark for enormous positive change. For Badiou, an event only becomes so when it "compels the subject to *invent* a new way of being and acting in the situation."[21] Badiou became famous for his attacks on both the left and the right of politics and the relationships they have had with the crucial political events of the last 250 years. As a philosophy of the event, Badiou's thought reflects the pattern that we have already seen with the notion of the jolt. However, his political argument, developed in his 1992 book *Ethics,* is crucial to our second understanding of the photographic event—photography as an event in art and also in politics, as well as an event of technology and of desire.

Badiou's conception of the event relies on its exposure of a particular truth and the fidelity of those who have been made a subject to that truth and the change it proposes. Truth "punctures" knowledge as a realization, a blinding, a framing of perception.[22] An event can be a joy or a catastrophe, but if no change occurs in the situation from which the event arose, then truth may remain only in a proposition of change. Barthes's *punctum* is an example of the terrible moment when a truth

emerges and in which knowledge itself is the situation. Perhaps most significant for us, the event is not necessarily tied to a particular instant or act. This is the result of an insertion of the corporeal into the event—the recognition of a gesture in a revolution that, once made, constitutes an awareness that things cannot be the same again. This is not so much a matter of wishing that things could change but that change compels the subject. We might say that the subject does not invoke the event but that the event invokes the subject, such as in a call to arms to a person or people.

Badiou's most famous example of an event of this sort—the conversion of St. Paul—is a case in point. Paul's conversion is not linked to the actual event of Jesus' life, "the biography, teachings, recounting of miracles." For Paul, Badiou writes, "without the motif of the Resurrection, Christ's existence would have been of little more importance than that of any other oriental mystic."[23] The realization of the particular truth of the Christ-event, death and resurrection, even though he did not witness it, radically changes everything for Paul. Similarly, one might choose any of the likely events from the revolutionary period in France and say that it constitutes the event of revolution. Yet, as Peter Hallward elaborates, for Badiou the storming of the Bastille, the execution of the king, or the creation of the new calendar are ultimately not as significant as the "moment of transition after which the groups of people involved conceive themselves precisely no longer as members of this or that group but as so many subjects of the revolution itself."[24] The event divides *before* and *after* by intervening or rupturing a situation. Thus Marx, for example, can be an event for political thought long after his life and his writing.[25] What the political event brings into focus most clearly is the identity of the gap or "void" in a situation. This void, such as the proletariat, is in whose name the event occurs and whose position is defined against the complexity or plenitude of the situation.

If we ask what constitutes photography as an event of art, then at first glance the argument clearly follows that of invention, and it is this idea of the event that we must begin to lay aside. The void of art, it might be argued once again, is non-art, since it is in the basic comparison with non-art that art finds its singularity. This is where, for example, Jacques Rancière finds a correlation between his own ideas and those of Badiou's: "art is what testifies to a passing of the idea through

the sensible, in the differing of a sensible datum from the ordinary regime of the sensible."[26] Rancière uses this schema to develop the *risk* that art has in terms of good and bad art, in the sense that all artistic practice risks being mere piecework as much as it promises a truth. He is also separating the act of making from the concept of art as the "passing of the idea."

Imagine photography's first idea, which is most often identified with Henry Talbot in 1833. Talbot, a friend of David Brewster and John Herschel, was familiar with both the scientific struggle for a method of fixing automatic images from the sun and the practical drawing instruments of the camera obscura and camera lucida. Jacques Aumont once recounted how the history of photography is not flattered by the "flagrant" delay between many of the scientific discoveries of photography and its eventual invention, and Henry Talbot's predicament in 1832 is testament to this.[27] In early 1832 Henry Talbot was no nearer inventing photography than he or anyone else had ever been. What, then, was sufficient to give rise to the idea of photography? We must look at what Talbot's life had been missing until that time: in December 1832 he both married and entered politics. Because of his election to parliament, Talbot delayed his honeymoon in Italy to the following year. While drawing by Lake Como, the idea of photography came to him. Talbot was sketching with a camera lucida, an optical instrument that superimposes on the drawing paper the scene before the eye. He was not having much success and found his "faithless pencil" unable to match his intentions.[28] Larry Schaaf notes that Talbot's comparisons between his sketches and the sketches made by his wife, Constance, who was quite accomplished, must have made him envious and frustrated.[29] Talbot was an educated man who felt that one needed only knowledge of the Dutch school to develop a painter's eye.[30] Had his hand been as skilled as his eye, he might never have conceived of the automatism of photography. This is the truth of the photographic event of art: photography reveals to us how art as thought is independent of mere skill and that it is rooted in the *concept*. Duchamp's ready-mades, for example, only reaffirmed what this event of photography originally proposed. Photography's relationship with science, however, gives Talbot's revelation its primacy. Photography is the scientific event of art, since it releases art from the duty of resemblance; it is also the artistic event

of science, since scientific observation will, from that time on, always be part of a poetic regime. This is the truth identified in the photographic paradox, in what Didi-Huberman called photography's "mendacious irrefutability," a paradox we shall meet more than once.[31]

The Betrayal of Art

What does fidelity to the photographic event mean? Since a political event such as a revolution requires maintenance of its revolutionary effect, the notion of fidelity is crucial to Badiou's concept of an ethics. His anger is thus ranged at any acceptance of the status quo that emerges after the truth of a situation is revealed as a necessity. Fidelity does not mean a general piety or virtue but necessary dependence on the truth, the *immanent break* that the event constituted.[32] The battle is never won; there can be no ultimate victory, only a situation immanent to non-truth. It means that his sharpest criticism in *Ethics* is of the left-wing politics of consensus and its betrayal of the truth of its key political events (October 1917, 1792). Laziness or infidelity to the truth of a situation is what allows situations such as Stalinism, or Thermidor, to occur. Even in science, the deployment of truth is a matter of ethics because, for Badiou, the danger always exists of "an attempt to sell its fidelity to the State."[33] Badiou's elaboration of the time of this ethics, its unfolding as a process that requires dedication and stamina, exposes two significant problems for photography.

In *Ethics,* Badiou acknowledges the inevitability of truth forcing knowledge.[34] For instance, a mathematical theorem may constitute a radical departure, but fidelity to the event involves a consistent recognition of its effect, its tumultuous breaking of the skin of knowledge. It is easy to see how a practice of "uncovering truths" as an archaeology—indeed, once again, as a photography—might develop as a particular skill of self-interest: stylistics as a simulacrum of ethical thought. Conversely, the awareness that all truths will become knowledge (which, for Badiou, is little more than collated opinion) can lead to a temptation to "give up . . . to regress back to academicism under cover of a propaganda that denounces the avant-garde as *'passé.'*"[35] The second problem is that an event that is identified has many destinies, one of which is a truth process leading to positive change, another through incorporation as a

jolt. This raises the possibility of events that convoke the *subject* in other ways. One might argue, for example, that the truth of photography's democratic vision had never existed, since it seems obvious that photography is an instrument of surveillance. This is a very different subject to Badiou's ideal but is nonetheless a subject whose life is changed and who is made *subject to* the camera by the photographic event.

This is why the paradox of photography is so critical to its event. Photography's scientific value ensured that it would be essential to the creation of knowledge, that it "had the duty of being knowledge's memory."[36] Yet art cannot help but penetrate the scientific photograph's surface. Photography was already outside itself looking in; it always constituted a heterogeneity, a break with itself. The documentarian tradition that arose from the decisive moment would eventually have to answer for poetics, as photographs were chosen for gallery walls because of who took them rather than what truths they had brought to light. Style is art's betrayal of science.

This is the argument suggested by the attacks on photography culture and education by the New Photography in the 1970s and 1980s.[37] Of this group of artists and writers, Allan Sekula and John Tagg turned their attention to photography's early role in the apparatuses of social control that emerged in the nineteenth century and that relied on photography's twin destiny of art and science.[38] The New Photography, according to Frank Webster, saw photography's intimate connection with an iniquitous modern visual culture as a legacy tied to its paradox: "the age of Empire could admire its achievements and respectability without fear of doubting the veracity of that which was recorded."[39]

In this respect, rather than in invention per se, the coming of photography was certainly an event. Didi-Huberman suggests that the proliferation of images of illness, particularly hysteria, deserves a new chapter of art history, with photography nothing less than a "historic change in sight."[40] For John Tagg, the accumulation of photographs as observations made by the apparatuses of the state "amount to a new representation of society."[41] In Tagg's assessment, photography's power came not only from its evidentiary precision, and thus its relation to other scientific instruments, but also from the mobilization of the image in the parlor and the institution. Photographic materials and equipment and the images they produced soon became the normal accoutrements

of the asylum, hospital, and prison. This was perhaps the camera's first real appearance as a black box, if we follow Latour's argument. By the 1850s it relied on several other black boxes—the album, the archive, the medical apparatuses, the various permutations of photographic techniques used for scientific observation—in order to produce the necessary results for its efficiency to count. It relied on these black boxes to produce the archetypal social photography, the classification of institutionalized memory. Furthermore, the subjects of the institutional gaze, in particular inmates, prisoners, and patients, constituted *material,* in Didi-Huberman's terms, with the institution's observation, recording, and finally classification as the mechanism in a routine to which they were *subjected.*[42]

The convocation of the subject in such circumstances came in the person's passage through the institution, as reflected in the case of Arthur Conan Doyle's character of Hugh Boone. Boone is famous as the "Man with the Twisted Lip," suspected of the murder of a gentleman in the City.[43] Boone, a beggar, maintains an existence unknown to authorities through the charade of legitimate match selling, but when incarcerated for his role in Neville St. Clair's disappearance, Boone is revealed to be St. Clair himself, a subterfuge revealed after he is scrubbed clean by Sherlock Holmes. Thus the detective is the personification of empirical observation and *classification.* Boone's real, or legitimate, identity is confirmed when he is matched with the portrait photograph of Neville St. Clair. The situation resolved, St. Clair returns to his life in the Kent suburbs, and Hugh Boone simply ceases to be. While St. Clair's character is finally presented as implicitly legitimate, Boone becomes material whose convocation, classification, and "death" as a subject hinges on the photographic act.

By the 1890s, when Doyle was writing, police photography and record keeping were already extremely sophisticated. In France, the system known as Bertillonage was already identifying recidivists among the criminals who were archived in the Préfecture. Named for its inventor Alphonse Bertillon, the system involved the classification of criminals through anthropometric description. Eventually this would be made automatic through the use of photography, and indeed the system began to run like an automaton, with each element—filing cabinet or photo-

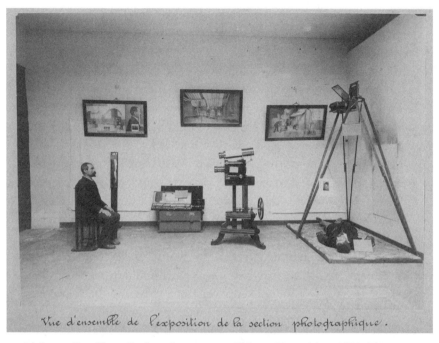

Vue d'ensemble de l'exposition de la section photographique.

Alphonse Bertillon, display of apparatus, Chicago Exposition, 1893. Photograph courtesy of the National Gallery of Canada, Ottawa.

graphic apparatus—relying on the other to achieve a "transformation of the body's signs into a *text*."[44] Bertillon's own ideas of social engineering relied on the management of these texts, though this did not lead him to a belief in biological determinism. The material was only meaningful in the development of minute differences as a method of identification. Sekula concludes, an "individual existed *as an individual* only by being identified . . . Viewed 'objectively,' the self occupied a position that was wholly relative."[45] Photography revealed differences in ever smaller details as much as in more basic ways, such as color and gender. In those "texts" was read a fear of crime equal to a fear of disease or mental fragility, a manifestation of photography's persistent threat that the photograph reflects the future of the viewer. Photography was employed in the search for any "criterion that could ground 'signalment,' that is, the recognition or assignment of identity." This, for Didi-Huberman, is

the founding evidence for art's complicity with the nineteenth-century regime of identity, since "*at a certain moment,* any passion for forms and configurations implicates an art."[46]

An obsidian reflection of equality is achieved in the institutional archive; a community of pathology or crime is rendered through similarity as a device of othering. But, the cry goes up, how can art, which seems so far removed from the photograph as pure evidence, be culpable? In response we can answer that the classification of form, the regime based on isomorphism, is a "means of assessing imitations," which is in fact a "regime of visibility" of images and what Rancière in *The Politics of Aesthetics* calls the "regime of poetics."[47]

In Rancière's three-fold schema, the ethical regime of art governs the role of simulacra in the social good (Rancière cannot dismiss Plato), while the aesthetic regime governs art's ability to free itself from the hierarchy of art—subject matter, genre, medium. Art in the aesthetic regime "asserts the absolute singularity of art and, at the same time, destroys any pragmatic criterion for isolating this singularity."[48] Is this not the creation of a singular time as in the modernist ideal?

The history of modernity and art's response to it (particularly through cinema and photography) is one of the unification of time and space. Modernity is the creation of a unified regime of time that is codependent on capital—time as a black box. Contemporary philosophy, particularly in the penumbra of Deleuze, seeks to reintroduce us to what it sees as the real character of time—heterogeneous, unfolding, and an experience of multiplicity. For the most part, contemporary philosophy, including Rancière, looks to art to reveal this heterogeneity, and this book is no different. However, it is important to stress at this stage how clear it is that *things are not as they should be.* The revelation of heterogeneity in art—such as in the long take or jump cut in cinema, both of which disrupt cinema's unifying depiction of time and space—occurs because of a regime of the visible that imposes homogeneity. Yet if time is really heterogeneous, then what actually constitutes an event is the moment, no matter how instantaneous or how delayed, when truth enforces a singular time as a process. Nothing else could lead Badiou to suggest in *Ethics* that fidelity to the event is to "maintain in the singular time of my multiple being . . . the Immortal that a truth brings into being through me in the composition of a subject."[49]

We can see how political and artistic events constitute the truths around which "singular" histories are written, so that the history of the event of Marxism becomes its betrayal by totalitarianism, and the history of modernism becomes a fixation on the medium and its dispersal in the postmodern. In such cases, the singular event, rather than the truth it gives rise to, dominates the process. The response to the event is either repetition (what Badiou calls simulacrum), dispersal (betrayal), or a consistent invocation to the ignorance of truths that may yet be revealed (the unnameable). One cannot demonstrate fidelity by trying to repeat Duchamp's ready-mades, nor by denying their power, nor by claiming that "we're all Duchampian." Fidelity instead is an ethical process in which one is always on the lookout for new truths that disrupt the knowledge that is bound to coalesce and stagnate around an event that has passed. This lookout is tempered with the painful awareness that the event may pass one by or that to attempt to force an event is merely to produce a simulacrum. The Duchampian event will never happen again, but one should remain faithful to it. Hallward suggests that the event is "evanescent," but history (particularly history of art) is very good at trapping the event in amber. The *time* of art is the duration of its truth process, the fidelity to the change it produced at that moment, at that event. For Badiou this duration is eternal, and one suspects that the eventual forcing of knowledge serves only to support the fact that the truth always will be and always has been.

Badiou's ethics and Rancière's politics of aesthetics have one crucial thing in common in their approaches to art: both are ambivalent to the artist and the artist's relationship to the work of art. The artist enters into configuration of art, for Badiou, but only when his or her "thinking has been set in motion,"[50] at which point the artwork becomes the coalescence of artist and work based on the principle of connection that convokes the subject "as what designates the junction of an intervention and a rule of faithful connection."[51] This occurs, according to Deleuze and Guattari, as the material "passes into sensation."[52] For Rancière, the artist's manipulation of the world is to "dream of an art that would transmit meanings in the form of a rupture with the very logic of meaningful situations."[53] Thus the essential role of the artist is to produce the conditions for the event, even though that event will seek to overturn the logical system of which their very own practice is

a structuring element. Instead, political expression has become tied to art as a function of its poetics. Once again, Rancière's characterization of risk comes into play:

> These plastic or narrative devices can be identified with an exemplary political awareness of the contradictions inherent in a social and economic order. They can, however, just as well be denounced as reactionary nihilism or even considered to be pure formal machines without political content.[54]

Ultimately, for Rancière, committed political art practice becomes an event, in Badiou's sense, only by chance. At all other times it is strictly limited to poetics, the blind alley up which Rancière points after modernism.

The practice of art, as a social world of discourse, is at every level a reflection of politics. Yet that simple idea does not reflect the complexity of the relationship between the two, which is often reduced to facile simplicity. It is not enough to say, as the New Photography did, that everything is political. The very assumption denies the extraordinary power of the political event of art and vice versa. Rancière even goes so far as to suggest that the great political revolutions of the twentieth century, and the great artistic events that made up their bipartite history of modernism, were largely coincidental—modernism as a tale to tell future artists of the world's massive change.

Modernism is therefore a response to the unification of space and time (science) as a unification of the heterogeneities of form (art). The ethical camera borrowed its precision from the scientific instrument, but since it is impossible to separate that precision from form it became inevitably tied to the bourgeois culture of representation. The major problem with photography as a political art, Tagg suggests, is its coalescence into particular forms of representation, particular formats, and particular avenues of distribution and critique. Academicism is, for Tagg, a clear example of this stagnation. Instead, keeping a lookout for new events must involve pinpointing "those strategic kinds of intervention which can both open up different social arenas of action and stretch the institutional order of the practice by developing new modes of production."[55] Tagg, we must remember, was writing in 1982, the year after Sony introduced the Mavica. Even in the mid-2000s, photography and

cinema were still tied to the aesthetic of 35mm. The legacy of photography's missed opportunity has been to further indemnify the industry against potential change. Even more important, the prolonged debate over the development of new technologies and their potential to *really change things* has allowed the activity of intellectual mapping—as a consumption of hermeneutics—to flourish.

The Age of Cinephilia

At the end of his two-volume study of cinema, Gilles Deleuze outlines the philosophical potential of cinema and cinema theory: "A theory of cinema is not 'about' cinema, but about the concepts that cinema gives rise to."[56] This coda to a long hermeneutic study of the "psychomechanics" of cinema addresses both the future of film practice and the theory applied to it. Deleuze argues that one does not adopt a theory and then look for films that appear to support it. To do so suggests an agency other than cinema at work on cinema, working cinema over. The nadir of this practice can be seen whenever the critical analysis of a film becomes a leisure pursuit and whenever interpretive practices become desirable as a facet of cinema as commodity.

One of the problems of the popularity of Deleuze's work is created by the ease with which contemporary cinema offers itself up to readings from a Deleuzian perspective. For example, if one chose to confine analysis to the two motifs that we might employ from Deleuze and from Deleuze's work with Félix Guattari, then three 2000s films readily offer themselves to Deleuzian analysis (they can be read as time-images, as images of becoming): *Le fabuleux destin d'Amélie Poulain (Amélie), Chicago,* and *Morvern Callar.* The eponymous Morvern Callar's adventures after the suicide of her partner, for example, demonstrate a becoming-woman—a "beyond" of the subject-identity—experienced through her enacting the Nietzschean *ressentiment* in various forms.[57] The stark juxtaposition between the becoming-woman at the end, flirting with the publishers of her (in fact, her partner's) book, and the girl at the beginning is a key theme, as demonstrated in the conflation of the two images in the film's theatrical trailer. Morvern's description of what "doing books" offers her is played over the images of her subsumation

into a menial existence (working in a supermarket) and eventual escape from it, all the while dominated by the evanescent presence of her dead partner, either by the soundtrack tape given to her as a Christmas present or in the constant sickly glow of the festive lights that illuminated their last (and the film's first) embrace.

If becoming-woman is a solitary activity, a personal transformation, in *Morvern Callar* (UK, dir. Lynne Ramsay, Company Pictures, 2002), then it is a molecular activity in *Chicago* (USA, dir. Rob Marshall, Loop/Miramax/Producer's Circle, 2002), as the passage of women through the prison's doors suggests a constant milieu, a transcendental space of becoming, a "haecceity [with] neither beginning nor end, origin or destination."[58] Here, Roxie's becoming-woman engages every role expected of her, from winsome girl next door to wisecracking femme fatale, and plays them out in the extended mental space of the imaginary Onyx Theater, the huge sound stage created to allow the big musical numbers to be performed in situ.[59] As in the musical comedies on which it is based, here the dream-world is one of movement "that the dance will outline."[60]

The same implied reality is inferred in *Amélie* (France, dir. Jean-Pierre Jeunet, Studio Canal/UGC et al., 2001), although it is better read as a world image, a concatenation of memory images ("sheets of past") of France and French film, Truffaut and *poetic realism* in particular.[61] Through this, Amélie herself is a Deleuzian becoming-child, a child of cinema and its culture, as is the film—noted by Dudley Andrew.[62]

Deleuzian readings of films are thus quite adaptable. But since the development of some of the first really perceptive Deleuzian analyses of cinema by Rodowick, Ian Buchanan, and others, the stakes have changed.[63] Deleuze's position in the academy—indeed philosophy's position—limits the potential activity of applied philosophy as a detection of the creation of concepts. Deleuzian readings are complicated by his late disavowal of analytical film theory; his critique seems to predict that even those types of cinema that, for him, once provoked new thoughts and thus new theories—Italian neorealism, *la nouvelle vague,* New American cinema—would eventually become part of the analytical toolbox to *take* to a film. With a generation of filmmakers and film watchers likely to have grown up with Godard and Antonioni, Kubrick and Dogme presented in the lecture theater as well as the cinema theater,

we might ask how can cinema extend itself—do something new—if the tools for analysis and production are from the same cultural milieu?

The effect of this convergence of theory and practice can be observed in both theory and practice. The cinema image, marketplace, and exegesis have taken on the character of *cinephilia,* a cine-literacy that goes beyond creative homage or postmodern reference and employs the theoretical reading of a film as a token of its cultural exchange value. This includes knowledge of the historical and contextual position of film studies itself and has led to a debate over the forms of cinema and their relationship to politics. Like the New Photography—indeed, British film studies shared some of its major personnel—film studies experienced a political Marxism in the 1970s and early 1980s that has become part of the repertoire of film scholarship. The academicization of this political approach has been mirrored by the diversification of the forms of spectatorship that film watching involves—from the cinema to home video, DVD, and the Internet. For Thomas Elsaesser, this transformation of the political and technological spheres of cinema has had two effects: The political approach of early film studies, especially the emphasis on the subject demonstrated in journals such as *Screen,* has been drip-fed into the new academy "in ever more diluted versions." At the same time we, as contemporary cinephiles, "know too much about the movies, their textual mechanisms, their commodity status, their function in the culture industries and the experience economy."[64] Elsaesser's accurate assessment is complicated by the receding into the past of the event of film studies' political transformation of cinephilia. It is unclear whether the political approach of the 1970s should be viewed as a mistake or simply as an event from which later generations of film scholars are excluded since they were not its witnesses. Contemporary cinephilia is left looking for new possibilities of rupture and seeks strategies with which to do so.[65] Deleuze's *cinephilia,* with its occasionally simplistic or dated treatment of authorship and technology and its neglect of the role of the social in cinema, seems outwardly incompatible with this technological expansion and pedagogical change.

That Deleuze is seen as ignoring or refuting the subject in cinema is perhaps because there are effectively two Deleuzes that have been adopted in film and cultural studies. One Gilles Deleuze worked with Félix Guattari on the deterritorialization of the subject, most famously

set down in their proposals of becoming: becoming-woman, becoming-animal, becoming-imperceptible. The other Deleuze identified cinema's psychological automatism, its relation to movement, time, and perception in modernity. Both approaches are combined in the study of the creation of the subject through societal, psychological, and cultural formations. In holding to a notion of subjectivity as always coming into being, this privileges the agency of thought in the production of art (hence Deleuze's attention to the role of the director in cinema). Thus cinema is involved in the creation of the subject in societal, physical, and aesthetic ways. For Deleuze it also involved going beyond the subject, provoking new concepts of subjectivity in its own particular way. These could be detected, as it were, by theories such as those that Deleuze developed with Guattari. Born of cinephilia, Deleuze's philosophy is a useful test for when cinema does indeed go beyond the commonly available knowledge of production, analysis, and interpretation—the *technique and critique* that he described as "informatics." When it does, this cinema engages or passes through aesthetics to question the terms "source" and "addressee." Above all, Deleuze firmly held that cinema is a prelinguistic regime of signs from which language, narrative, and the subject are created, and that the "life or the afterlife of cinema depends on its internal struggle with [this] informatics."[66]

The nature of the subject as forming and formed by the mechanical arts reflects the photographic paradox and represents, Ian Buchanan suggests, "the supreme paradox cultural studies must confront."[67] The problem inherent in the "transcendental empiricist subject" that Deleuze develops from Hume is that it converts to universals (common sense, public opinion) what it experiences through relations. The subject exists *between* thought and experience. For Deleuze, as for Henri Bergson, the cinematograph was a production of a modern thought; it corresponded to the society created by modernity and then helped shape that society's perception of itself.[68] Society is suggested here as being an interplay of what William Bogard (after Guattari) described as "smoothing machines" that mesh together and that are "geared to the production of subjects." These inhere practice and experience: the rituals of cinema-apparatus-auditoria is thus a "paradigm of smooth social exchanges."[69]

The aesthetic dismantling of the classical apparatus was the focus of the politicized film studies of the 1970s that began to undo the work

of the smoothing machine ahead of (and from outside) cinema practice. Hermeneutic theory had an agency that would break the spell and liberate the subject from the ideological constraints of western, mainstream cinema. The dismantling of the notionally unified subject seemed complete when, in 1993, Miriam Hansen suggested that "*the* spectator" required new analytical tools because the modes of distribution, access, and reception had changed. Hansen also noted that, retroactively, scholarly activity might itself have had a crucial agency in the psychomechanics of cinema: studies in spectatorship may "have mummified the spectator-subject of classical cinema."[70] Jacques Aumont reminds us, for example, that "the dark room and immobile spectator have been retained as an absolute and universal model."[71] In spite of the diversification of cinema distribution, it remains rooted to this ideal, and added to it are conventions of monstration and narration (such as the one-hundred-minute running time or particular narrative trajectories). Anxieties about the advent of digital technologies have taken longer to appear in cinema's discourse because only in the middle years of the 2000s did the threat from digital technologies seriously mature. Yet the subject convoked by cinema remains in place, and this has had a particular effect on the destiny of the political approach that fostered its analysis.

The Hermeneutic Crisis

A frequent point of debate, if not an actual crisis, is the lack of confidence in engaged hermeneutics. This does not share Elsaesser's ambiguity and is instead encapsulated in Chris Rojek and Bryan Turner's critique of cultural studies as "decorative sociology." At heart is the conflict between the aesthetic or interpretive study of texts and the sociological or political study of systems. In place of a collective agenda for social reform is a diluted aestheticization of politics as well as a politicization of aesthetics—the "academic reading of culture" through texts.[72] This is echoed by Michael Sprinker's identification of cultural studies' tendency to think of itself anthropologically while acting within the society it studies. The widespread expansion of cultural studies in the academy means that the discipline adopts the right (political) attitude but an ambivalent position vis-à-vis the culture industry. If not actually

"free advertising for the industry," as Sprinker intimates, it at least suggests a political/commercial ambiguity and cultural studies as a cultural practice.[73]

This has parallels in consumer studies, where André Jansson has noted that the consumption of objects relies on both a reflexive awareness of the object's image and an outward appearance of *that* interpretive skill. Consumer products and media products become cultural products on the basis of the hermeneutic processes, and cultural communities are based "on semiotic expressions of a shared interpretive framework."[74] Jansson takes as his guiding principle Scott Lash and John Urry's notion of "reflexive accumulation," referring to penetration of the consumer economy by the notion of culture itself. The active self-construction of identity and the centrality of interpretive consumption have combined to create fixed and consumable identities that "may largely be trying people on."[75]

This consumption of hermeneutics places a huge emphasis on the role of the intermediary, analogous to Jürgen Habermas's notion of opinion leaders in an age of mass media.[76] For Habermas, the modern public sphere is constituted by the coming together of private individuals, in which is formed a "common sense" formalized by the culture industry as self-evident and as *public* opinion. Plebiscitary linkages appear to connect authority from above with the (grassroots) society of the private, autonomous, and free individual. Such a dynamic describes the role of the social interlocutor in the creation of public opinion as a *universal aesthetic judgment,* the black box of hermeneutics. Opinions guided through commercial interests are disseminated in a public forum (e.g., style culture), with knowledge attracting a premium, and finally expressed as the critical judgment of the autonomous and cultured individual.

At the same time, the rise of cinephilia as a characteristic of consumption following this reflexive paradigm is illustrated in diversification of the cinema industry beyond the multiplex and into the home. This again follows the pattern of digital technology's jolt to the industry. When digital video discs (DVDs) were introduced in 1997, less than 25 percent of studio revenue came from theatrical releases.[77] Sell-through DVDs provided a vastly higher profit return than did video rental, and the profitability of repurposing studio libraries in this digital

lingua franca made the expansion of the DVD market in this area easy to predict, as Nicholas Negroponte famously did in 1995.[78] One-fifth of the first issue of DVD titles were films from library stock, followed up by an increasing share of the home video market driven by classic film.[79] Studios now openly target their graying audience with diverse products such as anniversary issues, special editions, and best picture boxed sets. Instrumental to this audience activism is the plebiscite (the TV film poll, magazine top tens, and the studio consumer poll), serving as an industry feedback mechanism to develop a corpus of best films that appear to convey public opinion as a universal aesthetic judgment.

Jay David Bolter and Richard Grusin have suggested that digital media offers unprecedented access to the highest quality version of films, an essential part of the home cinema concept and something different from the ordinary consumption of video.[80] This obvious targeting of the consumer connoisseur served to ally sell-through DVD with a perceived respect for, or love of, cinema itself. Combined with the cultural reinforcement of film polls and sales through indie record stores (as happens in parts of the United Kingdom), this emphasizes consumer choice based on the hermeneutic dynamics of lifestyle consumption. Sell-through DVD is thus a paradigmatic example of reflexive accumulation, with hermeneutics operating as what John Rajchman calls "achievement" skills.[81] Where does this leave us? Reflexive accumulation of this type is based on a conviction on the part of the interpretive consumer that the subject *will* be created by this knowledgeable consumption of cinema or at least (in Habermas's terms) by the publicity of this consumption.

The Uses of Deleuze

We can ask further where this leaves a Deleuzian approach that always hovers between reading texts and the *detection* of the creation of concepts. The problems created by the popular reading of films are demonstrated in the controversy that followed *Amélie* from multiplex cinema through Cannes and into the mainstream and political press. The ambivalence of *Amélie* and its/her open indebtedness as a child of French cinema led it into a consequent cultural inertia it found difficult to rise above.[82] *Amélie*'s cinephilia involved a combination of nostalgia

and the flourish of new technology. Computer-generated effects show us Amélie's heart racing, her emotional melting at the sight of Nino. It also romanticizes Paris by cleaning it of dirt, graffiti, and the racial heterogeneity of the contemporary city. Its ultimate drawback was not its racially whitewashed Montmartre, the focus of critical opprobrium, but its inability to even enter a discussion about this image of French and Parisian identity. The erasure of its one ethnic other, Lucien, and the homogenization of race and gender suggest a missed opportunity to discuss it as a culturally reflexive phenomenon.[83] In an early sequence Amélie gazes across a digitally cleaned vista of Paris, imagining fifteen Parisians coming to orgasm—they are all white, all heterosexual (or almost all are unambiguously so). There seems no hint of irony in the depiction of Frenchness, and yet this itself provoked a violent difference of opinion. Nostalgia can be a reverie for one, a sickness for another (a vertigo, what Deleuze described as "a becoming-mad of depths").[84] Such contradictions account for the mixed reaction to *Amélie*'s depiction of Frenchness (and especially race) as both populist and reactionary, leading Frédéric Bonnaud to suggest the film reflects "the French public's confusion in the face of worldwide homogenization."[85]

The cinephilia of *Amélie* is neoclassical, a purification of cinematic form that incorporates new technology in a memory image of the past. Following Elsaesser, we might say that it is a mediated memory of Frenchness. A more complex problem of cinephilia is created by the

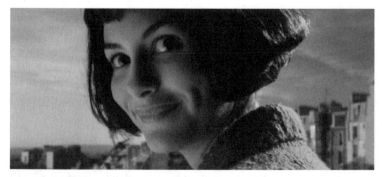

Le fabuleux destin d'Amélie Poulain (Amélie) (France, dir. Jean-Pierre Jeunet, Studio Canal / UGC et al., 2001)

gradual establishment of once avant-garde or nonmainstream techniques within a more general cinema practice. John Rajchman suggests, "Deleuze declares that the highest function of cinema (as distinct from the generality of films) is to show, through the means peculiar to it, what it is to think."[86] But what happens when the generality of films adopt the modes of resistance that produce the necessary rupture to provoke thought? Put more simply, what happens when filmmakers begin to see audiences as "becoming more sophisticated"?[87] Such are the cumulative effects of cinephilia. The parallel with cultural studies' crisis is clearer here. The notion of the time-image, for example, is expressive of alterity, a breaking away from the mainstream through diverse techniques and interpretations that is attractive to a politicized reading of aesthetics. Intermediary processes, such as the academy and the *use* of theory, potentially contribute to a consumer society in which the *visibility* of particular knowledgeable interpretations of cultural forms is at a premium. In the creation of a certain type of interpreting (cinephilic) subject, cultural studies always risks becoming an information machine whose product is opinion and whose practice is taste.

Deleuze did predict, in the last few pages of *The Time-Image,* that the new image would "depend on an aesthetic before depending on technology": the time-image would use the existing vocabulary of cinema, the "original regime of images and signs."[88] This would be taken up by new technology as an act of closing down or opening up of the image. Echoing Rancière, we might say that cinema practice is always balancing on a knife edge between the promise of a genuine becoming-thought and the *risk* of collapse into cliché. Peter Hallward notes, "We have a knack for transforming our active, open or creative dimension into reactive closure and inertia."[89]

We might ask, once again, what role the artist as maker plays in the provocation of thought. Auteur filmmakers, for example, are judged on how they demonstrate their schooling in the work of others: Lynne Ramsay is indebted to Bill Douglas, David Lynch, and Andrei Tarkovsky. It is this enthusiastic critical commitment to Ramsay as an auteur, in deciphering her "forte,"[90] that is complicated by the in-joke at the end of the film, the publishers' courting of Morvern as a prodigy. Certainly, Ramsay's attention to the cinematography suggests a strong

Morvern Callar (UK, dir. Lynne Ramsay, Company Pictures, 2002)

poetic sensibility, with an acute awareness of depth of field and the contrasting flatness of the screen that tells the story of Morvern's grief through mental connections—a raindrop on a windowpane becomes Morvern's teardrop, while points of light are thrown in and out of focus, bathing whole scenes in variegating sickly colors.

Yet the film is also a critique of authorship through Morvern's theft of her partner's book, replacing his name on the cover page to thus assume his identity (she raids his bank account, hides his body). No matter what the text might tell you about the author, the person actually answering for it, as Morvern does to her publishers, may defeat any reading. Morvern as forger reflects the storytelling function, Ramsay as forger, just as Orson Welles was a forger for Deleuze.[91] The publishers' attempts to elicit the "real" Morvern demonstrate how our universal aesthetic judgment relies on the "self-evident truths" of an author's biography. Gregg Lambert summarizes, "[For Deleuze] the forger appears precisely at that moment when the philosophical pretension to 'truth' is revealed to harbor within itself another hidden motive."[92] The power of *Morvern Callar* comes, whether intentional or not, from Ramsay entering into a configuration with the film as its proclaimed author, even though the configuration suggests that all authorship is in one way or another a forgery and that Ramsay's visual deftness is the forger's sleight of hand.

For *Chicago,* director/choreographer Rob Marshall came from the stage, freeing the film from the drag anchor of cinema auteurship. Similarly, no other element of authorship stands out from the film, neither progenitor Bob Fosse nor the film's many stars. *Chicago*'s precarious possibility for the provocation of thought—what cinema did next—comes from an engagement with new technologies as well as a continued experimentation with what cinema can still do as cinema. In the elaborate musical numbers, the movement of lights guide the image; theater lighting and operators are brought in to allow the sequences to be shot in situ as performances: "the movement of light is like our camera-eye."[93] Then the montage was orchestrated to follow those lights as well as the musical score, close-ups inserting corresponding visual beats. The whole is a configuration or coming together of all the elements in a manner specific to cinema as a production process that relies on both the stagey effect of the musical numbers as well as the suspension of disbelief. Renée Zellweger is still Renée Zellweger, but she *is* Roxie Hart. That Deleuze makes a similar point about Gene Kelly or Fred Astaire does not explicitly ask us to seek out direct parallels with his own examples in a manner of divining them. In its heyday of Astaire and Mark Sandrich, Kelly and Stanley Donen, and especially Kelly and Vincente Minelli, the musical was, for Deleuze, a cinema never closer to "the mystery of memory, of dream and of time."[94] Roxie's becoming-woman is similarly a dream danced on a fantasy stage (the Onyx) but also ranged against these figures of the musical's history and the paradox of photography that they represent. Watching Kelly dance as Don Lockwood dancing as Gene Kelly. Renée/Roxie does not simply complete the character references made in her imitations of the musical's famous women. We never stop watching *Zellweger* as she passes through this configuration of memory and dream—cinephilia as a configuration of cinema's impurity.

The signature number "Roxie" denotes these refracted identities in its reminders of the virtuality of celebrity, "somebody everyone knows." The person *becoming* chooses identity, puts on identity, rather than be subsumed by it, to have identity put *them* on. Samantha Morton puts on Morvern Callar (another act of forgery), and Renée Zellweger puts on Roxie. Renée/Roxie's becoming-woman passes through the generic path laid out for her in the history of the musical. These *ressentiment*

Chicago (USA, dir. Rob Marshall, Loop/Miramax/Producer's Circle, 2002)

narratives of the musical are something to pass *through* as she cheats marriage (Ginger Rogers, Jane Powell, Audrey Hepburn) or death (Nicole Kidman, Björk, Natalie Wood, and Jean Seberg). Instead she inheres these roles and more—Ginger, Marilyn—but also Madonna, Fred, Gene, and, even in the last gasp of her signature song, Elvis. This is an altogether different convergence than that seen in *Vidocq, Amélie,* or even in *Chicago*'s computer-generated 1930s streets. The mix of live stage, real film, and digital editing is an imperceptible use of technology to transcend identity and a convergence of mediated memory no longer linked to particular archetypes of the photographic image.

Whether we can call this an event of photography remains to be seen. The latest event of photography may be, as we shall see in chapter 7, a move away from cinema altogether and toward a different flickering image. The latest event of photography is not digital, though it may yet be provoked or enabled by the new technological capabilities. The latest event of photography and cinema is not likely to be political, given the ambiguous status of interpretive strategies and academia in an age of the consumption of hermeneutics. This has affected cinema far more than photography or art in general, and crucially it has forced us to consider for a moment the efficacy of philosophies of aesthetics in the divination of the event. This is necessary since Deleuze is an important touchstone for us in rethinking the time of photography.

The project that follows is precipitated by an interest in how photography and cinema came to cement their peculiar relationship with time and memory. After Badiou, we might say that classical and neoclassical cinema achieved this through the process of purifying *itself* through reference to its other—photography as the black-and-white print, as the grainy, jittery image of Super 8. Rancière explains Badiou's position from the opposite perspective, "Cinema is not just made up of the mixture of other arts. Its own proper, defining characteristic consists in impurifying them."[95] Between this chapter and the last, our task is to develop a taxonomy of photography based on its own introspection and impurification—when cinema looks at photography and when photography looks at cinema. It is a demonstration of how the relationship between photography, time, and memory got to the point where digital technologies were unable to break its regime. Deleuze, for example, is useful in detecting how photography's relationship with cinema offers new concepts of time and memory that lie under the surface of the tropes that we have come to know so well and that cinema attempts to purify. But this book will also produce a new understanding of photography as always coming into being, as a relationship between technology and intention that always offers the precarious possibility of a new event. Even while we map the indeterminate field of photography, we are using a strategy that always has the potential to overturn the very regime that we describe.

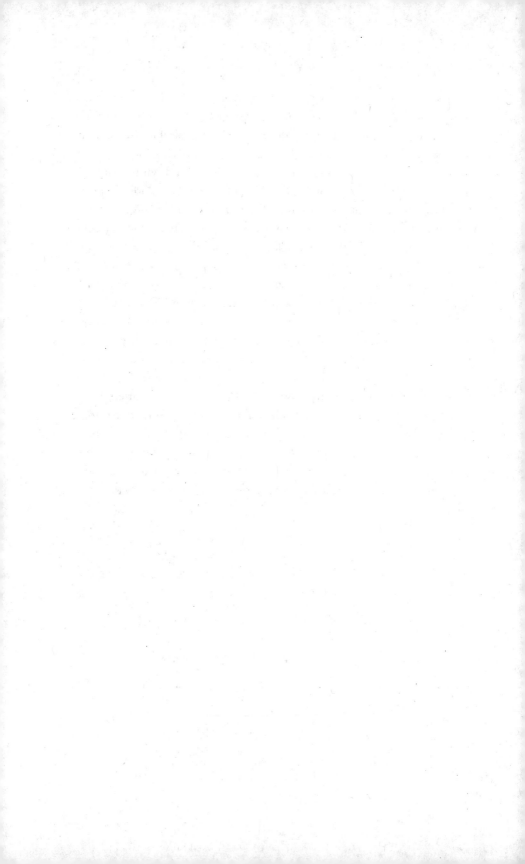

2 PHOTOGRAPHIC MEMORY, PHOTOGRAPHIC TIME

A Snapshot of Memory and Time

In Michael Powell and Emeric Pressburger's 1946 film, *A Matter of Life and Death* (UK, dir. Michael Powell, Rank/Archers, 1946; released in the USA as *Stairway to Heaven*), pilot Peter Carter (David Niven) suffers brain damage after bailing out of his stricken plane over the North Sea. During his recovery, his position on Earth becomes hotly contested between the doctor trying to cure him (Roger Livesey) and the fantastical bureaucrats of the next world, whose oversight it was that caused him to survive the plane crash in the first place. As this battle of wits ensues, Carter is given over to a series of nervous attacks during which he is seemingly stopped by a heavenly official or conductor in the guise of an eighteenth-century French aristocrat (Marius Goring).

> CONDUCTOR 71: She cannot wake; we are talking in space not in time.
> CARTER: Are you cracked?
> CONDUCTOR 71: Look at your watch. It has not moved since you said, so charmingly, "Drink, darling?" Nor will it move. Nor will anything move until we have finished our little talk.

These attacks are almost always signposted by depictions of time of differing abstraction, and the most striking of these interrupts a table tennis game. The ticking sound of the ball as it is passed from player to player is abruptly stopped, ball in midair, as if a clock were stopped. Time itself appears to be interrupted. In this silent world, the present exists only as an internal experience. Chronological, abstract time has been halted, and his experience is one of pure change or duration. Time,

A Matter of Life and Death
(UK, dir. Michael Powell,
Rank / Archers, 1946)

no longer governed by movement or sound, is simply duration: as long
or as short an impression of being as it needs to be.[1]

The film is useful to us because we can use it to take a snapshot
of our experience of memory and time: Carter's experiences of walking
in the interval between time and duration mirror our own experiences
of the photographic image. At its deepest level, life exists as absolute
change, a duration defined only by the interaction of objects and percep-
tions. This duration is the foundation of life, a transition or change that
is substance itself. Gilles Deleuze, in his work on Bergson, describes du-
ration as "a *becoming* that endures."[2] Our own position within duration
relies on us making sense of experiences of the present, our memories
of the past, and our awareness of the oncoming future. This situation is
full of tumult and paradox, and perhaps this is why the photograph—
with its own paradoxes—always seems to reflect it. Photographs can be
used to quantify time in the same way that a measuring stick or trac-
ing can quantify space. Perhaps this is what led the photography critic
Estelle Jussim to describe time itself as a metaphor reflecting the dif-
ficulty we have in expressing a "complex set of experiences concerning
past, present and future."[3] If this is the case, then it is a metaphor reliant
on memory and our experience of recollection and on the ways in which
we map our own past through memories and their traces.

In the physical world, we generally understand the organization
of time through movement in space, a *sensory-motor schema* we can best
describe through the sweep of the hands on the face of a clock. This

is generally regarded as objective and incontrovertible, constant and knowable. However, in *A Matter of Life and Death* Carter's experience of time within his interludes is governed only by his own perception, reduced to its most fundamental relation of memory and duration. His experience involves two alternating impressions of time: one is the *objective* time of the world, and the other is informed only by his memory and imagination. Throughout the film, he is forced to deal with his predicament through a discussion of life built up from his own recollection. This comes to a final dénouement in his "trial" as he is forced to argue over not only his own past but also a greater past of Britain and America. The political aims of the film in 1946—to cement postwar Anglo-American relations—give rise to an unfolding of recollection: the past of the English and Carter's own past are intermingled as both the prosecution and defense call up jurors from Britain's past. This mirrors the process of memory Bergson called contraction: we place ourselves first into the past in general and then into regions of the past, an operation he called a contraction-image. This past continues to exist as a virtual image; it continues to grow as change endures. The past thus coexists virtually with the present that recollects it. In *A Matter of Life and Death,* for example, Carter continues to return to the chronological present of his lover, June (Kim Hunter), and his convalescence after his rescue, creating a recent past as the film progresses. Carter falls in love after he is missed by the Conductor, a fact that is offered in testimony in his later "trial" in heaven, yet his falling in love in the chronological present coexists with his nonchronological interludes of perception (his heavenly encounters). Here we see the two types of time. On the one hand we have the chronological time of our ordered world, Carter's world of RAF bombers, four o'clock tea, and chess. On the other we have the nonchronological time of experience, a mixture of personal memories, shared memories, and imagination—demonstrated in the heavenly conversations we see between Carter's doctor and John Bunyan, for example.

Another way of understanding contraction in memory is through the experience of the chaos of the present—the paradox of past and future that it seems to represent. Our memory is thus always focused on locating ourselves in the present, recollecting all relevant pasts, and predicting all possible futures in even the simplest, most banal sense.

We create images of ourselves in the present, our identities created by the organization of recollection and imagination:

> We find ourselves in a movement—which we will examine later—by which the "present" that endures divides at each "instant" into two directions, one oriented and dilated toward the past, the other contracted, contracting toward the future. . . . It is clear that memory is identical to duration, that it is co-extensive with duration.[4]

So we have three elements that make up the time of our own identity: duration as the ongoing change, memory as our awareness of duration (the image of duration) and time, and the sense of past, present, and future from which our awareness is created. These are in constant motion and interaction, even though we depend heavily on time as reliable and our identities as unchanging. In Carter's story his illness makes unclear the distinction between them. After Carter consults with the heavenly Conductor, his perception images of the earthly world change. In a meeting with the Conductor, they discuss Carter's need for a heavenly advocate for his trial, the oncoming stage of his illness when he will have to fight for his life. This is the future as a virtual image of perception, yet one that will eventually come to pass and be actualized, especially significant when the doctor is killed and joins Carter's heavenly counsel (where he meets Bunyan, a hero of Carter's). Once this has happened, the doctor's advocacy in the trial stands for Carter's physical struggle, metaphorically as well as psychologically. At this point the earthly and heavenly become not only reversible but also indiscernible from each other, and the actual world and the virtual world become crystallized together. The ways in which time is organized are disabled, or more precisely, memory and imagination begin to reflect or refract each other in a manner that creates a disorienting self-consciousness. Carter's interludes are therefore what Deleuze calls crystal images of time:

> Time has to split at the same time as it sets itself out or unrolls itself: it splits into two dissymmetrical jets, one of which makes all the present pass on, while the other preserves all the past. Time consists of this split, and it is this, it is time, that we *see in the crystal*.[5]

Carter's medical condition blurs the distinction between the two "jets" that he experiences; he seems to exist in the interval between them and

even crosses between them. The interval in this case is like a surface or plane, a facet of the crystal, as if Carter views time as a collection of reflections and refractions on it. When the predicament Carter faces is at its sharpest, he stands next to June and looks through a windowpane at the surgical operation being performed on his own body.

Crystal images of time expose the difference between time as a metaphor and the duration that it attempts to express. For Deleuze, lived experience is effectively a composite of duration and space, one giving us internalized progression ("a becoming that endures") and the other giving us an exteriority without progression (understood through movement). Consciousness is the exchange between the two. Memory is composed of recollection images and contraction images—the two basic *directions* of perception. It is from recollection that perception flows, and the brain makes sense of its world by organizing recollection. Part of this organization is chronology as the organization of heterogeneous duration—expressed as in the dissymmetrical split—into a homogeneous progression based on movement in space. The hands of a clock express time only through their ordered homogeneity. Duration still endures as a nonchronological becoming but is hidden from common sense by an image based on a sensory-motor schema. Duration as pure becoming is obscured by a chronology that is used to comprehend but also ultimately "denatures it."[6] The formulation of cinema chronology, for example, can also be understood as an organization of recollection. This organization is a mirror of perception: a psychologization enacted in order to make sense of Being. The brain seeks to create discrete recollection images from the continual whole of memory in order to make sense of it as a history of one's own experience of duration.[7]

When we turn to *A Matter of Life and Death,* we can see how it provides a useful illustration of our impression of time and its relationship to the photograph. As Carter experiences his first heavenly episode and time stops, he exists within the moment in a similar manner to the way we experience a photograph. The photograph opens out to an attenuated moment, a suggestion of time passing that has a different experience internal to it. This is an image of duration as an "intuition of the Whole," D. N. Rodowick notes, which is only later organized into past and future.[8] The stilled moment in Carter's imagination is like

A Matter of Life and Death

the photograph that balances succession or progression of time between past and future. Carter's episodes are a figuration of the individual frame or photogram[9] of cinema or the internal equilibrium of the snapshot. The instantaneous photograph reverses our relationship to duration, a reversal that gives photography—both as optics and as imprint—its curious power. With a photograph we are presented with an image that is static but that nonetheless can give a powerful sensation of time passing. We are suddenly internal to the change of the world and can glimpse the enormity of past and future that the photograph suspends. We are therefore like Carter's doctor when we see him in a giant camera obscura observing the constant passing of the everyday. Ordinarily we might recognize without comment that the camera obscura is the model for the photographic camera. However, the photographic camera as we know it, when pressed to the eye, appears to capture time, taming it or making it subordinate to our subjectivity. In so doing, we extricate our subjectivity from the photographic plate, imagining our objective control. Yet when we step back into a camera obscura, and there are many examples still in place around the world, we are given a powerful illustration of the nature of our real relationship with time. This is the relationship with time that Deleuze understood from Bergson:

> Bergsonism has often been reduced to the following idea: duration is
> subjective, and constitutes our internal life. . . . But, increasingly, he
> came to say something quite different: the only subjectivity is time,

non-chronological time grasped in its foundation, and it is we who are internal to time, not the other way round.[10]

Photography's history, however, has been one in which subjectivity has been excluded from the internal mechanism of the camera. First the drawing implement and then photographic cameras operated as a lens or mechanism through which the world could be viewed, subjectivity hidden behind the laws of optics and chemistry. What was forgotten was photography's ability to depict time as a passing. This is perhaps also because in much criticism this ability has been reduced in popular conception to the frame from which cinema is constituted—photography's subordination of time down to the instantaneous moment is, for many, evidence of its final destiny in cinema. The photograph is often considered timeless, negating time or simply poor in comparison to cinema. André Bazin, for example, might have talked of cinema as "change mummified," but photography, for him, "embalms time" itself.[11] Such an approach only considers time as chronology and does not consider the possibility of an image of time that is not based on a sensory-motor schema. What we have forgotten, and what the camera obscura and Carter's experiences in *A Matter of Life and Death* remind us of, is a different experience of time altogether, one that is very different from chronological time and that can be considered only in terms of pure duration. This is developed by photography, to the extent that "timeless" does not *necessarily* mean "durationless." This forgotten time of the photograph is given shape once again by Deleuze's philosophy of time that, ironically, relegated the photograph to playing a small part in a cinema's technology.

Movement-Image, Time-Image, and Crystal Image

Deleuze is perhaps now most widely known in aesthetic criticism for his books on cinema, which reconsider its practice and history and reorient them around a discussion of time and perception that Deleuze developed from the work of Henri Bergson. The books are not an attempt at a written history of cinema, although Deleuze himself has described them as a natural history of sorts. His aim instead was to classify cinema according to images, signs, and compositions "as one classifies animals."[12]

Deleuze intentionally avoids orthodox classifications of cinema, such as division by genre, public taste, or genealogy, and instead guides the reader toward two basic understandings of cinema: the *movement-image,* whose narration is based on a rational organization of time and space (the sensory-motor schema), and cinema of the *time-image,* which breaks such a system of representation to confront directly our perception of time. All cinema has developed from these two types of image.

Deleuze does not propose, in the movement-image and time-image, opposing systems of meaning or necessarily conflicting modes of representation but rather a single principle that flourishes in two alternate modes: the movement-image, which has its ontological basis in the movement within the cinema apparatus; and the time-image, which exploits any awareness of this reliance thus (arguably) leaving it behind. In a reversal of this relationship, Rodowick suggests that all cinematic images are potentially time-images because they begin as purely optical or sound situations that are organized into succession by montage.[13] How can these two approaches to cinema be reconciled? Perhaps the answer lies in many of the criticisms of Deleuze's classification of cinema that tend to delineate the movement-image and time-image as being characteristic of mainstream/Hollywood and avant-garde/European cinemas respectively. Rancière, for example, extends this criticism to suggest that Deleuze becomes mired in the Modernist turn toward the autonomy of the work of art expressed through its relationship with its medium—what is often called medium specificity. For instance, both movement-image and time-image cinemas have the capacity to realize the "original identity of thought and non-thought," a powerful philosophical capacity.[14] As such they also share a similar capacity to make the classification of cinema as an art form the vehicle for the control of the world and the restriction of any potential for new thought. This is the artistic risk discussed in chapter 1, and it is one that both schemes of cinema share equally. Rancière's proposition is that the two images of cinema instead exist in a spiraling interdependence, as if they are a kind of DNA of cinema. The two images of cinema are the result of the two "lives" of the same gene—indeed, the notion of the genetic in Deleuze's classification will have profound relevance for photography.

Deleuze's first volume is an elaboration of the differing types of movement-image cinema that have grown from one fundamental con-

cept: the cinema apparatus divides time into discrete and static units—frames or photograms on the filmstrip—that it reconstitutes to give the impression of time through the representation of movement in space. Deleuze saw the photogram as an immobile section of time because it fixed movement into stasis or equilibrium. He saw the reconstituted cinema image (or shot) as a mobile section of time because it strung these photograms together to create an image of motion. The organizing principle within the apparatus and in the movement-image it throws up is chronology: the logic of the action image created is, in a way, a reflection of the movement of the film through the camera/projector.

The movement-image requires more than simply the movement of the filmstrip in the camera and projector. Something else must be added in terms of a quality of movement. Consider an early scene in the Fred Astaire and Ginger Rogers musical *Shall We Dance* (USA, dir. Mark Sandrich, RKO, 1937). In the scene, ballet dancer Pete (Astaire) yearns after jazz hoofer Linda (Rogers) who he has seen only in a souvenir flip book. Pete and friend Jeffrey (Edward Everett Horton) gaze at Linda, an object subordinated to their male gaze via the flip book passed between them. Pete skims the pages, exclaiming: "That's grace, that's rhythm." At the end of the scene, as Jeffrey skims the pages, the flip book dissolves into film of Linda on stage, dancing and fending off another male admirer.

The later plot of *Shall We Dance* involves Linda attempting to avoid Pete by settling down to marry another man. After a number of misunderstandings and rejections of each other, as is common in the Astaire/Rogers series, Linda is reunited with Pete in a rooftop number in which he dances with a chorus of masked "Lindas." At one point he dances along the chorus line, flicking the arm of each dancer until the real Linda is revealed—thus ends a narrative that began with the flip book and the dissolve into film. In order for the dissolve to work, the sequence from the flip book is obviously printed from this subsequent shot of Rogers dancing. This is a display not only of the quaintness of precinematic forms (the flip book was, of course, a simple variant of the kinetoscope) but the machine of cinema itself. This moment of reflexivity, when cinema looks in on its own photographic evolution, is telling.

Photography plays a supporting role in *Shall We Dance,* yet the film's foregrounding of cinema as animated photography is crucial. On

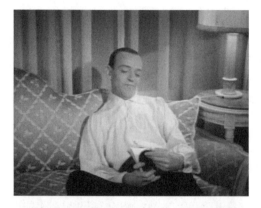

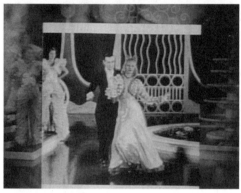

Shall We Dance (USA, dir. Mark Sandrich, RKO, 1937)

the one hand, it demonstrates the movement-image of cinema: the abstract movement of the photograms through the projector's gate. On the other hand, it self-consciously refers to the press and merchandise industry that surrounds cinema, and Astaire and Rogers in particular. Fred looks at Ginger in the same way that fans do, so that the illusion of cinema also foregrounds the illusion of stardom, and the tactility of the flip book—which invites touch in order to reveal its charm—contrasts with the intangible memories of the film. Cinema merchandise relies heavily on the desire for memory itself as much as the desire for particular memories or for particular stars. As such, photographic objects like this, as with any "timely" picture, are intended to evoke particular memories. They exist, Jussim reminds us, "not just as excitements for the present, but as potential memories in an undefined future."[15] Through this reflexivity cinema is also able to explore conceptual issues

of subjectivity and the image. The "whole universe becomes cinematic," Patricia Pisters suggests, in these instances of metacinema.[16] The individual photographs of Linda are propelled into movement by desire, ours and Pete's, while the flip book reference to cinema is more than a conceit—it is an organization of scopic desire itself, legitimized in the dissolve. The spectacular culture of the cinema and its desiring gaze, part of a wider gendered culture of looking, is inherent in the apparatus of cinema and its organization of space and time into chronology.

From the immanent link between machine and visualization, Deleuze classifies movement-image cinema as a system of representation that organizes itself around larger and larger sections in chronological order. The shot is an extension of the sequence of photograms or still frames; montage is extrapolated from the shot, and from montage flows narrative based on cause and effect. However, Deleuze was not satisfied that this cinema adequately expressed time in a way that truly mirrored or engaged our own perception of it. Drawing on his work on Bergson (as he had done in the concept of the movement-image), Deleuze identified certain cinemas that did not rely on the sensory-motor schema in order to depict time and that instead depicted it directly through a disruption of this schema. The organizing principle is not chronology but a disruption of chronology that reveals time understood only as change, a pure causality that Bergson described as duration *(durée)*. This organizing principle creates the cinema of the time-image. In detaching itself from the chronology, this cinema does not offer any direct readings or perceptions that might be based on a sensory-motor recognition, as in the movement-image. Instead, interpretations and reinterpretations can be understood as unfolding in time from a cinematic image that confronts the perception of time directly and in the absence or disruption of the sensory-motor schema.

Perhaps the most intriguing of Deleuze's classifications is the crystal image, which can be seen as a character—or genus—of the time-image. In *A Matter of Life and Death,* the crystal image is a strange self-consciousness created by the intermingling of sensations of time. Similarly, for Deleuze, shots in film that linger a little too often, the constant use of mirrors, and sometimes the mobile camera are examples of when the subjective perception of film is forced into an awareness of itself as subjective. Of course, they are crystal images because they disrupt the logical system

of cinema narration on which they rely, but they do so by adding to the time expressed by cinema. Cinema offers a perception, a particular way of seeing. When we watch cinema, we surrender wholly to this way of seeing, not expecting it to be foregrounded or questioned. However, with the time-image, and the crystal image in particular, there is not only perception but also the perception of that perception, a kind of cinematic self-consciousness. This is never simply a reflexivity, or basic self-awareness. Instead, Deleuze views this relationship as one of being in circuit: not only is it an unbroken exchange (the circuit is a perfect example of irreducible movement), but its only direction or progression is to lead to further reinterpretations: "The actual optical image crystallizes with *its own* virtual image, on the small internal circuit. This is a crystal-image."[17] It is the constant emanation of mental images that creates the crystalline structure. Interpretations are never allowed to rest in the crystal image and only ever lead to others.

This calling into question of cinematic meaning is the time-image's political potential, and a common acceptance has been of the time-image as de facto a politicized cinema of the left. Rancière's subtle argument of the risk that cinema takes in being an art is clearly a critique of this assumption, or at least of ways in which the philosophy can be read. The strength of Deleuze's philosophy is really in its destabilization of the binary organization that structures so many of the ways in which we consider the world. The values of subject and object involve just such a binary system of organization. Binary logic is incapable of accounting for the diversity, multiplicity, and heterogeneity of our culture, suggests Deleuze, and cinema (especially the time-image) plays an enormous part in his attempt to develop concepts beyond the limiting values of subject and object. The time-image questions that most basic, most fundamental of assumptions, the apparent order of time and space and the logic of this order that goes unchallenged. The time-image reveals the pure change of the world and, most important, our attempts to understand it. Using cinema, Deleuze can critique perception and intellection, as Bergson attempted before him. From this point Deleuze is able to challenge anything that relies on a stable, fixed, timeless identity or quality; subjectivity is one such thing. Furthermore, in connecting cinema's relationship to perception with its mechanical apparatus, especially the photographic apparatus, Deleuze's philosophy has an ability

to connect a philosophy of perception *of* cinema to a philosophy of perception *in* cinema and finally to narrative and authorship, thus making it a philosophy that connects the material or the plastic with concepts that are relative to it. It is with this in mind that we turn our attention to photography and especially the photograph.

The Photography of Perception

For Deleuze, the photograph's destiny was as a photogram on the filmstrip, and he was fairly satisfied with its part in the sensory-motor schema. He thus tied the photograph to the *false movement* of cinema that Bergson described in his *Creative Evolution* of 1907:

> Cinema, in fact, works with two complementary givens: instantaneous frames which are called images; and a movement or a time which is impersonal, uniform, abstract, invisible, or imperceptible, which is "in" the apparatus, and "with" which the images are made to pass consecutively.[18]

The reason why Deleuze never fully explores the photograph as time-image is simple and direct: its part in the sensory-motor schema renders it antithetical to Deleuze's conception of a direct image of time:

> Photography is a kind of "moulding": the mould organises the internal forces of the thing in such a way that they reach a state of equilibrium at a certain instant (immobile section).[19]

Deleuze's use of photography does not end here, and he returns to an earlier, crucial point in Bergson's *Matter and Memory* of 1896. There Bergson describes the role that photography plays in the way that we conceptualize our own view of the world:

> The whole difficulty of the problem that occupies us comes from the fact that we imagine perception to be a kind of photographic view of things, taken from a fixed point by that special apparatus which is called an organ of perception. . . . But is it not obvious that the photograph, if photograph there be, is already taken, already developed in the heart of things and in all points of space?[20]

This passing notation is in fact fundamental to Deleuze's conception of photography and his Bergsonian concept of space. Deleuze follows Bergson's idea of space as being continuous and contiguous, exemplified in the notion of the "any-point-whatever" as the only way to express the

indivisibility of movement itself.[21] Perception is perspectival, Bergson suggests, and involves "the discarding of what has no interest for our needs."[22]

Perception itself creates an image of the brain as a perception organ that acts individually and that reflects its image of the universe as if onto the ground glass or mirror that it is unable to penetrate without refraction or distortion. On the other hand, the universe is already an infinite multiplicity of viewpoints that makes up the whole. The screen or mirror for this is a plane of immanence that Deleuze suggests is made up of "as many eyes as you like," from which the eye that senses is "one movement-image amongst others . . . because the eye is in things."[23] Thus perception is a limitation of the whole by an interested point of view. According to Bergson, *"What you have to explain, then, is not how perception arises but how it is limited . . . reduced to the image of that which interests you."*[24] We can see how this might easily assume the specular paradigm of photography, whose very nature is a selection and framing of time and space. Opposed to this is the notion of images without a viewer or addressee, in the manner that cinema cannot have any fixed correspondent; films are not a means of direct communication until a very specific logic is used to formalize them (the movement-image involves such a logic). This does not suggest that cinema is without meaning, in fact, quite the opposite. The importance of cinema conceptually relies on the abundance of meaning that exists while the image is indirect—as a pure optical situation, or opsign. Deleuze further develops an idea from Pier Paolo Pasolini of an image that corresponds "neither to a direct discourse, nor to an indirect discourse, but to a *free indirect discourse.*"[25] The *proposition* of this exists in all images as pure optical situations, and so unbeknownst to Deleuze his philosophy in fact calls into question the redundancy of the photograph. However, the weight of custom is behind Bergson's "photographic view of things." The photograph is historically prized for its ability to privilege certain views—not only of space but also of particular instants of time.[26]

For Walter Benjamin, writing many years later, the articulation of time as a process of historiography was a process that seized "a memory as it flashes up at a moment of danger." Photography is therefore a kind of "materialistic historiography, based on a constructive principle"—a kind of forging of memory, as we shall see more and more.[27] From this

constructive principle Eduardo Cadava concludes that "there has never been a time without the photograph, without the residue and writing of light," as if the very process of history were itself a lightning trace of privileged instants from the past.[28] Cadava picks on the florid example of the 1886 novel *L'ève future,* by Villiers de l'Isle Adam, in which the gift of photography is the gift of *history* itself. Yet Villiers's novel, which incorporates a semi-mythological Thomas Edison, owes as much to the thrusting technological evolution of public seeing as to the philosophical dimension that Cadava gives it. Early on, in a chapter translated as "Snapshots of World History," Villiers laments, through the character of Edison, the absence of photographers to record epochal moments of biblical history and mythology:

> Photography too has come along very late. . . . Too bad. For it would have been delightful to possess good photographic prints (taken on the spot) of *Joshua Bidding the Sun Stand Still,* for example. Or why not several differing views of *The Earthly Paradise,* taken from *The Gateway of the Flaming Swords;* the *Tree of Knowledge;* the *Serpent;* and so forth? Perhaps a number of shots of *The Deluge, Taken from the Top of Mount Ararat?* . . . And photographs of all the beautiful women, including Venus, Europa, Psyche, Delilah, Rachel, Judith, Cleopatra, Aspasia, Freya, Maneka, Thais, Akedysseril, Roxalana, the Queen of Sheba, Phryne, Circe, Dejanira, Helen, and so on down to the beautiful Pauline Bonaparte! to the Greek veiled by law! to Lady Emma Harte Hamilton![29]

Thus the whole of history is reduced to a staccato procession of *cartes de visite* of significant figures. The predominance of the (gendered) view suggests a spatial imperative clearly informed by the nineteenth-century popularity of photography of the exotic—a power structure that demands noting. This is a photography of the past modeled on the investigative nature of looking itself, tied to the time expressed by looking.

This strong relationship that photography has with history relies, in part, on the cognitive relationship between photography and memory still accepted to this day. The phenomenon of "flashbulb memory," developed in the 1970s by Roger Brown and James Kulik, is used to explain how the surprise of a public event can improve the brain's ability to recall the event in extraordinary detail.[30] The defining paradigm for this is the anecdotal rehearsal of the moment of hearing that John F. Kennedy had been assassinated—"where were you . . . ?" Brown and

Kulik themselves drew on the work of Robert B. Livingston, who suggested a kind of neurological "Now print!" order caused by biological or social situations that force a memory to be created, as a survival mechanism or due to emotional stress.[31] People will remember those events that have economic or political significance to them. Brown and Kulik further suggest flashbulb memory as only an *analogy* or *metaphor,* since these recollections are indiscriminate in the same way that photographs are: "There is something strange about this recall. . . . Indeed, it is very like a photograph that indiscriminately preserves the scene in which each of us found himself *[sic]* when the flashbulb was fired."[32] Later researchers have even noted the increasing role of mediation in the "telling" of major surprising news events, compounded by a close interest in the aftermath and effects of events, such as the September 11, 2001, terrorist attacks. These have been recognized as the "ideal to-be-remembered emotional stimulus" for memory research *because* of the role that the mediation of the event had in its event-*ness*.[33] Where Brown and Kulik disqualified test subjects influenced by the media, new studies recognize the role of mediation, especially via social membership and rehearsal, and its effect on the reinforcement of particular memories.[34] The shared notion of flashbulb memory is crucial to peoples' responses to events, an effect suggested by feelings of "liveness" noted by Brown and Kulik in test subjects' recall. Rehearsal of the event, even in the tests conducted by researchers, contributes to the feeling of reliving it as opposed to everyday memories. Examples such as this suggest that Bergson's 1896 argument *is* convincing as a beautifully wrought metaphor, perhaps because photographic technologies were developed partly as a response to an urge to organize perception that *could only* be met by photography, and later cinema.

With the technological advancement of photography governing its role in understanding perception, photography came to be seen as the archetypal image of objective vision, albeit a vision that frames or categorizes time and space from the point of view of an individual image of self-identity. To this perspective cinema adds the dimension of time, appearing to offer what photography cannot: "objectivity in time," says Bazin.[35] Christian Metz suggests, "Movement and plurality [in cinema] both imply *time,* as opposed to the timelessness of photography which

is comparable to the timelessness of the unconscious and of memory."[36] In fact, it might instead be argued that cinema rediscovers a particular power that photography *has always had,* and it is this, rather than a particular quality of cinema, that Deleuze's philosophy develops.

In Bergson's 1907 analysis, perception is cinematographic in that it strings the photographs of the mind together (we shall investigate this further in chapter 4). This is where Deleuze aims his chief critique of Bergson, in the sense that the earlier philosopher appears to have forgotten the "any-point-whatever" that his discussion of photographic perception revealed. Time, Deleuze reminds us, is indivisible and irreducible, hence Bergson's famous "glass of sugared water." Bergson watches sugar dissolve in the water and experiences a self-conscious tedium created by his not knowing where or when it reaches solution:

> In this respect, Bergson's famous formulation, "I must wait until the sugar dissolves," has a still broader meaning than is given to it by its context. It signifies that my own duration, such as I live it in the impatience of waiting, for example, serves to reveal other durations that beat to other rhythms, that differ in kind from mine.[37]

Time seems to speed up or slow down, with different sensations of time ("other rhythms") competing with each other. The experience is familiar to us all, for instance, as we wait for a kettle to come to the boil, but is perhaps more interesting in comparison to the similar experiences of space. The absence or relocation of a favorite piece of furniture can cause the same kind of experience, but in this case the character is clearer— our memories and the way we imagine objects to be suddenly compete with this new sensation. While we are aware of an objective measurement of time and space, a sudden shift or a kind of *transience* can cause discomfort—time and space seem to bend or unfold. This is the same effect created by the photograph and the way that it seems dislocated from the whole of time and space, only this is achieved through stasis or slowness. At a crucial moment in *The Time-Image,* Deleuze takes up this point of Bergson's in his analysis of the cinema of Yasujiro Ozu:

> The still life [in Ozu] is time, for everything that changes is in time, but time does not itself change, it could itself change only in another time, indefinitely. At the point where the cinematographic image most directly confronts the photo, it also becomes most radically distinct from it.[38]

For Deleuze, cinema does more than add mechanical movement to the photograph, but it still needs to mimic a photographic view in order to really express the qualitative difference. It is cinema being self-conscious, cinema saying it has grown up (or grown apart). A different perspective on this relationship is that cinema borrows something from photography that it was not able to achieve simply by movement. In mimicking the still image, the stilled image (such as Ozu's still life shots, but also cinematic landscapes, close-ups, and so on) attempts to find once again the ability to glimpse the unfolding, discomforting sensations of transience that the photograph can achieve. It manages this through that self-consciousness, which is in fact more than simply a reflexive gaze; it is the *free-indirect proposition* that we have seen. Photography has always had this ability to speak without having an addressee, to demonstrate without a viewer, and yet to do these while foregrounding a clear, conscious intention. In the self-conscious image an exchange is created between the scene photographed and the act of photographing or filming it. This act is not exclusive to either cinema or photography but something that constitutes their principle commonality. We notice it more in cinema only because photography makes an unremarkable feature of its foregrounding of the act of taking.

Memory, Tense, and Photography

For many years, particularly in the postwar growth of film criticism, an understanding of photography was achieved through comparisons with cinema. Deleuze's approach, for example, owes much to Metz and, before him, to Bazin. Similarly, Roland Barthes and Peter Wollen saw photography only through its limitations compared to the cinematic image.[39] The photograph has a distinct contiguity with the time and the place at which it was taken, but its relationship with time is characterized by a powerful, transfixing immobility. Photography and cinematography (the process of the photogram) indeed share the recording of reality that Barthes called the *eidos*.[40] Christian Metz suggests that cinema is an "unfolding" of the photograph into the cinematic shot, from which movement is derived.[41] The photograph here is only a photogram of reality waiting to be connected in a series that is the paradigm of cinematic movement. Wollen adds that movement itself is not a necessary

feature of action cinema, but it is elaborated by the shot. The shot itself often does not move; rather it is a string of shots that implies movement abstractly.[42] Ultimately for Deleuze, where the photograph can become a mold of space, the mobile section (the shot) presents a similar mold of change. This is the imprint of Bazin in cinema philosophy.[43]

The photograph waits for connection in order to create a sense of movement and thus time—this is the principle behind the photograph's inclusion in cinema and the history of cinema theory that has grown around this assumption. The weight of custom in our conception is often revealed in avant-garde cinema, as it is in contemporary art. Steven Pippin's photographic installation *Laundromat/Locomotion* (1999) expresses the depths to which we have become reliant on the photograph's assumed relationship with time and space in order to conceptualize movement and thus create a movement-image (as in cinema). Pippin's series of photographs display the strange absurdity of the methods by which we attempt to measure or record perception, to the extent that those methods come to project our ideas onto it. For *Laundromat/Locomotion,* Pippin built wood and brass camera mechanisms in order to convert a line of commercial washer/dryers into an array of cameras. Pippin then photographed in sequence a cantering horse and rider as they went by, recalling the Palo Alto experiments of Eadweard Muybridge.

The relationship between photograph and cinematic shot has its roots in the nineteenth-century experiments in instantaneous photography by Muybridge and his contemporary Jules-Étienne Marey. Thierry de Duve, Metz, and Wollen all see Muybridge's studies in animal locomotion as a natural precursor to the science of cinematography, perhaps best illustrated in Muybridge's development of the zoopraxiscope, a variation on the zoetrope.[44] Muybridge, a British-born, San Francisco–based commercial photographer, was commissioned by the ex-governor and railroad baron Leland Stanford to photograph Stanford's racehorse Occident pulling a sulky chariot. The experiment involved attempting to prove that all four of a horse's hooves leave the ground at a certain point midgallop, and it was finally successful in the spring of 1872. The first photograph to achieve this has disappeared from history, replaced by the results of the many continued experiments that Muybridge carried out with Stanford's support. Pippin's photographic apparatus for *Laundromat/Locomotion,* for its part, repeats not only the considerable

experimentation that went into Muybridge's shutter system—one of the first to adequately split the second—but also the disappearance of that first image. Yet the photographs produced in *Laundromat/Locomotion* could yet be the afterimage left by those first locomotion experiments, of Occident riding in from the background of the history of photography in which the horse plays such an important part. It is an afterimage of the technological trial and error of that first experiment and Pippin's re-creation. Pippin's photographs recall the mania for instantaneous photography that filled the trade and popular press in the 1870s, a mania that reflected, Rebecca Solnit notes, how instantaneous photography seemed "violent, abrupt, glorious, like lightning, a sudden shock showing a transformed world."[45]

This "lightning" of those first experiments, and the later work of many motion analysts, suggested that an instant of time lies under a perception that could be revealed by photography: while the instantaneous photograph pleased nineteenth-century sitters unhappy with having to hold their pose, it also appeared to reveal the true nature of time. As a consequence, the notion of motion blur developed negative connotations because it obscured what the eye found plain to see. Henri Cartier-Bresson's axiomatic "decisive moment" served to ratify *chronology* as an order of the world merely waiting to be discovered.[46]

Since then, the blurs and smears that indivisible movement can so easily leave on the photographic plate have become the subject of those wishing to reveal the time that has been forgotten. Produced as if to parody the fascination with the technology of photography, the work of the Bragaglias or Francesca Woodman, Adam Weinberg notes, act as visual metaphors for the "elusiveness of self knowledge," and thus the elusiveness of knowledge itself.[47] These are purposeful mistakes promulgated to signify and bring to light the absurdity of the quest for the knowledge of how perception works and in particular the reliance on the metaphor of photography.

Pippin's washer/dryer images, for instance, are crusty and dappled through the folding of the photographic paper to line the drums. They pick up the apparatus's scratches and imperfections as if the lightning of photography had left a black trace to highlight our ready acceptance of instantaneous photography.

Pippin's installation provides a link between those early photographic experiments and today's methods of motion capture in modern

Steven Pippin, *Laundromat / Locomotion (Horse)* (1997). Photograph courtesy of Gavin Brown's enterprise, New York. Copyright Steven Pippin.

films such as *The Matrix* (USA, dir. Andy and Larry Wachowski, Warner Bros., 1999). An array of still photographic cameras are used to allow the film to stop and pan around the frozen actors: space and especially time both seem totally knowable. An alternative use of the movement-image, Pippin's installation involves results that are blurred almost beyond recognition through the slow sensitivity of the paper and the poor image created by the washer/dryer's glass dome. The effect is that the horse remains majestic and the movement urgent and vigorous, and the photographic image refuses to be contained by the process and is unable to reduce time to any delimitation of the instant.

Pippin's work brings with it the historical legacy of locomotion studies. Every trace of the process—scratches, shadows, motion blur—adds to an overloading of the superficial that rolls up or "contracts" the history of Muybridge's experiments, locomotion studies more generally, and the history of photography that we write around them. This is a twin operation of time in the photograph, as it begins to adhere to memories that give it qualitative movement, an interaction between the different senses of time. Before we arrive at photography's time, there is this other time of photography, its implied history that, Benjamin says, arrests thought in a "configuration pregnant with tensions [that] . . . crystallizes into a monad."[48] For Peter Wollen, this occurs because the photographic *tense,* a fixed point of "then," recedes from the moment of looking at the image that *"has no fixed duration"* in itself.[49] Similarly, for Christian Metz, the time of the image collides with the "time of the look," an indivisible and unregulated time not reliant on a depiction of time regulated by movement.[50] In fact, the photograph contracts all pertinent images of time: there is the present of the photographic image, the past it represents, and the future of that past, which becomes the present of the image. This is Bergson's "contraction" in that, Deleuze notes, "recollection-becoming-image enters into a coalescence with the present."[51] The past does not, in fact, exist; it is only an image of memory that coexists with the present as a contraction of the past in general, and regions of the past in particular. Like memory, photography constitutes a past as an *other,* and as with memory, we enter the photograph's "pastness" in order to make sense of the collapse of the "then" and "now" that it represents: "Far from recomposing sense on the basis of sounds that are heard and associated images [opsigns and their compositions],

we *place ourselves at once* in the element of sense, then in a region of this element."[52] Deleuze uses Bergson's "cone" to demonstrate the whole of memory and the regions that make up the recollection images that perception contracts in the present. Any particular recollection image also contains an image of the whole of recollection, and both coexist with the present. Tense is annihilated in favor of contraction: "The past AB coexists with the present S, but by including in itself all the sections A'B', A"B", etc., that measure the degrees of a purely ideal proximity or distance in relation to S."[53] This contraction occurs with all photographs and is only accentuated by works such as Pippin's, whose historical references *involve* or entangle the image. Ordinarily we place photographs into sequences and contexts—the family album, the newspaper, the filmstrip—and create motor-material connections in order to tame or make sense of the paradoxes of movement and time that they are. However, whenever the photograph is left without a motor-material connection, either through dislocation or, alternatively, entanglement and involution, signification can be radical and random.

For Deleuze, this means that a photograph can occupy only the first level of signification, a "firstness" that is a kind of incomplete potentiality that he takes from the semiotics of Charles Peirce.[54] This is perhaps why Christian Metz, for example, suggests that cinema's movement is substantiated by sound, whereas the photograph's "immobility and silence" means that the image cannot unfold over time.[55] Montage, the creation of movement from the shot, is made possible by the out-of-field (or off-frame) space implied by sound between successive shots that maintain

From Henri Bergson, *Matter and Memory*. Courtesy of Zone Books, New York.

narrative continuity. The fictional space—a sensory-motor situation—is implied by a temporal structure of overlapping noises. Deleuze meanwhile suggests that firstness can deal with the logic of language but not the *proposition* of language. There has to be something prior to the first state of signification that offers the potentiality of meaning and connection and that does not rely on connection to work. This is why he chooses to parse the opsign and sonsign (the pure sound situation). The fundamental turning point in cinema is, for him, in Italian neorealism or *la nouvelle vague,* both of which often had no synchronized sound.[56] This meant that the image could be liberated from the motor-material link of cinematic narration by illogical editing, such as the jump cut or the long, lingering take.[57] The image is no longer reliant on the sequence of editing, nor indeed is it reliant on the sequence of photograms on the filmstrip.

This is what happens in the close-up shots used by Sally Potter in her film of Virgina Woolf's *Orlando* (UK/Russia/France/Italy/Netherlands, dir. Sally Potter, Adventure Pictures, 1992). Here the filmed image relies on the photograph's zero-ness. In the long, slow pans onto Tilda Swinton's face, the image seems to part from the music, and they seem to lead in different directions. The resultant image begins to adopt the attributes of the photograph, and its internal logic is not that of equilibrium but of an effervescence of movement, even though the image seems so still. The image is rent from movement and time because it resolves toward a grammatical zero state and from this time can only burst outward. An "absolute zero of time," the image has a pure potentiality offered by its sense of *"not anymore* and *not yet,"* as de Duve describes.[58] Empty of a logically based depiction of time, what is this time shown in the photograph? It is the traumatizing nonchronological time, which shatters the temporal flow of space-time and projects "the immensity of past and future" out into the time of the look, the out of field.[59]

Thus cinema's depiction of time relies on the photograph in more complex ways than are represented by locomotion experiments of the frames on a filmstrip. Each of Pippin's images has a qualitative movement of intensity as well as extensity. Not only might we imagine the whole of the horse's gallop, reconstituted in our own zoopraxiscope of the mind, but the images also reverberate with the history of Muybridge and Marey, which is laid onto the images by the artist as if it were the

lightning of photography's history. For de Duve, another paradox exists in photography that gives the image its qualitative movement. The photograph is neither purely objective nor subjective; it is an image balanced between a state of transparency (referential), such as in the instantaneous image in which the photography is imperceptible, and a state of the pictorial (surperficial) in which the photography is foregrounded. In Muybridge's animal locomotion studies, the horse's "unexpected, yet 'true' postures" revealed by photography contradict the artist's role in representing the sensation of their motion.[60] No matter how objective a photograph appears to be, there is always a self-consciousness (in taking, viewing) that threatens to overwhelm any assumed verité. The movement here is a quality rather than an extension of space, and yet this quality nonetheless exists in time. Without space and movement, this time can only be the unfolding of duration. The instantaneous nature of the photograph cannot reconcile the time of the photograph (intensity) nor the time it represents as a building block of perception and then cinema (extensity). De Duve's analysis of the paradoxes of photography—*not anymore* and *not yet,* but also the *referential* and the *superficial*—suggest in the final analysis the only possible solution: the paradox itself is the time of the photograph. This is the free-indirect discourse of the photograph, and the remaining task of this chapter is to understand the conditions under which we glimpse photography's true time.

Urgent Time

The history of photography is written as a history of the discrete instant: the photograph's perceived power is balanced on an ability or inability to freeze time. This is what gives photography its extraordinary position in cinema's history, a position that is as much a relegation as it is a promise. The conquest of action in photography, represented by the locomotion studies of the 1870s, overwrote the photograph as an exposure to time as well as light so that the older processes that took time to create—especially the daguerreotype—were lost to technological advancement. A different concept of time went with it, a time valued "as a function of the slowness of its exposure, [the daguerreotype's] status as a kind of work," as Mary Ann Doane describes.[61] This remains one of the magical qualities of photography, lauded by Benjamin and perfected

as a quality by some of the earliest pioneers. We owe the investigative qualities of contemporary timed photographs to the *photo-de-pose,* which, in de Duve's words "liberates an autonomous and recurrent temporality."[62] In the nineteenth century, Julia Margaret Cameron, for example, exploited the painful poses of her sitters—Thomas Carlyle, Lord Tennyson, Sir John Herschel—to effect a capture of life and an effect of this capture. Later, artists such as Bragaglia and Gjon Mili exploited the known effects of motion blur captured by the camera. Mili's photographs of Pablo Picasso drawing in the air with a "pencil of light" are concrete images of duration expressed by movement. The artist's whole body moves to create the image of the bull or centaur in the air, and he is caught at one point in the flash burst. Two kinds of lightning effect the photograph: the *durative* and the *punctual* together create a montage within the frame.

We might think of such images as cells of time, and as a cast or modulation of time these images are like the traditional photo-de-pose that is still practiced in amateur and domestic photography. This is the hiatus created whenever a photographer asks for an action, a performance, or a momentary stillness from the camera's subject. In this sense the command for Picasso, "Draw now!" is the same as "Keep still, try not to blink." Thus the time-lapse or timed exposure is reflective of the unfolding nature of time but also strangely limiting in its visual appraisal. The temporal ellipsis, demonstrated by Picasso's air drawing, defines the image as a discontinuous set. It is a camera-consciousness, a proposition of free-indirect discourse, but directed toward the photograph's ellipsis. The time of the photograph is here the time of the pose or the action, delimited by the action.

However long the exposure of a photo-de-pose—whether the aching minutes of a nineteenth-century portrait or the blinking hiatus of family or friends gathered for a snapshot—the time within this image becomes that of *passing:* duration is depicted indexically and metaphorically enunciated by blurring eyelids, misdirected looks, blood-red retinas. We see the passage of the photons themselves in these photographs, and it is this passing of time and light, an evanescence from presence to absence, that renders the photograph steadily immobile with the silence of the funerary, described by both de Duve and Metz.[63] Ultimately, the timed image is a confinement of time and space, a tracing as sure and complete of family and friends as Picasso's painting in the air.

Of course, all photographs are timed photographs, since the opening and closing of the shutter marks out a slice of time to capture it. But it is the notion of the instantaneous image, which appears to seize the empty grain of the passing moment, that has become the mythological entity around which photography's popularly understood relationship with time revolves. We still, to a certain extent, live with the photographic paradox. Doane, for example, contrasts the temporal hiatus of a dancer caught in a snapshot ("its signification exhausted almost immediately") with the unnerving unquietness of the still image: "instantaneity in photography is unreal time, because it always confounds presence and pastness."[64] It is the instantaneity of photography, albeit one that artificially presents time as a granular rather than fluid phenomenon, that provides the photograph with its image of time, an image that led to its "natural" evolution into cinema. The photograph is one of the building blocks of cinema precisely because it is de Duve's "unexpected yet true posture": the movement has been performed, yet the photograph refers to it in the act of happening. It is both past and present.[65]

A tragic image from the terrorist attacks of September 11, 2001, was of a World Trade Center victim, possibly the restaurant worker Jonathan Briley, falling to his death. This instantaneous image captured him in a posture suggesting he was flying, which made the photograph an iconic image of the event. Rob Kroes narrates the passage of the image from photographer to public, as photographer Richard Drew knew to "not even look at any of the other pictures in the sequence."[66] For Kroes, the falling man in the photograph "does not appear intimidated by gravity's lethal force but rather seems to defy it. . . . Yet only seconds before or after, like the others who had jumped, he had flailed, twisted, and turned" (81). Kroes reminds us, as the rest of the sequence does, that the man is tumbling. On its own the image implies an out-of-field space of the photograph, a continuance of time and space that is guided by our desire (for salvation, for hope against death). Time no longer flows from movement, for that movement has been halted, or *annihilated,* by the photograph—*and yet* change will endure. This is a qualitative change limited only by the time of the look. It is not the true ending of the fall that gives the photograph its enduring impression on memory but the possibility the photograph represents—that Briley is not falling but flying. The impossible posture of the photograph defies the logic of movement; it defies even time as logical progression—*chronological time.*

This is almost the same as Barthes's concept of the "illogical conjunction of the *here* and the *formerly,*" amended and reconstructed by de Duve to create a proposition for the shattering of chronological time: the "*not anymore* and *not yet.*"[67] However, where Barthes saw immobility as a negative value, a semblance of death, using Deleuze we can see this as the seed for nonchronological time—the "non-organic Life which grips the world."[68] The falling man photograph is also a flourishing opsign; we are trapped in the unfolding moment of improbable possibility. His is a last urgency of life that simultaneously reveals the continuum—the "non-organic Life" of Deleuze—underlying it. The horrible promise of the photograph, confirmed by the rest of the sequence, is suspended indefinitely as hope fills the cracks left by the shattering of time. The different force of time here cannot be explained by the linear progression of chronology, and Deleuze tries to identify it very specifically in opposition to chronology (chronos): the *time* of the time-image is nonchronological (cronos). All photographic images have the potential to reveal cronos, but it takes particular, sometimes unusual circumstances for us to see it. Often, as with the photograph of John Briley, it is the contrast with the photograph's expected context that discloses it.

This is the most useful aspect of Deleuze in understanding time that we can take to photography, since his approach to the time-image is to mark it out against the images by which it is normally contained. The time-image exists in spite of and because of the logic of narration as much as in alterity to it. This is why the philosophy of the movement-image and time-image is more than simply a theoretical analysis of cinema; it is instead a conceptualization of how we organize our lives and our perceptions. Underlying our useful and practical knowledge of time and space is a time of experience and life, a pure change that is unimaginable except through the shadow it leaves or glimpses it affords when its existence is revealed. This might occur naturally, but through the occasional fragment of a life or the agency of artists, the photograph can expose time through the encouragement of hazard.

The New York–based artist Nan Goldin has spent much of her career provoking the awkward revelations afforded by candid flash photography. Her photographs, taken of friends and lovers encountered in her life in the bohemian quarters of the city, are often mistaken for snapshots because of her sometimes intrusive use of the camera and its

unremitting stare. They rarely share the linguistic codes of snapshot photography, and only a few even involve frontal poses in front of her camera (one image that tears at the soul is of Goldin displaying her wounds of domestic abuse). What stimulates the visual connection with the snapshot is the moment of *double exposure* in which the characters in Goldin's life appear to reveal themselves as the shutter opens. This sensation of personal as well as optical exposure is an imprint or impression left by the unfolding of time. Photography's often cited ability to excavate the hidden depths of a person's character, the cliché that people open up for the camera, comes precisely from this glimpse of cronos. Any awkwardness we sense from the photographs is not from the sitters or those represented but from our inability to fully articulate the strange sensation of time as it unravels. Karen Beckman writes: "Goldin has stretched the temporal and spatial implications of the photograph and has linked the shifting, mimetic nature of photography to the expanded, provisional, and at times destructive views of gender, family, desire, love, and community."[69]

Some of Goldin's photographs of the everyday deal more frankly with the photographic paradox, such as "Edwidge behind the Bar at Evelynes, NYC" (1985). Why should a photograph like "Edwidge" stand out? It is neither one of Goldin's more famous images nor at first glance is it particularly well produced—it is photographed off center, with a flash glare that after a while dominates the image and that casts a light that reflects off every surface in the frame, not least of all the pale skin of Edwidge. She herself does not seem particularly happy or at ease, caught in a moment of vulnerability as she leans forward, attentive to an anonymous (and alienating) bar order. Yet somehow this photograph contains all the tenses within it, annihilating those tenses to create an image of zero duration. From this *zero-ness,* it offers the free-indirect proposition that enables the depiction of time directly.

Edwidge leans out of Goldin's photograph like Suzon in Édouard Manet's *A Bar at the Folies-Bergère* of 1881–82. The two artworks are more than similar, as if all the visual echoes (the mirror, the bracelet, the bottles) were just lazy imprints of the time that continues to burst from Manet's painting, and as if we have stumbled across a strange pool of artistic memory in Goldin's photograph. It has become well known that, because of its awkward reflection, Manet's painting urgently, even

Nan Goldin, "Edwidge behind the Bar at Evelyne's, NYC" (1985). Copyright Nan Goldin. Courtesy of Nan Goldin.

violently, resists interpretation—acting, Thierry de Duve suggests, as a Rorschach test for every critic.[70] De Duve's interest is excited by the mirror, which traps the spectator in a profound and epic gaze yet simultaneously reaffirms Manet's reputation as *un peintre de morceaux,* a seer of the everyday.[71] The same situation subtends in the photograph of Edwidge. We are interior to the time of each reflected image as the uncompromisingly flat mirror, which seems to bend or twist around, creates a membrane that traps us in the unfolding moment. The exchange between looks is unequal; it is impossible to say whether Suzon and Edwidge address us or address the dandy or an unseen customer. In each image the mirror no longer reflects the light contained within the space of the image but seems to refract the light that comes in from the space behind the photographer/painter and behind the mirror. At the same time, interpretations run into each other as if each were a refraction or reflection of another, just as the light cast by the chandeliers and the flash burst become indiscernible from the reflections off the glistening surfaces of the bottles, off the bracelets.

De Duve observes that the mirror in *A Bar at the Folies-Bergère* "obliterates the irreducible interval of time" between possible views and ensures that no viewer ever "leaves his or her place and never takes the place of the client."[72] This is a running together of interpretations that exist in time in almost the same manner as viewpoints can change, alter, and distend in space. There is no position to be cemented in this exchange of looks; the paths of light instead crystallize in a point of view, a *concetto,* that is to be had of the exchange *as* an exchange. In its visual echo Goldin's photograph does more than mimic its artistic predecessor. It is difficult to imagine this image being contrived to reflect one of modernism's most famous paintings, more so perhaps because of the indelible afterimage left by the flash glare from Goldin's camera: the point of view as a literal blind spot. It is we who bring Manet to this image, making Suzon and Edwidge virtual reflections of each other. However, where Manet gives us the question of the painter's identity, the photograph questions the photographer's existence. Instead of guaranteeing a photographer (and thus being complicit in the popular conception of the photograph as guaranteeing a referent, whereas a painting cannot), Goldin is both made visible by the flash's glare and hidden by it. She is there, and she is not there. We are trapped in the photograph by its referential series that reveals nothing but the superficial light cast on the mirror; within the punctual image of the flash photograph is the durative image created by interpretations that begin to issue from that simple bifurcation with an urgency only a break with chronology will ensure. This is no longer the timed image in opposition to the instantaneous image. This photograph is instead contiguous with the change in reality it provokes, and the act of narration occurs within its own description—the lightning is still striking, the flash still bouncing off all those surfaces. The durative unfolds within the punctual image so that, far from exhausting signification, the time of the image unfolds to enwrap the instant, splintering interpretation over and over. Deleuze's philosophy gives us a name for this: the *crystal image* of time.

3 THE DIVISION OF TIME

Modernity's Intensive Image

In a short film from 1901—the type commonly known as an actuality—
a crowd of workers and their families are seen exiting a factory. They
amble by, clearly amused, and choke the camera's fixed gaze. A man
struggles into the crowd and, obviously noticing the bottleneck out of
shot, urges the crowd on past the camera.

This is unlike many of the factory gate films that occupy a pivotal
place in film history and its philosophy. The most famous, *La sortie des
usines Lumière,* a film by the Lumière brothers in August 1894 of work-
ers leaving their factory in Lyon, continues to exercise anyone trying
to come to terms with cinema's creation of modernity and its time and
space. The factory gate film is the very image of modernity's regime
of movement in that it captures the regular decanting of people from
a space of work in which individual, unique acts are regulated and
made equivalent. The factory gate films remind us that this was also a
smoothing of reception space as well; the halls, theaters, and fairground
sideshows of early exhibition would eventually become, through one
hundred years of architectural and social development, the black boxes
of the multiplex. The Lumières' film of the factory gate exemplifies this
because it enters what Gerry Turvey described as the aesthetic prin-
ciples of actuality filmmaking, in which the filmmaking itself seems
to lean toward the kinds of events and daily occurrences that seem to
complement it so well.[1] It is a repeatable capture of a repetitious event,
in which one day's recording is the same, qualitatively, as any other.
Cinema was created to make the individual, unique event equivalent

and transferable. In fact it made this its principal mechanism of time: the event of workers leaving the factory is like the frame or photogram on a strip of film, "at once singular and typical," Sean Cubitt suggests.[2] What interests Cubitt in these earliest of films, particularly those of the Lumières, is the strange instability of a zero state of the image that these moving images present: "every image is an unstable identity seeking equilibrium among the society of images that precede and follow it."[3] Cinema seems to seek transferability of images, an equivalence that would lend the Lumières' images to the principle of the shot and thus cinematic time. In this analysis the actuality would be a short-lived example of cinematic spectacle, Mary Ann Doane relates, because in itself it is "semiotically insufficient."[4] Actualities seem outwardly to have only extensity, grasping fugitive moments in order to string them together, and their drive toward signification—and cinematic or photographic significance—stretches outward from their internal instability. The actuality, Turvey notes, would eventually become integrated into the processes of film narration and become part of the "'invisible techniques' of the 'classical film text.'"[5]

Both Cubitt and Doane recount how the Lumière films are the focus of a long debate over the birth of narrative cinema, either through the relationship of the films to the picturesque, to Edison's first few years as a filmmaker, or to the very drive of narrative cinema itself. This was the case for cinema historiography for many years, certainly between the years 1978 and 1994, before the discovery of a substantial number of provincial British actuality films, one of which shows our gentleman, James Kenyon, trying to direct human traffic. *Pendlebury Spinning Co.* turned up in the old offices of Mitchell and Kenyon, local photographers based in the northern English town of Blackburn from about 1899 to 1922. The 1994 discovery of a large number of Mitchell and Kenyon films, mostly of local events and sights from around northern England and Scotland, outwardly appears to have had little effect on the history of cinema, and certainly not on the history of narrative written around the Lumières and other early filmmakers. Despite the sheer abundance of these films (826 rolls were eventually donated to the British Film Institute in July 2000), the arrival of the Mitchell and Kenyon collection seems only to provide more of the same—more of the same events, more of the same crowds, more of the same factories. However, *Pendlebury Spinning Co.,*

as this film is known, represents a different relation of the actuality with the time and space of the modern. Substantial archival and restoration work has been undertaken, continuing the process of creating equivalence and transferability started in the late 1890s by filmmakers and exhibitors in order to create a market and later the "invisible technique" of the one-shot actuality. The result is a quaint instance of cinematic orchestration among a fascinating yet interchangeable archive of living documents of turn-of-century life.

For some historians the film illustrates how many exhibitors, like Sagar Mitchell and James Kenyon, were at ease with orchestrating their actualities. Where the Lumière films were probably made as experiments in contingency, experiments partly to test the apparatus and partly to advertise it, Mitchell and Kenyon made their films for commercial gain. Their business was to film the crowds and then to present their lives back to them, for a fee, as viewers. In contrast to the situation in Lyon,

Extract from M & K reel number 61: *Pendlebury Spinning Co.* (1901). Courtesy of British Film Institute.

the camera that toured northern England and Scotland was a visible camera whose attraction was partly in its very presence and partly in its spectacularly reflexive results. In the films of Mitchell and Kenyon, contingency melts away, such as when some workers in West Gorton miss their cue and "jump into action *after* the camera has started rolling, [betraying] the degree of construction hidden in what initially appear to be unmediated records of reality."[6] These instances break the "aleatory logic" so often ascribed to early film by scholars such as Tom Gunning: "a firm quadrangle encloses, but cannot contain, a world of unpredictable vitality and motion."[7] In this sense, the contingency within the frame is constrained, seeking equilibrium through the logic of the movement of people past the camera, as if it is the logic of the film running through the gate. For Gunning and others, Kenyon is a showman, and his presence in front of the camera is only a mild variation on the restless faces or jaunty bodies that grin and wave at the filmmakers. They will become the invisible, and then elided, images of the classical film text. So too will people like Kenyon, one of the first visible directors of film (more so than as a director of human traffic). His presence will become the same kind of footnote as the Lumières' appearances in their earliest films. Kenyon's "directing" of the people, and thus the film, has the capacity to alter or reorient our view of early film and its photographic principles away from the apprehension of reality or the grasping of fugitive moments and toward an awareness of the two-dimensional, framed image. In contrast to nineteenth-century photography, and presaging the first home videos, we can see in these films people moving in or out of the frame, composing themselves and posing themselves, shying toward and shying away. This is a logic of the image based on intension, rather than extension, a logic not of the movement of the camera or of movement across the camera's view, as if mirroring the filmstrip, but instead a movement within the frame itself.

These "recognition films," showing a healthy disregard for candid reality or actualities of everyday life, are still couched in the style of film that seems to fit the realist ontology of the actuality. For Gunning, the recognition films heal the breach in time between filming and screening, a power their local flavor gives them. The time of exposure and the time of projection become the same time, even though this is at the expense of audiences recognizing a real breach that has been crossed—the breach

between film and world. The directing of films, the acknowledgment of an intensive image within the frame from within the frame itself, is altogether different. It is a reminder of cinema's synthetic image, its creation of time and space within the image, which Cubitt describes: "cinematic time as a special effect."[8] James Kenyon waving the crowds on is a reminder of cinema's synthesis of time and space before the aesthetic discourse of the actuality rendered it invisible. Very soon, visible interventions would become cinematic malfeasance. For Cubitt, this elision would have a profound effect on our culture's understanding of time—"Cinema thus does not represent time but originates it."[9] James Kenyon's intervention on screen reveals Cubitt's brilliant thesis, where Cubitt's own example, Lumières' *La sortie des usines Lumière,* does not.

Deleuze's philosophy demonstrates that an understanding of cinema and photography is essential to understanding the division of time. When photography finally became cinema, turned toward or evolved into cinema, it illustrated a fundamental change in our understanding of time, so much so that photographic and cinematographic metaphors came to illustrate Bergson's own philosophy of perception. Rebecca Solnit emphasized the parallel interests of nineteenth-century scientific society. Scientists had one eye toward the defeat of time by splitting the second and rendering everyday time and space completely knowable and translatable. This fueled the work of Muybridge and Marey, as well as the railroad, telegraph, and telephone. The other eye was bent toward nineteenth-century science's dawning realization of the age of the earth, of the slowness of evolution, and the seemingly infinite slowness of time itself in the earth beneath our feet: "The railroad shrank space through the speed of its motion. Geology expanded time through the slowness of its processes and the profundity of its changes."[10] Attention turned toward photography, and photography became the metaphor for an objective perception that divided the world in an instant and privileged the view. The instant reflected the transition of public and private space from the open-endedness and continual change of duration to the staccato jerks of the modern, interchangeable moments that were colored or filled by work or leisure. The photographic instant divided time according to labor and leisure and returned to us an image of our perception of time and space, famously summarized by Bergson:

> Instead of attaching ourselves to the inner becoming of things, we place
> ourselves outside them in order to recompose their becoming artifi-
> cially. . . . We take snapshots, as it were, of the passing reality, and, as
> these are characteristic of the reality, we have only to string them on a
> becoming. . . . Perception, intellection, language so proceed in general.
> Whether we would think becoming, or express it, or even perceive
> it, we hardly do anything else that set going a kind of cinematograph
> inside us.[11]

So the moment became the defining characteristic of perception in the
modern—moments of arrival and departure, moments to remember,
moments to experience. This appreciation or apprehension of the mo-
ment began to be taken for perception itself, time and space understood
only through a reflexive experience: to appreciate the now in which we
live. This stringing together of moments is just as much a false percep-
tion of experience as cinema is a false illusion of movement: the central
thesis of Deleuze's work on the movement-image.

It is foolish to completely dismiss Bergson's appreciation of cine-
matographic perception since as an illustration it reflects a culture leav-
ing one sense of time for another, the older disappearing underneath.
Cinema, for Bergson, was the new spectacle of a machine that broke
up the visual world into discrete elements in order to create it, and that
was all. This very unstable zero state is what made it the perfect meta-
phor for perception, as each appreciated moment was spent suspended,
waiting to end or to roll onto the next. Cinema actualities captured the
momentous as a new appreciation of the present or of the constancy of
immediate memory. This was the cinema of Bergson's own time; the
period between *Matter and Memory* (1896) and *Creative Evolution* (1907)
was also a period of the dominance of the actuality and the spectacle of
cinema itself, the period that Tom Gunning described as the "cinema of
attractions."[12]

In offering the illustration of perception as cinema, was Bergson
simply responding, like any good teacher should, to the exciting tech-
nologies of the day in an attempt to convince the most novice of students
of a hypothesis of perception and memory? In this case, was technology
leading the philosophy, so that the metaphor stumbled into cliché? The
power of Bergson's observation is in its description of perception having
to come to terms with reality in all its complexity. Memory itself is the

mechanism that seeks to re-create the whole of experience by means of constituent parts, and it does so by laying this image of time over the image of duration that we live in. Duration is rendered invisible under the momentous time of the modern, and it is only when this is disrupted (waiting for sugar to dissolve, in Bergson's case) that it is once more appreciated. This period of young cinema and middle-aged photography is so interesting because of the remaining glimpses of duration that exist in the image even as it is reduced to extensity, even as it is made equivalent and transferable. The intensive is observable in the films of the Lumière brothers and Mitchell and Kenyon, matched by the photographs of Eugène Atget, which "stripped reality of its camouflage," subtracting the crowds of the twentieth century and revealing the older city of Paris that remained.[13] Walter Benjamin tried to describe the intensity within the image that photography had, by that time, all but hidden in the discrete, instantaneous image through the concept of aura: an ambiguity of distance and time. This was something characteristic of photography, and now cinema, and was even expressed through the comic strip: modernity's division of time.

Inscribing the Moment

The historical context of Atget's photography, and Bergson's and Benjamin's writing, was a period of wide social and cultural change represented in the visual arts, commercial art, and the industrial arts of photography and cinema. Ben Singer has described this period as being characterized by "hyperstimulus," after the sociologist Michael Davis, a category of sensory effects that either caused or exploited the new technologies and that were the subject of popular concern and debate.[14] New technologies brought new experiences of speed and rapidity, and the city brought experiences of bustle and claustrophobia. Spectacular and leisure activities exploited the sensory appeal of the dangers of new technologies and transportation, and cultural forms such as the yellow press and cinema exploited their sensational appeal either by report or by mimicry. In documenting the world changing under these conditions, Benjamin's writing and Atget's photographs act as a telescope to view the nineteenth century.[15] They were joined by commercial artists

like Winsor McCay, whose career illustrating the adventures of Little Nemo (1905–14) also reflected modernity's effect on the experience of the everyday.[16]

The comic strip emerged alongside cinema as a new form of visual entertainment that expressed the popular consciousness of time. Tim Blackmore suggests, "The reader in 1905 welcomed the speed, compression and wit of the comic strip" that was, in turn, the "product of a new mode of thinking."[17] In McCay's work Blackmore saw a friction between a mechanical mode of the stepped images of the comic strip and the languorous, intense images of narrative illustrations. Blackmore has no problem in reading McCay's *Little Nemo in Slumberland* as a knowing allegory of the mechanical onslaught of the modern world on the magical world of the premodern. McCay and illustrators in his style are described as if they were sorcerers, while the adventures themselves are presented as a paradoxical hiatus between the magical and the mechanical:

> [The] artists' work reflected the perverse situation of needing the machinery which was publishing them, while showing that the same machinery guaranteed the slow demise of the artform, the gradual grinding down and wearing away of the comic artist's fantastical powers.[18]

Little Nemo exhibits a high-level of sophistication in demonstrating time and space within one or two panels. Each individual panel of the strip, like many other comics, represents an attenuated passage of time— the characteristic moment—that both Martin Barker and Lawrence Abbott have noted as being essential to comic strip narration.[19] In most comic strips this approximates to the breaking up of time into an abstract chronology, but in *Little Nemo* structuring elements appear that present chronology as if it were *in the process* of regulation. Some panels present a discrete passage of time as defined by a movement or a collection of individual movements. At other times McCay's illustration serves to "squeeze and stretch panels to reflect the action they contain; the dynamic compositions which resulted are far from mechanical."[20] In the first case, illustration is defined by and subordinate to the movement depicted, and perception follows suit. In the second case, movement is unending in the sense that the frame does not limit (or follow the limits of) the action depicted. This is the same intense, unstable zero state that

we saw in the actuality film, yet here it is contained within the graphic illustration. The frames are instantaneous in terms of their depiction of movement and time from a point of view that is aleatory or arbitrary. (This could be any-instant-whatever of the action.) On the other hand, the time in these frames seems elongated; the frame cannot quite curtail movement or limit the time expressed. It seems that, within the regulated patterns of illustration that were coming to dominate even McCay's work, the temptation to resist the regulation of time was too strong. McCay, through his characters, pushes against the architecture of the page and the architecture of time created. This is an illustration of the creation and application of modern time, and its glimpse of duration is revealed not through the breakdown but rather through the formation of chronology itself.

In a discussion of modernity, it is easy to rely simply on the effects of the modern to display an understanding of what had gone before, to use technological discourses as analogies. Deleuze's philosophy of cinema, for example, involves stripping away the narrative characteristics of cinema, particularly the conception of time that came with it, to see what remains of time underneath. In McCay's *Little Nemo* strips, the formation of time demonstrates the philosophy that Deleuze developed from Bergson of how time, memory, and perception work. The inscription of the moment in the comic strip, here in its earliest and perhaps

Winsor McCay, *Little Nemo in Slumberland,* 20 June 1909 (detail). Courtesy of Oceanic Graphics Printing, New Jersey.

most sophisticated of forms, reflects inscription of the moment in the public consciousness.

From Bergson's work in *Creative Evolution* and *Matter and Memory* come two very different senses of time that mutually coexist, and it is these that Deleuze develops—first in *The Logic of Sense* and later in his writing on cinema.[21] Crucially, the division of one sense of time to create another gives us cinema and, through the illustration, Bergson's model of perception. In *The Logic of Sense,* Deleuze conceives an open-ended time, comparable to Bergson's concept of the *durée,* expressed only as an impression of future and past. This *potential* time Deleuze names Aion, and it has the same characteristics of *cronos,* the nonchronological time that he describes in the *Cinema* volumes as that which "splits into two dissymmetrical jets, one of which makes all the presents pass on, while the other preserves all the past. Time consists of this split, and it is this, it is time, that we *see in the crystal.*"[22]

Deleuze initially conceives Aion from the point of view of the event, which exists as an aleatory or arbitrary point on a line of "proximate past and imminent future." Incorporeal and only potential, Aion is therefore the possibility of a past that has gone before and a future that exists merely as a promise. Since these exist only in the view of the event, any event "is adequate to the entire Aion," containing the past as recollection and the future as contraction.[23] If we follow Deleuze's lead, we can describe an essentially incorporeal structure of time that operates like a funnel, the inside of which acts as the instant, encompassing the largest unthinkable amount of time and dividing Aion to create the smallest unthinkable amount of time.

Into this instant, as if into a whirlpool, the corporeal is sucked to create the moment. Rendered entirely random, or aleatory as Deleuze maintains, any point becomes the potential for every point. It is any point whatever on the line of Aion. By the time of Deleuze's writing on cinema, this has become the any-instant-whatever of Deleuze's early treatment of Bergson. In any given instant, perception grasps the event and inserts itself to create the present, which "absorbs and contracts past and future."[24] Deleuze insists that this present is random, and that Aion, if it is ever subdivided, is only a time made up of interlocking presents that overlap. The present is thus limited by the sense of the now, but

The corporeal instant. Diagram by author.

infinite in that the now cannot be adequately extracted from the whole
of duration as a discrete element: when does now end?

Deleuze's crystal image flourishes from Chronos, which is the label
given to this living present in *The Logic of Sense*. The term has come to
describe abstract chronology as the perceptual backbone of the sensory-
motor schema. How does Deleuze produce this shift? If there is a cer-
tain difference between the Chronos of *The Logic of Sense* (Chr) and the
"chronos" of *Cinema 2* (Chr'), it is at the point where the instant or liv-
ing present is burdened with a regulated succession in which the future
and past are mapped out, either conceptually by chronology or practi-
cally by the filmstrip. A tremendous force of organization regulates the
living present (Chr) to become the chronological (Chr') and in so doing
inserts an element of the corporeal into the present that simultaneously
coils up all relative presents, creating an actualized image of the whole.

This is the memory image, since it is viewed from the present and contains both the past in general and the past in particular, as we saw in Bergson's cone. This has only one effect for Deleuze, an overwhelming sense of the past that clashes with the unquiet sensation of the present that still exists. The presents pile up, creating a vertiginous effect of the here and now that cascades into an uncontrollable then. This, Deleuze describes, is variously "the becoming-mad of depth" or "depths".

But first, returning to our concept of moment, chronos (Chr') is an insertion, or drawing in, of the corporeal into the instant (Chr). Time cannot be envisaged without this corporeality: "The essential difference is no longer simply between Chronos and Aion, but between the Aion of surfaces and the whole of Chronos together with the becoming-mad of depths."[25] Thus there is a clear organization from Aion into chronos (Chr'), which passes through Chronos (Chr) toward its regulation. What we see in Lumière, Atget, and here in McCay's *Little Nemo* is the image of Chronos (Chr) that exists before the corporeal is inserted into the incorporeal and, significantly, when the instant becomes the *moment*.

Benjamin was deeply suspicious of the open-endedness of time, especially Bergson's *durée,* and instead was profoundly seduced by those "countless movements of switching, inserting, pressing . . . [and] snapping that characterised the breaking up of time that was effected by the mechanised age."[26] Even so, Benjamin was obliged to admit to elements of the living present that remain or images of the subdivision of Aion that are revealed: "Even though chronology places regularity above permanence, it cannot prevent heterogeneous, conspicuous fragments from remaining within it.[27] This is to say that within a new emergent sense of chronological time, perceptible in the workplace (the factory, the office) as well as in popular representation (photography, cinema, the mechanized press), there remained discrete elements of the former consciousnesses of time—the Aion that stretches out to become an intangible past and future, or Chronos (Chr), the ever-present present that expresses only the here and now. These are nomadic forms, constantly slipping through the grasp of ontology or phenomenology.

McCay's *Little Nemo* was never quite as popular as its contemporaries—*The Yellow Kid* or the *Happy Hooligan*—because the length of story and the surreal illustration refused to conform to the speed and clat-

ter of the comic strips that appealed to wider audiences. Instead, McCay's illustrations reflect Deleuze's "architecture of time": the visual architecture of the image reflects the duration of our reading the image. Most notably, McCay demonstrates this by reversing it. In Slumberland, the space of Befuddle Hall and its events unfold according to Nemo's dreams, with which we identify. As he dreams, so we see; perception is foregrounded and placed within the frame of the strip. As the shape of Befuddle Hall changes, the time sequence of events changes accordingly. McCay thus highlights perception before movement and time, which both increases the charm of his stories and makes an issue of the regulation of perception according to chronology. Once perception is made reflexive, the two senses of time collide, and they do so because the urge toward chronology (to follow discrete instances or frames) is in counterpoint to the line of time on which they rest and that they simultaneously make visible.

Winsor McCay, *Little Nemo in Slumberland*, 27 January 1907 (detail). Courtesy of Oceanic Graphics Printing, New Jersey.

Through a sequence of chronological panels, two perceptions of time are clearly visible. Each individual panel represents a discrete element of the whole, an illustrative trajectory that closely follows the emerging paradigm of comic-strip narration. Perception seeks to turn the movement expressed by the whole into a cause-and-effect chain that simultaneously represents the space in which it appears to occur. Scott McCloud suggests that we have been "conditioned by photography to perceive single images as single moments. After all it does take an eye time to move across scenes in real life."[28] McCay's strip presents the process of such a conditioning. The individual panel edges break the space into discrete elements, according to an urge to see photographically, as it were, and in so doing reveal an indivisible space that has been there all along. By seeing chronology in the process of emerging and by foregrounding the perception that achieves this, the strip reveals the duration underneath. And so chronos (Chr') reveals Aion.

Deleuze's development of his thesis on time and movement in cinema is made much clearer through this discussion of cinema's earliest culture. The movement-image is a regulation of Chronos (Chr) to become the image of chronology (Chr'): the "good Chronos" and "bad Chronos" that Deleuze develops in *The Logic of Sense*.[29] Moreover, as we have found, cinema's division of time is evidence of a wholesale change in the perception of time in which the durative was replaced by the punctual, and the attraction of the population to the mechanics and apparatus of cinema suggests a public awareness of this. This cultural shift produced an experience of time that could only operate through technologies of vision that were themselves spectacular apparatuses, inventions, and gimmicks. This can be seen as a relationship of coincidence, as Miriam Hansen does: "film rehearses in the realm of reception what the conveyor belt imposes upon human beings in the realm of production."[30] For Leo Charney, the drawbacks of modernity became its aesthetic advantages, "Shock, speed, and dislocation became editing."[31] Cinema was a stimulus that both caused a change in perception and represented its effects. This is discernible in photographic culture in general rather than in cinema in particular. However, the use of photography or cinema as an analogy, or metaphor, for the change in perception of time and space often neglects the *direct* influences it

had, influences that are lodged in the visual culture of the period more clearly than McCay's comic strip.

Early Cinema's Living Present

What can the Lumières offer us in understanding cinematic and photographic time? Deleuze was reluctant to consider them as anything more than gifted inventors. And since the Lumières are not renowned for significant marks of authorship in their work, it is not surprising that he gives them little more than lip service. For Deleuze, the films of the Lumières "immediately [give] us a movement-image," fitting neatly into a genealogy of cinema based on the transferability of the shot, which in turn is based on the equivalence of the equidistant snapshot.[32] The Lumières' scientific and commercial aims place them outside cinema, existing independently of narrative cinema as we know it. It is true that the Lumières had few pretensions to being filmmakers as we might understand the term. Instead, they were undoubtedly happy as "filmmakers"—engineers of materials and equipment, Jacques Aumont suggests, rather than storytellers.[33] Famously, their interest in cinema soon waned, as they pursued what was for them the massively more successful Autochrome color still process, perfected in 1907. In so doing the Lumières knowingly unburdened themselves of the task of creating narrative for exhibition and instead proffered a zero state of cinema.

This is what makes the Lumières' Cinématographe such an interesting focus of photography and the philosophy of perception. The spectacle of the process itself reveals the profound effect that cinema had on our apprehension of time and space. As a reversible process, in which the camera was also the mechanism for the projector, the Cinématographe presented itself as both the imitation of natural perception—the eye—and the demonstrator of that perception. Furthermore, life seemed to "participate in [its own] self projection," Dai Vaughn notes, given the apparently axiomatic ease with which the camera divided time and reconstituted it for the audiences.[34] The effect of bringing the still image to life cannot be overestimated. Both the scientific and popular press eagerly anticipated the Lumières' invention (spurred on, no doubt, as the brothers were by Edison's success with the Kinetoscope), and the company

provided photographs and articles on the Cinématographe process to titles such as *Le Monde Illustré, Nature,* and *La Science Illustrée.*[35] The Lumière exhibitors' stock included a representative cutting on the outer tin of each film, and the company happily supplied newspapers and journals with portions of film cut from existing footage.[36]

Anthony R. Guneratne notes that early demonstrations by the Lumières, as in the case of Muybridge before them, involved presentations of single static images *before* they were shown to reconstitute real movement.[37] For patrons, casual viewers, and the public at large, time itself must have appeared to be made up of individual and discrete elements in progression, and the Cinématographe or zoopraxiscope only facilitated the revelation or recording of that fact. Much has been made of the widespread astonishment of so many at the process, such as those patrons who, according to many stories, ran screaming from the film of an oncoming train. Such instances serve only as a further relay of the scientific advancement that was revealed within the illusion.[38]

The notion of bringing the still photograph to life is one of the strongest factors in cinema's presentation of the world, and it is at the heart of Deleuze's movement-image. Yet Deleuze was writing before the more recent extended interest in early cinema and its culture. The distinctive picture of early cinema that we can now draw, colored by new discoveries such as that of the Mitchell and Kenyon collection to which scholars such as Gunning have turned, must be used anew as the context of Bergson's account of "cinematographic perception." As Gunning develops, in the first decade or so of cinema the apparatus was itself an attraction for the patron.[39] Bergson could hardly have failed to notice the worldwide public fanfare that arose shortly after the Lumières' invention, which reached such a peak that grand claims were circulated for it to an eager public, such as the Cinématographe's faithful color.[40] Even so, Bergson was writing within a culture likely aware of the practicalities of the cinema, and a culture whose new social and work environments were characterized by regulated shocks or pulses. Furthermore, this was also a culture that consistently placed special emphasis on the properties of photography in revealing previously unappreciated truths of the world, a culture that continually placed perception within the frame of the photographic. Is it surprising then that for Bergson the Cinématographe was more than just a metaphor?

Cinema did not just reflect the popular understanding of time and space and how we might apprehend it. Instead, it actively enforced it from a privileged position as a tool of scientific investigation as well as a leisure activity and popular stimulus. This tool translated the new environment of modernity onto the screen, and its coming must have seemed providential to anyone trying to understand the way that our perception responds to our environment:

> The cinematographic method is therefore the only practical method, since it consists in making the general character of knowledge form itself on that of action, while expecting that the detail of each act should depend in its turn on that of knowledge. In order that action may always be enlightened, intelligence must always be present in it; but intelligence, in order thus to accompany the progress of activity and ensure its direction, must begin by adopting its rhythm.[41]

Rather than forgetting the thesis of *Matter and Memory* by the time of writing in 1907, as Deleuze has it, Bergson's cinematographic perception is a logical appraisal of a visual/perceptual culture structured according to the discontinuous moment as a kind of pulsing of the photography of mental life. Deleuze's overall project is to see the time elided by the sensory-motor schema that extended from the image of the shot on early cinema and that appears largely when the system of narration breaks down. However, by viewing Bergson's formulation from this new perspective, we reveal the larger philosophical analysis behind Deleuze's approach to cinema. Structures of visual culture both respond to and subsequently affect perception, hiding Aion and the unfolding experience of Chronos (Chr), but it takes those structurations to reveal the true nature of time and our perception of it. Deleuze's relationship with the "photography" of perception can be understood thus: *where the movement-image is perception subordinate to photography, the time-image is photography subordinate to perception.* The approaches of Bergson and Deleuze are each separated by a simple equation: Bergson sees perception *as* film, whereas Deleuze's approach reinvigorates perception *of* film. For Deleuze, the Lumières' work would, like all actualities, become subsumed into the movement-image, the corollary of the classical film text. However, the destiny of the actuality, especially the Lumières', in the evolution of narrative cinema is not so simple.

In hindsight, Lumière films can be seen as protonarratives, or ele-
ments of narrative. This is the argument of André Gaudreault, whose
investigation of narrative in the more famous Lumière films leads him
to the understanding that

> there are two types of narrative in the cinema; the micro-narrative (the
> shot), a first level on which is generated the second narrative level; this
> second level more properly constitutes a filmic narrative in the generally
> accepted sense.[42]

For Gaudreault, cinema has a narrativity from its birth, a narrativity de-
nied to photographs since they reproduce no movement. The Lumière
films are discrete narratives in the cinematic sense, narratives that will
extend out from beyond the shot.[43] This narrative determinacy means
that films with a more limited structure are routinely seen as being pro-
tonarrative, or primitive forms of later narrative paradigms. However,
it is a mistake to force a narrative ellipsis onto the shot in order to reveal
a simulacrum of intensity. For the most part, Lumière actualities were
limited only by the uniform length of a reel of the Blair film that the
Cinématographe used (about sixteen yards). Restricted by mechanics,
the Lumières were not necessarily restricted in time. Indeed, contempo-
rary film exhibitors in Britain advertised "Pictures by the mile."[44] The
commercial economy of exhibition exerted enough pressure to encour-
age distributors to shorten or excise shots or to begin to splice them into
ready-made programs. But the events that actualities recorded existed
in the everyday (unlike Edison's narrative films or the filmed sketches
that were soon to appear). They included regular occurrences (leaving
work) as well as views of the street and the avenue. They express a won-
der at the contingent and repeated that wonder to regular patrons. It is
not hard to connect them to the practice of contemporary photography
of the last few years, in which cell phones are turned toward sights that
would otherwise go unnoticed or remain unremarkable. Nor is it hard
to see in the repetition of the subject matter (so many regiments pass by,
so many circuses, so many factories and workshops are filmed, so many
crowds waiting for sporting events or pageants) a fascination with the
movement of the world that ekes out the time between moments of
stimulus. Mitchell and Kenyon turned their attention to the crowds that
attended fairgrounds and piers as well as sporting events and pageants.

As much as the events themselves, the crowds were essential to Mitchell and Kenyon's success and the abundance of the material they produced. This was, of course, because of the commercial imperative: by filming as many people as possible, Mitchell and Kenyon ensured a growing crowd of curious patrons to the exhibition of those same films. This produced an asymmetry in production and reveals a different effect to that expected of the creation of the moment through hyperstimulus. Behind the history of the event of the spectacle (the sporting event, the procession, the holiday) lies the time that continues. This is the time that rustles, like the leaves on the trees behind the Lumières as they feed their child for the camera in *Le repas de bébé* (1895). This is the time that bustles and throngs in the crowds on Blackpool pier or exiting the factory in Lyon. This is the time that cannot be represented by the event or by the patient waiting for the unfolding of duration. This is the inscription of time through the aleatory and the contingent, which defeats narrative because of its own quiet intensity. In representing the aleatory event, these films naturally reflect the possibility of infinite time within the shot.

In the Lumières' *Barque sortant du port* (1895), two women and a child stand on the end of a stone pier as two men attempt to row out of the harbor before them. Each time the small boat appears to make headway, the surf rolls it back. The boat never reaches the open water. This film is unlike *La sortie des usines Lumière,* in which the closing of the factory's doors creates a discrete event of the decanting of the workers. It is said that patrons of the Grand Café, where the Lumière films were first shown, poked at the screen after seeing *Barque sortant du port,* so astounded by the depiction of the water that they assumed it must have been an elaborate puppet show. Yet the film must also have seemed similar to the magic lantern slides that were so common in that even some of the most sophisticated could achieve only the simplest, cyclical movements and articulations, and from which the characters could seldom leave. *Barque sortant du port* seems to connect the magic lantern slide with the most sophisticated of modern loop technologies, and indeed it could go alongside film and video works by Andy Warhol, Douglas Gordon, Bill Viola, or Jane and Louise Wilson. Like the exercises in patience and stamina produced by contemporary video and

Barque sortant du port
(France, dir. August and
Louis Lumière, 1895). Cour-
tesy of Association Frères
Lumière.

digital performance, *Barque sortant du port* seems to emphasize the sen-
sation of experience, the feeling of the moment that will pass but is
suspended by photographic means.

The frustration felt in such circumstances, and *Barque sortant du
port* is merely one of the more famous examples, is the sensation of
the creation of memory in which the processes of memory formation
are suspended midway. This is the photographic view of things, but
one suspended before the cinematographic perception can be started.
Cinema, in this sense, is the cruel reflection of perception, reminding
us that the contingent life of the universe is subsumed by chronological
organization. This is when memory seeks to organize it, thus creating
the cascade of moments that exists as the becoming-mad of depths.

Cinema's gift to the modern perception was a framing of the crea-
tion of *moment* as part of the new awareness of distance and proximity
that is essential to experience. Miriam Hansen's work on Benjamin and
experience emphasizes this: the moment is the sum of experience plus
the experience of *that* experience, a cumulative doubling analogous to
the very birth of thought.[45] The proximity of the instant is counteracted
by an awareness of the creation of the passing moment, experienced
both as the instant that passes and the instant that will pass, creating a
sense of immediate loss. The spectacular sights and stimuli of modern
life are experienced as ephemera but with attention paid to the sensa-
tions themselves. To see the modern as defined by shock alone is limit-
ing, since it discounts the reflexivity of sensational apparatus. We search
for this in the photographic image in which, Benjamin reminds us, "the

spectator feels an irresistible compulsion to look for the tiny spark of chance, of the here and now, with which reality has, as it were, seared the character in the picture."[46] Wiped out of narrative cinema by the retake, this spark of chance is still apparent in the Lumière films. They offer the potential of future action as well as the instantaneous creation of the past. This is an *ever-present present*. In truth, the sailors rowing out of the harbor will never leave.

> *Sometimes* it will be said that only the present exists; that it absorbs or contracts in itself the past and the future, and that, from contraction to contraction, with even greater depth, it reaches the limits of the entire Universe and becomes a living cosmic present.[47]

Memory rushes in to turn this present into the *moment;* we see Aion becoming chronos (Chr') from the vantage point of recollection, which occurs in the instant (Chr). The time-image of the Lumière film is not simply the instant of chronos (Chr) as it immediately appears, but the point at which the loss of that "living cosmic present" to chronos (Chr') is felt. This is time felt in the instant, but time becoming the moment as we experience the immediate loss of the present. This is the instant as an infinitely large amount of time: the everyday event becomes the *anyday* occurrence, which opens out once more to every instant that interlocks on the line of Aion. These films demonstrate that it is not necessarily time itself, but the experience of time, that makes up perception.

The Movement of Statues

It would be a mistake to assume that the invention and success of cinema wholly reduced the photograph to the constituent of the movement-image. At the same time as the growth of cinema saw it go from shot to montage to sound, an idea of photography and its depiction of time was established in the work of Eugène Atget, even though that depiction (like that of the Lumières and Mitchell and Kenyon) was to act as a membrane between the modern time of chronology and the time that exists beneath it, time antemodern. Atget's career as a photographer (1898–1927) spans the invention of cinema and Benjamin's writing on the modern, yet his photographs, mostly of Paris backstreets, boule-vards, and a countryside devoid of people, essentially present a vision

of a city still being shaped by Haussmannization.[48] Benjamin, on the other hand, embraced the ephemeral moment and its experience of sensation. This was delicious for Benjamin because of its repeatability, its emphasis on the momentary, the passing of which was an essential part of the modern experience: "at once a conjuring of life and a witness to death."[49] Atget's photographs, for their part, seem antithetical to the pulsing of modernity and representative instead of Bergson's concept of *durée,* which Benjamin described as having the "miserable endlessness of a scroll."[50] What then did Benjamin see in Atget's photographs that would make him orient the most important of his writings around the work of this unassuming journeyman?

Of all the photography that Benjamin discusses, Atget's images are most useful in appreciating experience as a mixture of culture and sensation—subsumed into the enigmatic notion of *aura.* Benjamin first encountered Atget's work when asked to review it among a series of books in 1931.[51] The discussion of aura changes its object in Benjamin's "Artwork" essay of 1936, by which time the discussion takes on a political dimension.[52] Here Benjamin uses the term to describe how a unique work of art inheres its history of production and embeds itself in tradition. This facilitates Benjamin's discussion of photography as something that both diminishes the aura of the work of art (since it renders it ubiquitous) and simultaneously has no aura of its own. So when Benjamin describes Atget's images of Paris streets, aura is a "sticky" or "stuffy" atmosphere coalescing around specific objects, an atmosphere cleansed or purged by photography.[53] Atget's photographs capture the sensation of aura as an accrual of time through use and ritual. For Mary Price, Benjamin's competing definitions relate aura as either "cloud" or "fog": one is a cumulus of experience and practice; the other is a cloying blindness to ritual and tradition.[54] Aura in this sense is a kind of memory of the world experienced through objects and the traces left on them of practice and use. This is the contraction of memory we saw in Bergson, in which the past in particular takes in the past in general, analogous to Proust's *mémoire volontaire:* "Where there is experience in the strict sense of the word, certain contents of the individual past combine with material of the collective past."[55] The past is made useful by perception through this contraction, and only when we return somehow to its formation do we understand this as a process of making

useful. Proust's *mémoire involontaire,* for instance, produces a heightened awareness of the experience of the past, appearing, so it seems, out of nowhere. For Benjamin, famously, photographs trigger such memories, often because of their "posthumous shock."[56] Referring to the photograph of Dauthendey's suicidal wife, Benjamin cannot help but see in her image his own knowledge of her death reflected back: "her gaze reaches beyond him, absorbed into the ominous distance."[57] *Mémoire involontaire* allows the photograph as an object the ability to look at us in return.[58]

For Proust and Benjamin, perception unravels the past that informs the present, and this is perhaps why Benjamin showed a fascination for Atget's images that seem to "strip reality of its camouflage."[59] The images reveal the hidden processes by which humanity leaves the traces of its existence. In photographing the streets empty of that humanity, Atget distills a "miraculous purity" from the city, Alain Buisine suggests, a purity reduced from the extraordinary bustle of capitalist modernity.[60] Atget used antiquated equipment with no mechanical shutter, photographing the city in the early hours of summer mornings when the city streets were empty. Resistant to the onset of fast exposures and their role in the new entertainment medium, Atget's technique made it possible for him to "counter the heat and momentum of the period, to stifle its shocks, [and] to rein in its cinematic acceleration."[61]

This is why Atget's images, empty of the momentary pulsing of modernity, still dominate Benjamin's discourse. As images analogous to *mémoire involontaire,* they present memory as a sensation of looking back on events from the perspective of the traces that they leave for future recollection (through taste, in Proust's example of the madeleine). The images also present memory as a process oriented toward the future: memory is a contraction because it catapults perception forward, reconstructing the past in the real time of imagination. Only this could explain the strange contradiction in Benjamin's descriptions of Atget's images. At first they are scenes of action, waiting for the dramatis personae of the everyday to populate "every corner of our cities" (in comparison with Atget's photographs of *petits métiers,* who could be actors without scenes).[62] Later, the locations seem more like scenes of crime: "The scene of a crime, too, is deserted; it is photographed for the purpose of establishing evidence."[63] One interpretation suggests the

echoing of a past in which memory becomes history through evidence. The earlier interpretation instead suggests a pregnancy of the moment of capture, in which memory fills the stage set by the image. Both evoke the presence of people but do so because of their absence; the silence of the image directly reflects the absence of the bustle in the streets. This is perhaps the closest photography comes to having sound, the noise of the out-of-field inhabitants of the streets and boulevards, the noise of the thronging of life that is absent in the image:

> [The out of field] is connected in this case to the Whole which is expressed in sets, to the change which is expressed in movement, to the duration which is expressed in space, to the living concept which is expressed in the image, to the spirit which is expressed in matter.[64]

Buisine, echoing Metz, even goes so far as to describe this absence as a more skillful and subtle *punctum,* in Barthes's terms, than the presence of something within the image.[65] This is the wound created by an incompleteness, or emptiness, of life that remains unreconstructed in the memory. This is the punctum as aura, the "peculiar web of space and time: the unique manifestation of distance, however near it may be."[66] For Benjamin, something comes rushing back to him from the past, whether his own or not, that inhabits the space left by the ephemeral or romantic city that Atget's photographs have forsaken. When Benjamin looked at Atget's images, he was reminded of the city that inspired him to write on Baudelaire, on Proust, and on the Arcades. Benjamin saw in Atget not a connection to the modern but to what had been lost to modernity. Atget's pictures stripped bare the experience of time not as a series of shocks but as a "continuous cumulation" of the past, the physical traces left by modernity's expansion.[67]

This is why photography in general has such enormous power for Benjamin. In presenting to our eyes the "optical unconscious," photography offers not merely that which is literally beyond vision but that which is behind vision: the afterimage left in memory of life as it passes by.[68] This is why the specter of death haunts Benjamin's writing on Bergson, his coming to terms with Bergson's philosophy of modernity and the influential role of photography within it. Indeed, Eduardo Cadava urges, it is for this reason that we must reinvestigate the relationship between Bergson's philosophy and its context. Like a camera's

latent plate, closing one's eyes to the world reveals the ephemerality of the moment and an awareness of a different experience altogether, an experience marked by absence and loss, "the experience of our non-experience."[69] This is the afterimage that dominates the images of death and that presents photography as a kind of death. Whether it is through Dauthendey's wife or in recalling Kafka's immeasurably sad eyes, in the rush to fill the instant of recollection with something tangible it has become an actual body; the corporeal has become the corporal.

In this similar rush to fill the instant with the corporeal, or with what are essentially *mémoires volontaire,* the potential of such images has been forgotten. John Fraser points to Atget's images as empty "stage sets" but takes this further by suggesting a life to the objects depicted, rather than simply their passing through. Writing of a photograph of a cobbler's/boot shop on the Marché des Carmes, Fraser talks in the present tense when describing those who have worn (and will wear—it is a shop, after all) the boots and shoes on display: "the total effect in the boots picture is a simultaneous apprehension both of the lives of other people animating those boots and thousands of pairs like them, and of one's own shod feet upon the sidewalks."[70] A similar analysis could be made of any of the photographs of mannequins and any of the photographs of shirts and corsets arranged on shelves, across packing cases, and hung from windows. Atget's images immediately present themselves as images of Chronos (Chr) becoming chronos (Chr') in the way that they force the present to confront both past and future through the life of the objects represented. They are crystal images because they present directly the plucking of the instant from Aion and the flourishing of past and future from the image:

> [The present] extracts singular points twice projected—once into the future and once into the past—forming by this double equation the constitutive elements of the pure event (in the manner of a pod which releases its spores).[71]

What is curious about this particular character of time in Atget's photographs is that it is the passage from the instant (Chr) to the moment (Chr') that reveals Aion, even though Atget's photographs were never instantaneous, and it is only the empty streets and pin-sharp focus that suggest to us that they are. This passage from instant to moment is the

stage at which Aion is closest to cronos, the nonchronological variant of Deleuze's philosophy in the *Cinema* volumes. John Fuller suggests that the tranquility of the backstreets and alleys "will be interrupted by violence."[72] For Max Kozloff, each picture is a "frothing present conceived as a vision of the distant, immobile past."[73] This is the waking of modern life itself, as much as the waking of a city, as if the nineteenth century were at the same time a dark night of dreams and nightmares and the twentieth century a brilliant sunrise to be accompanied by the sound of the throng. This is also what drew Benjamin to Atget's photographs, as well as to Baudelaire and Hugo. Atget's photographs are the memory of clamor and noise, of the sound of the city itself: "When Baudelaire takes the dawn as his theme, the deserted streets emanate something of that 'silence of the throng' which Hugo senses in nocturnal Paris."[74] "Throng" always needlessly conflates "thronging." In an image of a coiffeur's shop window on the Palais Royal, Atget's camera and his body's shadow can be seen reflected alongside the artificial heads and wigs, suggesting that the image seeks to reassemble passing window-shoppers and to reanimate the life of the city. Atget was drawn to the sites of activity and bustle and picked places where the crowd would naturally throng (in front of shops, along boulevards, along backstreets as well as in ornamental parks), but he photographs them when they are deserted except, of course, for him. Since his photographic apparatus requires careful use and much attention, he foregrounds the perception of the photography/photographer even though he steps aside or huddles behind the camera. Atget's dawn images of Paris have a camera consciousness; if there is loneliness in his images, it is because there *is always* someone there.

Atget's contemplative style was informed by his use of older technology and revealed only rarely when a passing artisan left a smear of movement on the photographic plate (a barrow boy exiting a shop, in one instance). Yet these elongated instants tell us more about the relationship of the photographic image to time than the impossible posture of the snapshot. It is in Deleuze's philosophy of time that we find the true definition of the instant, the pure division of Aion as a living, cosmic present: "it will be said that only the past and future subsist, that they subdivide each present, ad infinitum, however small it may be."[75]

Eugène Atget, "Coiffeur, Palais Royal" (1927). Photograph courtesy of Scala/
Museum of Modern Art, New York.

The question remains: how do we appreciate this without falling into
the trap of the instantaneous photograph, without being caged by the
ellipsis of the shutter in a timed exposure?

The answer is to subtract from the image the retinal traces of the
mechanism, to appreciate the photograph not as the instant that reduces
but as an instant that unfolds to reflect the infinite reaches of time.
Looming out of the photographs of the Parcs des Sceaux or Versailles
are the statues placed there to create a historical landscape of grandeur
and elegance. What Atget captures instead in the early light of dawn is
the unkempt array of figures "being read the riot act by nature," Max
Kozloff observes, "which chips and fissures and has overgrown them
in a tantrum of decay."[76] For Buisine, the elegant portrayal by Atget
of *Gladiateur mourant* at Versaille is not so much an image of a gladia-
tor dying in battle as instead a "ghastly leprosy gnawing away at his

body."[77] The magical contradiction of time was best appreciated by Jean Cocteau who, in his 1945 film *La belle et la bête,* portrays the beast's castle as if it has been revealed within Atget's photographs of Parc des Sceaux or Saint Cloud. Like Atget's images of monuments to Venus and Vertumnus, Cocteau's restless and omniscient statues, coming to life to protect and defend the castle, present a sense of time lost to the modern world.

In other photographs Atget presents time ordered as historical memory, such as in a row of statues in the Tuileries; a cascade of actualizations, they provoke for Kozloff an acute awareness of their distance from the present—a becoming-mad of depth. In other photographs that he took, however, the "riot act" of nature is a glimpse of the future. These statues will be overrun by nature, and those chips and fissures will open up to the extent that the statues will return to the natural forms from which they came. The image of time thus presented is both limited and infinite. Unlike Bergson waiting for his sugar to dissolve, we and the statues are overwhelmed by the wait itself. The longest unthinkable time of Aion is presented, as a contraction, by the smallest unthinkable time. The instant is presented in its infinite regress by the slowness of the statues in their movement toward dissolution. Always still, they always move toward the unimaginable future, and only the becoming of time is evident: they always move in general. Underneath Kozloff's becoming-mad of depths, there is a powerful effect felt from the movement of the world emphasized not in speed but in slowness:

> One common misperception about Atget's work is that since it is largely depopulated it must be lifeless. On the contrary, he was exquisitely attentive to the vitality of the world, but did not think that is was available on short or casual notice. With him, movement was never so affecting as when it was only a whisper of some imminence.[78]

Kozloff's urge was to categorize Atget's photographs as discrete images of the past; he expected to see images that reminded him only of passing, just as Benjamin did. Expecting perception that follows the punctuation of photography on the modern experience—perception subordinate to photography—they were presented with a photography that presented the limited and infinite perception of time as a passing in general. This is photography subordinate to perception, and to understand it, it seems, one needs to appreciate the movement of statues.

Death of the Photograph

This is not the sensation of time that Atget's work left to photography, which adopted instead the retinal simulacrum of his photographs in the years after his death—so many black-and-white images of storefronts and statues that mark out a history of melancholic representation. Photography became an art obsessed with the element of time that modernity ushered in, given material shape by the seductive imagery of nostalgia and loss, through which the photograph became a vertiginous image of the cosseting past: the *becoming-mad of depths.* At the source of this was the cult of Atget that grew up in the 1930s and continued with major retrospective exhibitions into the 1980s. The legacy was a photography, and even a *Photograph,* that could only be shaken from its primacy when the technology itself gave way to digital media and the Internet.

In his short article "The Death of the Author" in 1968, Roland Barthes aims a polemic at the cult that has come to surround the literary author. Barthes laments over the primacy of the author's intention over any other possible meaning, a primacy that has indirectly led to a method of scholarship that establishes hierarchies of canonical texts and contexts. In such cases one particular interpretation dominates over a text, oeuvre, genre, or in the case of photography, even the medium. Barthes's call is for a liberation of the reader from the thrall of the Author and this kind of cult that surrounds him: "the birth of the reader must come at the death of the Author."[79] This statement employs a complex metaphor, suggesting that there has already been a death, that of the ability of a text (whether novel or photograph) to live. The Author and his cult guarantee the death of the text in duration, since it fixes it in history. The cult of the Author kills discourse.

The same can be said for the photograph, which, in the 1980s and 1990s became a dead space in critical discourse. A moribund intellectual debate developed that surrounded the photograph and found its subject in the constant equation of the photograph with death (an equation that, in many ways, is still hard to dismantle). This is one of the consequences of the photographic perception, which attempts to divide duration by the moment, a geometry of the infinite bisection of time. This is the photograph as a vertiginous image of the past that either terrifies or seduces (or both) the viewer, a consequence of the failure to

see beyond the photographic perception as an organization of memory. It is a failure to see perception as subordinate to photography and as a failure to reclaim perception and thus to reclaim photography. If photography is to be seen as a *becoming,* then it must be because of this reclamation. *"The birth of photography must be at the cost of the death of the Photograph."*

Bergson suggested that memory needs objects, needs *photographs* especially, in order to leave a useful trace: "the full is an embroidery on the canvas of the void."[80] In memory, perceptual moments stretch back into the past as a coexistence with the present and form a cascade that takes shape in Bergson's cone, which we saw earlier. Perception is attracted to objects of manufacture, whether personal or industrial, in that they seize the event of creation and preserve it. Photography only does this more explicitly, as part of its ontology, so that perception—the way that we see the world—starts to follow a photographic pattern:

> Our perceptions are undoubtedly interlaced with memories, and, inversely, a memory, as we shall show later, only becomes actual by borrowing the body of some perception into which it slips. These two acts, perception and recollection, always interpenetrate each other, are always exchanging something of their substance as by a process of endosmosis.[81]

The photograph offers itself up as an ideal body into which perception and recollection slip, first as an object that records the past and second as an object that mimics visual perception itself. Each characteristic partly obscures the other, so that the photograph appears expressible of either ("it's just a photograph"; "a photograph is a memory"). This easy connection of perception to the photograph is symptomatic of the becoming-mad of depths, a seduction of the intellect that enjoys the nostalgia of memories stuffed into a shoebox or a stack of photographs. Photographs have become the material of memory to the extent that the family album, Annette Kuhn once suggested, constructs the family story "in some respects like a classical narrative—linear, chronological."[82] The becoming-mad of depths, once recollection and perception have slipped into the photograph, now inverts Bergson's cone.

In it memory images are discrete and connected only by histories and organic chronologies *(mémoire volontaire)* in an (often vain) effort to prevent rogue images *(mémoire involontaire)* from emerging out of its depth. Rogue images disrupt the order of family and social histories

The becoming-mad of depths. Diagram by author.

collected around photographs, and their peculiar power is all the more seductive in this personal disruption—witness the extraordinary auto-biographical theme of Kuhn's study and of course of Roland Barthes's *Camera Lucida*. Overwhelmed by the power of a single photograph of his mother, Barthes is compelled to write on conflation of the here and now of the past with the here and now of the present, encapsulated in the beautiful, tragic photograph of the condemned presidential con-spirator Lewis Payne before he went to the gallows:

> *"He is dead and he is going to die."* . . . I read at the same time: *This will be* and *this has been;* I observe with horror an anterior future of which death is the stake. By giving me the absolute past of the pose (aorist), the photograph tells me death in the future.[83]

This photograph, like the image of Dauthendey's wife for Benjamin, sears the imprint of death onto all photography as time after time read-ings of photographs as material memories reconstitute the becoming-mad of depths: a vertiginous array of present that extends back into the past and threatens to overwhelm us.[84] This is the sickness of *nostalgia*. Presenting the past as if to haunt us, this is now the becoming-mad of

death, and this is why Benjamin, and later Bazin, Barthes, and Metz are all drawn to photography. This is what Deleuze described as the "revenge taken on future and past by the present in terms of the present," such a powerful seduction by the "delirious future" and "delirious past" that "Chronos wants to die."[85]

Deleuze's philosophy of time offers something else to the photograph, a glimmer of hope still predicated on the conflation of tenses, but the conditional tenses of the uncertain future and past that are given riotous birth by the event:

> One cannot *say* of someone mortally wounded that he will die, but that he *is* having been wounded and that he *is* due to die. This present does not contradict Aion; on the contrary, it is the present as being of reason which is subdivided ad infinitum into something that has just happened and something that is going to happen, always flying in both directions at once. . . . The event is that no one ever dies, but has always just died or is always going to die, in the empty present of Aion, that is, in eternity.[86]

This is the living present of Chronos (Chr), which is expressed in the wonderment of the photographic instant that saves memory itself from death. What was once an "instantaneous abduction" that "maintains the memory of the dead *as being dead,*" according to Metz, is now an affirmation of lives lived and still living.[87] Lewis Payne *is* dead, but saying "Lewis Payne is not dead" is not quite the same as saying that, in this picture, "Lewis Payne is alive!" How can we speak of every photograph as having this emphatic connection with death if this image resists death, even embraces life? For Barthes, Jay Prosser has noted, the photograph is a "new place or text that includes recognition of the loss, of the oversight—of the dead as interminably lost, living *as dead.*"[88] For Benjamin the photographs of Atget marked only the apparent death of a Paris that was revealed when the streets were empty, as if within the death of the nineteenth-century city it was very much alive. In these images the Paris of the past coexists with the present, its life remains in the present, and so long as memory subsists, it will continue to remain in the present. This is the nonorganic life that is retained in the photograph in a strange contradiction: life (in memory; in the present) within death (the dying moment; the silent, dead past). The history of photography since Atget has been a continual struggle to reexamine this contradiction. For the most part it is the suspension of life as a living

dead within the photograph that has been understood as the legacy of Atget and that ratifies the photograph's relation with death for critics such as Barthes.

Atget's work might have gone unnoticed had the American artist Berenice Abbott not met the aging journeyman while she was working as assistant to Man Ray in Paris in the 1920s. Abbott took Atget's work home with her to New York after his death in 1928 and split the collection with Julien Levy. Pierre Mac Orlan, in his preface to the 1930 monograph on Atget, talks of photography as "creating sudden death . . . The camera's click suspends life in an act that the developed film reveals in its very essence."[89] From the publication of that first monograph, the rise of Atget as the "père spirituel" of American photography was assured, despite the artist never having exhibited seriously in his own lifetime in France or in America.[90] Atget thus by accident became a major artist. He had held no pretentions to artistic status, only commercial and stock photography for use by artists. Atget had even declined a credit for those images submitted to André Breton's *La révolution surréaliste,* in which they stood as *generic* images of an empty, surreal Paris. Indeed, Max Kozloff observes, the "most staggering detective work [revealed] hardly a smidgen of artistic credo."[91]

Abbott was seemingly the first to recognize that Atget's images of modern life (which were a huge influence on her own work) were created through this responsibility to the passing of time and its strange contradiction. Abbott, in her 1964 book on Atget, describes the emphatic nature of the photograph, and the photographer's responsibility to it, as "the photographer's punctilio . . . his recognition of the *now*—to see it so clearly that he looks through it to the past and senses the future."[92] This idea would later be expressed in Barthes's punctum and its concept of the terrifying defeat of time, but meanwhile Atget's images had already begun to have a profound influence on the expression of modernity through photography and the very identity of the photograph in twentieth-century life. An epigrammatic style of photography was established in the American school, beginning with Ansel Adams and Walker Evans (who both reviewed the 1930 monograph) and detectable also in the work of Diane Arbus, Richard Avedon, and Lee Friedlander.[93] By the time of the New York Museum of Modern Art's major 1985 retrospective, Atget had, according to Abigail Solomon-Godeau, been

"positioned as the exemplar, progenitor, and patriarch of modern pho-
tography . . . celebrated unanimously by the photographic community
with an enthusiasm that brooks no question."[94]

What was adopted from Atget was a sense of past times, dead
times, time that wants to die. This sense of time was applied to Atget a
posteriori: it was the melancholia of Benjamin, Mac Orlan, and Abbott
that was adopted, only imaged—or *imagined*—for them by Atget. Photo-
graphs of things that were, for these critics, in the past, became the stan-
dards by which photography was measured as a capturing of things that
had passed away. Photography of the melancholy became a style that
haunted the photography to come, from which it has since struggled to
be free, and that spread—like a virus, according to Kozloff—through
Bill Brandt and Robert Frank.[95] The academy, with its hierarchy and
ritual, made Atget's work the memory of American photography.

Yet life revealed in "its very essence" was Mac Orlan's claim, and
that "what reveals movement, is stillness."[96] This is the sense of time
imprinted on Atget's photographs by the absence of a sense of moment,
an opening of the shutter that may never close. This has been forgot-
ten from Atget's work in favor of the "melancholy objects," as Susan
Sontag describes them, which have since become the stock-in-trade of
the educated photographer.[97] What is forgotten is the life within the
photograph, the sense of duration that has been lost to the momentary
sensation of the instantaneous image. This is instead the duration of the
photograph that provokes the "intelligent recollections" that Mac Orlan
described[98] of the crowds who throng in the shops and leave traces in
the wares collected and sold in the many clothiers, cordwainers, and
milliners: all those feet for all those boots, and all those heads for all
those hats.

4 CINEMA'S PHOTOGRAPHIC VIEW

Photography's Monadic Image

In a New York street photograph from 1940, a group of children are gathered by the curbside. Two boys pick up the pieces of a broken dressing mirror that is held upright on the sidewalk, one of them bending with his back to the road in which he stands. Looking down at him is a small boy on a tricycle, who appears for a moment to be the larger boy's reflection until the secret of the mirror is revealed—the glass has shattered completely, and the boy on the tricycle is peering from behind the frame. The camera is looking through both the actual frame of the mirror on the sidewalk and through the virtual, imaginary mirror that reflects the ongoing life of this New York street. The optical conceit, which has made this photograph by Helen Levitt one of the most famous of her New York images, is the absence of reflections within the "mirror" and the subsequent echoing of the frame within the point of view of the photograph. This photography enfolds time, rather than time unfolding from it, as we saw in photographs by Eugène Atget and Nan Goldin. The absent mirror is a loss of subject as gazes and glances intersect and overshoot in the photograph's center, an invisible membrane stretched across the mirror's frame. The rest of the image is a pulsation or undulation of moments defying both the primitive clasp of the snapshot and the contemplative extensity of the lazy timed exposure. Time here is not constrained by the cinematic cut; instead it is the frame and its echoing of the photograph's framing that provides the constraining edges of the image. Just as the cinematic time-image was reliant on the cut for the language of cinema, so the photograph relies on the

framing of the image in order to express duration and the forking of time itself. The photographer and camera seem invisible to the children, to the collection of moments that intersect the image. Like Atget and Goldin, Levitt is both there and not there within the photograph. In contrast to those photographs, there is no trace of the photographer (no flash glare, no reflected body), and the only other presence is the pure camera of subjectivity.

As with much of Levitt's other work, this photograph was a result of a search for formal consistencies and inconsistencies that could be observed in everyday life, an approach that characterized American photography of the 1930s and 1940s. This lyrical style, as it became known, was heavily influenced by introduction into the U.S. gallery scene of the work of Henri Cartier-Bresson and, as we have seen, Eugène Atget. Levitt's early work emerged under the influence of Atget, as well as photographers such as Walker Evans, Ben Shahn, and others including Janice Loeb, James Agee, and Berenice Abbott (all from the background of New American photography). The then relatively unknown Cartier-Bresson had visited New York in 1935. Unlike so much of the melancholic and contemplative style of American photography that characterized the groups within which she worked (profoundly influenced by Atget's plate camera images), Levitt did not employ the photographic act as the gestural death of the stolen moment. Levitt took to the streets of East Harlem with the camera but not intent on photographing the "stage sets" that the city presented, as Berenice Abbott had done in her work. Such photographs seemed to capture only intermittently the inner world of the city, its soul, in the children who actualize briefly in dance, mime, and play in the virtual world they see around them. Levitt's photography instead attempted to convey the city's eternal and indivisible theater in which the day-to-day activities of the people become a thronging continuum from which the observer struggles to extract a fixed moment or instance. Levitt's contemporaries, such as Abbott, felt that the photograph should be related to "the life of the times—the pulse of today," so that the city's truth could be revealed whenever photography was used in an apparently objective manner.[1] In opposition to this didacticism, Levitt became known for identifying photography as *a way of seeing,* a viewpoint within and among many, and her photographs embodied the disjointed and subjective isolation of photography's episodes from the ongoing spectacle of the street.[2]

Helen Levitt, "New York" (1940). Illustration from *A Way of Seeing* (1965). Photograph courtesy of Fraenkel Gallery, San Francisco. Copyright Helen Levitt.

Sandra Phillips noted how the city at this time presented a de-centered and uniform space that excited the formalist attentions of city planners and artists alike.[3] Yet Levitt's streets are not identifiably New York streets, and there are none of the landmarks that have come to represent New York in photography. Levitt's is a decentered existence, one in which *any* street is *every* street. The New York of Helen Levitt immediately reflects the city as Deleuze saw it:

> What can be apprehended from one point of view is therefore neither a determined street nor a relation that might be determined with other streets, which are constants, but the variety of all possible connections between the course of a given street and that of another. The city seems to be a labyrinth that can be ordered.[4]

The point of view that apprehends the streets is Levitt's camera, which at once sees the street and the city unfolding and enfolding in time. Just as each street corner, stoop, or gutter becomes an object in space separated from the continuum of touching and interaction, so the act of photography creates an object in time. The *act of touching* is thus a monadic fold on which the *way of seeing* is the inflection.[5]

The monadic universe is a structure without centers and in which there is only a continuum of pleats and folds. In this universe there is no fixed subjectivity but instead only the possibility of points of view, or inflections, that take in the whole. Any appearance of multiplicity is accounted for in the pleats of the monad, and any diverse elements are simply folds and pleats of a singular structure. This is one of the extraordinary lessons we learn from Deleuze. Yet Deleuze's work on Leibniz offers us much more than this. To divide the continuum is to divide one monad into a series of monads to an indivisible degree. This is the structure of multiplicity in unity, the appearance of the monad in the *concetto* as the apex of a cone, a view that fully realizes the relation-ship as that of *any* and *every*.[6] Levitt's photograph of the broken mirror is an inflection of all her work, of every glance and gaze in all her obser-vances, in that no one single viewpoint can rearrange its constellation of glances and reflections—the broken shards and the shop window, the boy bending down, the boy on the tricycle, the other children and the passersby. Instead, the subject who looks, which Deleuze replaces with the point of view, is an ephemeral inflection folded within the image, and the monadic image is thus reflected in a monadic, shifting subject.

This is perhaps why Levitt's photographs would later become shots. *In the Street* (USA, dir. Levitt/Loeb/Agee, 1952) was conceived as "a cinematic version of Levitt's photographs" to be undertaken by Levitt, Loeb, and Agee, a filmic equivalent of the lyric poem.[7] In this film, the images extend themselves just long enough for each to become a pause, a temporal *concetto* that fixes the moment. The pause, for Phillips, becomes "a metaphor for passing," a "sense of the eternal in the momentary" in which every moment is presented in this "any-moment." Children play an important part in much of Levitt's work and their games, like any social structure, are fragmentary glimpses of order that are soon disrupted by the unexpected crowding of life, just like the children's faces crowding around the camera, accompanied in the film by unexpected syncopation in Arthur Kleiner's soundtrack.[8] The momentary appearance of the pause as a privileged instant only serves to emphasize its reality as any-instant-whatever. The stoops and sidewalks in Levitt's work act as a threshold between soul and world as much as between child and adult. Children are carriers of all the compossible futures represented by the adults around them and envisioned all too briefly in the games that the children play as not necessarily true pasts: the incompossible actualizations of the soul of the street.

It is easy to describe this notion of the threshold as liminal, or between values, and yet everything we have come to know about photography suggests that a better way of understanding photography is as a material continuum given shape by practices and sensibilities, a monad that reflects the world imprinted on it. This is why Levitt's progression toward film is so significant and yet why film cannot achieve the sense of the street as it is depicted in the photograph of the children with the mirror.

It helps if we consider how the ideal photograph, as an opaque decaying paper print of an immobile and silent image, is the antithesis of the translucent, living tissue of cinema. For more than one reason Metz argues that film "gives back to the dead a semblance of life."[9] Yet the ideal states of cinema and photography, as critical values, obscure any continuity, such as an unfolding of one to become another. This is a side-effect of the monad. Deleuze notes:

> Leibniz . . . showed that the world is made up of series which are composed and which converge in a very regular way, according to ordinary

laws. However, the series and sequences are apparent to us only in small sections, and in a disrupted or mixed-up order, so that we believe in breaks, disparities and discrepancies as in things that are out of the ordinary.[10]

The monad is a continuum in which *any* division can be made and resolved "into endless detail, because of the immense variety of things in nature and the *ad infinitum* division of bodies."[11] The critical distinctions of classical cinema, or straight photography, are really only points of relative stasis in the development of photography and film criticism. They act as inclusions—or *inhesions*—of forms, but as critical values they exist only in time, as *events*, or *objectiles*, temporal modulations in a "continuous development of form."[12] This is why Deleuze attaches importance to the *everyday* in cinema. Any division or inflection reflects every division. *Every* becomes *any*, and any particular point is merely a reduction of every possible point ad infinitum. In the monad, *any-instant-whatever* becomes *every-instant-whatever*, and photographic practice that turns its attention to the everyday automatically reveals the monadism of photography in the self-consciousness of the act of taking.

Cinema rediscovers the photograph's *free-indirect proposition*, perception held within the frame of another perception. Deleuze, like so many before him, identifies this as a *camera consciousness*.[13] This rediscovery occurs because cinema and the photograph are part of a single heterogeneity—one medium whose discourse gives rise to a multiplicity of forms. Garrett Stewart explains, in referring to (or here, growing from) the photograph, cinema simply "stalls upon a glimpse into its own origin and negation . . . its own affective and cognitive disposition."[14] This conception is based on the comparison with cinema and on an understanding of photography only as an agent of subtraction: photography is cinema's origin *and* negation; cinema can do what photography cannot. Stewart and Raymond Bellour note that the discussion of photography within film serves only to reflect film's abundance when "grasped through the spectre of photography."[15] A photographic practice such as Levitt's substitutes the contest of truth through death with a contest of truth through the time of the photographic image and its creation of subjectivity.

Levitt's photography demonstrates what William Mitchell has called the "concrete social encounter" between the photographer as eye

of power and the subject as victim.[16] Mitchell's sharp description of this style of photography as an "open espionage" takes this up in respect of Barthesian semiology. The photograph's ideological power relies on the markers of its apparent objectivity: the conventions of photographic representation that have come to be seen as the "correct" way to take truthful photographs; photography *connotes* denotation itself.[17] Such an emphasized point of view created tension with the notion of documentary truth that was fast emerging in critical discourse: questioning truth as perceived through the photographer's selectivity.[18] This tension between the transcriptive and the subjective is evident in Agee's essay for the 1965 retrospective book on Levitt, *A Way of Seeing,* where he sees the artist's task as being to "perceive the aesthetic reality within the actual world, and to make an undisturbed and faithful record of the instant in which this movement of creativeness achieves its most expressive crystallization."[19] Agee presents Levitt's work as driven by the faithfulness of the camera to reality but through an awareness of the changing fiction of reality itself. Max Kozloff similarly attests that Levitt's photography was the least tainted by the photographer's presence but nevertheless possessed a *relativity* in its way of seeing;[20] however it is viewed, her photography exposes the subjective camera and its point of view.

Levitt's photography and film together make up a labyrinth of truth and subjectivity, as well as time and space, with a single fold creating its material, genetic element, "the very division where perception occurs," according to Régis Durand. Durand suggests that memory, both cultural and personal, provides the subjects for each image to become an "infinitely complex palimpsest" in the same manner as memory informs the actualizations of the crystal image.[21] This genetic element is neither cinema nor photography but an essential part of both as the opsign: the photographic image itself. This is embodied in the camera as the object of the photographic in general, as when Levitt's movie camera is exchanged, almost imperceptibly, with her Leica.

The Baroque Camera of the Subject

While Deleuze never fully consolidates his attack on the notion of the subject in the cinema books, his later work on Leibniz, particularly on the *Monadologie,* more properly deals with the idea of a point of view.

Deleuze reclaims—or "rehabilitates"—Leibniz in order to explore the role of point of view as an inflection that strikes the monadic fold at a tangent—creating a relative, yet self-aware, apex of vision.[22] The embodiment of this is the post-Enlightenment camera, unnaturally fixing perception to exclude environment and mobility. The great E. H. Gombrich once suggested that the post-Enlightenment camera supported the principles of representation that he identified in the ancient Greek standards of mimesis in which "the artist must not include in his image anything the eye-witness could not have seen from a particular point at a particular moment."[23] This eye-witness principle is what Joel Snyder and Neil Walsh Allen had by then termed "the visual model," leading to the image as an event in both space and time, a point of relativity from which the world is viewed.[24] This echoes with Deleuze's "architecture of vision," which he takes from Michel Serres. The point of view builds the world through inhesion and inclusion based contrarily on negation or subtraction of any information not deemed useful or having sufficient cause or reason to be within the perspectival cone of vision. Perception therefore operates rather like a stonemason, hewing the material from the landscape in order to re-create it in a new image.

Deleuze never completely denies relativism: "A soul always includes what it apprehends from *its* point of view."[25] Instead, he demonstrates this elastic point of view as the organization and actualization of the decentered, virtual world and the real character of relativity. Relativism, point of view, and perspectivism are not apprehensions of a disorganized world but are the apprehension of the variation of such order and a "condition for the manifestation of reality." The subject is nomadic on the folds of the monad, and useful self-awareness comes from the realization of subjectivity as a nomadism. The photograph is always *a way of seeing* "not truth according to the subject, but the condition in which truth of a variation appears to the subject."[26]

For Gombrich, perspectivism relies on causality and a trust that viewers will believe the image because of their own environmental experience, and only a variation of optics may "jolt us out of our complacency."[27] Causality has its basis in reason, and in the *Monadologie* Leibniz announces that nothing is true without there being sufficient reason.[28] The power of this is emphasized by the pictorial conventions that have been attached to the visual reason, such as the manner in which the rect-

angular photographic image has become the practical ideal photograph. Rectilinear images follow the conventions of art practice adopted in its earliest years, rather than the practical characteristics of optics, a circular lens casting a circular image.[29]

The traditional photographic image might be chemically made, but it is culturally shaped. A real paradox exists between physics and point of view. By its operation, its mechanics, the camera carries out not the commands of the photographer who wields it with apparent freedom but rather the encoded *program* of its makers. Built up over generations, according to laws so naturalized that they have become imperceptible, these encoded instructions ensure the dimensions and characteristics of the abstract image created while the camera becomes a black box in practice and in fact. Vilém Flusser saw the camera as only a set of codes within another—sets within sets—that ensure the cultural and critical reception of photographs, so that programming widens to become *information:*

> If one now attempts a criticism of apparatuses, one first sees the photographic universe as the product of cameras and distribution apparatuses. Behind these, one recognizes industrial apparatuses, advertising apparatuses, political, economic management apparatuses, etc. . . . the whole complex of apparatuses is therefore a super-black-box made up of black-boxes.[30]

Cultural programming informs the image from the very object of the camera (with manual controls informed by pictorial ideologues) outward to the social conditions of the act of photography. Indeed, Flusser claims that we know only enough to understand "how to feed the camera . . . and how to get it to spit out photographs," while "the structure of the cultural condition is captured in the act of photography rather than in the object being photographed."[31] Flusser's is a philosophical picture of culture that synthesizes Marx, Althusser, the Frankfurt school, Leibniz, and finally Deleuze, and perhaps influenced Bruno Latour. The real intersection of Flusser's "nomadological" text and Deleuze's work is in his treatment of the image and its relation to the world.[32] The photograph is the image of a concept, and in this case, it is the concepts of the Cartesian camera that are imagined, not the free will of the photographer. Nevertheless, said Sarah Kofman,

> No eye is without its point of view, and none is passive, even that of
> science. . . . It is the perspective of those who are unaware that, behind
> the veil, there is yet another veil. . . . Descartes concludes that there is no
> resemblance between object and image. It is the mind that sees, not the
> eye, and the mind is consciousness without point of view.[33]

Kofman suggests that the post-Enlightenment camera was a tool of
drawing—yet still a *dark* room, opaque and distorting—in which the
individual eye organized the image and the whole camera's orienta-
tion, a tool to which we remain exterior. For her the camera in this
fashion offered only a "perfect model of passivity and objectivity" that
is nonetheless flattening and distorting in its outward gaze, a "frog's
perspective."[34]

Unhappy with the term "subject," with its connotation of Cartesian
perspectivism, Deleuze instead offers the *superject* as a point of inflec-
tion in the monad, a threshold where the soul meets the material. The
superject creates a virtual image of the material world, actualizing it in
the folds of the soul as "an ideal condition or a virtuality that currently
exists only in the soul that envelops it."[35] This superject finds its instru-
ment in the Baroque camera obscura in which the viewer is placed inside
the cell of the camera. The viewer inhabits a variable perception within
the camera obscura and watches an image that is a reflection of the vari-
able outer world on its walls. The camera obscura is not only the pri-
mary architecture of the Baroque for Deleuze but also the architecture
that presents us with our relationship to time. The camera obscura is a
spectacular apparatus for watching life and its changes writ large and is
rather less an objective method of dividing the instant from them.

The camera consciousness is therefore a foregrounding of the su-
perject as an ideal condition of the *soul* rather than of the object per-
ceived. Crucially, this can be identified in what Deleuze later describes
as a prehension of a prehension: a *self-enjoyment* (Leibniz's *Gestaltung*)
of its own becoming that pluralizes the monadic space.[36] This leads
to a nomadization of the monad by a self-enjoyment that is "the very
essence of an event," Tom Conley notes.[37] The camera consciousness
draws attention to itself as an event of perception, *a way of seeing* that
exists in time and that is subject to the variation of point of view. The
crystal image is a product of a baroque (Baroque) camera. This is where
Baroque architecture, in particular the camera obscura, manifests the

threshold between the inner cell or upper room and the outer world. The monad has no windows, but Deleuze notes that folds replace holes (as well as wholes) in the Baroque. Rather than windows acting as apertures to see the visible world, instead the world is visualized, actualized, and organized in the inner walls of the monad. If we follow Deleuze through Leibniz, we find that the crystal image is an inner monad of actualized images, each an event in time, reflecting the virtual world that is photographed. In the crystal image, actions and places that are photographed will take on the pattern of the labyrinthine, and that in turn reflects the folds of the crystal.

The seed of the time-image is truth as variation rather than as fixity. Deleuze recognizes Leibniz in this, as the time-image allows for the expression of all possibilities from all situations, destabilizing causality in such a way that "time puts truth into crisis."[38] Since the crystal image offers a "webbing of time embracing all possibilities," it is the crystal image that facilitates the *compossible,* the actualization of the variation of truth and the creation of a particular point of view.[39] This is the recuperation of the camera obscura as a top-down approach: a recuperation of the singular way of seeing from the abyssal variation and relativism of the point of view—Kofman's "frog's perspective."[40] A return to the principles of the Baroque camera offers the conditions of *incompossibility,* not a veil of objective truth but the truth of variation as it appears to the subject. We can see that it is the Baroque camera that forms the camera consciousness.

The time-image, we can say, places the compossible within the frame. In foregrounding the camera consciousness, the time-image is a tremendous vibration of both the values of truth and our perception of them. The time-image is the condition in which the truth of variation appears to perception: it is the envisioning of the exchange of fiction that occurs when an object photographed is viewed. The truth of variation is the truth that the compossible values of objectivity and subjectivity are, in fact, incompossible. When the photographic image refers to its own fiction, it is the power of the false that takes over, and the photographic image presents possible but not necessarily true pasts: this is incompossibility. Incompossibility is therefore the frame of perception around the photographic exchange, the central fold that runs through our cinephoto monad, and the "genetic element" of the crystal.

The chemistry of photography and the optics of the camera, to which are pinned the values of objectivity in modern photography, hide the modern camera's roots in the Baroque. The perspectival view has replaced the monadic, and the camera obscura's canvas has been replaced by polished metal, gelatine, and later celluloid and the diaphanous plasma screen. This is because of the way that technology of the camera obscura begins to isolate the observer and build the subject as separate from, but given foundation in, the empirical world. Jonathan Crary writes:

> The camera obscura is inseparable from a certain metaphysics of interiority. . . . The monadic viewpoint of the individual is authenticated and legitimized by the camera obscura, but the observer's physical and sensory experience is supplanted by the relations between a mechanical apparatus and a pre-given world of objective truth.[41]

The paper print or filmic photogram represents an attempt to fix the monadic and unfolding image after a rational fashion, as it were, while all the time the fact of the photograph as a point of view threatens to disrupt the artifice of objectivity. The contemporary photographer Abelardo Morell has employed the principle of the Baroque camera in a series of works in which hotel rooms are converted into giant cameras and then photographed. The results are topsy-turvy images of grand vistas cast onto the interchangeable interiors of plush hotels. But even as Morell's images reacquaint us with the principles, the wonders of the Baroque camera, they illustrate the normalization of a culturally homogeneous point of view and the creation of the modern camera and its functional, programmed way of seeing. The windows look out over Tuscan landscapes rather than French housing estates, the Empire State Building rather than the cruciform projects of Bedford Stuyvesant or New Rochelle.

For Snyder and Allen, the modern camera's apparent autonomy creates a sense of inevitability, "a feeling that a photograph is the end result of a series of cause-and-effect operations performed upon 'physical reality,' that inclines us to impute a special sort of veracity to photographs."[42] This obscures any possibility of the photographer's eye guiding perception. It is hidden behind a notion of photographic truth based on optics and chemistry—things that can be trusted empirically—that are so thoroughly mixed with conventions of representation as to con-

fuse the one for the other. Snyder and Allen's work was developed in the 1970s, but this elision remained in our culture of photography.

Despite this, Roger Scruton once maintained, not long after Snyder and Allen's article, that in the "ideal photograph" the image is in causal relation to the object.[43] The drama of cinema is the drama of the action photographed, with the camera merely a "gesturing finger." The "gorgeous irrelevancies" of photography obscure the dramatic aim: the masterpiece of *L'année dernière à Marienbad,* discussed later, is dramatic before it is cinematic. This analysis characterizes the acceptance of perspectivism and the eye-witness principle. Interest in a photograph stems from, and leads to, an interest in the object pictured, as in Bazin. The photograph never assumes the role of the object pictured, and the viewer never makes the mistake, but that acknowledgment serves only to strengthen the apparent causal link. Once accepted as natural, anything culturally attached, such as the conventions of artistic realism, are also accepted with similar ease. Scruton's approach is thus the antithesis of the plasticity advocated by Deleuze. Scruton does not question photography's *adequacy* in presenting the real in all forms, even though realism relies on such an adequacy, as Colin MacCabe attested some years earlier.

MacCabe's seminal analysis of realism demonstrates the classical realist text in cinema as a tool of ideology "in which there is a hierarchy amongst the discourses which compose the text and this hierarchy is defined in terms of an empirical notion of the truth."[44] These discourses "fully adequate the real" because they present the world according to cause and effect. MacCabe's political comment is simple, its genealogy traceable to Eisenstein, whose montage of attractions was based on the directness of his static images in opposing any fluid experience of duration.

Deleuze's call for a politics of cinema relies instead on an approach that is an antecedent of the very direct discourses of the mainstream or its opposition because Deleuze sees the political power of cinema as existing before language, before information. No amount of information, not even the blasts in Eisenstein's shocking montages, will overcome or defeat those forces against which cinema as an art must rail, since these are direct discourses:

No information, whatever it might be, is sufficient to defeat Hitler. . . .
What makes information all-powerful . . . is its very nullity, its radical
ineffectiveness. . . . It is necessary to go beyond information in order to
defeat Hitler or turn the image over.[45]

To be art as a political event, Abelard Morell's images would not just
look out over projects or housing estates but would have to go beyond
the directness of the respresentation of class itself to make cameras from
the very homes of the working classes (for a start). The massive screen
projections that we see in contemporary art have begun to engage with
this possibility, and in many ways the presentation of video art in the ex-
hibition space often re-creates the sensation of the camera obscura, such
as when Wolfgang Staehle's installations relay vast landscapes back into
the gallery. However, to re-create the sensation is not enough—one
must break down the newly formed language of the sensation, as Jane
and Louise Wilson do in *Stasi City* (1997) and *Las Vegas, Graveyard Time*
(1999). Each turns the gallery space into a camera obscura on whose
walls are projected the interrogation rooms of the GDR Intelligence
Service or the twinkling slot machines of Caesar's Palace. It requires
the claustrophobia of these spaces, each as unhuman as the other, to
breach the massive walls of the projection space and begin to work at
the very nature of looking at these spaces in the gallery. The political
risk that Morell takes is the *obviousness* of an apathetic Left; and the
obviousness of the commentary on civil liberties, police states, and the
massive movements of working-class dollars is what the Wilsons ad-
dress in their pieces.

The risk of apathy, cliché, or even a strange mimesis of hegemony
is also run by video activism, culture jamming, and any political prac-
tice that relies on the techniques of the center. Like all politically in-
spired art movements, they run the risk of what Simon Watney once
suggested was a tendency to "descend into mere whimsy."[46] MacCabe's
idea of resistance is a cinema that counterpoints the language of classi-
cal realism. Deleuze diverges from this because political practice should
emerge from the debris of its attack on language itself. Direct discourses
of power and resistance are predicated on defined truths and falsehoods,
but a politically active photography or cinema can come only from an
indirect discourse that is an acknowledgment of the monadic variation

of truth and an understanding that a point of view is apprehended from the any and every of variation.

Truth and the Searching Camera

For Sarah Kofman, the meandering unconscious finds expression in the metaphor of the camera obscura in the manner of an apparatus that reveals the role of point of view against the implicit trust we place in photography's infallibility: "After all, while everyone has their camera obscura, it does not follow that all such cameras are equally good."[47] The stress placed on depiction can toll heavily, and the artist runs a risk of cliché, as we have already seen, or worse—that the any-instant-whatever created by the time-image reveals a more disturbing point of view than expected, one that is an inflection, rather than a critique, of a societal way of seeing. This is the problem that emerged from the photographer Larry Clark's film *Kids* (USA, dir. Larry Clark, Miramax / Shining Excalibur Fims, 1995): the lingering cinematography and the blunt depictions of teenage activities resulted in conflicting readings.

Like Helen Levitt, Clark made his film after already establishing himself as a photographer, and in a similar manner *Kids* can be seen as an extension of earlier photographic works, in particular Clark's *Tulsa* (1971) and *Teenage Lust* (1983). In these projects, the first of which was an accumulation over many years of photographs of his fellow teenagers in Tulsa, Oklahoma, he developed a visual style influenced by the documentary of the New American photography (particularly that of Robert Frank) and later by cinema, video, and the mass media. *Teenage Lust* contains many sequences of photographs as if they were cinema frames. *Larry Clark 1992* (1992) and *Teenage Lust* both contain re-photographed teen posters and television screens. While later films, such as *Ken Park* (USA, dir. Larry Clark, Busy Bee / Vitagraph Films, 2002), more clearly resemble the photographs from *Tulsa* and *Teenage Lust,* Clark's direction for *Kids* reflects a combination of the style of his later projects and his photographic style (Clark also worked on a photograph series on New York's skate culture in the early 1990s). In *Kids,* New York teenager Telly (Leo Fitzpatrick) spends a day attempting to deflower another teenager, Darcy (Yakira Peguero), while hanging out

with his skater friend Casper (Justin Pierce). Telly doesn't know that he is HIV positive, a fact learned by Jennie (Chloë Sevigny) after she contracts it from him. Jennie attempts to alert Telly before he infects someone else, but after a series of close calls eventually arrives at a party too late to prevent him having sex with Darcy. Jennie is later raped by Casper while she is asleep, presumably infecting him also. In *Kids,* the stoops, parks, and streets are a stage on which images of childhood—comic books, skateboarding, sexual naïveté—are actualized alongside images of adulthood—violence, drug taking, and rampant sexuality—to such an extent that at times they are difficult to differentiate from each other.

Kids opens and closes with a series of lingering shots of two teen-agers having sex. The opening, in particular, of "innocent angels . . . hav-ing sex, smoking pot, drinking beer, having fun," the critic Amy Taubin noted, exposes through direct confrontation the tension between the transparency of the camera in fiction film and the camera as "gesturing finger" in documentary:

> This shot, which seems to last forever but might be as brief as 20 seconds, gives us time to become self-conscious about our own response as we con-front the activity that most adults want to shove out of sight, or at least turn into an abstraction.[48]

This shot becomes a *mise en abyme* for the whole film, presenting in the first few seconds of the film the labyrinth of viewpoints that are compos-sible and that are each crystallized before making way for another. The enhanced longevity ruptures chronology, and it is from this rupture that a time-image grows. This is the time-image that relies heavily on the cut in cinema, or rather the absence of it, but it becomes more interest-ing as a visual movement through the city itself as a teenage space in which the worlds of matter and soul are almost indistinguishable. The ellipsis of the film—twenty-four hours in the life of these teenagers—is an objectile in time as much as the streets and parks are temporary loca-tions of rest or play in the fluid landscapes of the kids' lives.

At stake here is Clark's commitment to two strategies: to confront expectations made of children and teenagers through an unforgiving (to us) camera that also implies complicity with its gaze on youthful sexual-

Kids (USA, dir. Larry
Clark, Miramax / Shining
Excalibur Fims, 1995)

ity, and a commitment to presenting "one theme from different angles"
by making as a cynosure a documentary approach that reverses what he
had tried to achieve in his photography—"documentary with a fictive
quality."[49] Clark tries to employ the forces of photography—the referen-
tial and superficial series, as in de Duve—together to exploit through art
the *affect* that such a combination produces. The attempt is to make use
of what Kendall Walton described as photography's "mixture of fictions."
The notion of a paradox of photography is a direct result of the inability
of rational discourses (those understanding it as either fiction or truth)
to account for the exchange of values that gives the photographic image
its particular power. Walton, like Snyder and Allen, reminds us that the
object *was* photographed and that we cannot escape the subjectivity that
selected, composed, framed, and shot it. To look at the photograph *is* to
see an object in the Bazinian sense, but it is also to see the object *as seen*.
The paradox is really a confusion "between the viewer's *really* seeing
something *through a photograph* and his *fictionally* seeing something *di-
rectly*.[50] Photography's event of art exists when the clash or paradox cre-
ated by the forces of causal connection and aesthetic creation is revealed
and when this paradox becomes the essential mechanism for the configu-
ration of the artwork. For Deleuze and Guattari, this configuration is a
glimpse of becoming, an "extreme contiguity within a coupling of two
sensations without resemblance or, on the contrary, in the distance of a
light that captures both of them in a single reflection."[51]

It is perhaps more useful to express this contradiction in terms of
exchange, since each permutation of the conflict between subjective and

objective creates an actualized image that only resets the circuit once more. Each interpretation creates new enfoldings of the image, new permutations of the exchange, always threatening to reveal the quest for truth through photography as yet another variation of point of view, when in fact the only truth that exists is of this variation. After Telly and Darcy have sex, a shot lingers on them lying in each others' arms. For the critic bell hooks, they are returned as children, which "undermines the violence of their encounter by suggesting that its outcome has been bliss." The result is a confused message at best and misogyny at worst, and hooks argues the film presents the sexually titillating when it claims to be objective: "The question, of course, is whose truth is being told?"[52]

Any confrontational strength in *Kids* relies on the objectivity of the camera, a clinical eye that should critique the society it investigates and our complicity within it. It is an attempt to present the Baroque camera as one that observes from within the discourses of truth in vision, even attempting the camera's panoptic mobility. At the party, the camera pans along the seminaked bodies of the young boys whose stretching bodies appear out of the gloom like the subjects in a Caravaggio or a Fiorentino. As in Baroque figure painting, which took a naturalistic human form and attenuated it to reflect the convulsions of hell or the ecstasies of heaven in the earthly body, their pale bodies, half adorned by the armor of skate culture (cut-off jeans, exposed torsos), carpet the floor of the apartment as if they were themselves one folding mass stretching between the two worlds. The party becomes a grotesque El Greco; in one scene cherubic boys watch the world of the teenagers' sexuality unfold while they themselves pass around a joint.

The mobile camera in the film reveals the variation of truth itself, and the investigation that the camera makes only leads to a deeper and deeper *labyrinth*. As the camera follows both Telly and Jennie, the point of view swerves unceasingly; while the search is a truthful becoming for Jennie, it is not a search for knowledge but instead an attempt to unmask conceit.

The labyrinth is a character of knowledge for Deleuze, as it was for Nietzsche, and the people of the labyrinth characterize the various approaches to the search for truth. Indeed, Deleuze describes the laby-

rinth as the site of Nietzsche's own "problem of truth."⁵³ For Kofman, the labyrinth is full of disavowal, masquerade, seduction, and the reduction of women. Ariadne and her thread represent a *becoming:* the search itself. In contrast, Theseus and the Minotaur represent ideology, a fixed and centered truth. The story of Theseus, and especially that of Ariadne, is a story of the passionate search for truth in which Ariadne's love (and the thread) is the "innermost secret of inquiry." In this respect, Dionysus and the labyrinth represent a search for affirmation in which the only truth that exists is the search itself; this awareness is the *being of becoming.*⁵⁴

Through the camera as an investigative agent, we search with Jennie, and we are most often offered the views that Jennie will see. The camera follows her past experiences as much as it prefigures her future: the camera that hovers over the fumbling, near-comatose kids at the party predicts her viewpoint as she later stumbles over them to the bedroom where she finally finds Telly. As she walks through the city from the sex clinic, Clark's framing places Jennie in a long shot in Washington Square Park with the Empire State Building far in the distance. The city has lost its center, and Jennie now has to search for her own thread of knowledge to lead her out. Her search through New York as a labyrinth, crisscrossing Manhattan, is one of affirmation: Telly has given her the disease that will end both their lives, but by telling him she might stop his own search for new conquests, new victims. As she journeys across the city, always one step behind Telly, it is as if she were winding up the thread until it leads her finally to him.

Kids

Jennie is ultimately doomed in her quest. Like Theseus, Telly will abandon her to her fate and to her death. From Jennie, Telly can receive only the affirmation of his own death, a castration. Deleuze interprets Ariadne's double affirmation to Dionysus (her search for knowledge affirms his) as a release for her from *ressentiment*—the reflection in woman of masculine power and dominance—and the discovery of her own power and knowledge. Jennie's search has been her *becoming,* as the labyrinth is the becoming for Deleuze. But for Jennie there is no Dionysus, and Casper's forced advances are reflected in her vague (un) willingness, reaffirming only the circular action of the disease she carries. As Ariadne she affirms only that Casper is the Bull, that her future and theirs is already decided.

Firm truth is an illusion, just as the center of a labyrinth holds only nominal value. For a "philosopher with integrity," knowledge is in the passionate search rather than in the result, and so Nietzsche identifies with the god Dionysus through the joy of knowledge as a process of "ceaseless questioning."[55] Kofman reminds us that woman is excluded from the search for knowledge because the search is an objectification, an investigation of the woman as different. To search is to make a masculine decision—to admit to a loss of virility and investigate woman as a fetishistic denial, or to cling to virility and not look behind the veil. This is why the search in *Kids* is actually driven by a nullifying, life-denying illness for which the search for truth has no reward. To be sympathetic with Telly is to be sympathetic with a man whose need to deflower virgins is a castration anxiety. To be sympathetic with Jennie comes at the expense of her femininity: "the search for truth is an assault on her own decency, a disavowal of sexual difference."[56] The search seduces Jennie and reduces her.

The Photograph That Reveals

Freud used the photograph as a model for the unconscious ("to see is always to obtain a double," Kofman remarks in her essay on Freud) in the manner of the development of latent images.[57] The developing child passes through successive phases, like the stages of the photographic process from latent negative to resolved print. This is why photographic

processes can be used in cinema to produce dramatic effect—to reveal the truth of a character, to express a character's revelation or crystallization as a true image of each. In cinema the obverse of truth-as-the-searching-camera is the photograph-that-reveals. In cinema, photographs always carry a latency that, like a negative, is a hidden darkness or, like an afterimage, is the remnant of a bright and clear light. In pursuing photography, rather than the photograph, cinema finds a radical display of its own ontology in the most unusual places. For instance, in *Blow Up* (UK/Italy, dir. Michelangelo Antonioni, Bridge/Premier/MGM, 1966), it is not the photograph that David Hemmings's bored photographer accidentally shoots that reveals the crime; the obsessive use of the technology and the elasticity of the process as he enlarges the print produces larger and larger images that reveal less and less. Yet in *Funny Face* (USA, dir. Stanley Donen, Paramount, 1957), photography reveals for us the cultural creation of a star, a "whole" person, by capturing a natural, truthful talent within images of artifice.

Funny Face may seem like an unlikely place to find a complex treatment of photography and the ontology of cinema. However, Peter Krämer once noted that photography acts in the same manner as the dance numbers,[58] and for Deleuze, dance in cinema maps out the directions in life of its characters, particularly in the musicals of its fifties heyday. In the musicals of Stanley Donen, the dance that maps the world and the dance that is taken over by the movement of the world become indistinct—Gene Kelly's "Broadway Melody" routine from *Singin' in the Rain* (USA, dir. Donen/Kelly, Loew's/MGM, 1952). The "dancer's individual genius" allows this to occur, since in these sequences we are not watching Kelly's character, we are watching Kelly, but when we return to the film's implicit narrative, this interlude has made it all the more believable. The musical is therefore "a gigantic dream, but an implied dream, which in turn implies the passage of a presumed reality in the dream."[59] *Funny Face*'s photography sequences—including the opening titles, a montage of studio setups, and several set pieces—are like dream sequences except the photography itself is the dance, and the model (here Audrey Hepburn alongside Fred Astaire) is the dancer. The sequences give purely visual pleasure through the indiscernibility between star, character, and performer. Each number—and each photography

Funny Face (USA, dir. Stanley Donen, Paramount, 1957)

sequence—presents choices that the star-to-be has to make along the way. At heart is the development of a clear image of the star from a latent potentiality.

Funny Face contains both the elements of classical Hollywood in general and the elements of the reflexive musical so popular in the 1940s and 1950s. Its Cinderella narrative addresses popular interest in romance; its song and dance numbers are exemplary of the genre's emphasis on visual pleasure and the reflection of popular style and fashion. Hepburn plays Jo Stockton, a Greenwich Village bookstore clerk plucked from obscurity by photographer Dick Avery (Fred Astaire) to become the new face of *Quality* magazine. Jo agrees to go to Paris in order to work for the magazine, but this is just a pretext to visit the subterranean café society of Paris, home to her philosophy idol Flostre (Michel Auclair). Jo is eventually coaxed back to work for the magazine after she begins to understand the real motives behind Flostre's attention to her and after Avery convinces her that she can have the best of both worlds, cemented in his romantic interest in her. The labyrinth of the Parisian underground leads us to Being, and Being is the bull (Flostre). The Paris of *Funny Face* is a labyrinth divided in the Baroque manner, with the underground cafés and country retreats as the folds of the soul, and the streets of the city as the pleats of matter. Jo is the fold between them, constantly poised between the philosophical and the

material, and the first photograph of Hepburn as Jo in the opening titles
is the facialization of the enfolding of philosophical and material. It is a
visual labyrinth reflecting the film's narrative labyrinth. Avery offers a
marriage (her Ariadne, his Dionysus) of her wisdom and his photogra-
phy; her search for truth among the intellectuals of Paris has educated
him as much as the glamour has seduced her. He in turn is her release
from the *ressentiment*.[60]

Jo is accepted into each new milieu that she encounters by way
of a song and dance number, and in this manner *Funny Face* exempli-
fies the classic formula of musical that came out of Hollywood at that
time, a formula that included director Stanley Donen and the film's
two stars, gowns by Edith Head and Hubert de Givenchy, a Pygmalion
story, as well as the easy parody of the star system itself. The story of Jo's
passage and development as a model and a woman is contracted into
a pivotal sequence made up of photography sessions in which Avery
first directs and then is directed by her. Donen exploits the flat picture
plane of the photograph and its relationship to the filmstrip by cutting
to real photographs of the same setup, a sequence of variations on the
"frame" on which the film stops, including colorized and negative ver-
sions. The photographic nature of film is highlighted through being
rent from the soundtrack, creating pure optical and sound situations of
the time-image: as each image strobes from one color wash to the next,
each movement is accompanied by a burst of syncopated music. The
whole sequence mirrors the opening titles, in which transparent photo-
graphs of fashion shoots are laid over light boxes, the silken slides strik-
ing a parallel with the film running through the projector, as the rule
and eyeglass of the designer press them against the paper and the light
box glass. That very first image is a close-up of Hepburn, which we
will later see created in Avery's darkroom and pinned onto the presenta-
tion light box. Here cinema does not so much stall on photography as a
process as begin to expose it by paring away the diaphanous material of
the slide from the similarly transparent celluloid of the moving image,
returning the photograph back to its genetic primacy.

All the possible allusions to photography that Garrett Stewart and
others have noticed are here: the inset photograph, the freeze-frame, and
the exposure of the film's structure (especially in negative). Jo's matu-
ration in the modeling sequence is shown by her awkwardness in the

Funny Face

first few setups (she is unable to move) to her mobility at the sequence's climax (she is unable to stop). Krämer notes how Audrey Hepburn's roles have been received as characters poised "forever at her moment of momentous choice," and each musical number or photography sequence presents bifurcating paths that fork to create wider and wider possibilities. These still images, fixed for a moment as photographs within film, do not represent death as we found in Barthes and Bazin; instead, they contain the possibility of a life unfolding in time from each image.

As we have seen, death is the recurring theme in comparisons between cinema and photography. Stewart's brilliant study begins and ends with death and in particular with the stasis that the freeze-frame or inset photograph imposes on the movement of film: "Narrative cinema, in other words, when fastening upon a single image, can invoke the deathlike stasis of photography."[61] Thus the photograph's metonymy of death is transferred to the film; the photograph is a memento mori for the filmic spectator: "Cinema dies, dies back into film."[62] But this takes the photographic image as a given constituent of cinema that can only present movement, time, and hence life when strung together in a becoming (i.e., in the process of cinema). Yet cinema dies back into film because of the photographic act of shooting onto the same substance. Not only is the still image or photogram an essential, inseparable part of the movement created from it through cinema, but "the strip (and its thrown image) is inseparable from the photogrammes."[63] Cinema relies

on the photography that comes to life, of which the still and projected image are both constituents. However, the monadic, folding substance is the *photographic* itself, the coming-into-being of the image that is an essential part of both.

Time-image cinema is made up of photograms in series, just as the movement-image is, but the time-image remains independent of an attachment to the sensory-motor schema. It does not need a direct acknowledgment of the practical base of cinema, and in fact it thrives without it. The time-image is merely dependent on the *act* of photography, shared by both cinema and the photograph. To equate the photograph with death simply because of its often-assumed relationship with chronology is to miss the depiction of time that the photographic image offers in all forms. The frame of perception in the time-image (whether in cinema or photography) is not placed around the photogram—or any material base per se—but instead around the photographic image or act that only leaves a trace on the material. If each photographic interlude, or "number," in *Funny Face* offers a "moment of momentous choice," then each presents not the metonymy of death but that of life, since the still image will come to life and is alive through its dislocation from the movement-image. Furthermore, the particular narrative for Jo, that of the tension between philosophy and the soul and that of fashion and the material, is reflected in the photographs that punctuate each sequence. The crystal image does not emanate from the inset photograph or the freeze-frame but from the *act* of photography that they reflect, as focused around Jo, and particularly around Audrey Hepburn *as* Jo. We will see the photograph from the opening titles being created during a dance number ("Funny Face"—performed in near darkness) between Jo and Avery in the photographer's darkroom. This is a womblike space from which Jo/Hepburn will emerge ready to become the face that Avery prints during the number. This transparency is now no longer an inner skin of cinema, pared away to clean the moving image's progression. The image instead is revealed as a fold in the substance of photography itself, since it is this photograph that will drive the film forward, this photograph that begins the coming-to-life of Hepburn as Jo Stockton. Nothing demonstrates this more clearly than the stilled frames of the film used for the fashion photographs produced in the Parisian modeling sequence. The sequence reveals what so few films about photography make clear. The strip of photograms that make up cinema are

not broken moments reconstituted into movement but instead are folds in the monadic continuum of photography; the still image itself is the fold between two images of time—the rational order of the movement-image and the glimpsed duration of the time-image.

Hepburn is never properly separated from the characters she plays, and they never become independent of Hepburn's own real-life image. The film is richly reflexive of both the musical genre and of the photography culture that it parodies but, at the same time, is deeply indebted to. Fashion photographer Richard Avedon, whose photographs are used in the film, already had a working relationship with the ingénue Hepburn, and in life and art her image already mixed the cosmopolitan glamour of America with the old-world glamour of Europe, especially Paris. The film blends her character with her existing star persona, and through much of the film's middle sequence in the Montmartre cafés, she wears the same gamine costume that she made famous in *Sabrina* (USA, dir. Billy Wilder, Paramount, 1954) and that became a trademark of the Hepburn look. A key moment in *Sabrina* has Hepburn framed by a doorway to create a silhouette that would be as recognizable on-screen as her face in later films. She thus becomes herself a seed of the crystal image:

> The actor is bracketed with his public role: he makes the virtual image of the role actual, so that the role becomes visible and luminous. . . . But the more the virtual image of the role becomes actual and limpid, the more the actual image of the actor moves into the shadows and becomes opaque.[64]

Hepburn's star persona is a fictional exchange; at stake is not the reality of actor and character, but their aesthetic value. This is reduced to the Hepburn silhouette that appears in *Sabrina* at a crucial moment, when her character (Sabrina) realizes that she is being sent away by her lover (played by Humphrey Bogart).

The same silhouette—this time a black, skinny pantsuit with loafers—reappears in *Funny Face* when Jo goes in search of Flostre. The underground café bebop number, "Basal Metabolism," is danced by Hepburn as Hepburn, the star who "grows up" in that sequence in *Sabrina*. This is the real Hepburn, an awkward and confused innocent who escapes the frivolity of the fashion world for the more intense intellectual pleasures of philosophy represented by jazz and bebop. Happi-

ness and physical fulfillment (in Jo's case, an emotional and intellectual blossoming) are represented by popular and traditional melody. The Dionysian Astaire, whose background was in both jazz and traditional musicals, bridges the gap as both star and character. This uncovering of the body is the facialization of Hepburn the star in that her body is reduced to the simplest elements in the same manner as her face had been in the darkroom number. Hepburn's character and her own persona as international model and film star become indistinguishable and give way to the later modeling sequence in which we watch Hepburn the model at her best. This more explicit facialization of Hepburn reduces her face to a series of black holes on white walls so that the image of Hepburn as Jo has become a series of abstract connections from the outset. This image, like the silhouette in *Sabrina,* presents a realistic picture of neither Hepburn nor her character but reduces the two to a series

Sabrina (USA, dir. Billy
Wilder, Paramount, 1954)

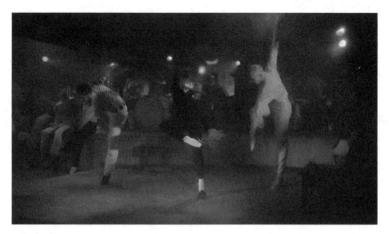

Funny Face

of simple elements as enfoldings of the photographic surface. Both are inflections of the labyrinth and the search for truth that provides the film with its narrative drive, a search for fulfillment that is reached only through Dionysian salvation.

Tensions of Description

The charm of the labyrinth, its joy and its terror, is being in it. The labyrinth is a metaphor that illustrates Deleuze's approach to truth from his early writing and throughout his career and why it appears in his work on Bergson and Leibniz as well as in his work with Félix Guattari. For Deleuze, of course, the truth is not at the center of the labyrinth: the truth *is* the labyrinth. This is perhaps why cinema of *la nouvelle vague,* especially through its connections with *le nouveau roman,* intrigued Deleuze so much and why films such as *L'année dernière à Marienbad* (France, dir. Alain Resnais, Argos/Astor, 1961) appear so prominently in his work on cinema. For Deleuze, *Marienbad* provides an excellent example of the crystal image, a place made up of the memories and fantasies of the protagonists from the one or many hotels they may have met in before ("the entire Marienbad hotel is a pure crystal, with its transparent side, its opaque side and their exchange").[65] Deleuze devotes considerable attention to the film and its makers—director Alain

Resnais and especially the screenwriter, novelist Alain Robbe Grillet. Jean-Louis Leutrat states the obvious when he suggests that "there are two *L'année dernière à Marienbad,* a film signed 'Alain Resnais,' and a screenplay signed 'Alain Robbe-Grillet.'"[66]

While Deleuze comes down very firmly on the side of Robbe-Grillet as the film's creative force, there are many reasons to consider the visual influence of Resnais, who had worked on the adaptation of Marguerite Duras's *Hiroshima mon amour,* an earlier attempt to "visualise the thoughts" of two lovers.[67] Deleuze writes, "Throughout Resnais' work we plunge into a memory which overflows the conditions of psychology."[68] To attribute the cinematography of Sacha Vierny or Resnais's direction purely to the detailed visual directions in the Robbe-Grillet screenplay neglects the contribution they all made to *Marienbad* as a serious meditation on the power of description within images—memory images, fantasy images, and of course the photographic images as their substance. Vierny and Resnais manage to exploit the flatness of photography on-screen, using careful techniques of staging and foreshortening, as well as exquisite lighting and sensitive film stock. The pacing and composition of *Marienbad* suggest that it can be more accurately described as staged photography rather than cinema. *Marienbad* is a Baroque film like no other, from its mobile shots of stucco walls to its static tableaux whose contours the eye must follow across the screen, to the sensation of interiority of the hotel as camera obscura upon whose furnishings are projected the fantasies and memories of the past. When the narrative itself turns to the photograph, it serves to reveal the substance of photography as the surfaces of the film fold into each other: Chanel gowns are

L'année dernière à Marienbad
(France, dir. Alain Resnais,
Argos/Astor, 1961)

photographed against silk furnishings and hard stone and marble; the whole film seems to be shot on stock made of crushed velvet and taffeta. Photography itself offers no corroboration of fact and instead refracts the cinematic images as a context of memory and fantasy, a mixture of fictions.

The labyrinthine plot relies on these visual elements far more than on the spoken narrative, and much of the film consists of voice-over for the tightly composed, luxurious black-and-white images: At a vast chateau hotel, a man, X (Giorgio Albertazzi), tries to convince a woman, A (Delphine Seyrig), that they have met the previous year and that she agreed to meet him again and leave her partner, M (Sacha Pitoëff). Most of the film is taken up with descriptions from their first meeting "last year at Karlstadt, or Marienbad, or Baden-Salsa" and subsequent events while A attempts to remember, to deny the meeting, or even to relive the memory. Emma Wilson writes, "*[Marienbad]* plays with the possibility that these are shared images that the lovers conjure between them."[69]

The role of the labyrinth in avant-garde fiction of the time, especially in Robbe-Grillet, is considerable. We might be satisfied with A as Ariadne, but is X Dionysus or Theseus? Is M Theseus or the Bull? We might prefer one reading in particular: X's account is the labyrinth, he is the labyrinth, A's departure with him is an affirmation of this and is an escape from the *ressentiment* represented by M. This would not adequately suppress other possible, or compossible, outcomes and readings: critical writing on *Marienbad* is replete with these. Yet the labyrinth is as much the creation of the search, as we have found, and the creation of an investigation that is really a disavowal of point of view in favor of an implied truth. To resist the labyrinthine plot is to create new layers and permutations: "As Leibniz stated, there can never be 'a straight line without curves intermingled.'"[70] Beverly Houston and Marsha Kinder suggest that it is best to let oneself "be carried along" by it rather than attempt to create a coherent and causal whole from it.[71]

Marienbad is largely made up of extended tableaux with mobile cameras that track, rotate, and encircle, alternating with a static shot that flattens the image through deep-staging, reflection, and *mise en abyme.* The activity of watching becomes one of following the contours of the flat image, provoking the process of reading as subjectively interpreting (which was Robbe-Grillet's desired effect for literature in his *nouveaux-*

romans). In so doing, Resnais produces a cinema that corresponds to other images that must be read—such as a comic strip. Resnais was a huge fan of the *Chicago Tribune*'s *Dick Tracy* comic strip, sent to him in France despite a national ban. Scott McCloud notes how Chester Gould's illustration for the strip (a style continued by current artists Dick Locher and Michael Kilian) uses "bold lines, obtuse angles, and heavy blacks to suggest the mood of a grim, deadly world of adults."[72] The effect on Resnais can be seen in the emphasis on blacks and whites in the interiors of *Marienbad*—suggesting an intense mental world of adult games—in contrast with the muted and low-contrast tones outside in the hotel's ornamental gardens, a space for sensual play and physical seduction. Comic strip panels do not express a singular moment but instead an attenuated passage of enfolded time, what Lawrence Abbott calls the "characteristic moment."[73] Reading a panel of a comic strip, Abbott suggests, is as much an act of reading an image as it is of reading a text, yet neither can fully articulate the moment on their own. This is *ekphrasis,* in which, according to William Mitchell, the description of an image cannot completely serve this function, and the image cannot fulfill its description. Inconsistencies between the two give rise to complex exchanges of meaning resulting from an imbalance. The power of ekphrasis—and hence its common use in poetry—lies in the images that flourish from the *inability* of image and word to represent each other adequately.[74]

Marienbad*'s visual structure is composed of shots presenting characteristic moments in the same way, such as when the camera encircles

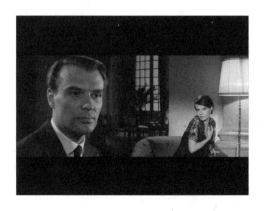

L'année dernière à Marienbad

a ground of cardplayers, including M. Duration is compressed into a particular moment, characteristic of memory. On other occasions, cinematographer Sacha Vierny used specially made bifocal lenses that hold the near foreground and background in sharp focus at the same time—something that cinema finds it difficult to do routinely. Now commonplace, this innovative approach allowed Resnais to compress the action of a scene—particularly dialogue—into a single frame. Resnais and Vierny also shot down corridors, or across halls and gardens, flattening the image through deep-staging so that the represented space of the hotel mutates and unfolds according to the memories and fantasies of X and A. Characters of *Marienbad* appear to occupy the same time and space—the same image—as their memories and fantasies collide. The Marienbad hotel is a memory space created through these flat images, each one an "architecture of time."[75]

What Robbe-Grillet brings to the film is his ability to use description to expose subjectivity in the creation of truth, something he developed in novels such as *Dans le labyrinthe* (1959).[76] Description in *Dans le labyrinthe* serves only to offer myriad interpretations and conclusions that unfold in the subjectivity of the reader, while events depicted have as evidence of veracity only the images that arise. Much of the novel is written with precise and repetitive description that prefigures the visual repetition of camera movement and shots in *Marienbad*. Thus a series of tensions are set up around description: Play/terror, falsity/veracity, fiction/memory, narration/vision. Deleuze remarks, "Robbe-Grillet put into play a new asynchrony, where the talking and the visual were no

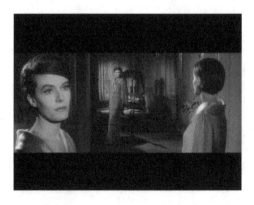

L'année dernière à Marienbad

longer held together, no longer corresponded, but belied and contra-
dicted themselves, without it being possible to say that one rather than
the other is 'right.'"[77]

In both, events and places that appear to be similar are revealed
to be different, and familiar spaces often appear alien due to obsessive
attention to detail. *Dans le labyrinthe* is about a returning soldier (pos-
sibly a deserter) attempting to deliver a package on behalf of a comrade.
As he wanders the city, the streets and street corners merge and become
indiscernible, a labyrinth of half-remembered vistas, and he experiences
confusion of place and person, virtual and actual realities. In a parallel
movement in *Marienbad,* the camera at several times pans across the
same hall to rest on a different vista through the window. In both, virtual
and actual images support each other in a coterminous way, provoking
what Mitchell has called "ekphrastic fear . . . the moment of resistance
or counterdesire that occurs when we sense that the difference between
the verbal and the visual representation might collapse."[78] In these situa-
tions, new variations of events and their consequences are produced by
the inability for word and image to be fully adequate to each other. Such
events, Mitchell suggests, are the products of a desire for the potential
inherent in these strange miscoincidences to be released. To read these
words or to see these images is to search for a center around which to
orient the story of the film or the book.

In *Dans le labyrinthe,* the soldier stumbles across a photograph of
another, and several passages are taken up with the soldier's attempts to
animate the moment of the photograph in his mind. Recollection im-
ages vibrate with dream images to the point that *any* soldier becomes
every soldier:

> A coat with flaps folded back, puttees, heavy marching boots: the uniform
> is that of the infantry, as witness also the helmet with the chin strap and
> the complete gear of packs, kit-bag, flask, belt cartridge–cases, etc. . . .
> The total effect is neat and as it were, lacquered, due no doubt to skilful
> touching-up by the specialist who made the enlargement; the face itself,
> graced with a conventional smile, has been scraped, changed, softened,
> that now it has no character left, and resembles for ever all those pictures
> of soldiers about to leave for the front.[79]

The photograph ceases to be an image of the past and becomes an object
of the present, in which fingers can trace on the lacquered surface the

imprint left by legions. Robbe-Grillet emphasizes the tactile quality of the photograph, echoed later in *Marienbad* when A lays photographs out on a deep-pile carpet, and they bob on its surface. In the scene from the *ciné-roman,* A is surrounded on her bed with photographs she has discovered in her dressing table of herself taken by X, as evidence of their affair, and more particularly the violence of his advances: "After a while, all the photographs that she found in the writing-desk were strewn all around her: on the bed, on the night-stand, on the carpet, all of them in a great disarray."[80] This leads directly to a flashback in Robbe-Grillet's directions, in which X enters the room and violently rapes her. For the film, this scene is excised and replaced by another discovery, this time many copies of the same—banal—holiday snapshot of A in the garden at Fredericksbad or Marienbad. The rape scene is replaced by a sequence of bleached images of A reaching to embrace the camera, repeated again as if the memories are there to be reconstructed, added, and then taken away until one remains, as in the game of nim we see X and M playing (and which A plays with the photographs). Whoever picks up the last piece loses.

For A, in *Marienbad,* the photograph represents a contest between memory of horror and dream of bliss, with photographs at the nexus of terror and play. The game reflects how all the film's photography is contestable, since there is no anchorage to memory or to imagination offered. The camera is a vibration between an objective view, the photographic image, and a subjective perception (dream or memory). The photography of *Marienbad* acts as the fold between the real and the virtual.

L'année dernière à Marienbad

The intention is to expose the real truth from within: to expose the oscillation between order and disorder that is the real truth of the world, a vibration of the objective and the subjective. Resnais, Vierny, and Robbe-Grillet thus work with dicisigns, perceptions placed within the frame of perception, and the result is an exchange or vibration that acts as a seed for the time-image as a labyrinth of interpretation.

Robbe-Grillet and Resnais were unable to agree—in public at least—on the "true" ending of the film or even the true events of the "last year at Marienbad," a starting point for many different interpretations of *Marienbad,* not least of which being that *Marienbad* is "just a bad film." But this would be to misunderstand the *ambivalent efficiency* of its photographic ekphrasis. The combination of image and narration is an agent to *unfix* meaning, as well as to fix it.

5 HOW DOES A PHOTOGRAPH WORK?

Stilled Lives

The interpretation of photographs comes easy to us. They are, after all, images of the real world that, at first glance, require little or no extraneous information. Ordinarily we expect only the most limited context for an image, and then only occasionally would we expect that context to be other images. Instead, we're familiar with captions, image credits, lists of illustrations. We're familiar with turning the pages of magazines, of family albums, of newspapers. In these situations, the act of looking at photographs is perfunctory. We have no time, no need, to examine the ways in which we interpret photographs or to appreciate the interval they create in experience, within which memory and perception create interpretation. Consider, for instance, when photographs are taken out of their context. Without text to accompany them, without pages to frame them, and most important, without other images to nourish them, they force us to confront the processes of interpretation. Furthermore, they present a glimpse of the structure of interpretation itself.

Some photographs seem more readily able than others to offer this glimpse, and some photographers seem more consistent in this practice of photography. Take a photograph by the artist Cindy Sherman, for example. In it ("Untitled Film Still No. 4," 1977) a woman is seen leaning against a door, her back to us. The image is rough and grainy, and the angle seems low, giving the image a clandestine quality. This is a "film still," but from which film? This is a horror film; she is about to die. This is a melodrama; she is about to enter a lover's hotel room. Each new narrative immediately forms itself and begins to gather structure.

But the knowledge that such an interpretation might be wrong only leads to a new interpretation. This is a thriller; she is a spy. This is a detective film; she is being followed. Plotlines mingle and create new ideas, new interpretations. The set of interpretations becomes mobile within itself and starts to change. The horror film is also a melodrama . . .

It is what the woman is doing that focuses this indiscernibility, that makes it a feature of the image and its effect. Sherman's women are always in the act of doing when they are photographed. They provoke no distinct future, nor do they portray any distinct past; they only represent a point of potentiality between the two. An indivisible intensity divides past and future. This is the point of indiscernibility—the quality of the image that makes it a crystal image.

Pick out a later example, this time with as much text to help us. In "Untitled Film Still No. 56" (1980), a woman stares keenly into her own reflection in a mirror. Dust on the mirror picks out the light behind her, and she is framed by its penumbra. We cannot see her face except through the mirror; this virtual image assumes independence from its actuality through this looking glass. We are watching Alice about to climb through—no, the hairstyle doesn't fit. This is Monroe's last look before her death . . . The woman is Cindy Sherman herself, as anyone who has followed her work will know. Yet in most of her other works, almost all self-portraits in performance, Sherman looks out at the spectator, through the camera, or into the out of field. In this image Sherman appears to be questioning herself as much as acting a role or completing a performance. The mirror creates a space coded as feminine, a mental space coded as one of masquerade and the creation, reflection, and refraction of identity, focusing the exchange of actual and virtual identities through the potentiality of the actor. Suddenly the framing of the shadow seems to be pushing Sherman out of the picture, masking her as easily as the makeup or prostheses she uses in her photography. Sherman is pushed out of the picture so that the *picture,* the artwork, and Sherman the Artist remains.

Sherman's work and Sherman the Artist are both claimed by those interested in the photographs, the cultural representations they portray, and the issues surrounding them. In many ways, because of the attention that her work has received since the late 1970s, her work fits oddly between art practice and popular culture. Her work speaks across

Cindy Sherman, "Untitled No. 56" (1980). Copyright Cindy Sherman. Courtesy of Cindy Sherman and Metro Pictures Gallery.

criticism in much the same way as the work of artists such as Barbara Kruger, Jo Spence, or Tracey Moffat, women artists confronting the patriarchal visual culture in which they have found themselves. Sherman's work became interesting to scholars in film, photography, and cultural studies, as well as art criticism, because of the ways that it references cinema, magazine and billboard images, hardcore pornography, history painting, and childhood fantasy and mythology. The visceral nature of her work, which often deals with personal issues and representations of women in late twentieth-century culture, has meant that critics such as Laura Mulvey and Rosalind Krauss have used appropriate psychoanalytic approaches, particularly that of Julia Kristeva, to interpret her photographs. These are almost always flavored by personal approaches, as if Sherman's photographs coalesce with the critical identities of the writers. The analyses are interesting because they demonstrate a striking element of Sherman's photographs: their ability to provoke *multiple* interpretations that will not easily be fixed by discourse. In fact, the

prevalence of a diverse feminist, psychoanalytic approach only serves to demonstrate the inability of any one of Sherman's images to have any one unified meaning—and that is their great strength and the enormous potential given to the critical analyses that they have provoked.

The role of critical theory in the career of Cindy Sherman cannot be overestimated. On the one hand, Sherman's images have been as important a contribution to feminist debates as many of the critics who have written about her. In this sense, it was the timing of her entrance that was crucial. In turning the camera on herself and exciting critical approaches to the cultural representation of women, Sherman's images were able to add in a timely way to the critiques that were becoming established in the academy. Mulvey pointed out in 1991, "Sherman's arrival on the art scene certainly marks the beginning of the end of that era in which the female body had become, if not quite unrepresentable, only representable if refracted through theory."[1] On the other hand, Sherman's work was able to facilitate a discussion as much about the self-representation of women as it was about their representation in patriarchal visual culture. One of the first critics to identify this was Judith Williamson, who contrasted a critical appraisal of feminine masquerade with a critique of the ways in which Sherman's images also highlighted the complicity of visual culture in subjugating women.[2] Mulvey and Williamson were joined by others, such as Rosalind Krauss and Jan Avgikos, in demonstrating how theories of gender representation, including the male gaze, masquerade, and abjection, are central to Sherman's artistic practice.[3] The result of this trend is that, as early as 1992, review essays of Sherman's work had as much to say about the various approaches that feminism makes to the whole corpus as any image in particular.

To these critiques, Sherman's work appeared to make a conscious reference to cultural representation based on dominant social experience. This interpretation was possible only with the suspension of disbelief that Sherman's work inherits from cinema and media fiction. This disbelief is disabled by the recognition of the spectacle and artifice of the image; her self-conscious references to popular cultural forms have led to an analysis of her work as *saying something*. The context of Sherman's work consists not only of visual signifiers of mass media and its subject positioning but of the enforced subjective male gaze itself.

Many of Sherman's images seem to act as the color separation overlay—a backscreen projection—to Laura Mulvey's 1975 essay, which articulated in perhaps the most far-reaching way the complicity of the culture of the camera in the objectification of women.[4] The images continue to offer, after many years of Mulvey's criticism, a space for the curious spectator she has more recently defined:

> Curiosity, a drive to see, but also to know, still marked [in the time after "visual pleasure and narrative cinema"] a utopian space for a political, demanding visual culture, but also one in which the process of deciphering might respond to the human mind's long-standing interest and pleasure in solving puzzles and riddles.[5]

Mulvey harks back to a committed viewing that still obtains whenever Sherman's work is shown again and whenever the artist offers new sensations marked by knowing curiosity—the history series (1990), the clowns (2004)—even as Sherman's work becomes a staple of photography education.

The fact that photographs create this space of curiosity is a sharper weapon than the open subversion of representations of women—by parody or pastiche—precisely because it is the viewer's memory that gives her images meaning. Viewers effectively reveal to themselves the workings of visual culture because they are forced into the self-conscious awareness of their own part in accelerating the representation of women. As Williamson noted:

> Because the viewer is forced into complicity with the way these "women" are constructed: you recognize the styles, the "films," the "stars," and at that moment when you recognize the picture, your reading *is* the picture. In a way, "it" is innocent: *you* are guilty, you supply the femininity simply through social and cultural knowledge.[6]

That identity should rest in representation seems an entirely postmodern notion, and one that is still supportable, according to Lucy Lippard: "[Sherman] began to explore *female experience*—more important to her than *female appearances* for which she is better known. . . . This search for the artificial rather than the 'real' epitomized the postmodern aesthetic."[7] Indeed, Sherman's work coincided with a postmodernism in art practice in which the surfaces of appearances could be critiqued and interpreted through the lens of theory without fear of charges of academicization.

Sherman's images are accessible because of their subject matter, summoning up with a sense of déjà vu images from the mass media with which the photographs reverberated. These reflected a growing awareness of the transferability of stereotype and the exchange of images as commodity, helping make the notion of postmodern critique accessible at the same time. Douglas Crimp argued that an acute awareness of the postmodern was essential to both the formation and reception of these photographs.[8]

Sherman's images were routinely viewed as re-presenting identity stereotypes that already existed. Later works that appeared after her Untitled Film Stills series widened the scope on the visual landscape of identity that Sherman had initially set forth, appearing to mimic TV shows and romance magazines (the series of images generally known as centerfolds) as well as continuing to reference popular and avant-garde cinema and art history. In the aftermath of the death of artist Robert Mapplethorpe and the controversy over representing sexuality in the gallery, Sherman started working with objects (prosthetic limbs, shop dummies, film props) instead of herself as model, producing dark reflections of mainstream pornographic images (1992). Sherman's clown images returned the camera's gaze toward Sherman the performer, Sherman the memory of cultural childhood and the grotesques by which children are introduced to the world of adults. These photographs, using an identifiable Sherman in front of digital projections of abstract color, return in one sense to the earlier set of film stills and similar images, such as the centerfolds (1986) and the mimetic nightmares of the family portraits (2000). The clown images, like the others, have an interiority to them, as if they gaze out at the visual culture they appear to reflect, inflections in the camera obscura that peer out at the world: not so much film stills but cultural stills, or even better, stilled lives. Even when the photographs did not appear to reference particularly stable identity types, they still reflected the very same fluidity of identity as a postmodern anxiety. This is why, from the beginning, they have had an unrivaled position in discourses of identity and representation. Mulvey rightly suggests that it is feminism's investigation of the fluidity and interchangeability of gender stereotypes—encouraged by analysis of Sherman's work—that partly led to the recognition of such a fluidity in identity by postmodern critics in general.[9]

Photographs such as "Untitled Film Still No. 56" continue to highlight the actual complexity of these seemingly simple parodies of media culture. As Ted Mooney's mock interview confirms, the detection of the plot or story behind the photographs became as much a part of the work itself as any serious criticism:

> Q: Any other possibilities?
> A: I guess it could be from the movies—a still. The woman looks a little like Monica Vitti in an Antonioni film. *L'Avventura* comes to mind.[10]

Even Mulvey found the film stills difficult to fix analyses on, as the very notion of the subject is fractured:

> Just as she is artist and model, voyeur and looked at, active and passive, subject and object, the photographs set up a comparable variety of positions and responses for the viewer. There is no stable subject position in her work, no resting point that does not quickly shift into something else. So the *Film Stills'* initial sense of homogeneity and credibility breaks up into [a] kind of heterogeneity of subject position.[11]

The powerful effect of photographs such as these has been therefore to represent flash frames of a totality of representation and self-representation of women. Sherman's images, in many senses, are "Now print!" orders for a particular generation of feminist critics and for particular experiences of representation and the negotiation of femininity within a dominant masculine culture. Most important, this has meant that Sherman's images reflect not only the critique possible of patriarchal culture but also the necessity of coming-into-being, or becoming, of woman herself.

Deleuze and Guattari conceive of becoming as a continuum of experience that includes the effects of the abstract machine of visualization—the ways in which culture manifests itself in a seemingly automatic way. In one of the most elemental molar hierarchies, they see in particular "man as a standard" against which becoming-animal, becoming-woman, and ultimately becoming-imperceptible are ranged. Becoming is a negotiation with the molarity, or majority, of man in the sense that hierarchies are organized with this majority in mind: "It is not a question of knowing whether there are more mosquitoes or flies than men, but of knowing how 'man' constituted a standard in the universe in relation to which men necessarily form a majority."[12] To avoid

hierarchies such as phallocentrism, one must be imperceptible in their terms. In order to be so, one has to negotiate these plateaus (and more) that intervene, according to Deleuze and Guattari. One cannot simply be a woman but must go through becoming-woman in order to desta-bilize the hierarchy itself. "All becomings begin with and pass through becoming woman" since becoming-molecular has to negotiate the central dualism of culture: woman culturally opposed to man.[13] Rather than this leading to a continuance of the fundamental binarism of otherness that underpins psychoanalysis, for example, becoming-woman is the primary quantum of becoming that leads to becoming-imperceptible.

In this way, the cultural constructions of femininity, particularly involving the masquerade of feminine identity, constitute becoming-woman only because they are cultural constructions. It is the negotiation of these that constitutes becoming-woman, not the adoption of any essentially female characteristic:

> When the man of war disguises himself as a woman, flees disguised as
> a girl, hides as a girl, it is not a shameful or transitory incident in his life.
> To hide, to camouflage oneself, is a warrior function. . . . Although the
> femininity of the man of war is not accidental, it should not be thought
> of as structural, or regulated by a correspondence of relations.[14]

The difficulty of Deleuze and Guattari's position is that it proposes the notion of desexualized humanity in which all people are equal through being sexless, but it does so from a position of dominance. Deleuze and Guattari can speak only as men. Rosi Braidotti put it this way in 1991: "One cannot deconstruct a subjectivity one has never been fully granted."[15] Instead, *means* are more important than *ends,* and the route through resistance to emancipation cannot be taken by any shortcuts. If becoming-woman is as powerful as Deleuze and Guattari suggest, then it is so through the continued confrontation with the same stereotypes that Sherman's work confronted in the 1970s and 1980s and that are still with us, still as potent. The power of Sherman's images, and the power of them as works of art created through criticism, is in the agency they afford to new spectators. What Braidotti asked in 1991 is just as relevant a question eighteen years later: "Can feminists, at this point in their history of collective struggles aimed at redefining female subjectivity, actually afford to let go of their sex-specific forms of political agency?"[16] With this in mind, the images of femininity that Sherman's

work presents are thrown into contextual, cultural, and historical relief. Sherman's work now illustrates an ongoing struggle over complicity with and resistance to dominant specularity, one that is predicated on the structure of the images themselves and their development into a body of work. At the heart of this is the simple fact that the images prevent interpretations resting and clamor to be seen and reinterpreted, even if new interpretations are only refractions of earlier attempts. They deserve another look. Crucially, Antonella Russo writes, "By refusing to signify and to make sense in her pictures, Sherman succeeds in turning our attention to the fragmentary condition of photography."[17] By considering the foregrounding of the cultural construction of these images, we can look at Sherman's work as representative first of the schismatic difference to film/cinema and then of the structure that the photograph's image of time has. In the continued space of the curious, we can catch a glimpse of the crystal image of time.

The Immanence of Storytelling

Context, in Sherman's work, is the implied narratives of films, magazine stories and other fictions, and the wider cultural specularity of the feminine. Sherman's pictures exist not only as photographs but each as a nexus of perception-images formed around a basis of narrative experience. These are held within the self-conscious matrix of the photograph. Sherman's images are saturated with points of entry, and the singular image leads to multiple recollection images. This entails a narrative, plot, or informative background that is not a given and a perception image that unfolds heterogeneously. The photographs project beyond the image into the past and into the future in an asymmetric, heterogeneous action. The images thus have a quality within them that emphasizes their connection to the viewer's memories, fantasies, and dreams. In simple terms, this might be called narrativity.

Narrativity as a concept has a basis in literary criticism. Philip Sturgess's approach, for example, is to suggest that any fragment of a text will imply a narrative direction and resolution. Genre conventions, medial conventions, and recollection will help create a mental image of the plot and its resolution. *Narrative* is the set of events implied by storytelling through the use of an established yet often arbitrary grammar.

Narration is the exploitation of a naturalized grammar of storytelling that structures the patterns of narrative, rather than a collection of discrete units by which some possess more narrative ability than others. It is an immanent quality of any story structure.[18] *Narrativity* is the immanence of story, and to exist in any part of the text it must be indivisible over the whole. Narrativity is only expressed in movements and intensities of story: the operation of narrative as the telling of the story.

This quality is one of implication, of a story-ness, and that of a story that appears definite but is actually indefinite. It is a quality of contingency that implies a limited structure of movement and time, as in a traditional story, and hides a perception that is not given and therefore only exists within duration. Fragments of text, according to Sturgess, when dislocated from chronology have a quality that is *a-chronic,* that does not operate within chronology but is instead beyond it. Struck from the homogeneous chronology of narrative, and independent of it, these imply heterogeneity in narrative direction. We must see that narrativity is not a liberation of the narrative *from* chronology; instead chronology is a *limitation of* the quality of narrativity—a quality that exists in duration.

Narrativity is ultimately a translation, a constant alternation from a distinctness of narrative and transparency of narration toward a foregrounded narration for which narrative acts simply as an armature and from a reflexive narration toward a self-elaborated narrative. This is a translation that occurs in Cindy Sherman's early work, which mimics the actual photographs that populate a media culture (in this case, mostly classical Hollywood and a few avant-garde films, TV soaps, and so on) that is already part of a huge intertext of imagery. They are not only photographs that provoke recollection images; they are also implicit in their reference to these other media texts.

It is the characteristic of narrativity as a *quality* that a story falls into the category of autonomy of narration or the category of autonomy of narrative or a free alternation between the two. In referring to an "imagined" filmic text, Sherman's images imply a connection to a definite narrative, and in their "refusal to signify" they imply an indefinite and heterogeneous whole that is beyond narrative ellipsis. A fragment of narration is able to demonstrate its overall intentionality as a *mise en abyme.* The narrative world constitutes a fictional universe of parts

and objects that act as a whole. Each set of objects and events is contained within an indivisible continuity of sets within sets, leading out to a whole that is open at the top.[19] Thus the narrative is an inflection of culture, a glimpse through the aperture of the black box.

Robert Scholes has adapted his structural understanding of narrativity to show that it is a quality of narrative crucial to signification, especially in traditional reception practices. Narrativity in cinema is a property of the spectator but promoted by the grammar of cinematic fiction.[20] In cinema of the movement-image, for example, we might say that narrativity is the quality of viewing that places individual scenes, as immobile sections, within an imagined context. In this way narrativity also provides a context of unseen landscapes and events for scenes dislocated from such representations. Narrativity relies on an intertext of memory images from cinema and other media as well as the viewer's own experience. Furthermore, narrativity exists as part of the institutionalized grammar of cinematic signification. Narrativity is essential, in Scholes's analysis, for logic and causality to have optimum effect because narrativity is the process of acquiring the reading skills that are in turn required for narrative comprehension. The remembered viewing experience is central to the future understanding of narrative. Narrativity is thus a useful description of the way in which narration is made transparent by narrative grammar.

Narrativity, which fulfills and *rewards* narrative expectations, does so by connecting the immobile sections of a discrete unit of narrative with the larger set of which it is a part. Narrativity is the strand that connects the set with its larger set, and on to the indivisible whole, and the immanent substance that gives the black box its macrocosmic structure. However, we must think more openly, not just of the culture that creates images, and consider how the notion of narrativity not only highlights the photograph's connection with its imagined whole but also expresses the nature of photography's relationship with time. While the photograph might immediately offer itself as a slice of time, no more expressive than the shot in cinema, it actually demonstrates an aspect of duration that is independent of chronology. Its constant state of present attests not only to the past of objects but to the future of them. This is obvious in Sherman's Untitled Film Stills series, which implies temporal ellipsis and abstract time, but it is no less apparent in her other

works, which imply the open whole of indivisible time mapped out by cultural forms and the imprint of society.

It is narrativity that enables Williamson and Mulvey's recognition of the conventions of representation in Sherman's work. We can see all those facets of narrativity being engaged and subsequently demonstrated in analysis. Judith Williamson bases her interpretations primarily on her knowledge of cultural conventions that require, enforce, and reward narrativity according to Scholes's definition. Williamson and Mulvey both stress the effectiveness of Sherman's work in conveying meaning, underlining the nature of narrativity as quality perceived in the narrative. They point to the ambiguity of interpretation that develops from a restriction of *mise en scène* and a denial of linguistic message, with Williamson pointing to the role of women in cinematic convention as "thermometers" of narrative. Williamson sees the role of women as an imprint of action in narrative cinema, most explicitly in the horror genre. The perceived emotion of the women acts as a signifier for the imagined narrative. This is continued by Mulvey in her developing analysis of the untitleds of 1981, in which the women's reactions to the camera that Mulvey perceives are parallel to the fetishized spectacle of the pornographic gaze. In purely functional terms, Sherman's accuracy of psychoanalytic or cultural comment is perceived, it seems, by Mulvey as issuing from the artist's ability to demonstrate particular directed narratives and the spectator positions that support them. Narrativity is thus a reward for these directed readings.

Any photograph that expresses a dominance of narration over narrative, in which the construction of image is more significant than subject matter, lends itself to the study of narrativity. However, the operation of the photograph has a very different character from cinema because it can only offer what initially appears to be a discrete element of the past. Deleuze's initial dismissal of the photograph as capable of depicting duration was in the light of Bergson's own perception of photography central to the imaging of memory through abstract and discrete elements. We can see this operation working in the same way with narrative, and therefore an understanding of narrative should prove useful. Narrative can be seen as the organization of recollection images into a perception image. Narrative constitutes a jump or leap into the past.

This jump is made first into the past in general and then into a region of the past that corresponds to our actual needs. This past is perceived as externally different from the here and now, the present, whereas in fact it is a perception image that is coexistent with the present. This coexistence is seen in Bergson's cone from *Matter and Memory*.

It is not the coexistence of memory with perception that interests us but what Deleuze describes as its "psychologization" or actualization. The past is actualized in a process of contraction, first of the past in general and then of regions of the past. We will retain only those recollection images that are most useful to us or interest us (the flashbulb memory or "Now print!" order), and so this actualization is stripped of irrelevances. Furthermore, the perception image of duration is one of chronology because the passing of time is remembered as a recollection of objects moving in space, and it is one of homogeneity because those movements are self-contained according to our own interest. Thus is created an intuitive understanding of narrative, a sequence of events recounted in a logical progression of cause and effect. The past, and the narrative, remains virtual in a more or less contracted state and coexists with the present. Narrative recounts the past as if it were a different time from the present—an *other* time—whereas this is just a virtual image that occurs (coexists) with the actual present. Since narrative is an organization of recollection into perception, it is therefore "the actualization (and it alone) that constitutes psychological consciousness."[21] The referentiality of a photograph is its representation of the *formerly,* and this collides with its existence in the present as a pictorial or superficial image of the *here,* as we have already seen.[22]

In traditional narrative, and here we can see it as analogous to the movement-image, the objective discourse appears to be *direct.* The narration, such as language or any other storytelling apparatus, is subordinate (or imperceptible) to the narrative. Thus the free-indirect discourse is an unfulfilled proposition. This changes when the perception of the objective as indirect is acknowledged and when the narration draws attention to itself as narration. This is a self-consciousness that leads to a perception image seen through another perception: the free-indirect discourse. Sturgess's approach to literature saw such a self-consciousness as an aspect of a story's discursive representation, and he called it narrativity.[23] He

saw James Joyce, for example, as forcing a conscious acknowledgment of the language that he used, which subsequently forced a questioning approach to his intentions and the meaning of his prose. Narrativity is thus a quality of self-consciousness that we can take, in theory, to the photograph. The subjective is a perception image in direct discourse with the photograph, which it perceives as an objective representation of events. However, the photograph's objectivity cannot be guaranteed, and its discourse is therefore indirect. The photograph's indirect discourse is either hidden, which leads to a free-indirect proposition, or it is exposed, which leads to a free-indirect discourse. Thus it is the quality of narrativity that gives substance to the heterogeneous array of dialects and utterances. This is an affection image with a "specific, diffuse, supple status, which may remain imperceptible, but which sometimes reveals itself in certain striking cases," the result of a "correlation between two asymmetrical proceedings, acting within language."[24]

When the photograph is perceived as objective, it is a perception of objectivity that flows from the subjective. When the superficial is recognized within the photograph, it is a subjectivity perceived through a subjectivity—perception within the frame of another perception. Here Deleuze's antagonism toward subjectivity is clear. Subjectivity is not a given but is instead simply a point of classification of perception. Subjectivity is an aspect of actualization in which recollection becomes perception. In so doing, it hides not objectivity but the discourse within which they both exist.

Perhaps the classic way of understanding this is through cinema and in particular through the notion of the cut. In cinema, editing and montage are usually made to be as imperceptible as possible. However, editing is also a manner of discourse that is often distinct from the narrative being portrayed, bearing no obvious connection to the events depicted. In these cases editing advances the story through a qualitative power quite apart from logical storytelling. Absence of logic in editing manipulates the narration by using the editing value as an asyndeton. It has meaning precisely because the meaning is not immediately apparent. Editing effects as simple as those of Kuleshov and Eisenstein rely far more on a rhetorical narrativity brought about through the splice, or *coup,* than the individual frame or shot. Eisenstein developed movement from two static shots simply through the cut between them. The edit, as

narration, produced an impression of movement through the composition of immobile units. In *Battleship Potemkin,* Eisenstein develops an impression of movement of a gunshot through the use of two static shots in succession. The portrait of an old woman is immediately replaced by the woman's face having been shot. The impression of movement is given through the organic connection implied from one image to the next. Eisenstein called this action "without transition," that is, without fade-in or fade-out, a direct cut that is imperceptible. The impression of instantaneous movement is perceived through logical progression.[25] This constitutes the staple of organic composition in Deleuze's movement-image.[26] Eisenstein composed a montage based on illogical movement in which statues of lions appear to rise up against the Odessa massacre. The quick succession of the images of the three statues creates one rising animated statue whose movement opposes the march of the soldiers down the Odessa steps. Narrative is implied through the impression of movement, but the flow is illogical and creates a visible opposition as the two movements counteract each other. The affect of this comes from its visible difference from logical montage.

What Eisenstein saw as montage based on emotion more completely provides us with an understanding of the asyndeton. Kerensky's contest with Kornilov in *October* is followed in a montage of attractions, a montage of "jumps," or what Deleuze calls "qualitative leaps," between attractions. In this case the sequence depicting the two is alternated with "plastic representations": statues of Bonaparte. This creates a direct political message that is enforced by its lack of movement.[27]

The emotional composition is a rhetorical edit whose quality of narrativity is exposed in its break from the logical. Rather than convey narrative through implied movement, as in the logical edit, it conveys narrative through opposition. Thus Eisensteinian montage, one of the foundations for the movement-image, goes from free-indirect proposition to a direct discourse in the break from montage based on logic to a montage based on rhetoric. The shot, or film still, when separated from montage, neither offers logic nor opposes it, but in proposing the possibility of both it draws attention to itself. Eisenstein's direct political message, while eloquent, is a reduction of the power that the free-indirect proposition contains. Sherman's Untitled Film Stills series, on the other hand, offers neither logic nor a break from logic, but in referring to cinema

as a language with expectations of narrativity, it offers this proposition as a subject in itself.

What Makes a Film Still?

By displaying photographs as if they were film stills, Sherman reenacts the relationship that the immobile section of the closed set has with the abstract time of cinema of the movement-image. Consequently, in demonstrating the still's connection with the abstract time of cinema, she also demonstrates the relationship that the photograph as mobile section has with pure time. The film stills' direct connection with the narrative of the imagined film mirrors the connection that photographs in general have with duration. The photograph is always taken out of context because the context only exists as a *virtual image.*

What is clear from the early Sherman photographs is how they dislocate themselves from the sensory-motor schema of which they were once a part—from the cinema, from culture itself. They are not only critical inflections of culture but also pure optical situations. Their constant provocation of subjectivity, furthermore, reduces them to the zero state of duration, and they must be recognized as free-indirect propositions, or dicisigns. It helps to distinguish generic industry film stills from Sherman's work. Industry film stills in general reflect their production only as a transparent apparatus—they are derived from real movement-images and express possibilities of the narrative only according to recollection images of other, finite narratives. A general film still constitutes a leap into ontology based on the recollection of film: we place ourselves at once into film and then into regions of film genre, narrative resolution, and so on, and perception-images of filmic narrative flow from this recollection. It is a matter of technique in that *"sensation is realized in the material."*[28]

This gives, however, extraordinary power to Chris Marker's *La jetée* (France, dir. Chris Marker, Argos, 1962), perhaps the most famous example of the creative use of film stills within cinema itself. *La jetée* is a dystopian science fiction tale in which a man is sent back from a future world ravaged by World War III in order to get help to its paranoid survivors. Fixating on a memory he has of a woman on a jetty at Orly airport, a memory from before the nuclear holocaust in which he

also watches a man who is shot and killed, he eventually returns to that moment only to find that he is himself the victim. Told almost entirely through still photographs, the reputation of *La jetée* has preceded it as a dissertation on the paradox of time that the photograph represents in that it simultaneously throws the image into both past and future, speaking to the future from the past, even though it is essentially mute. This is the significance of the dying man revealed at the end, who has no message to give to the future except his presence in the past, a message so overwhelming that it is itself traumatic.

The material sensation of *La jetée* relies on the continuity system of cinema that it follows quite closely, in which narrative is relayed through still photographs that Catherine Lupton has described "like memories of a film, which in our mind seem to be motionless and quantifiable, but if we search through the print never exactly correspond to one individual frame, or to the frozen drama of production stills."[29] In one sense *La jetée* thus relies on the notional construction of cinema from still frames and on the fact that this construction is not actually perceived. The immobility seems impossible, so impossible that perception creates the impression of movement, animating the photographs on behalf of the film by connecting them through persistence of imagination rather than vision. In another sense, the film relies in quite an ordinary way on the photograph as a grasping of time that is a creation of memory that we all too often shudder to realize. Playing off the emphatic effect of the paradox of the photograph as a selection that both tells and does not tell us the truth about the past, the film reminds us, Garrett Stewart writes, that "life is more like a photo album than we want to think—or than we think from the midst of our wanting."[30]

Barthes famously noted that the film still "scorns logical time," and we must remember how logical time is suffused with structures of meaning and interpretation through our working daily lives.[31] The photograph is one of the structuring elements, and Sherman's photographs open the film still's relation to time out to the chronology by which we live and within which we create meaning. When Sherman left the Untitled Film Stills series behind, and thus the last vestiges of an apparently metonymic connection to the narrative and time of cinema, as in *La jetée,* her photographs began to evoke instead the time of the glance at billboards, magazine pages, television screens, and the

spectacle of painting, pornography, and circus. They attenuate the any-instant-whatever of everyday life and still the constant movement of eyes over the images we encounter in culture. Sherman's photographs no sooner provoke an interpretation—an actualization—than they question it once again, virtualizing it. This exchange between virtual and actual must be seen as the elemental process behind its creative force.

Consider how the applied description film still acts to prevent signification resting. The urge to detect or discover the film it refers to is immense, and in the first few years of appreciation this characterized critical approaches to her work. This is not really any different for the other works—the film stills just seem more specific. The passage from "untitled film still" to simply "untitled" in Sherman's work points to the fact that all photographs are selections from an imagined life we live through recollection and perception. A doubling of consciousness takes place in all the photographs, perhaps more locatable in the film stills only through that small signifier. Because these are not stills from existing films, they offer a fiction of a fiction and instead draw attention to themselves as photographs that look like film stills. They capture a popular imagination with "the odd allure of movies never made."[32] Once recognized as fictions of fictions, the photographs are scrutinized for their attention to detail; the photography they use to refer to cinema becomes the focus of attention. The film stills are a translation from a dominant narrative that immediately appears to a narration that takes over. They become less important than the imagined movies. Suddenly the photograph becomes two images, actual and virtual, working side by side, but the incompatibility of these images is the source of the creative force necessary to produce the artwork. All artworks involve this prehension, this doubling of consciousness between the plasticity of the work itself and the affect it generates. We might understand this as the simple notion of art where there is a palpable difference between the artwork and our interpretations. One of the conclusions that Deleuze's work on Bergson provokes is the dismantling of the interiority of interpretation and the exteriority of the artwork, when *"the material passes into sensation,"* as he later wrote with Guattari.[33] This is the *affect* of Sherman's photography.

Deleuze's critical process begins with his reconsideration of difference in the light of Bergson's phenomenology. In *Bergsonism,* Deleuze

notes that Being is misrecognized as a passage from the possible to the real, a closing-down of possibilities. Instead, possibility flows from the real, for the possible must contain it. In this case, the actual gives rise to virtualization (perception) because recollection is memory of what has already passed.[34] Photographs are popularly conceived through the translation of the possible to the real: they unnaturally divide movement into discrete units. In fact, they are seeds of environments of the possible because they annihilate chronology in favor of a nonchronological time that is indirect. This is achieved through their passing into sensation.

The objective and the subjective should not be conceived of as fixed categories of perception. To consider them as such would be to privilege the objective world of objects (which would deny perception itself) or to privilege subjective perception (which would deny objects their own existence). This is an intuitive view of perception, one that Deleuze develops from Bergson's own approach in *Matter and Memory*. "For common sense then, the object exists in itself, and, on the other hand, the object is, in itself, pictorial, as we perceive it: image it is, but a self-existing image."[35] Instead of envisaging objectivity and subjectivity as two differing perceptions, we should therefore consider them as nominal values in a continuum of perception itself, as we have previously found. One is neither totally subjective nor totally objective. Experience is a combination of the subjective (the internal experience of duration) and the objective (the external experience of space).[36] Perception is therefore a discourse between these as a self-consciousness. In order for the photographic or cinematographic image to be an image of duration itself, it must first reflect this. Furthermore, a different exchange exists, suspended across the difference between subject and object and coinciding with them. This is the virtualization of objects and things, mental imagery of perception images but also dream images and recollection images. We create mental maps and objects, attach faces to voices and sensory memories to new situations, and recollections give us the past in the present. Most important, virtualization brings sensation within and connects us with the immanence of matter: "We perceive things where they are, perception puts us at once into matter, is impersonal, and coincides with the perceived object."[37] This is monism of an extraordinary kind, since it leads to the organization of space and time into chronology. We perceive ourselves existing within a particular time and space,

organized through the objects that we create and that illustrate or represent that for us. Cinema of the movement-image is, for Deleuze, an example of this par excellence. But it is the photograph (as photogram) within that is the illustration of chronology on which we rely so heavily. Sherman's "cultural stills," or "stilled lives," which reflect the situations of mediated culture, illustrate our own internal passage from moment to moment as if from photograph to photograph. We photograph ourselves through perception images according to how we see ourselves and want to be seen. Sherman's images offer these images back to us, which is why building lives around her images has a certain satisfaction and joy.

Rather than difference between virtual and actual being a negative supposition in which they negate each other, Deleuze sees this difference as an exchange that leads to a positive emanation of being. Art is a creative process from actual to virtual, from real to possible, and from singularity to multiplicity. But this situation can only occur when organization is unforeseeable, and this leads Deleuze to look for the creative image of time in cinema that disrupts homogeneous language in favor of heterogeneous creativity. Without the ordering principle of chronological narration in cinema or photography, which is a reduction of the possible, creativity unfolds as a true image of creative duration. Hardt notes, "Without the blueprint of order, the creative process of organization is always art."[38] Critical interpretation of art necessarily has the side effect of closing down the artwork's power. Artworks such as Sherman's now seem well-worn in criticism, and yet what remains is not particular interpretations but the substance of interpretation itself. The images may provoke unique interpretations of film and culture, but the sensation is shared by those who enter into discourse about the images and who subsequently create the artwork.

The photographs thus produce actual and virtual images that enter into an exchange. Initially, the photographs demonstrate an abstract connection to time in their implication of the temporal ellipsis of film narrative. Each image implies a narrative of which it is a part and that projects backward and forward in time around it. In responding to conventional codes and practices of mainstream filmmaking, these images correspond to Deleuze's first thesis on the cinema of the movement-image. Each photograph presents a set of objects as an immobile section of abstract time. Time, in this sense, is presented only by its connection

to movement in cinema. Initially, these images appear to *ache* for sequential movement to be returned to them. They await the next frame to create their third (and only possible) meaning, Barthes suggests, as if the next frame needs to be laid upon it like a "palimpsest."[39] Within the image is Sherman herself, who ceases to be the artist and instead is in a configuration with the artwork, as interpretation creates the Artist:

> No longer the object of a male painter's gaze, [Sherman] is both artist and subject. . . . Recreating, as her own personal artist statement, a role—that of the young, urban, working woman—made archetypal in the 1950s by the (male) directors of Hollywood films, Sherman refuses to exercise her option of subjectivity; private points of view, in her works, merge with the public icons of femininity.[40]

This can be further explained through the relationship of text to context. Mulvey and Williamson, and later Krauss, recognize the benefit of foreknowledge in analyzing Sherman's work. For example, the terms "grainy," "Renoir-esque," "New Wave," "Neo-Realism," "Hitchcock," and "Art movie" all appear in these articles as descriptions of the style of the images and also of the style of the films referenced, hinting that the fragment is of "at least 90 minutes' worth of something."[41]

These interpretations rely on the action of memory in organizing duration into discrete recollection images as a becoming-mad of depths. The recognition of conventions of representation prompts their analysis and what they recognize as the common analysis by a spectator. Not only do they comment on the images as reminiscent of particular film styles, but further to this, in a double operation of narrativity and the perception of that narrativity, they acknowledge the reflexivity of the images themselves as images that explicitly reference established cinematic motifs. Furthermore, their approach to the work is on the condition of recognizing Sherman herself. Her visual presence in almost all the photographs is a visible marker of the camera's self-consciousness:

> But the obvious fact that each character is Sherman herself, disguised, introduces a sense of wonder at the illusion and its credibility. And, as is well known in cinema, any moment of marveling at an illusion immediately destroys its credibility.[42]

Once the illusion of cinema is broken, the image is released from the sensory-motor schema of the movement-image. This has a double consequence for Sherman's film stills, for they constitute a break not in

cinematic illusion but in a virtual cinematic illusion. The sensation of reward and frustration flows from the image itself. Sherman's images are seeds precisely because they are not real film stills. They present a film within a film that is already a virtual image of possibilities emanating from the photographic discourse of cinematographic syntax. They are derived from real photographs that are in turn derived from possibilities of narrative. This environment is one of multiple states of the crystal image: virtual images of which none in particular is privileged. The specific interpretation of each image, whether it is finally identified as "Renoir-esque," or "an Antonioni," is highly personal and unique—despite the similarities that communal cultural and social experiences promote.

Thus the images are more than the photographs on which they are traced and more than the inflections of the postmodern culture to which they are so often assigned. They are crystal images in which the sensation of frustration is the reward, in which interpretation can only dissolve and create new meanings:

> There is a formation of an image with two sides, actual *and* virtual. It is
> as if an image in a mirror, a photo or a postcard came to life, assumed in-
> dependence and passed into the actual, even if this meant that the actual
> image returned into the mirror and resumed its place in the postcard or
> photo, following a double movement of liberation and capture.[43]

Inside the Crystal

Through this intertextual connection with cinema, Sherman's film stills display their first dimension in time. The patterns of narrative that are evoked in traditional readings of her images mean that Sherman's work presents an elliptical narrative that extends as an affection image around each still, *but her work remains limited* by the conventional parameters of cinematic narrative. Their nature as film stills implies their imagined narrative's genesis and conclusion. A narrative image projects backward and forward around each still to generate an affection image of a complete film. It is this facet of Sherman's images that promotes and extends structural readings of her imagined narratives as exemplified by the gender-based debate examined earlier. Narrativity, as a demonstration of a still's *mise en abyme* and of its nature as an immobile section, is ultimately restricted in the first instance to the movement-

image, but as Sherman's work broadens out through the constriction of textual signifiers (first the title, then the rarefaction of the *mise en scène*), those earlier works and those "concrete" interpretations begin to exist in an exchange with the larger, wider, greater images of culture and history that the later works invoke. Most important, the passing from the material into sensation is caused by the exchange between the discernible construction of the film stills and indiscernible construction of the later photographs, such as the Disgust series (1986).

Crucial to this is the central fact that, in envisioning the separation of the image from its track through the cinema apparatus, Sherman's film stills *remember* for us how photographs in general are rent from time as it passes. Without chronology, we are caught in the cerebral *intervalle*—the space for curiosity—created at the point where recollection subjectivity (in which we choose those recollections that are most useful) and contraction subjectivity (the perception of quality) actualize memory, according to Deleuze's reading of Bergson.[44] We see now that the narratives of Sherman's images are aspects of memory: memory as the experience of duration in its pure state. It is memory that unfolds the pure time that is in the crystal, that creates the complex structure of the crystalline, that enacts virtually the narratives of the photographs. We exist within the free-rewriting time of the photograph that Wollen described, and each time that we write a narrative and it is crystallized, a new virtual narrative is formed that does not replace the first but refracts it. The crystal image of time in its pure state emanates from this internal circuit and, as these are crystallized, so the whole grows and continues to project outward and heterogeneously with its incredible force.

Time splits in Sherman's photographs, not into the abstract notion of narrative ellipsis but into a pure image of time that narrativity plants as a seed. The past of the image is constituted simultaneously with the present, and each is launched into a time-image—one of a past of the image, another of the future: "two dissymmetrical jets."[45]

In this splitting, the photograph encapsulates the moment of indiscernibility, the "mutual image" or "bit of time" that defines the crystal.[46] The transparency of photography presents the crystal pane at its purest. The depth of the crystal is time seen in perspective in the image, moving back into the image and back in time. In this sense the crystal image is *not* a time-image but rather an image of the environment

created by the time-image as pure optical situation. It is the image of the exchange, the point of indiscernibility reached, and the structure created by the emanating interpretations of the dicisign: flashbulb memories, "Now print!" orders, actualizations. The photograph as object is the plane of immanence that is the limit between the virtual and the actual, yet in freezing the past, delivering and yet not delivering it, the photograph presents the future as heterogeneous and unbounded. It is an unequal exchange of virtual and actual that is perfectly presented in the photograph in which the pane of the crystal, the transparent surface of the picture, marks the limit between the objective and the subjective and freezes its affect. The finite of the actual image gives way to an infinite virtual, an eternal potentiality that extends into a future made up of passing presents and of making up pasts.

In this way the split in time should also be seen as a paring away of the layers of the past, revealing the membrane of the image itself. These layers constitute the language of the photographic image, causal intention, narrative and narration. At times, in film, narrative appears propelled by its own causal conventions. Sturgess suggests that these are often little more than the learned or acquired understanding of a widely accepted protocol of storytelling, an organization of perception. In this case what is *remarkable* in cinema or any other storytelling is the narrative itself. The events in the narrative are distinct and appear independent from any extraneous characteristics of narration, which remain *transparent.* In mainstream cinema, for which verisimilitude is crucial to narrative comprehension, the story appears to propel itself logically and seamlessly. The obverse occurs in cinema that runs counter to institutionalized storytelling. In alternative cinemas, or countercinemas, narration becomes more distinct and the narrative more subordinate. The story is not as important as how it is told; the narrative is propelled by the force of a distinct narration.

Neither state of affairs exists independently, and it is the quality of narrativity that ensures narrative comprehension. Narrativity can be expressed by the narrative as the set of codes that govern logical progression, and by narration as those codes that govern the incidence of telling. As we have seen, narrativity is a quality of anticipation of the narrative to follow a pattern or to deviate from it through narration. To comprehend the subversion of logical narrative, one must understand the rules

to which it normally adheres. Part of the organic development of the in-stitutionalized narration that makes up cinema of the movement-image has been the exploitation of logic that began with Eisenstein. Logic is reinforced early on by apparent and well signposted opposition to it. Jump cuts, unannounced flashbacks, digression from the story, and pi-caresque illogicality are now mainstays as much of mainstream cinema as of the countercinemas that spawned them as techniques. Independent filmmakers rely heavily on general protocols of narration in order to go through the process of destabilizing them. Deleuze noted that the cin-ema of the French New Wave involves characters whose identities and destinies exist in the any-space-whatever of a pure time-image only by opposing the characterization in the movement-image.[47]

We can add this analysis to that proposed by structuralist criticism, particularly of Peter Wollen, who first saw such radical filmmaking as conscious opposition.[48] Deleuze's proposition is a conscious opposition that unfolds to become a self-conscious discourse. The indistinctness of these situations gives narrativity its rhetorical power because these situa-tions are *never* stable but rather are always in a state of flux. Narrativity unrolls from the indistinctness between narration and narrative. The splitting of the crystal image is one constituent of the refraction of the image, as in the lens flare that picks out reflections of each component of the optical device.

Narrativity is therefore a quality with the structure of a crystal in that a multiplicity of images (refractions, reflections) emanates from one image. We can see now how narrativity is a structuring principle of the crystal image:

> The crystal-image is, then, the point of indiscernibility of the two distinct
> images, the actual and the virtual, while what we see in the crystal is time
> itself, a bit of time in the pure state, the very distinction between the two
> images which keeps on reconstituting itself.[49]

Deleuze described the indistinct moment, or the point of indiscernibil-ity, as the mutual image between an objective actual image of distinct-ness and a subjective virtual image of indiscernibility. It is an exchange not between subjective and objective but between a point of discernibil-ity and a point of indiscernibility. Narrativity is a quality of perception that exists within this internal circuit. We can perceive the crystal as

having particular states, or in effect we see the circuit as resting at one particular point. This is not a false image and does not imply a division of the circuit but instead implies the reflection and refraction of a crystalline structure that emanates from a particular origin, as Deleuze follows:

> So there will be different states of the crystal, depending on the acts of its formation and the figures of what we see in it. We analysed earlier the elements of the crystal, but not the crystalline states, each of these states we can now call the *crystal of time*.[50]

Narrativity is the action of the crystal image as an internal circuit of actual and virtual, of narrative and narration, and from this circuit the photograph or film still constitutes a crystal image that is a seed for an environment of the possible. Ronald Bogue has pointed out that the states of the crystal are numberless (Deleuze chooses four to discuss) but share the crucial central characteristic of revealing "different ways in which the whole of the great ocean of the virtual past may be related to the ongoing actualization of time in a present moving toward a future."[51] There is no one photographic crystalline state, but images as crystals of time frame the present's relationship with the past. Such images exist within a milieu or environment created by bodies of work (the whole of a film, the whole of a filmmaker's oeuvre) or by the interpretations that continue to emanate from the image as a point of indiscernibility. The same is true of any photographic image since the circuit is embodied in the photographic act. In this circuit, text and context become indistinguishable from each other. Their indistinctness creates the environment of the time-image, for which it acts as the seed.

Photographs are thus immobile sections of movement that change qualitatively into duration through a process of translation. One cannot argue against the physical processes within photography that divide time and space any more than one can argue against them in the cinema. But as in cinema, it is the translation of indiscernibility into the crystal that gives us an image of time in its pure state. This process of translation transforms the closed set of objects, which is the picture as object and the pictorial space, into the image of duration through its refraction of the surface of the photograph itself. At once limpid, transparent, through which we see the objects photographed, such images become opaque through the refraction of surfaces photographed.

Time wears away at the surface of images—photographs crack in heat, acids from human fingers corrode the surfaces, pages rub against each other fraying newsprint ink and smoothing the ridges of the paper. These are instances where the materiality of the process is revealed in the same way that scratches appear on aging cinema reels or pops and crackles are heard on a soundtrack. These provide only a material reminder of what already occurs in the photographic process—the elision of the material and the translation of the image into a membrane or screen. The new interest in screen culture (discussed later) merely expresses the materiality of what the photographic images have always fundamentally been: a membrane or screen, reflecting perceptions back as much as they let interpretation through. The crystal image occurs when the membrane becomes glassy and reflects or refracts images that are the limpid actualizations of the skin of both objects and perceptions, which dissolve into virtual images of an expanded past and future. The camera has always pointed at surfaces: at faces and landscapes, at bodies and liquids, at the surface of the sky. Photography is a medium of surfaces, and artists like Sherman work to reveal the real surface of the image, the membrane through which we see and that, through the play of surfaces within the photograph, is occasionally made opaque.

The Surfaces of the Image

As Sherman added props, prosthetics, makeup, and her own body and face to her work, she began to reveal more and more emphatically the construction of her images. She also revealed photography as a construction that makes layers and surfaces of the world. Even in the back-projection images, which echo the use of back projection in Hollywood to take actors to exotic (and even domestic) locales, Sherman was working with surfaces that reflect what it is that we *want* to see more than the objective reality that is given to photography. In another memorable "centerfold," "Untitled No. 96" (1981), Sherman lies like a wistful housewife against a ceramic tile floor, crumpled paper in hand, as if dreaming of a long-lost lover. The color of her clothing blends in places with the tile floor, and this interleaving of surfaces makes the paper stand out all the more.

Later, Sherman made herself the focus of the play of surfaces, as in the history portraits where the plastic breasts, facial prosthetics, and

opaque makeup created the surface as a landscape from which the faces of Sherman emerge only to recede. Each image exists in a circuit between the virtual images and their actualization, either in the reflection of their *mise en scène* or in the refraction through the *mise en abyme* of art history they represent.

In the Sex series, vivid and lurid sexual acts are depicted in situ through the use of inanimate sex toys, medical dummies, and Halloween masks. The dummies are made virtual as each sexual foray is crystallized in imagination (we often comment, of sexual imagery, that it leaves nothing to the imagination, but this is wrong). In one image, "Untitled No. 257" (1992), fluid is caught, midflow, as a droplet suspended in midair. This is the actualization of the immobile section, freezing time as in a snapshot, cinema image, or pornographic photograph. Sherman destroys the abstraction of time in the snapshot by using dummies and glycerine (or resin). She confounds the chronos (Chr') of the immobile section by photographing immobile objects. Their movement is not in space as a movement-image but in intensity as a time-image.

In between the early Centerfolds and the History and Sex series, Sherman worked with the elaborate staging of objects by dealing with the careful use of glance and returned gaze in a series based around disgust. These include images such as "Untitled No. 175" (1987), in which a pool of vomit barely mingles with the crushed detritus of binge consumption—sweet and sticky foods that contrast with the vile fluid next to them. Sherman appears to scream at the camera, seen through a reflection in a pair of sunglasses at the top of the frame. In this series Sherman becomes less and less a visible presence. However, unlike the Sex series, in which Sherman is almost always absent, she lurks in the corners and holes of the Disgust images, mostly in mirrors and looking glasses.

In "Untitled No. 167" (1986), the mirror is the focal point of indiscernibility, one of many objects that together create a landscape of memory and imagination. Each object serves to anchor further a concrete imagined narrative—a murder, a suicide, the living dead—made substantial by the strength of these signifiers. These are visible, limpid narratives separated from the opaque, grimy surface. Deleuze saw surfaces as providing the barrier or membrane between the limpid and the opaque, comparable to the actual and the virtual. The surface of

the water, for example, in *L'Atalante* (France, dir. Jean Vigo, GFFA, 1934) and *Moby Dick* (USA, dir. John Huston, Moulin/Warner, 1956) separates the knowable, limpid image of the decks, which constantly remain visible, from the dark and obscured opacity beneath the waves.[52] In this image from Sherman, the scattered objects (a makeup compact and the backing paper from photographic film) remain visible while the disturbed earth hides the opaque image of what might be buried. Indiscernibility has a shifting operation within this photograph. There is the mirror as a focusing nexus of indetermination between the actual objects of the studio setup and the reflection in the compact, which seems to be a ghostly presence even in the staginess of the photograph. But in a departure from the circuit portrayed in the early film stills, there is no immediately recognizable character reflected in the looking glass. Instead, this shifting action takes place with the fragmented face that, unearthed from the dirt, appears to be rising to the surface from a deep pool. This is the face that really becomes a landscape, the face emerging from a landscape made into a "Now print!" order of woman. The objects half obscured by the earth pass into virtuality, but in being crystallized they are actualized to become the dead face that emerges from the grave. The masked face in the mirror, now virtual, becomes the ghost of the dead (helped, no doubt, by its resemblance to one of cinema's many serial killers), liberating in the mirror the body trapped in the mud. But in being crystallized, the actual image of death makes the objects become more and more obscure; they slip back under the dark earth to become an opaque image of disintegration. They return to virtual landscape. The returned gaze alters the state of the crystal from one of growth to one of decomposition. The returned gaze is refracted and fragmented, with the dirt and the grime signifying not clarity and light but dimness, indistinctness, and entropy. Deleuze's vision of the crystal in decomposition was in the incestuous world of the rich and aristocratic, inward looking and incapable of escaping its own reflexive ontology except through decay.[53] Here it seems to be transposed onto the world of fashion or glamour photography, whose objects (the film, the compact, but above all the mask) suggest the debilitating decay of identity within a superficial world of glamorous decadence.

Decay in this sense is not the staccato death of Benjamin, but the evanescence—a return to former shapes—that we found in the statues

Cindy Sherman, "Untitled No. 167" (1986). Copyright Cindy Sherman. Courtesy of Cindy Sherman and Metro Pictures Gallery.

of the Parc des Sceaux or the Tuileries. It presents no division of measured time, no abstract notion of a past or of a limited future, as do the film stills. Instead of presenting chronos (Chr'), a chronological time, "Untitled No. 167" presents cronos as the point of Aion, the foundation, or seed, of pure duration, and it does so by presenting the indivisible mutability of form, the return to change itself as the slightest, faintest imprint left by duration.

In so many of these works, there is the limpid, actual image of the objects and the virtual image refracted in *mise en abyme*. But Sherman's personal absence denies the internal circuit its plane of immanence. Shifting from potentiality to potentiality, the circuit has no point or peak around which to revolve. It unravels in a process of decomposition. As the crystal unravels and loses its autonomous integrity, the limpid slips into opacity. Unlike the unraveling of time within the crystal image, in which cronos is liberated from chronos, this is a chaotic unraveling or decomposition of time. The past disintegrates in integrity

as an actual image, and the present only exists as a deeper and deeper abyss. The limpid becomes ever more mysterious, dark, and profane. This photograph is the one that will mostly lead into the Sex images, on which the body itself will become more and more indistinct and take on mysterious shapes. These images will become echoes of the internal circuit, degenerating as the circuit unravels. Most important, this is the photograph that will haunt much of the rest of Sherman's work, since its ostensible subject matter is photography and dressing up, something that would become the theme of Sherman's work in the 2000s.

In the 2000s, many of the photographs that Sherman produced reduced the image to its barest cultural essentials as Sherman posed more and more in the manner of family studio photography—which is to say posed less and less in the terms that her earlier work had laid out. In these images Sherman herself became, more than ever, the collection of surfaces that meaning would pierce. Absence of reflective *mise en scène* creates instead a *mise en abyme* that, following the nature of the crystal, refracts rather than reflects. The nexus, or plane of immanence, of the crystal is no longer the mirror but the seed, and the seed is Sherman. The image gains mobility as the internal circuit revolves around the concentrated image of Sherman as actor. Faces emerge, but it is impossible, as Mulvey and Williamson found, to separate Sherman the actor from the fragments of character that she portrays. The virtual image, untied from direct connection to objects, becomes less certain and is invested with more potential. The simplified form of "Untitled No. 424" (2004), in which Sherman as a clown is cast against the rude primary colors of a digital back projection, frees the image from direct or restricted narrative potential.

With the actual image limited to Sherman herself, the starkness of so many of the images from the 2000s present an abyss of virtuality in which the surface membrane of the image (the picture plane, the screen for the projection) becomes a well of imagination and interpretation, a traumatic halo of family memories, childhood imaginings. The clown images remember for us the contradictory impulses of the circus: the terror and the fun, the honor and the degeneracy.

The 2000s series of images reemphasized for Sherman the importance of acting first enunciated in her film stills, except that these represent uncommon understandings of acting—such as the generation of

Cindy Sherman, "Untitled No. 424" (2004). Copyright Cindy Sherman. Courtesy of Cindy Sherman and Metro Pictures Gallery.

self within the family or society or the anarchic comedy of the whiteface clown. And of course, it is around Sherman the performer that critical approaches have circulated. The actor is at the heart of the crystal, the embodiment of the exchange between (actual) actor and (virtual) persona, and never more so than in the freakish or the horrific. Deleuze writes:

> The more the virtual image of the role becomes actual and limpid, the more the actual image of the actor moves into the shadows and becomes

opaque: there will be a private project of the actor, a dark vengeance. . . .
This underground activity will detach itself and become visible in turn,
as the interrupted role falls back into opacity.[54]

This is why critics have been unable to separate the women in her
pictures from the woman who plays them, Sherman herself. Whether
attacking this duality of persona as willfully engaging in the female
masquerade or defending such an engagement with the masquerade
as a criticism of it, it is nevertheless crucial that Sherman is both actor
and character. It is not just the women in the pictures who represent the
potentiality of the point of indiscernibility but Sherman herself. Her
presence in each image actualizes the objects of the photograph. Each
photograph is a scene in which Sherman belongs to the real, and yet her
ability to become transparent crystallizes the virtual image or the charac-
ters she portrays. The crystal nature of the photographs, the coexistence
of virtual and actual, is the reason why the image of Sherman is never
dislocated from Sherman as image. They are never fully distinguishable
from each other. Sherman as actor cannot exist alone without crystal-
lizing the virtual image of the character she portrays, and as her pres-
ence in the real becomes virtual, she retains the crystallizable quality—
the quality of narrativity—that enables the circuit to repeat. She never
ceases to be Sherman, and yet she never ceases to be those women (or
occasionally men) she portrays. David Campany writes: "Does Sherman
pose or act, or act as if posing, or pose as if acting? . . . It is this triple
register of the look that Sherman crystallized so effectively."[55]

The crystal exists around a focal plane, a plane of immanence.
In Sherman's work, the plane of immanence is a point of indiscern-
ibility that begins as an object within a set of objects and is embodied
in her. In those images in which she is absent—or becomes absent—the
crystal decomposes. She constitutes the peak between the distinct and
the indistinct, but she is also the translation from this immobile section
toward a mobile section of pure duration—a time-image. At times the
plane of immanence is the mirror, which makes a continual reappear-
ance throughout the work; at other times it is a set of objects that imply
her presence but cannot replace it. Sherman is the "diffuse, supple" ob-
ject at the heart of the internal circuit, and the point of indiscernibil-
ity is the concatenation of Sherman as actor and Sherman as character.

Narrativity lies in this indistinctness. Yet this narrativity, provoked by the foregrounded staging of the images, suggests that photography is an indivisible process that can only be described as a becoming. This suggests that if we take narrative away from the photographic image, we are likely to see becoming-photography in its pure operation.

6 BECOMING-PHOTOGRAPHY

Odalisque

My Hustler (USA, dir. Andy Warhol, Andy Warhol Films, 1965), starring Paul America, Genevieve Charbon, Ed Hood, and Joseph Campbell, was filmed in 1965 and shown intermittently until it had a general release in 1971.[1] It remains one of artist Andy Warhol's most successful films, perhaps far more than much of his experimental work, and yet it is often overshadowed by his later Andy Warhol Productions films that he produced with Paul Morrissey. Its sparse, two-reel structure develops the aesthetic of both his "fixation films" and the more complex narrative and split-screen films he made with the model Edie Sedgwick. *My Hustler* was also Warhol's first outing (in more ways than one) with Morrissey as collaborator and marks a point of transition in the cinema of Warhol where the experimentation of the early work becomes rooted in the camp cause and effect of the later movies. *My Hustler,* both historically and stylistically, is a film very much in the middle of the artist's experimental career in photography and cinema.

 My Hustler is essentially divided into two single shots, an exterior and an interior, which each last for about thirty-three minutes (the length of a reel). While the first, exterior shot has a few in-camera edits and at least two 180-degree pans (both the result of Morrissey's ideas), for most of the shot the camera frames the reclining figure of the hustler in question (Paul America), over which can be heard the conversation between his john and the latter's houseguests. These include a retired hustler (Campbell) and a woman who attempts to move in on Paul America (Charbon). The second static, interior shot covers the bathroom

in which hustler, houseguests, and subsequently jealous "owner" banter, barter, and bicker over each other. The film is thus composed of a number of tensions—inside/outside, movement/stasis, sound/image, looked/looked at, camera/screen, homosexual/heterosexual—played out within the tightly constricted space of the frame and in the material of the twin shots. At the center of this is the body of Paul America, which prevents the image from becoming rooted to action, from becoming the action image, and which disturbs the mapping of space created by the camera and its frame. Tightly framed by Warhol's camera (America stays in much the same pose throughout the first reel), the body in fact interrupts the image, creating what Deleuze called "a pre-hodological space, like a *fluctuatio animi* which does not point to an indecision of the spirit, but to an undecidability of the body."[2]

The concentration of image on the body of Paul America disrupts the organic flow of movement-images, and from this disruption come new relationships of filmmaker and audience, looker and looked at, camera and screen. Tony Rayns notes how very little of the dialogue is actually about Paul America, and it is entirely possible that a print of the film exists without Morrissey's edits and only the two fixed shots.[3] This means that the film's dialogue—its sonsign—increases the potential complexity of the crystal image, but it is not *necessarily* required to do this. Morrissey's direction threatens to anchor the image to a sensory-motor schema based on one particular character (the john, Ed Hood) and his desire for another (America). This is ultimately not carried through because of the strength of the opsign itself, particularly as the internal circuit of virtual and actual merges in the body of Paul America *as odalisque*.

The exotic body of the odalisque in mannerist and romantic painting is easily recognizable in Warhol's framing of the youth as he lies on the sand, echoing especially Jean-Auguste-Dominique Ingres's *La grande odalisque* (1814), *Odalisque and Slave* (1839), and *La grande odalisque* in grisaille (1824–34). The features of the body and the space of the odalisque in classical and modern painting are instantly recognizable. Its pose makes it a body as face: Titian's *Venus of Urbino* (1538), Giorgione's *Venus Asleep* (1510). However, *My Hustler* draws on a wider significance and history of the odalisque, including Edouard Manet's *Le déjeuner sur l'herbe* (1863). Manet's composition in *Déjeuner* is one whose features are recognizable in Marcantonio Raimondi's engraving

of the *Judgement of Paris* (1520), on which it is based. Warhol may have been only vaguely familiar with the odalisque tradition, but both the Ingres grisaille (purchased in 1938) and the Raimondi engraving (1919) are in the collection of New York's Metropolitan Museum of Art, one of whose curators, Henry Geldzahler, was Warhol's close friend. Finally, the film always threatens to have Paul America stare back at the john, at us, as does Manet's *Olympia* (1863).[4]

Like *Olympia*, Paul America courts looking, and although he doesn't return the gaze as *Olympia* does, the barely reflexive dialogue with its occasional reference to him still ensures that the viewer is *caught* looking. The body of the odalisque makes the distinction between the public space of commerce and the private space of sensuality disappear. This is explicit in the boudoir of *Olympia,* as in Ingres's paintings, but it is also evident in *Déjeuner,* whose pastoral riverfront location is nonetheless an enclosed space, a privacy broken and made public by the viewer's gaze. This is translated into *My Hustler*'s Fire Island beach location, which acts as a stage for the complex cultural codes and taboos created to deal with what R. Bruce Brasell describes as the "public inaccessibility within this supposedly gay space."[5] Brasell carries this notion of inside/outside space into the second half of the film, whose single shot of the bathroom makes indiscernible the public and private space of the bathroom in gay culture.

The camera has replaced the returned gaze. The visual genealogy of the odalisque points, in Warhol's case, to a deep knowledge of the odalisque as a sexual tradition, motif, and metaphor; yet because of this, something about Paul America as odalisque seems almost *too* easily recognizable, suggesting that such an interpretation should in fact be resisted. Instead, we have to consider how he evokes the open, languid, attenuated figure of Adam, stretching his arm out to touch God, from Michelangelo's painting on the ceiling of the Sistine Chapel (1508–12). This is the image of *coming into being,* the creation of the hodological space that is man's body, and *My Hustler,* in reflecting this central figure, reflects also the discourses and hierarchies of desire that circulate around it.

At first glance, *My Hustler* neatly fits the progression of Warhol's career as told by many biographers. Stephen Koch notes, "Warhol was shortly to begin—more and more in collaboration with Morrissey—his long filmic meditation on the male body," a process that would lead him

to a more narrative-oriented movement-image in which sexual mes-
sages were linked to action and sexual aggression made safe by camp.[6]
The dialogue in *My Hustler* is an injection within the film of some of
the traits of camp—acerbic wit structured around innuendo and char-
acter analysis, as well as self-deprecation and self-loathing. These par-
tially mask the film's ambiguity, as Brasell describes. They attempt to
constitute a move from the possible to the real, resting the discourse at
particular readings of the vicissitudes of male desire. To suggest that
the subject-object relationship in *My Hustler* has a distinctly homo-
erotic looked/looked-at exchange would only be to demonstrate how
such readings close down the images. They hide other possibilities of-
fered by the presence of Genevieve Charbon, whose own body creates
a point of indiscernibility not adequately controlled by queer readings
of the film.

For Brasell, the banal conversation and tight framing create a
claustrophobic space of heightened homoerotic sexual tension, missed
by those critics unaware of gay subculture.[7] The film is thus already cre-
ated from layers of meaning inscribed on a preened body, meanings de-
tectable to different audiences and reflecting differing sexualities. This
does nothing to diminish the tension created by the many sexualities
within the film, crystallizations of the virtual space of the image, made
all the more reflexive by the later use of mirrors (the bathroom mirror)
or the multiple gazes of fictional characters not quite separated from
the real people who play them. Significantly, it is when Charbon enters
the frame in the first reel that the previously detached sound and image
fully coalesce—except that this only serves to make the crystal image
more complex by making the identification inherent in looking at Paul
more ambiguous:

> ED: Look what she's doing! You know . . . she's just down on him like a
> bunch of flies. What do women get out of doing things like that?
> JOSEPH: What is he getting out of it? That's what I want to know.
> ED: Oh, he's getting his little masculine ego kicks, stuff like that.
> JOSEPH: It just makes the price higher baby, that's all. The more of a man
> he is the more you'll want him.

The presence of Charbon cannot be brushed aside as simply an attempt
to make the john jealous and provide camp comedy. When Ed Hood

My Hustler (USA, dir. Andy Warhol, Andy Warhol Films, 1965)

talks of Genevieve running her fingers through Paul's hair, it highlights the absence of touch and tactility with which he's portrayed, as if he yearns to be touched: what is it that really prevents the assumption that Hood is jealous of *Paul* rather than jealous of *Genevieve*? There is much more at stake than readings such as Brasell's suggest. Ultimately, the image and sound of this sequence of *My Hustler* ensure that we can never really be *assured* of just who exactly desires whom.

Warhol's experimental films, at least up to his work with Paul Morrissey, do not easily fit into the queer readings that his later films might do, mostly because of this reduction of the body to an image of unplaceable sexuality. The development of more conventional narrative in Warhol's cinema—and the simultaneous emphasis on camp—actualized some of the images of sexuality more than others and completed a process started by his experimental cinema. This was a process of exploration of faces, bodies, and finally landscapes. The coming into being of the sexualized image in *My Hustler* was part of an exploration of visual representation and the abstract machine of visual culture of which the camera is a part. This momentous film, in the middle of Warhol's career, was also an exploration of photographic becoming.

Inside the Black Box

Structures of language are rooted in fundamental differences. Similarly, structures of visual language are based on fundamental differences expressed in the face. The becoming-world is converted to a face or to

a landscape that assumes faciality. Since faces form important "loci of resonance" in signification, we look at the face of a person speaking to concretize what is being said to us.[8] Visual culture is thus a concatenation of specific machines, creating a single *abstract machine* that facializes signification. Deleuze and Guattari argue that it is only part of our nature, our becoming, to facialize any image in this way.[9] In so doing they open up the potential for movement within the fixed image, in the form of intensity, that we can take to the photographic image. It is this involution, or intension, within the image that creates its enormous, achronological power, the power that leads to the immense and complex structure of the crystal. This is a different movement within the image, still a variation of speed and slowness but in intensity, made by the elements of the image running into each other.

The real lesson of Deleuze and Guattari's work on the face is that of deterritorialization. The *abstract machine,* the facialized image, for example, reterritorializes the universe. It takes the open and diverse and enforces an order that constricts any possible permutations. Facialization is a closing-down of potential meaning and effect. Deleuze and Guattari argue for an understanding of absolute deterritorialization: the abandonment of conventions and hierarchies and the open potentiality of progression—a line of flight—from the image. This is to understand the dualism of face and landscape and the potential to go beyond it, to create an image where the "cutting edges of deterritorialization become operative . . . forming strange new becomings, new polyvocalities."[10] To cast off such traits of the face, to create a deterritorialized image, one must exist as becoming.

In developing the notion of becoming, Deleuze moves beyond his Bergsonism to understand duration from the point of view of more than just an implicit awareness of pure change. With Guattari he turns his attention to the coming into being of entities and objects; the movement of space creating objects, change over time creating objectiles. Becoming is the assembling and disassembling of entities by which we live our lives. At the smallest level this occurs in the movement of the earth and the manufacture of objects that we name. At the greatest level this occurs in the creation of molar entities as abstract assemblages, created by abstract machines. Singular and fixed, they hide the multiple becoming

of the universe and force everything else in orientation around them—
man as standard, for instance, as we have already found.

Becoming has its own parts, or plateaus, that make up a contin-
uum. These are waves of becoming that intersect each other but, above
all, intersect the culture that surrounds us. It is a mistake to assume
that Deleuze and Guattari's vision of becoming discounts the exterior
and merely deals with a sort of self-becoming. Context is doubly im-
portant to becoming, since what we once called the context of a work,
or a person, is now simply a point in their *molecular* becoming. An ex-
ample that turns up in the *Cinema* books and in *A Thousand Plateaus* is
Moby Dick, a becoming that encompasses John Huston and Herman
Melville, film and book, not to mention the whale itself: "Captain Ahab
has an irresistible becoming-whale."[11] Deleuze's view takes in the input
of writer, director, and the possible exterior influences or projections
(from J. M. W. Turner to Orson Welles) of this becoming.[12] All these are
quanta of the becoming that is most conveniently described as "Moby
Dick." This demands an alternative way of seeing Deleuze's approach
to the work, not in terms of a relationship of author to text but one in
which each forms a greater or lesser part of a becoming that extends
outward toward a whole that remains open. To center a phenomeno-
logical approach to, say, authorship around the text, the author, or even
the reception of the work is to create a phenomenon that is molar in
nature and centered only by abstract organization according to rules of
criticism. Such criticism does not look for patterns in these relationships
but molds the relationships around preexistent patterns. If anything,
authorship remains central to becoming because authorship *is* a becom-
ing that has a molecular structure involving these relationships.

New readings may be made of Warhol's film, and each will be an
actualization of the whole of the becoming. Whether or not they take in
the primacy of Warhol, they are restricted by the paradigms of author-
ship analysis around which his life is wrapped—his gayness, his camp-
ness, his Catholicism, and so on. Such becomings must be seen as assem-
blages in the sense that they are, as Deleuze describes, "multiplicities
with heterogenous terms, co-functioning by contagion" from which any
order is the development of such assemblages into abstract organiza-
tions. Deleuze's advance with Guattari from this is not to differentiate

between types of becoming as if they were different species of animal, but instead to treat all becomings as if they all had the same multiple characteristic—as if they were an animal pack. It is these that we organize in culture, in order to make sense of them, by grouping them around a molarity: "That is why the distinction we must make is less between kinds of animals than between the different states according to which they are integrated into family institutions, State apparatuses, war machines etc."[13] In a closer analysis, film criticism is the organization of the author/text into an abstract machine, limited to the direct influences on the filmmaker, his or her life, or the film's social reception or other dynamic yet abstract models. To discount these processes is to miss the point: the understanding of becoming is not a destructive force that negates the study of abstract machines, it *is* the study of abstract machines. To understand the becoming of photography, we must understand it as an abstract machine.

Vilém Flusser proposes just such an understanding of abstraction in photography, centered not on the image or camera but instead on the culture surrounding it. For Flusser, the post-Enlightenment image, connected physically to the camera as apparatus, is merely an actual image of a virtual world, which is "only a pretext for the states of things that are to be produced [only] amongst the possibilities of the camera's program."[14] This program inheres the apparatuses of photography, working outward to the machines and organizations that circulate around the camera and its discourses. The process of photography in Flusser is molecular: it is quantum photography.[15]

Flusser therefore shares Deleuze's suspicion of the flat image as an abstract machine that reveals itself only in dualisms. Flusser sees the double dualism of black and white, and of black-and-white and color, the latter hiding behind the encoding by culture of natural colors. Deleuze emphasizes the dualism of face and landscape. The abstraction of the image to become a face, even for images of everyday inanimate objects, constitutes a facialization that in turn leads to an organization of the picture plane; in a further abstraction, the face dissipates as a face and reemerges—reterritorialized—as landscape. All images become landscapes, or faces. Again there is a further, double dualism or articulation. Not only is the facialization one of "black holes on white walls"—shapes that are actualized once and for all, the black holes creating patterns on

the plane as writing does on paper—but this actual image becomes part of a larger abstract machine as it enters into processes of identification and language that seek to fix its meaning:

> Concrete faces cannot be assumed to come ready-made. They are engendered by an *abstract machine of faciality (visagéité),* which produces them at the same time as it gives the signifier its white wall and subjectivity its black hole.[16]

Thus the odalisque, as we saw, is an abstract machine of faciality that, by reproducing the body in repose as if it were the "passional power operating through the face of the loved one," organizes the space of looking into one of easily coded desire: "It is not the individuality of the face that counts but the efficacy of the ciphering it makes possible, and in what cases it makes it possible."[17] The genealogy of the body as face in the odalisque, which includes courtesan and goddess, forces the facialization with such strength that any concrete interpretation—not least in terms of gender or orientalist exoticism—actually collapses. The facialized codes of Venus and odalisque are so strong in *Olympia* that her gaze becomes a line of flight: "Sometimes the abstract machine, as the faciality machine, forces flows into signifiances and subjectifications . . . to the extent that it performs a veritable 'defacialization.'"[18] For *My Hustler,* too, the instant recognizability of the odalisque frees the image from concrete interpretation. Rather than create a signification for the image, Paul America as odalisque deterritorializes it.

Thus Deleuze and Guattari focus the rays of each dual inflection that informs the image: face/landscape, white wall/black hole, signifiance/subjectification. They do so in the light of the face's most important power: to signify. Liberation comes in total deterritorialization; face becomes landscape, becomes face, becomes imperceptible as either. For Flusser, the release comes from a similar deterritorialization from the encoded programming of the black box and the abstract machine of the photographic universe. The photographers that Flusser talks about have the potential to break free from the Cartesian program encoded in the camera by exerting themselves beyond it. They see the program of the camera, and they become nomads on the photographic monad. They are the embodiment of the new abstract machines that Deleuze finally calls on, freeing themselves from the faciality machine to become

Deleuze's *probe-heads* and "break through the walls of signifiance, pour out of the holes of subjectivity."[19]

To catch a glimpse of photography as becoming, a photographer can no longer consider it in terms of singular elements. Becoming is not revealed in the molar but in the molecular, and one has to be prepared to accept the multiple assemblages of becoming and the multiple stages, or *involutions,* of becoming that Deleuze sets out. Ultimately the task is to reveal the becoming of photography, to reveal becoming-photography, and that must include an understanding of imitation that reflects the photographic universe: photography does not imitate reality but constitutes a block of becoming-reality.[20] Flusser's photographers, in this way, see the photograph not as reality but as an imitation of reality, since they appreciate that they can never know the full extent of their black box. Perhaps the key to understanding the genetic element of photography, the becoming of photography, is to understand this type of photographer as one who sees the abstract machine for what it is, and as one who constitutes a block of becoming-photography.

Becoming Andy Warhol

The surface of Warhol's work misrepresents the complexity of his career. There are hints of a carefully sequestered private life, private even from the social life that Warhol enjoyed as a figurehead of New York's avant-garde. Richard Hellinger points to facets of Warhol's very private persona that were revealed only after his untimely death in 1987, such as the enormous collection of fine art that filled some of the rooms of Warhol's Manhattan townhouse. This showed an understanding of art history that was only hinted at in Warhol's "Magpie-ish" 1969 show *Raiding the Icebox 1 with Andy Warhol* but should have been apparent to all from films like *My Hustler.*[21] The townhouse and warehouses were also filled with Time Capsules, boxes filled with objects that Warhol took a fancy to, for some reason or another, over a period of time—sometimes a day, sometimes more, sometimes less. Warhol lived his life at various intensities of speed and slowness, and his art continues to extend beyond the public person and the word "Warhol."

Warhol defies the kind of metonymic concatenation that Barthes, for example, saw in Albert Einstein, who became facialized in signs that

incorporated values that took over in language and culture from the person and outlived him.[22] The two signs of Einstein, his own face and the equation $E = mc^2$, have become facialized onto the surfaces of popular culture. Metonymy, in this sense, is a result of the abstract machine of faciality. But it fails to do the same to Warhol, not only because the reach of Warhol encompasses so many other things but also because Warhol constructed images of himself that produced the story and meaning of "Warhol" through a material sensation that was a conscious reduction to surface technique. Flusser writes:

> They are supposed to be maps but they turn into screens. . . . Human beings ceased to decode the images and instead project them, still encoded, into the world "out there," which meanwhile itself becomes like an image—a context of scenes, of states of things.[23]

Deleuze saw this problem, especially between painting ("adventure of the line") and photography; one is a map and the other is a tracing of "states of things" rather than becomings. In the abstract machine, the image is inseparable from the apparatus, from the program, and from the information. The abstract machine extends from object to image, actualizing the virtual world. This is mythology at work. Barthes was able to describe only the "states of things" that are created, that are facialized. Flusser described the components of the abstract machine that facializes.

One of Warhol's most famous images, which accompanied the 2005 retrospective Warhol Legacy: Selections from the Andy Warhol Museum at the Corcoran Gallery of Art in Washington, D.C., is his self-portrait photo-silkscreen of 1964. It is an implosion of the abstract forces of facialization: to be confronted by a self-portrait of Warhol is to be confronted not by a representation of the values of Warhol but instead by a *probe-head*. The image refers to the Warhol that *cannot* be facialized. This image stands for Warhol only as much as his silk screens of Marilyn Monroe or Elvis, or any one of his Campbell's Condensed Soup paintings of 1966. Diana Crane describes him as the avant-garde of the sixties who "internalized values and goals associated with the middle class and with popular culture."[24] The screens upon which these goals and values were projected included the cinema screen and the silk screen of Warhol's studio. In the case of the Monroe silk screens, one is

"ever mindful of her tragic life," as Deren Van Coke put it, and it is just as impossible to think of Monroe and not immediately call the multiple images to mind.[25] These people, even as myths, become part of Warhol rather than him becoming part of their stardom or fame, just as the word "Warhol" continues to be used to draw into it the celebrity that accompanies broadcast media.

"Warhol" also extends through the people, the coterie, that filled and filed through his studio, the Factory, the establishment that was the workshop for much of his art: Edie Sedgwick, Candy Darling, Nico, Billy Name. David James notes the actors of Warhol's films became, and in many ways still are, the vocabulary of the public intercourse about Warhol.[26] This was also the case for the many other artists and film-makers, such as Gerard Malanga and Jonas Mekas, who now form a historical constellation around Warhol. P. Adams Sitney describes the period of the midsixties as "the mythical stage of the avant-garde."[27]

Warhol Legacy: Selections from The Andy Warhol Museum, Corcoran Gallery of Art, 2005. Photograph by author.

Mekas and the others are only one part of a much larger block of be-coming—larger even than the New York avant-garde itself: the multiple Warhol in which the man himself was startlingly anonymous.

This is the becoming-animal of Warhol: the packlike nature of the people and works that make up Warhol. In terms of the plastic arts, he transcended the traditional disciplines of industrial design (illustration) and fine art. In terms of activity within those disciplines, widespread knowledge of his work extends far beyond the fervent periods of his career. Just as each piece of art facializes Warhol but fails to adequately represent the entirety of Warhol, so they also connect in the same way that an animal pack connects. It is almost pointless to conceive of a Warhol film, print, or happening as any kind of singularity or as if it had occurred in some kind of artistic vacuum. Nor would it be any less absurd to try and crystallize Warhol in his/its entirety. Critical discourse is instead quicker to isolate a piece as a Warhol than it is defined as print or film, just as science is happy to classify animals by species. No single characteristic identifies Warhol, and it is not sufficient to consider his work historically, since its influence is felt today. As Deleuze and Guattari might say, Warhol is a verb rather than a noun. It is not a question of one or several Warhols; there is only Warholing.[28]

It is difficult to find an origin from which Warhol's personal motivation issued; the great influences on his life might precede Warhol but are fundamentally changed in the eyes of art criticism by their connection to him. Arthur C. Danto re-instigated the critical link between Warhol and Marcel Duchamp, whose own controversial use of mass-produced objects—in particular the "readymades"—gives Danto reason to question Warhol's originality. For Danto, Warhol's *Brillo Boxes* (1963) fail because they are indistinguishable from the real thing and are thus pale imitations of Duchamp's *use of* the real thing.[29] But perhaps Danto misses Warhol's point and the point of Warholing: originality is not and never has been an issue, except for the status of art objects by those only interested in labels. Perhaps Warhol's lack of originality, or more precisely lack of origin, should not be considered a failure. The fact that Duchamp and Warhol shared ideas is clear, and not only in their short-lived film collaboration. Warhol's use of ready-made objects quickly extended beyond household objects to include household names and faces. It is unlikely that all urinals will be seen as Duchampian,

but it is arguable that Marilyn Monroe, star, image, and even person, is a "Warhol" in popular culture before any other connection is made. Monroe was Warhol's "readymade."

Paul Mattick takes up another point:

> It is the recognizability of the sign . . . that allowed Danto to think of the artwork and the original as indiscernible and the difference between them as therefore problematic. But the point of the *Brillo Boxes,* it seems to me, is not so much the difference as more the visual similarity between the two, which the differences set off.[30]

The silk screens of Monroe reveal the schism between the star and the life of the person. When we start to think of the facialization involved in the label, we can see this operating in Warhol's films. The odalisque pose and naked torso of Paul America is a label for homoeroticism, if not for homosexuality. The face and body of Edie Sedgwick is the label for narcissism and minor celebrity. And of course the image of the Empire State Building is the label for great architecture or, alternatively, "a big nothing."[31] Mattick notes that it is the label that interested Warhol: the label is the facialization, the product of the abstract machine. Most important, it is the "recognizability of the sign" that leads to those interpretations and that obscures the workings of the abstract machine. To recognize the camera's framing in *My Hustler* as the homoerotic gaze is akin to thinking that *Brillo Boxes* made a comment on industrial design or even that the boxes simply contained scouring pads. Warhol's effort was to make the abstract machine visible by changing the materials, exacerbating them, or taking them to the extreme. Sitney writes, the only way to "permit ontological awareness" is to direct it; to see the process at work one has to expose its mechanic.[32]

Warhol defies an origin as much as he does a definitive public persona. There was a famous decadent New York artist who called himself Andy Warhol, but this same man lived with his mother, Julia Warhola; he stood behind a barrier, snapshot camera in hand, to meet the Pope; and he was a devout Catholic until his death. Even the simplest biographies have to start with the Andrew Varchola who left Pittsburgh to make his fortune as an illustrator. Warhol the public artist appears to have had a severe reaction to the attention his activities received from the sixties onward, particularly after the attempt on his life by Valerie Solanas. Given that his works are more recognizable than he was (a

common occurrence in any of the plastic arts), Warhol might have felt complimented by Danto's criticism that "he became what he did."[33] Even this undervalues the near total success and sheer innovation of Warhol's becoming-imperceptible. For Warhol the artist and person, the best hiding was in plain sight; disappearing could be achieved only by being ever present to the point that his attendance at parties, on television, at gala events, became passé. He changed his name when he entered public life and dyed his hair gray from an early age, but he also had himself on the books for modeling agencies and was reputed to be happy to advertise anything. As his explicit authorship was gradually erased in his films, David James notes, his never-presence in public life was enforced by his ever-presence.[34]

Naming his workshop the Factory gives only a hint of Warhol's desire to become imperceptible within his manufacture of art. He was interested in, if not obsessed with, recording his life using machines: movie cameras, photographs, tape recorders, video cameras—but never writing. There is very little written correspondence by Warhol but many recorded telephone conversations. So many, in fact, that the sheer number and volume becomes unlistenable in its entirety. The constant availability of recordings only serves to make Warhol disappear even further. Warhol spoke to Benjamin Buchloch of developing a painting machine "that paints all day long for you and do[es] it really well, and you could do something else instead, and you could turn out really wonderful canvasses," demonstrating an understanding, even in jest, of the abstract machine.[35] While such a self-confessed fantasy seems to eliminate the authorial process that Buchloch and Danto have held dear, it actually demonstrates the author's necessary role as part of becoming-molecular. The abstract machine offers a way for artists to free themselves from the molar identity into which they are sometimes thrust by art criticism, and hence the restrictions of its limited universe, and instead enter a molecular relationship with their work that involves other influences. Becoming-imperceptible, it seems, is the freeing of not only the artwork from the author but of the author from the artwork. Could it be that Warhol understood the power of the abstract machine before Deleuze and Guattari articulated it?

Perhaps, paradoxically, becoming-imperceptible is also revealed in the increasing campiness of the later film work, continuing through the

Paul Morrissey–directed Andy Warhol Productions. The popular conception and appeal of camp facializes a sexual minority as part of the abstract machine to the extent that it creates significances that no longer need to be negotiated and instead are treated as if they go without saying: camp makes the unspeakable unspoken. Camp obscures the fluidity of Warhol's early relationship with women by making easily readable what was once ambiguous, and what was essentially ambiguous in *My Hustler* was the becoming-woman of Warhol. This analysis is not to re-create Warhol as heterosexual but to reveal the sensations of desire that intersect his work with such complexity.

What is becoming-woman in terms of Warhol and his work? Warhol and Duchamp both assumed a transvestite identity (Warhol was famously photographed in drag by Christopher Makos; Duchamp—as the character Rrose Sélavy—by Man Ray) in photographs.[36] Even on the surface there are clear parallels between the facialization of Duchamp's becoming-woman with Warhol's. The sexual politics of men fighting over/for a man/woman in *My Hustler* also has echoes of Duchamp's *The Large Glass (The Bride Stripped Bare by Her Bachelors, Even)* of 1913. However, Warhol's becoming-woman did not involve a desire centered on his person or on how his body appeared but instead involved his consumption of images and in particular the images of stars. This was where his "readymades" departed from Duchamp's (and changed both in the process). The perfection of the camerawork in *My Hustler,* or the repetition of Monroe's photograph, was part of a negotiation with the image, particularly the photographic image of *the star,* and this negotiation was the major element of Warhol's becoming-woman.

There is a strong tendency to immediately classify Warhol's cinema as a queer cinema, or his gaze as a homoerotic one, and subsequently classify his treatment of women as one of identification with rather than desire for them. The focus of much of this critical writing on Warhol's films, when not on the homoerotic gaze exclusively, organizes the various representations of men and women into roles in which homosexuality, its attendant anxieties, and the cultural mores attached to it are further crystallized. Warhol was homosexual, ergo his identification with Shirley Temple, Mae West, or Marilyn Monroe was organized along specifically (and culturally) queer lines that have been cemented in popular culture. While Amy Taubin claims that Warhol

"destabilized" sexual identity, her understanding of this destabilization is only in terms of a reterritorialization of identity onto other fixed notions. Taubin speaks from a mildly conservative position, from which she sees Warhol's sexuality expressed through exaggerated sexual positioning (tomboys, studs, drag queens) that act as an "imperfect shield for a terrible anxiety about sexual difference."[37]

For Deleuze and Guattari, sexuality is "badly explained by the binary organization of the sexes," and this is true in terms of both heterosexual/homosexual identification and its cultural mores as well as masculine and feminine identification itself.[38] Similarly becoming-woman cannot be facialized in terms of transvestism. All becoming passes through becoming-woman, since becoming-molecular has to negotiate the central dualism of culture: woman culturally opposed to man. Rather than this leading to a continuance of the fundamental binarism of otherness that underpins psychoanalysis, for example, becoming-woman is the primary quantum of becoming that leads to becoming-imperceptible. This presents a conflicting account of the emancipation of sexuality. On the one hand Deleuze and Guattari's philosophy moves toward "desiring machines" as the amalgamation of gender-free men and women in which the stereotypical images of gender are rendered useless. On the other hand, as we found in Braidotti, the efficacy of gender roles, particularly those employed in resistance and toward emancipation, cannot be overestimated, and results in an exaggeration of gender images, particularly through their deconstruction, which plays an important part in challenges to sexual hierarchies.[39] This misreads becoming-woman as the adoption of an identity rather than something that must be passed through. Warhol and Duchamp, in their attempts at *passing,* evoke less the constricting discourses of drag and more the fundamental operation of the abstract machine of photography: its gaze on the female body.

My Hustler relies on the odalisque as a feminine role in history: any multiple identification or desire for Paul America as odalisque, whether crystallized by heterosexual or homosexual interpretation, must pass through becoming-woman. The odalisque, like the masquerade, is the part of becoming-woman that constitutes the becoming-molecular of man, which is only later organized into homosexual or heterosexual identification by interpretation. Genevieve Charbon takes on a further

dimension, since her presence as a girl opposes the possible molarities of identification—man, woman, child, adult—to which we can add sexuality as a fixed identity. She is the destabilizing presence, preventing the body of Paul America from completely facializing as a purely homoerotic odalisque. This is why, for Deleuze and Guattari, *the girl* is a "line of flight": her presence prevents, rather than fixes, concrete and organized identification. Genevieve's body does not simply complicate the sexual tension of *My Hustler* but instead prevents desire from assuming any final identity.

The girl in Deleuze and Guattari's ideas on becoming-woman therefore has a particular power—that of destabilizing, or deterritorializing, identity, particularly desires based around perceived identities: "The girl is like the block of becoming that remains contemporaneous to each opposable term, man, woman, child, adult."[40] However, to conclude that this particularly powerful role is gendered is to misunderstand the sense of becoming that they aim to explain. "Becoming-woman produces the universal girl" was their particular way of expressing how there is a universal value of becoming-woman that exists before it is bifurcated toward heterosexual/homosexual desire and identification. This suggests that before Warhol's film production turned toward narrative, the ambiguity that created the free-indirect discourse of his camera work was centered on the role of the girl. We should not jump to the conclusion that this excludes John Giorno, the sleeping Adonis of Warhol's *Sleep,* or *The Thirteen Most Beautiful Boys* (1965), but instead take note of how the girl is a stage or plateau of becoming-woman. Deleuze notes: "The girl and the child do not become; it is becoming itself that is a child or a girl. . . . The girl is the becoming woman of each sex, just as the child is the becoming-young of every age."[41] Thus the girl is a plateau of deterritorialized identification and desire, later facialized by culture, according to classifications and structures of sexuality. It is this ambiguity of identification and desire that is presented by the early portrait films of Warhol as well as the Monroe silk screens. Indeed, this as yet unfixed discourse of desire is evident in his connection to the stars of these pieces—the very public stars of Monroe, Elvis, and Kennedy but also the clique of superstars, Giorno, Paul America, Viva, Candy Darling, and International Velvet—who populated the Fac-

tory. So much so that the "universal girl" is expressed through his, and their, becoming-star.

Adventures of the Face

In their writing on Warhol, both Tony Rayns and Matthew Tinkcom have suggested that the consumption of stardom is a particular characteristic of gay culture to the extent that the two are inseparable. Tinkcom notes how fans "are rendered helpless in the sight of the star's image" and recognizes that "the ways that stars embody gay images . . . [have] been notoriously complex to document, especially given the ways that many gays have *identified* with female stars while *desiring* male stars."[42] Rayns, on the other hand, points to the uplifting effects of star glamour through negotiation by isolated gay men "exulting in vintage Hollywood fantasies of class, wealth and emotional fulfillment" and for whom star consumption is an immensely fulfilling experience involving the ability to "mentally edit or re-direct movies, to take from them what's interesting, exciting or sexy and to repress or ignore the rest."[43] However, quite apart from the assumption that heterosexual fans do not consume stars in a similar way, this approach misrecognizes as an essentially gay practice the complex identification and desire at work in the relationship between fan and star of either sex.

Richard Dyer, in his pivotal work on stardom, observes that audience reaction to stars is a consumption of the values of which the star is a sign. Dyer notes the development across time in which the star moves from the status of god/goddess to that of person in the street, a move demarcated by the coming of sound:

> In the early period, stars were gods or goddesses, heroes and models— embodiments of *ideal* ways of behaving. In the later period, however, stars are identification figures, people like you and me—embodiments of *typical* ways of behaving.[44]

This involves a dualism difficult to fit over many of the stars in question. Greta Garbo and John Gilbert might be godlike, and Woody Allen a face in the street, but it also asks us to believe that stars such as Marilyn Monroe or Robert Redford are *typical,* and stars such as Buster Keaton or Mary Pickford are *ideal.*

Jackie Stacey, on the other hand, has pointed to an active relationship between the female fan and female star that involves both senses of Dyer's identification. Stars offer the fan images of ideal femininity that they acknowledge as being remote or unattainable. However, this is accompanied by, rather than being opposed to, various attempts at becoming-star, the most common of which are the copying and imitation of stars through mimesis of performance or extracinematic consumption of related fashions and products. This is therefore an acknowledgment of the ideal status of stars, but one that is not seen as something that *cannot* be made typical through a process of becoming. The pleasure is in the desire itself rather than in the hoped-for stardom. Their desire to become stars is really a desire as becoming. Their acknowledgment of the "gap between star and fan" suggests that their imitation is the facialization of a real becoming-star.[45]

In this way, Warhol's cinematic relationship with women, realized to strong effect in *The Thirteen Most Beautiful Women* (1964), constituted a chance for him to do in film what he had done with Monroe in silk screen. The adventures of identification associated with the star are reflected in the adventures of the very lines and shapes on the surface of the screen or print. Examples such as these constitute not only an awareness on Warhol's part of the abstract machine but a desire to be part of its becoming. In Warhol's work, the facialization of the star no longer fixes the identification but by repetition and deconstruction of the abstract machine—photography—allows it a line of flight toward total deterritorialization. It is the reduction of film to what Peter Gidal describes as "one extreme function" that releases it from any sensory-motor schema.[46] The face on screen becomes an adventure of the line on the surface of the image.

This is shown throughout the direct-view screen tests that Warhol conducted (personally or not) through the sixties that make up the constituent parts of *The Thirteen Most Beautiful Women* and other films. This loose collection of filmed portraits (each four minutes in length), in which sitters do little more than stare at the camera, comprises both the anonymous and the notorious of the Factory's coterie of stars. Some of those filmed for the screen tests played up to the camera: Eric Andersen and Debby Green kiss, while Nico drinks beer from a can that catches

the harsh lights of the studio. In these cases, they move toward the action image, since they replicate or parody the shot in narrative cinema. On the other hand, the implacable and unblinking stare of Marea Menken, for example, opens up the shot to the contemplative. It is impossible not to let one's eyes wander across the image, constantly reinterpreting these stares. These are time-images, since they not only confound the expectations of filmed shots and photographic portraits but at the same time present the body as a locus of indeterminacy. The pre-hodological space waits to be filled with interpretation yet simultaneously escapes it. Edie Sedgwick breaks down as the effort of staring-out the camera becomes too much. This moment draws the image back into action image and thus reveals (in our memory) the time-image that existed before. Once the stare (and the spell) is broken, one is free to return to the safety of the movement-image. Edie's distress is our comfort.

Warhol and these films of his "stars" demonstrate that the photographic image in general is dominated by facialization: photography should be seen as "adventures of the face" (Deleuze saw music as the "adventure of the refrain").[47] The stasis of the screen tests reveals their intensity, and the movement of black holes on white walls prevents a total facialization. Dennis Hopper's screen test, in which he stays almost completely still, involves such a vivid pattern of black and white that its negative image remains on the retina even as the film finishes and Hopper fades to white. Nothing else could present Deleuze's black hole/white wall system with such efficacy or emphasize the racial ambiguities of both Warhol's coterie and the black hole/white wall system themselves. The fade-out is the recurring element in the screen tests that fully ensures deterritorialization; as the image fades to white, it is replaced not by another shot but instead by the memory of the face. Such memories, of course, possess unlimited possibilities because there is no unifying chain of meaning into which the image fits. If one has no personal memory of Nico, the overt significance of her swilling beer is lost, *but the image itself is no less significant.* If we know something of Nico's life or Dennis Hopper's, it merely adds another layer to the crystal that emerges from the images. Memories of them simply actualize the virtual that is offered. Hopper's preppy image contrasts strongly with the present-day public perception of him; his intervening life makes

the crystal structure of actualizations more complex. In the face of this molar hierarchy of representation, his youthful awkwardness simply brings us back to Deleuze and Guattari's molecular and universal girl.

Paul Mattick noted how the Monroe silk screens in particular have a similar historical dimension because of their production just after the death of Monroe. Crucially, Monroe and other female movie stars were "representatives of desire and desirability, of the artificiality of gender roles." This star identification is made even stronger when the star retains youth and beauty through the image: "Monroe dead, for some purposes, can be superior to Monroe alive."[48] Thus Monroe the star is the universal girl who can never be changed or tainted and will always present a plateau of becoming-woman. Those images no longer stand for either Monroe or Warhol but for becoming-Warhol, and the relationship with Monroe as star was an essential part of his becoming-woman. Since photography was so essential to the becoming-

Andy Warhol, *Screen Test—Dennis Hopper* (1964). Copyright 2005 The Andy Warhol Museum, Pittsburgh, Pennsylvania, a museum of Carnegie Institute. All rights reserved.

star of Monroe, it was only logical that it should be her photograph that Warhol would work with. The screen inks that color the already simplified images of Monroe and the others add what Mattick describes as a "thin Warholian layer" to the image. Warhol was trying to insert himself into the process—trying to become the abstract machine—and thus continue his personal becoming-imperceptible.[49]

The serial repetition of the silk screens emphasizes the coming into being of the image. Hand marks on the silkscreen reveal the human intervention in the manufacture: a presence that, by contrast, must be revealed in order for it to become properly imperceptible. In the same way, the apparatus of filming is inseparable from the image produced, since the sitters for the screen tests know about Warhol's presence and for one reason or another ignore it, often because Warhol indeed wasn't there. Amy Taubin has written of her experience in the Factory:

> Like all newcomers to the factory, I was screen-tested: I was escorted into
> a makeshift cubicle and positioned on a stool; Warhol looked through the
> lens, adjusted the framing, instructed me to sit still and try not to blink,
> turned on the camera and walked away.[50]

The screen tests have the particular effect of creating a camera-consciousness by conflating the event of photography, the camera, and the screening. This is a reflexivity that creates a circuit with the camera as an abstract machine in which Warhol as operator is imperceptible. There and not there, the presence of audience and filmmaker becomes audience *as* filmmaker. Peter Gidal explains, camera and projector cannot be separated: "[In *The Thirteen Most Beautiful Women*] the film-apparatus can't be meta-physically subtracted from the film, from the effects produced, which are given, here, as specific transformations of and in film and film-meaning."[51] Most prominent among Warhol's super-stars was Edie Sedgwick, whose background as a spoiled rich kid placed her in a milieu between the screen test stars of the Factory and the unattainable stars of Hollywood, the real-life star factory that Warhol's establishment seems to have both admired and opposed. Sedgwick's films with Warhol included *Beauty #2* and *Lupe* (both 1965), although *Outer and Inner Space* and especially *Poor Little Rich Girl* (both also 1965) are perhaps the most striking. Both form parts of a series of films that Callie Angell, curator of The Andy Warhol Film Project, describes as

Basically extended portraits [that] can be regarded almost as documen-
taries—straightforward, unscripted filmings of Edie simply being
herself. . . . In Warhol's opinion, Edie was self-possessed and fascinating
enough just to carry a feature-length movie just by playing herself.[52]

Like *My Hustler, Poor Little Rich Girl* (which refers to both Sedgwick's
own life and the 1936 Shirley Temple film of the same name) consists of
two thirty-three-minute reels projected consecutively. The first attempt
was out of focus and Warhol reshot it. However, both reels make up the
film, normally shown consecutively. The first reel, in which Sedgwick
appears as landscape and unfacialized body, literally gives way to a fa-
cialization of Edie the star as the image snaps into focus. As in the my-
thology of stardom, Edie is literally plucked from obscurity.

A similar deterritorialization of the face occurs in the image of
Outer and Inner Space (1966), although this time it does so because the
doubling of Edie on screen forces further contemplation of her face and
each image of it. *Outer and Inner Space* involves the projection of two
similar thirty-three-minute reels simultaneously, side by side, of Edie
filmed in front of a video of her recorded previously. Video equipment
manufacturers would commonly give Warhol new equipment to play
with, and the results, such as *Outer and Inner Space,* document what
Matthew Fuller has at another time described as the camera "teaching
itself its own typology, marking out its own body . . . measur[ing] out its
collapse."[53] The space created by the live Edie and the recorded one is
uncomfortable: "Space is flattened, perspective destroyed," J. Hoberman
notes.[54] Callie Angell similarly recognizes "emotional fractures" that
demonstrate an "increasingly unhappy subjectivity" as Edie is seen to
wince at her own recording.[55] These are given visual presence in the
refracting and reflecting images; the differing camera angles of Edie's
face act like a hall of mirrors. It is in this space that the time-image is
given seed, and the space created is its environment. The pace of the
film further compounds this as the two reels oppose each other—one
zooms in while the other zooms out, evoking the outer and inner space
of the title. The sense of linear past and future is made nonsensical by
these movements, since they seem simultaneously to open up and close
down the image, suggesting the same occurs in time. Without a linear
pattern, time can only unravel or unfold as in the time-image.

Both films are often virtually soundless, with only an ambient soundtrack audible, and the image wrests itself away from the noise. As such, they point to the kind of image-sound situation that Deleuze saw as the "beyond of the movement-image [which] cut perception off from its motor extension, action, from the thread which joined it to a situation, affection from adherence or belonging to characters."[56] The images are returned to us as if from the silent cinema where stars were elevated to the status of gods, according to Dyer, and their becoming-star was one of total facialization. The absence of sound creates a vacuum that is filled by the internal circuit and thus the crystal image. Peter Gidal writes:

> The silence, durable, brings itself forth against the possibilities of (imagined) off-screen sound. . . . The vacuum established in that noiseless period of duration is full [of] the noise of so many other Warhol films. . . . Again and again it brings one back to the film, its concrete abstractions.[57]

The absence of sound in a world of sound creates the environment of the crystal and liberates the time-image, leading us to suspect the same about photography in general. The mistake has always been to consider the silence of photography as an agent of *limitation* by absence. But these films show us that this silence instead is an agent of *liberation* by absence: liberation from its connection to movement in space. The bodies in these films are faces/landscapes created by the shifting and merging of black shapes on the white screen. There are only intensities of black and white that form and reform, never concretizing long enough to be interpreted as a face, and yet they remain a faciality as landscape through the apparatus. This is most evident in *Poor Little Rich Girl.* Unaware of the technical hitch that produced it in recording, Warhol himself can have become aware of this only as he watched it for the first time. This facialization of a star refuses to signify, refuses to create a subject: is it a face on a screen or a screen on a face? Simultaneously, Warhol had erased his own presence by embracing the star and by making the image an adventure of the face. Warhol, Edie, the camera, the film, and the projector were together the abstract machine. But the abstract machine that turned the face into a landscape in *Poor Little Rich Girl* had, it turns out, already turned the landscape into a face.

Andy Warhol, *Poor Little Rich Girl,* reel 1 (1965). Copyright 2005 The Andy Warhol Museum, Pittsburgh, Pennsylvania, a museum of Carnegie Institute. All rights reserved.

Andy Warhol, *Poor Little Rich Girl,* reel 2 (1965)

Adventures in Landscape

As Warhol's career was turning toward narrative and a more concretely homoerotic position (but not totally, given the ambiguity, if not ambivalence, as late as 1968 in *Blue Movie*) influenced by his collaboration with Paul Morrissey, Warhol's relationship with time and the camera changed. What had gone before was a becoming-imperceptible that saw Warhol making explicit the abstract machine. In *My Hustler* there is an emphasis on the fixed, or fixated, image in the early reel that is brought into narrative, just as in *Poor Little Rich Girl* the blurred image is brought into focus. The later reels are more difficult to decode either because they are laborious to watch *(Poor Little Rich Girl)* or because the image presents too familiar a situation to make quick interpretations.

All this suggests that those "fixation" films of 1963 and 1964 (*Sleep, Haircut, Eat, Blow-Job, Empire,* and *Henry Geldzahler*) were not simply experiments with the camera but themselves had deeper significance for their filmmakers because they had more possibility in interpretation than they outwardly appeared. How do they figure in the larger, encompassing becoming-Warhol? They certainly present becoming in many respects, but each seems to have a flaw. *Sleep* invites too strong a homoerotic interpretation; *Haircut* sounds too camp, as does *Blow-Job.* All of them, including *Eat,* seem too much like film essays, Deleuze noted, with conclusions to be made and catharses reached, even in their depiction of the everyday:[58] Billy Name's haircut is ready, Robert Indiana finishes the mushroom, John Giorno wakes up, and the anonymous teenager comes. Even *Henry Geldzahler* appears to reach a final end point: when Warhol reenters the room, the gallery owner's otherwise deflated expression seems to brighten. Warhol reenters both the room and the apparatus and becomes perceptible in the film again. This visibility of Warhol the filmmaker is missing from his other films, and indeed from cinema in general.[59] It is too easy to think of the end of the film as a blessed relief for Geldzahler. There is nothing emphatic enough about these everyday events to suggest that they are interminable or that they will never end. These events create a sense of time, rather than reduce chronology to nonsense. That is, all except for *Empire.*

Empire is an extended film of the Empire State Building, shot on black-and-white silent film from an office on the southwest corner of the

Time-Life Building. The mythology of *Empire* has involved reports of it being twenty-four hours long or eight hours long, although its "reel" length (eight hours) is extended by the projection speed (16 fps) being slower than the filming speed (24 fps). In the film, which was begun in the early evening, the sun sets and the building emerges from the white-out of overexposure to become a collection of lights cast by the building's floodlights. Eventually, toward the end, these are switched off and much of the rest of the film is in total darkness. The middle reels, which mostly show the building lit, demonstrate a heavy, material quality as the rough grain of the film dances on the surface of the screen.

Reels showing the building in darkness went missing in the intervening years. A full print of the film was left at the lab in the early 1970s, rediscovered nearly thirty years later, and given to Callie Angell, the Whitney Museum of Art's adjunct curator of the Andy Warhol Film Project.[60] This perhaps led to the growing mythical status of the film, and Angell notes, in the 1994 Whitney program, that the absence of critical comments on the final reels of *Empire* suggest that before 1994 no one had sat through the entire film.[61] Even for many champions of Warhol and avant-garde cinema, it still barely warrants a mention beyond the sheer audacity or sheer monotony or even sheer camp of an eight-hour film of a building. The film has been partly vilified and partly ignored, but people still stare openmouthed when introduced to its concept alone. It seems to fundamentally oppose everything for which cinema is popularly appreciated. As a film in which the composition does not change, it might immediately be thought that any one photogram might represent (or be the label for) the whole. *Empire* defies this, and its longevity and inability to be represented by one photogram or a copy of one reel—even though nothing appears to happen through much of the film—ensures that to know *Empire*, you really do have to watch it.

In *Empire,* the Empire State Building does not react to the presence of the cameraman, or cameramen, even when they are visible in the window's reflection (it remains a rare example of Warhol appearing in his own film). There is nothing in the eight hours of film to suggest that the building will fall over when the camera is turned off or that the film will continue until the building topples. While its audacity has been described as egregious, there's nothing camp about *Empire,* although the

building itself attracts fans, including, of course, Warhol, who famously said during filming, "The Empire State Building is a star!"[62]

Why should *Empire*, a film of such little apparent purpose and of such a recognizable object, present becoming? First, it is clear that, as Gregory Battcock once attested, the building filmed will never be the same again. Battcock compared the opening reel, in which the building emerges from a combination of actual fog and image flare, to the sequence of *Anna Karenina* (USA, dir. Clarence Brown, MGM, 1935) in which Greta Garbo emerges from the steam of a train—a "star" comparison that Warhol would probably have liked.[63] *Empire* has already entered any mythology that exists of the building. Like any of the hangers-on of the Factory, it remains a part of becoming-Warhol (and is certainly the most famous of the Factory's stars). Thus *Empire* and the Empire State Building make up quanta of becoming-Warhol in mythology and in practice.

Empire, with its grainy, textured image, reduces all the stardom of the Empire State Building to a flat surface—black holes on white walls— and outlines the rarefied shape of the building with such strength that the facialization bursts forward as probe-head. What deterritorializes the Empire State Building is the intensity created by its own immobility. The black hole / white wall system is an effect of the static building in open space that changes around it: "The face, at least the concrete face, vaguely begins to take shape *on* the white wall. It vaguely begins to appear *in* the black hole."[64] The image of the Empire State Building becomes a face in close-up, like any other in cinema, a face that "is a visual percept that crystallizes" out of an intensity of stillness, building with it an entire career for the film's star in one breath:

> The film begins with an image of total whiteness in the midst of which, as the sun sets and the light decreases, the shape of the Empire State Building gradually flickers into view. . . . Its unwavering presence suggesting at various times (to this viewer at least) a rocket ship, a hypodermic needle, a heavenly cathedral, or a broad paintbrush that has been dipped in white paint and placed on the surface of a dark gray canvas.[65]

The power of *Empire* is that it is a landscape that becomes not only one face but many, and of them none takes precedence. This is a glimpse of the abstract machine at work, not just because the possibility of envisaging a crystal environment grows from this internal circuit but because

the duration of *Empire* enforces an awareness of this. The singular duration of cinema becomes, in *Empire,* multiple durations by each crystallization.

In this way the extreme length of *Empire,* its black-and-white image, and its absence of sound constitute choices made by Warhol to emphasize the abstract machine at work and lay bare its operation by allowing it to dictate the rules of representation. Peter Gidal writes, "The limit is the film's 100ft 'end' (or 1200ft 'end') not ontological and necessary but convenience given as such (enough is enough, philosophically and materially)."[66] *Empire* demonstrates that the silence of the photographic image frees it from movement, or allows it to remain free of any narrative trajectory or closure. The length of the film remains important only in material or exhibition terms. This is what Malcolm Le Grice stressed as the importance of equivalence—the experience of a film's length as equivalent to its action—to Warhol's films and avant-garde cinema in general.[67] To remain a single-reel film would invite comparisons with timed-exposure photographs—or as a filmed photograph— whereas several reel changes instead emphasize an attempt to represent the several lived durations of the Empire State Building that no discrete element can portray. With silence, once one reel change is effected, the project assumes a potentially endless length that is only curtailed as Mekas and Warhol become tired of returning to the camera. The film assumes multiplicity because it could be *any* length, and as a film made up of a barely changing repetition of a single photogram, it assumes a potentiality of *every* length. Time deterritorializes the face/landscape, but not time connected to movement; instead, it is time as intensity. This is what the photograph *can* offer, and what *Empire* does offer. For Warhol, the fact that *Empire* could be a photograph is the *reason* it needs to be a very, very long film. This is given a double significance by the building's own immobility: "It becomes apparent that the slowest of movements, or the last to occur or arrive, is not the least intense."[68] In this way, a photograph would indeed express nothing of the intensity of the Empire State Building. Only a succession of photographs, or a film, might be appropriate to do this. Flusser writes, there is a remarkable stillness in the photograph that elevates it from redundancy:

> It is precisely this permanently changing situation that we have become
> accustomed to. . . . The changing situation is familiar, redundant; prog-

ress has become uninformative, run-of-the-mill. What would be informative, exceptional, exciting for us would be a standstill situation . . . that would surprise and shock us.[69]

This is *Empire* as probe-head, bursting from oversignification brought about by its lack of event and movement and the extraordinary intensity of the "holey surface" that can be created by nothing other than the stillness of a building.

The Empire State Building resists actualization in *Empire* and Warhol constantly played with the obvious interpretations of its visual conceit ("An eight-hour hard-on!"). Yet this fact reflects in Warhol's own becoming-imperceptible as an artist. *Empire* was filmed by Warhol and Jonas Mekas, from an idea by John Palmer. It was Palmer who stretched the concept to its fulfillment in abstractness: "The audience viewing Empire will be convinced after seeing the film that they have viewed it from the 41st floor of the Time-Life Building, and that's a whole bag in itself."[70] Whether Palmer, in referring to "it," means the film or the building is suggestive of the fact that the two had effectively merged in concept, and we must add to this the merging of Palmer, Mekas, and the other Factory hangers-on (including Henry Geldzahler) into the "Warhol" who, as far as history is concerned, shot the film. Although Warhol was a cameraman for the film and can clearly be seen returning to the camera in its later stages, he was unfamiliar with this model and Mekas took most of the responsibility. Given that the concept for such a film was not entirely Warhol's, especially as we have seen how conceptual abstraction is the film's philosophical drive, and that he was remote from the process of filming, there is not much of a case to describe Warhol as the auteur of *Empire*.

Empire therefore presents a problem for David James's approach to the "erasure of authorship," Warhol's "most characteristic authorial gesture" that progressed during his film career.[71] This became clear in Warhol's self-portraits but also in his becoming-star: the erasure of the molar identity of the self, becoming-imperceptible. *Empire,* like the Monroe silk screens, were a simultaneous becoming-star and an erasure (at least in part) of Warhol's self. Rather than such a degradation of the traditional authorship role occurring over time, *Empire* is an example of Warhol's becoming-imperceptible, an evanescence of authorship at a very early stage in his career.

Andy Warhol, *Empire,* reel 7 (1964). Copyright 2005 The Andy Warhol Museum, Pittsburgh, Pennsylvania, a museum of Carnegie Institute. All rights reserved.

Warhol's significant part in *Empire* was to step back from direct contact with the project and become an imperceptible part of the abstract machine. Becoming-Warhol is not experienced through any traditional authorial signature; instead, the experience is a molecular one of camera, filmmakers, image, viewers, and the information that flows into all of these from Warhol's reputation, the building, and cinema and photography in general. The difficulty experienced in pinning down Warhol's input in *Empire* does not diminish it but if anything makes it more a part of becoming-Warhol. In reel 7, Warhol's reflection in the window of the Time-Life Building office (*Empire*'s shooting location) overlays the floating image of the building in the distance. For a few brief moments, Warhol is perceptible in the filmmaking. This only emphasizes his near-complete absence from the film because the image is fleeting, translucent, and finally disappears.

7 THE NEW USES OF PHOTOGRAPHY

Intensive Screens

The twenty-four-hour gesture behind Andy Warhol's *Empire* lurks beneath the history of the film as a work of art. The comprehensive nature of the attempt seems to match its elusiveness; it was a project doomed from the start, and yet this adds to its mystique. To engage in such a project now would be absurdly simple, as Wolfgang Staehle's 2001 installation *Empire 24/7* clearly suggests. Staehle's installation involved a live image of the building streamed over an Internet connection via a webcam, a practice that became common as the Internet expanded in the late 1990s and the popular desire for virtual travel and presence seemed insatiable. It is just as easy to complete a project such as *Empire 24/7*—indeed, it seems to be why, for Staehle, it almost had to be done—as it is to speculate that Warhol himself would have done it.

The difference between Warhol's film and Staehle's project lies in the relationship of each with time, corresponding to the particular technology each used. The film is oriented toward the past, its medium one of recording and inscription—the "graphy" of photography. The other seems oriented toward the present and the future, its medium one of connection and communication. The webcam adds the technology of telecommunications to spatialize the distance that is felt as a distance in time in cinema. This was given its strongest example in Staehle's live link to a webcam looking out across Manhattan from New Jersey in September and October 2001. The scheduled gallery activity of the webcam was interrupted by the events that unfolded on September 11, for which it had an almost unparalleled view. The webcam not only

reflected the "live" nature of contemporary news channels but emphasized the gulf between viewing and action created by all photographic means; distance between past and present became distance between here and there.

Such a convergence of telecommunications and photographic technologies, in video as much as in photography, gives us cause to reconsider the relationship between time and space in photography, in particular, photography's relationship with the intensive space of the "world" around us, a world given particular character and dimension by the "organ of perception," in a similar manner to its relationship with time in Bergson's analysis. On the one hand it is worth reconsidering the spatialization of time and memory through the photograph in cinema narrative, and on the other it is worth reconsidering the role of photography itself in giving a profile to global telecommunications for users of the Internet as they weave themselves into the network of contemporary social ties. Ultimately, both approaches demand that we reconsider at last photography's relationship with memory as that which reveals the profile of immanence itself. For Deleuze, immanence is the life that is everywhere and is revealed or "measured by given lived objects: an immanent life carrying with it the events or singularities that are merely actualized in subjects and objects."[1] This is life revealed in the imprint left by subjects and objects and in "memory" as only a visible or tangible articulation of *immemory*.

The co-option of Warhol's famous artwork into the live art of Staehle illustrates the critical difficulties of philosophies such as that of Vilém Flusser, discussed in chapter 6. For Matthew Fuller, Flusser's notion of a playful iteration of the camera's program is useful for disentangling that program and the way that ideology is inscribed onto the apparatus.[2] An artist's attention to, or violation of, the properties of the technology being used are the methods by which such a revelation is made. Fuller's point is that there is much more than a coincidental connection between technical experimentation and radical politics. Laura Mulvey also observes that the aspiration of experimental cinema demonstrates a "belief in cinema merging with belief in radical political change."[3] This is an awareness among filmmakers of the role of media in creating history on behalf of consciousness—the mediation creates the political event in art, for example. Put more simply, it is an

awareness that mediation is an organization of the "unspeakable and intractable nature of time itself."[4] For Fuller, the camera has a drive or "medial will to power" that is produced by the incommensurability of a highly regulated apparatus with a world of infinite variation and intensity awaiting description.[5] People are drawn to use technologies of photography because of the sensation we have that something must be recorded from the momentous and the everyday that passes, yet for the purposes of our discussion we cannot forget that this is also a monadic inflection of the industry of which photography is a part. Fuller and Mulvey express, in a general practical sense, that what Flusser's argument suggests is, perhaps, latent in all relationships with technology. Flusser's playful operative, the artist/user who actually sees the program in place around her, is even aware that her own resistance is recognized as a dominant idea that has a life of its own within the program.

The final task, then, is to understand how ideas differ within everyday and aesthetic practice, how thoughts of photography have come to have an influence on practices, and how those practices generate new concepts and ideas. This is doubly apparent as the technologies of cinema and especially photography converge with those of video and telecommunications. Convergence—a panoramic view of technological change—serves to highlight the ontologies of cinema, video, and photography as being fundamentally *ideas* whose particular lives are similarly given profile by the technology in *use*. Photography, if we remember, is a single substance stretched across all types of photographic image, folding to inhere photographs, cinema, electronic images, and digital images. It is a substance given form by the camera as its principle inflection and, more important, by the new embodiment of the screen, which now connects all technologies, all images. The paper print has been replaced by the screen, and the photographic album itself has been subsumed into the Flickr or Photobucket account. On the one hand, screens are the ubiquitous embodiment of public seeing, in restaurants and bars, in homes and in the street, an embodiment of public spectacle as well as surveillance, so that customers can see themselves on screen while they consume. On the other hand screens return (not disguise or replace) memory to the surface of the image. The new viewer does not look through the new screen but navigates across it, touches it and strokes it, moves it and closes it. Cell phones, for example, become hard

yet delicate objects with responsive screens. Computer screens can be multiplied and divided, screens within screens, so that images can be put together, taken apart, altered, and expanded, or alternatively they can be forgotten and unseen, waiting to be downloaded onto a screen near you. Screens have returned the photographic image to being the substance of memory itself, as the proliferation of photo-sharing sites, such as Flickr but also MySpace and YouTube, has meant that the exchange of digital images (which is transparent, since simply opening a shared image is to take possession of it, to receive it) takes place without a second thought. The physical screen is now the membrane of memory that is "no longer the faculty of having recollections: it is the membrane which, in the most varied ways (continuity, but also discontinuity, envelopment, etc.), makes sheets of past and layers of reality correspond."[6]

While the elements of sharing and connection incorporated into such sites suggest a widespread cultural shift toward an emerging globalized, networked, and homogeneous visual culture, many of the personal diaries of weblogs and photoblogs remain highly specific to their users' sense of individuality—even as they develop generic characteristics common to many blogs and hosting sites. Such a perspective inheres the globalized panoramic worldview, yet it is still what Bruno Latour has described as a common parochial attitude toward the global.[7] Views of the global, from the perspective of the online diary that delights in its multifarious connections, are at the same time "what vaccinates against totalization" and "miniscule rails resulting in some glorified form of provincialism."[8] Such a criticism seems at odds with the Latour who shares Flusser's understanding of the black box of technology, the translation of many thousands of calculations—scientific and cultural—into an object of use such as the camera. Latour's early close work on the sociology of science, as we have already seen, seems indebted to Flusser's beautiful abstract concept of 1984.[9] However, in his later work Latour certainly opposes the layered model of a societal program in which locations fit within each other, so that the local "micro" fits into a global "macro." For Latour, the Matryoshka metaphor of the black box is problematic in its panoramic view because it attempts to understand the local social sphere only as a function or effect of larger controlling contexts. It is not enough for the philosopher or sociologist to adopt the user's worldview and simply place the user's actions within a larger pat-

tern or narrative of globalized technological change. Photography as a program, for example, cannot be understood through a "Big Picture," whether this constitutes a big picture of assumptions of generalized social uses of photography or whether another type of big picture— the Photograph as art print or family snapshot—comes to dominate our understanding of social use. According to Latour, we must ask of this big picture, "In which movie theatre, in which exhibit gallery is it *shown?*"[10] Thus, understanding the existence of a layered program, a black box of cultural determination, is not as important as understanding how users see themselves within it and the necessity that exists to then "trace," in Latour's terms, the associations they make. The layers of the program, in this sense, are never as important as the connections made between them by users and objects. For us, the task is to see how users of photography orient themselves toward new understandings of time and space in an apparently globalized, networked world seemingly provoked by new technologies of connection.

Latour's return to theories of social networks was precipitated by the development of new media technologies, data terminals that leave data traces where social ties were, in the past, all too often only experienced as latent:

> Satellites, fiber optic networks, calculators, data streams, and laboratories are the new material equipment that underline the ties as if a huge red pen were connecting the dots to let everyone see the lines that were barely visible before.[11]

Central to this new "good" myopic rather than "bad" panoramic view of the sociologist is the role of the person as constantly framing and interpreting the social situations that they (as actors) observe. Despite the famous notion of actor-network theory that actors can be both human and nonhuman actants, it is clearly essential to understand the role of the perceiving individuals who make social ties, who understand themselves as individuals but who nonetheless are always undergoing a process of individualization through the connections that they make. The sociological and philosophical project is therefore to follow the traces that users make as actors when they form networks with the objects that are also acting. We can understand this immediately by considering the affect that new technologies, such as the camera phone, have

on the use of photography—perhaps the most obvious analysis to undertake. However, technology has a tendency to "bundle" applications (a new metaphor) in varying degrees of speeds and slowness. It took several hundred years for photography and then cinema to bundle the separate technologies of optics, chemistry, and the regulating automata of the machine. Such convergences of technology always seem vaguely absurd in their overelaboration, as we saw in chapter 2 with Muybridge and Pippin, until we understand the desires that bring the technologies together in social life. Another way of following the traces of actors in photography would be through appreciating the desires for connection that users experience and the ways that technology responds to such desires.

Considering users and objects as actors within networks encourages us to follow *use* and question the framing subjectivity of the user in a networked culture, in particular when practices allow for no other way of doing things and there seems to users "no going back" to earlier ideas or approaches. The adoption of the Internet is a case in point. The many stories of the phenomenal success of the Internet in the late 1990s can all be traced to an erroneous press release and misrepresent the actual rate of adoption, which remained relatively modest for a number of years.[12] The crucial conclusion, toward which Gisle Hannemyr works in her study of the adoption trends of the Internet, is that the global hyperbole of the Internet's growth itself produced the popular idea that the Internet could not be ignored in social life, an idea "enrolled in political discourse in support of various political agendas."[13] The impact on photography was, as we shall see, manifold.

Network approaches also help us understand the translation of popular conceptions of photography onto objects themselves, especially to understand the role of "named" theories as *actors*. Ideas are "things" as much as the effects that they provoke; they are not the dead labor of Marx. This view is taken up by Scott Kirsch and Don Mitchell, who suggest that "things" accrue value through the machines that create them on behalf of desires.[14] Thus photography is a practice in which the dead labor of the past (the camera) is given a new life as it creates new objects (photographs) that are themselves "ossified things."[15] New digital technologies dematerialize the object of the photograph and thus reveal the "thing" as a concept or idea that seeks embodiment

in objects. Such an object now acts in a network, they suggest, ossify-
ing social relations to the extent that the "thing" becomes the orienta-
tion point around which everyday patterns and rhythms revolve. This
is true no less of cameras and the images they can produce than it is of
persistent ideas of photography that coalesce into types of photograph.
Photographs such as those by Atget, or photo works such as Roland
Barthes's *Camera Lucida,* are therefore artifacts around which photog-
raphy practice continues to revolve: actors in networks created by the
museum, the studio, and the lecture theater. Latour's most valuable ob-
servation is of the particular nature of time in actor networks. "Time is
always folded," he says, meaning actors are always continuing to act.[16]
Thus all social interactions exist on the same plane of immanence given
a profile or consistency by the actions of the everyday. "Flattening" the
plane of social interaction in this manner makes it easier to discern the
effect of particular actants in terms of strength and weakness, discern-
ible through intensity rather than extensity. The relative intensity of
actants does not express distance in time or space but urgency, necessity,
serendipity, inevitability. Events can have lasting effects no matter how
minor their intention. Photography, we might conclude, is a monadic
network with a substance folding in intensity, and the history and criti-
cism of photography is a topological ululation of voices from near and
far in time, each voice indiscernible from its echo.

How Do You Rethink Photographic Memory?

Such voices and echoes can be heard in the work of Gene McSweeney, an
amateur photography enthusiast from western Massachusetts. McSweeney
is a laborer breathing new life into the dead—and forgotten—labor of oth-
ers, in the form of lost cameras and forgotten films. For years McSweeney
has been collecting old, unprocessed films in cameras bought from thrift
stores and yard sales and sent to him by people aware of his interest.
Fascinated by "the mystery surrounding lost films," McSweeney has
amassed an impressive collection of cameras, but it is overshadowed by
the collection of the images that the lost films reveal.[17] McSweeney pho-
tographs each camera and occasionally uses it after retrieving the lost
film. The results are posted on a growing Web page that McSweeney
maintains alongside pages dedicated to his other interests.[18] One page,

offset with a black background, links to an individual archive for each film, an online archive that grows continually. The images, almost all black-and-white, are arranged vertically under the photographs of the "host" camera, each taking up nearly the width of the screen as the user scrolls through them. Images are titled and interlaced with epigraphs, poems, and prose, providing a fictional back story to each one:

> Frame 1—"Uncle Harry"
>
> We've all looked at thousands of photographs in our lifetimes. Many of them like this. The standard, "let me take your picture" photograph.
>
> When we're very young and stand in front of the camera, we're usually stiff and disinterested. We're in a hurry to get on with play. Pre-teens mug for the camera. They make insane faces and stick out their tongues. Teens are often brooding and serious. Young parents beam as they pose with their children.
>
> As we age, and lines appear where there was once hair, we're less eager to get in front of the merciless lens. We're less interested in seeing the photographs of us. Our poses get stiff again and we smile less.[19]

The first impressions of McSweeney's Web site reinforce those particular ideas of photography and its role in family history as part of a wider impression of social upheaval. McSweeney's prose refers to imagined family relationships with the camera given sinewy strength by love, pride, kindness, and jovial irony, as McSweeney tries to express what it was that he felt was behind the desire to take each photograph. Taken out of their time and place, with only a few frames on either side to give any suggestion of intention (why so many photographs of graves? why so many of winter snow?), their placement on the Internet seems at first only to highlight them as relics from a predigital age. Antediluvian in their aspect, their intensity seems at first to rely on the technology of photography and its short chemical life.

Yet these cameras are forgotten objects, and time has defeated the desire to make memories, a desire that might have kept them from the attics and garages where they ended up. Furthermore, the peculiar technology of photography, with the delay inherent in the wait for processing and printing, means that these photographs never became things for their users. Even though the people and places in these photographs may have long passed, the images have never been properly translated

Gene McSweeney, "Uncle
Harry," screen capture from
Lost Films Web page (2007).
Courtesy of Gene McSweeney.

into the dead labor of the photograph in the album that attempts to re-
cord only the happy or otherwise memorable events. These photographs
have never died, since even now they are given life by the interpreta-
tions of new viewers—Gene McSweeney and the visitors to his site. If
we follow the actors in these photographs, other possibilities emerge.
The photographs have an ambiguous relationship with death and mem-
ory that makes them difficult to place in the landscape of photography's
big picture. The intermingling of the images with photographs taken
by McSweeney himself, some on the original cameras (often using the
remaining frames of the old film) and others taken with his collection
of pinhole cameras, makes it difficult to pick out voices from echoes,
past from present. Here memory is a creative act or fabulation, anti-
thetical to the dominant idea of photography's capture of public and
private memory. This is no less true for McSweeney's 2009 photographs
as it is for the majority of the images that have, of course, been forgot-
ten sometime after they were taken. Another possibility exists in the
disappearance of these objects from the lives of their users: the images
within these cameras were not wanted, or were taken to expunge or
expel memory, or the memories recorded are too painful or simply too
forgettable to live with. Many of these images are drearily dull, banal
to the extent that they may have made no imprint on the memories
of the photographers. They imply photography is an everyday habit,
the photographers responding to what Matthew Fuller describes as the

hunger of the camera that "compels the user, as Flusser suggests, to bring it into alliance with his or her own: a new medial appetite."[20] In so doing they propose that memory itself is everyday and banal, that it has a drive of its own that lies beyond the visible profile given to it by photographic memory as we might understand it. If these photographs represent memories not meant to be kept, does that mean we need ultimately to rethink photographic memory?

By now we should be able to discard the notion of intrusiveness as being memory's only guise or character, but it is difficult to part with the popular idea of memory that has underpinned so many theories of psychology, personality and identity. Even though, as we have seen, memory is a process or transaction always ongoing and only revealed by trauma and reverie, it is often too easy to cling to the idea that the latter *make up what memory is*. Trauma and reverie—the cloying seduction of nostalgia—have come to dominate ideas of memory to the extent that an artist, writer, or filmmaker need only say "my work is about memory" for viewers and readers to feel they appreciate the meaning of the work in question. Yet if the delightful inconsistencies of viewing Cindy Sherman's work tell us anything, it is effectively to remind us that memory is not reducible to particular characteristic forms of intrusion. The different memory images that circulate suggest only that memory is there as a process of translation that holds objects together in perception. We should understand memory as the mechanical process, drive, or exchange of energy of the human assemblage. We should understand that it is ongoing and that we pick from its movements particular repetitions, rotations, and cycles. These last things we remember as memories, and for most of us "memory" consists only of recognizing these apparent gestures of life. This is the process of historiography.

We can therefore separate memory as an underlying process from the thing called Memory, which is only the activity of identifying particular recollection images. Such an attempt to parse memory is a considerable challenge, not least because it involves understanding the close relationship between terms, so close that they are too easily mistaken for each other. Once again, we find that others have made this familiar ground in the work of philosophy. Deleuze and Guattari, for example, bring us back to our artist, the one who says "my work is about memory." Such a position mistakes memory for lived experience in the sense

that "memory summons forth only old perceptions," especially the involuntary reminiscences that give so much art or writing of memory its particular character.[21] For them, the important distinction to be made is between the backward-looking understanding of memory as made in the past and a more accurate appreciation of memory as a process in the present. This process takes recollection images as the material for a creative framing or "fabulation": "We write not with childhood memories but through blocs of childhood that are the becoming-child of the present."[22] The artist must resist the Memory that threatens to overshadow creativity, especially if it is only appreciated as involuntary or otherwise naturally inviolate and not appreciated as the process of selection and fabulation of sensations from recollection.

This still leaves us with the problem of how to adequately separate the ongoing *process* of memory from the *material* it selects in the production of memories. This involves picking up the pieces of memory work carried out by Deleuze and Guattari, and others, on the problem of *immemory*. John Rajchman locates immemory in the awareness shown by artists of the obstacle of Memory to creativity—as Deleuze and Guattari suggest. Rajchman shares their opposition to the "self-assurances of psychiatry" and its perception of Memory as important in establishing psychological narratives of identity. For them the idea that identity is formed by memory and understood through the rehearsal of recollection is a misreading, a misunderstanding, or even an ignorance of memory as a process of creative fabulation. Since memory is always a selection, framing, or narrative of the past, any rehearsal of recollection images is always in some way additive or creative rather than reductive to irreducible and infallible objective truths. For Rajchman, psychiatry took a blind alley: "How did we ever . . . come to think that remembering is a cure to what is traumatic and what happens to us, or in the wounds that precede us?"[23] This is a question that artists must pose, as they are perhaps the members of society most reliant on, and most at odds with, memory and history. The artist's role, for Deleuze and Guattari, is to make memory pass into sensation. This is why the idea of the monument is so important for artists. The monument and the artist who creates it are charged with the metonymic representation of memory itself rather than (necessarily) the events that the monument is asked to recall. The monument is thus a reminder that memory is a

process of selection, always whispering its instruction: not "do not for-get" but, Deleuze and Guattari suggest, "Memory, I hate you."[24]

This accounts for the sensational brilliance or phosphorescence of memory work in Shimon Attie's projection installations in Berlin, Copenhagen, San Francisco, and Boston. For *Writing on the Wall* (1992–93), Attie researched photographs from the 1920s and 1930s of working-class Jewish residences and shops in the Scheunenviertel, some taken during police raids, others of the neighborhood's daily life. Attie projected the images onto the still existing buildings or buildings nearby. For a retrospective show in Boston in 1999, Attie used nineteenth-century identity photographs and documents found in the archives of the show's venue, the Institute of Contemporary Art, which had once been a police station. The installation, *An Unusually Bad Lot,* involved projecting onto the walls of the ICA the biographies of "criminals" arrested and incarcerated for sexual deviancy, including cohabitation, miscegenation, and homosexuality.

These two projects emphasize in particular the coexistence of the present with memories of the past embodied in objects, especially photographs. Memory is famously attracted to the photograph because of its apparent ability to trap the details of the past in the same way that intrusive memory brings forth the previously unremembered minutiae of former events. The photograph is always an effect—the collapsing of past and future—translated onto an object that acts on future situations. The critical sharpness of Attie's work reveals photography's always latent monumentality. Decisions made by society, represented by judges, officials, clerks, and bureaucrats, lead to the creation of individual biographies to which evidence is applied as much as it is ever recorded. As well as extracting information from the faces of the camera's subject, photography always adds the information that circulates around the photograph, that has circulated, and that will continue to circulate. While photographs seem rooted to a particular type of historiography, one that provides evidence for events and thus combats memory's vicissitudes, they in fact always inhere the past and future of the image. Not only do they reach out into the future—the viewer's present, for example—but they do so in an unbroken line that cuts through time obliquely or diagonally. Photographs always disrupt our sense of time and history since they make the remote event current or they make the

present immediately historical: we can hear the voices of the judges or the Jewish artisans; we appreciate the historicism of preserving our Kodak moments. Photographs are thus "transhistorical," to borrow from Deleuze and Guattari, and it is the role of the artist not only to reveal this for photography but to present it in art itself.[25] This, perhaps, is why photography has, in the contemporary art of the 1990s and 2000s, become integrally woven into art practice itself. The photograph is already a monument if we use Deleuze and Guattari's terms: "A monument does not commemorate or celebrate something that happened but confides to the ear of the future the persistent sensations that embody the event."[26] We might say that all contemporary art, no matter what medium, is the photography of sensation.

Photography as Memory Work

The role of the artist, then, is to uncover or reveal the vertigo of photography, the dialectic of remembering and forgetting, created by its transhistorical relationship with memory. The artist is therefore a detective of the traumatic, like Leonard Shelby (Guy Pearce) in *Memento* (USA, dir. Christopher Nolan, Newmarket/Summit Entertainment/Team Todd, 2000), who searches through the broken elements of his own past to uncover not the truth but instead the creative fabulation of memory. *Memento* is memory work itself, in which Memory is named and divided between remembering the past (real memories) and the act of remembering through objects and documents, especially photographs. Leonard is an ex-insurance investigator trying to track down John G., the attacker who raped and murdered his wife and left him with brain damage. Leonard is unable to make new memories and is thus reduced to the axioms that make up the popular notion of identity. He lives only in the present and creates a narrative of memory through the creation and recording of significant moments or recording significant facts (through photographs, notes, and tattoos), which are then pasted into a life story; his identity is the result of his memory in that it gives him a teleology of his own existence.

Peter Thomas offered *Memento* as a fairly straightforward example of a film, within the milieu of trauma cinema, whose narrative style and structure "encourages the viewer to share Leonard's misjudgments."[27]

Memento (USA, dir. Christopher Nolan, Newmarket/Summit
Entertainment/Team Todd, 2000)

The notion that Leonard is a victim of trauma is not as important as the
dissertation on Memory that the film becomes, which defeats straight-
forward readings. Each "real" memory is ultimately undermined through
the testimony of the other characters or, in the last scene, the appearance
of a photograph as evidence that Leonard has already had his revenge.
By the time we realize that Leonard manipulates himself and others,
we have already learned how trauma has "distorted and dictated" the
memories he has.[28]

It is possible to produce conflicting readings of *Memento* from the
point of view of trauma study, and it is in these that the role of the pho-
tographs become crucial. One can view Leonard as victim, as William
Little does, or we can see the photographs as metaphoric of the replay-
ing of moments in traumatic memory.[29] The photographs are less im-
portant than the thought of photography. Leonard replays the moment
of remembering his trauma by externalizing the remembering of new
people and places that his path crosses. This thought of photography
is a thought of the catastrophic, that every photograph is potentially
a traumatic event. It is a thought that follows Barthes's most famous
line: "Whether or not the subject is already dead, the photograph is al-
ways this catastrophe."[30] But this mistakes a particular emphatic effect
of some photographs for the effect of all. It is the thought of photogra-
phy, represented by the photographs themselves and the fact of their
creation, that disrupts the reliance of identity on photography. In the

Memento

end Leonard destroys the photographs that prove that he has completed his search, a destruction of imprinted memory that will lead to a new search and another death.

The dialogue between Leonard and Teddy focuses on the reliability of photographs as an embodiment of memory. Leonard's memory is unreliable and he depends on facts; the Polaroid camera serves a very practical purpose for someone with short-term memory loss. Teddy, on the other hand, acts on behalf of the film's memory work, taunting Leonard about his keeping photographs, about his reliance on objects that in fact offer little information. Ultimately it is Teddy who suffers from the effect of the creative fabulation of memory as Leonard, realizing that he has been used by Teddy, selects facts that he knows he will unwittingly trust when he later loses concentration and begins to forget. In using the photographs and their evidentiary status to manipulate himself into murdering Teddy, Leonard is no longer the victim of trauma as outwardly presented by the film. Rosalind Sibielski notes that the film challenges the validity of "long-term 'authentic' memories."[31] Most important, it challenges the teleology of the trauma analysis— that identity is made of fixed and reliable memories distorted by the traumatic event. Rather than provide embodiment of memory and of wanting to remember, the creation of memory objects is done to create a narrative that will obscure or obliterate unwanted memories, as one reviewer noted.[32] Leonard is the filmmaker/photographer as forger, who reveals for us the secrets to the creation of identity. The film itself

is "'caught in the act' of becoming a movement-image," David Martin-Jones writes; its crystal image is one of decomposition, as the duplicity of Leonard, and the process by which he tricks himself into murdering Teddy, is revealed.[33] Leonard creates a logical, deductive narrative, not from the fragments of his memory but, emphatically, from the objects to which he assigns memory value. In this case, the hatred of memory is oriented toward guilt or culpability, because Leonard realizes that he may have killed his wife accidentally, as well as rage at being used by the corrupt cop Teddy. The "new" narrative of revenge is woven carefully into Leonard's reclaiming of his masculinity—the search for the attacker.

In *Memento* the distinction between types of memory is clearly drawn along "historical" lines, preserving the gap between the present and the past. The photographs are a metaphor of the reframing of memories, the reordering and overwriting of a past that does not fit the present, whose role in memory is suborned by the power of the intrusive, traumatic return of truth. The transhistorical only appears in the photograph taken by Teddy of Leonard after having killed the "real" John G. At this point the photograph does not reveal memory's truth. Instead, if we follow Chris Marker, it reveals its "lies as a form of natural protection that one can govern and shape at will."[34]

The debt owed by films such as *Memento* to the work of Chris Marker cannot be underestimated. Having established himself through *La jetée,* his most famous work, projects such as *Sans soleil* (France, dir. Chris Marker, Argos Films, 1982) and *Immemory One* (France, dir. Chris Marker, Centre Georges Pompidou, 1997) have continued a visible connection that Marker makes between memory and the media used to record or display it. In these projects, the role of memory is assigned to a medium whose particular inadequacies serve to illustrate the restrictive, fragile, or fragmentary nature of the memories—just as with Leonard's Polaroid images. Marker's CD-ROM project *Immemory One* in its own way exploits the foibles of the technology required of multimedia distribution. Any project written on a particular operating system and requiring particular software quickly dates in a manner that not even a film can, and Catherine Lupton has noted how the glitches and lags of operation seem to mimic the fallibility and sluggishness of memory as if they were written into the project.[35] *Immemory One*

takes the form of an interactive CD-ROM that uses photographs, clips, sounds, text, and other graphical imagery to create an environment around which the user can explore as if wandering through their own memory, even while appreciating this as the memory of Chris Marker himself. Proust's madeleine is never far away, but, as with the references to Hitchcock, it seems a too obvious point to make about memory, leading from Proust to Madeleine in *Vertigo*. *Immemory One* is less about the content of memories than about the structure of memory. Marker has been scathing about both in interviews.

Marker points to the ways in which media are used to construct memory, though not through the passivity of viewers' enacting what they see. Instead, the memories are formed around the practicalities of recording, photographing, taping, filming, just as they are formed around the act of visiting the cinema rather than through the integration of the images themselves. When Marker says he remembers the images filmed of Tokyo rather than Tokyo itself, he does no more than acknowledge the dominance of mediated memory.[36] For Rancière, Marker's best contribution to the understanding of memory is to show how memory "must be created against the overabundance of information."[37] This is the Memory of the fetishized Kodak moment, or the obsession with photography that causes so many people to see buildings, vistas, and events only through the eyepiece or screen of the camera. In this sense, memory becomes embodied not in the object but in the act of taking the picture, of going to the cinema, or of navigating through graphic menus. A distinction appears here that is reflected in the sociological studies of cinema attendance and memory, such as those brought together by Annette Kuhn in a recent commentary. Kuhn points to the structuring of time enforced not only by the cinema narrative but also by attendance, and the intrusion of both on daily life. The notion she develops of embodied remembering suggests much more than a particular kind of nostalgia for matinee performances or whirlwind romances: "embodied modes of remembering exceed cinema and cinema memory, assuming a far wider purchase within cultural memory."[38] Such comments by Kuhn and Marker suggest that embodiment itself reveals the function of memory, which we might understand as the translation of meaning onto objects to create things as effects—as we saw with actor-network theory.

Immemory One (France, dir. Chris Marker, Centre Georges Pompidou, 1997)

We might say that, in Marker's case, immemory is defined not by the content of the memories but by the navigation through and the selection, deletion, reformatting, upgrading, and corruption of memories over time and through use. The objects of Memory, keepsakes and mementos, act as the traces of immemory, or the shadows cast by its

luminescence. This is perhaps the best way to understand the difference between recollection and Memory, between process and material. Memories coalesce around objects, seeking embodiment in practices and activities that ensure the creation of memories for the future, ready for selection. We recall how chronos (Chr') filled the instant of nonchronological time. This process of coalescence is immemory itself, which is always ongoing and irreducible to any aspect or emotion associated with particular memories. Immemory gives actors their asynchronous aspect, as in Latour, or their transhistoricity, as in Deleuze and Guattari. Immemory itself is impossible to see, since the only way to conceive of it is through objects, activities, and passions. Those feelings of ennui, hatred, or joy that seem to contradict Memory's reverie, nostalgia, and trauma are merely occasions of greater delineation or clarity. Thus immemory is more properly understood as becoming, in the same sense that Deleuze and Guattari suggest that *"becoming is an antimemory."*[39] We can only see or understand it through the effects that it produces, or rather the slowing down of its effects. Memory is thus the writing of immemory, or better yet, Memory is the photography of immemory.

This is why the embodiment of Memory in objects always seems absurd, as it does in *Eternal Sunshine of the Spotless Mind* (USA, dir. Michel Gondry, Anonymous Content/This Is That/Focus Features, 2004) when Joel Barish (Jim Carrey) is toured through the laboratory clinic

Eternal Sunshine of the Spotless Mind (USA, dir. Michel Gondry, Anonymous Content/This Is That/Focus Features, 2004)

where he will have parts of his memory erased. Joel is seeking to erase an unhappy love affair with Clementine (Kate Winslet), partly to release him from sorrow and grief and partly as revenge because his lover visited the same company for the same procedure. On his arrival at Lacuna Inc., Joel notices the bags and boxes of objects carried by other clients or presented to them: jazz played on an old gramophone, an amateur cine film. To give up the object is to give up the memory, an assuaging of guilt that has "all the bitterness a memory purge entails."[40]

The sci-fi aesthetic of *Eternal Sunshine* is rooted in the ordinariness of the surgery in which Lacuna Inc. (http://www.lacunainc.com) operates. The procedure parodies both the asociality of local medicine and the cyborg absurdity of new media technology by using obviously obsolescent equipment to locate the area of the brain excited by a certain memory and, while Joel sleeps, literally to zap it. Despite its removal from real brain science, it nonetheless represents a wish-fulfillment fantasy of what *Lancet Neurology* described at the time as a cerebral "control, alt, delete."[41] The film focuses on Joel's late desire to cling to particular memories. *Eternal Sunshine* discusses not "what technology can do now" but how we have particular ideas of memory and personal history that are incommensurable with our real experiences, yet nonetheless are invaluable traces that we cannot live without. The memories, like the objects, will be destroyed, but to lose even one memory is to lose memory itself.

In *Eternal Sunshine* the equation of objects with the narrativization of memory, and their subsequent dislocation, begins with a souvenir—a snow globe. When Joel begins to offer his memories for dissemination, "there's a good story behind this," he is asked to "just focus on the memories." Later, in a scene in a bookstore in which Joel tries to convince Clementine (as his "remembered" lover) that the process is going on and he wants to resist, the books on the shelves begin to lose their spine details—the erasure process is illustrated as a whiteout of information itself. Memory is presented as an inscription, a *graphia,* rather than a transcription or evidentiary record. The most subtle representation of this is in the coffee mug, with a transfer photograph of Clementine, that the film follows from the cupboard to the surgery and that appears later in Joel's dream as the different memories of the experience of the visit to Lacuna Inc. intermingle. Real scientific tests routinely proceed from the

Eternal Sunshine of the Spotless Mind

common assumption that photographs make memory easier since they trap details so well, and it is detail that ensures the veracity of memories, no matter what their provenance.[42] The desire to keep or relinquish objects such as photographs is inherently related to the quotidian attention of the camera: photography traps details in a way uncannily similar to the way memory traps detail, hence "flashbulb memories." However, Gondry and Kaufman find in the coffee mug something even more pivotally everyday around which to orient the first few scenes of *dis*orientation. More banal and everyday than the keepsake photographs that represent happy moments in Joel and Clementine's relationship, to give the mug special attention seems as absurd as the command to "just focus on the memories." *Eternal Sunshine*'s memory work is about im-memory, the processes of memory that are given shape by objects but which nonetheless cannot be contained by them.

A Glimpse of Immanence

If there is a blind spot in our culture's panoptic view of photography, it lies in the relationship with Memory as an emphatic recollection of events and moments. It is a blind spot because it simultaneously dazzles us and obscures the everyday operation of memory that often leaves no otherwise discernible trace and remains unthought. That is, no trace is

visible until we call on memory to give us a life story. For John Rajch-man, this is expressed in the wider philosophical problem of the equa-tion of memory with identity in popular thought, reliant on a reassur-ance of psychiatry, "such that to lose our memory is to lose ourselves."[43] Often without *thinking,* we cling to the unthought of memory, and it is the unthought details of the everyday that whisper at us from photo-graphs. They surprise us because they are unthought, uncalled for, until they make a connection with the everyday of the present viewer. This is Barthes's *punctum,* not a special intervention of the photograph after all but a glimpse of immemory as immanent, as the nonorganic life from which Memory (joyful or painful, voluntary or involuntary) is fabulated. The glimpse reveals immemory as the process of fabulation, and it is the contradiction between the reassurance of Memory and the everyday un-thought of immemory that drives the *use* of photography across formats and technologies. This is suggested not only in the Internet's archaeol-ogy of photography—not only on Gene McSweeney's site but also on the various Web sites that host copies of great canonical photographs—but also in the ongoing use of photography through technologies of connection, such as in a moblog, a site for sharing photos from mobile devices. In Latour's flattening of the social, making the actor network visible as a plane of immanence, we can see a profile marked out of the nonorganic life that is given shape by forces and drives, that achieves consistency in things that are otherwise only casts or imprints of im-manence itself. We also have to see Memory in this way, marked out in objects and practices that are aggregates of the forces of immemory. In order to understand immanence as a force giving the network its con-nections, we have to understand that it is immemory, not Memory, that is at work in the practice of photography.

It helps at this stage to finally comprehend the nature of imma-nence in terms of movement and intensity that achieves consistency to create the bodies and objects that we come to understand. For Manuel DeLanda, Deleuze and Guattari's philosophy of immanence suggests a "neo-materialism in which raw matter-energy, through a variety of self-organizing processes and an intense, immanent power of morpho-genesis, generates all the structures that surround us."[44] Thus the world as we know it is a geological crust that exists above the lava flows of this nonorganic life. The Internet, a structure composed of connections

made through hardware and traceable, though intangible, is an example of the raw matter-energy that finds consistency in particular types of Internet forms. It is perhaps no coincidence that the Internet quickly found itself divided up into "sites," "environments," "domains," and "geocities" as flows began to rest and coagulate.

The discussion of the forces working to coalesce the matter-energy into structures necessarily focuses on the roles of desire and control, at least in the political dimension that the Internet is given through its connection of vast numbers of users. We might then follow the lead of Michael Hardt and Antonio Negri in suggesting that collectively shared ideas of culture (such as the Photograph) are raised to a coherent unity by the flows of social and economic forces, "flowing back, like an irrigation network, [to] distribute the command of the unity throughout the immanent social field."[45] The economic forces at work in photographic practice are those controlled by telecommunications companies, desiring a type of photograph that is transferable as communication rather than durable as an object. At the same time, wider forces, often involving the voices of the actors within the social field, adapt the technology to resilient ideas that have already become established in visual culture. As such the photographic market moved toward picture messaging at the behest of the telephone companies, then toward sharing sites as demonstrative of the noospherical concept of global connections, and finally back toward the lost photographic object—the print.

For Kirsch and Mitchell, networks of association such as those created on the Internet are directed by capital.[46] This is an indirect attack on those who use actor-network theory uncritically as a tool for understanding the adoption of technology driven by corporate expansion and the enrollment of new users, such as those in developing countries, as actors. For Neil McBride, actor-network theory can adopt the language of corporations to discuss actors as stakeholders and provide a method of following the actors to the objects on which their desires are inscribed as a collective network idea.[47] Technology in the form of gadgets and gimmicks—such as the camera phone—are essential to establish a stable actor network, in other words, a capital economy of dead labor.

This is where Latour's flattening of the social becomes useful once again. Latour understands an actor not necessarily as a desiring machine but as "star-shaped," in the sense that "the more *attachments* it has, the

more it exists."[48] Latour's project is to move the study of the social from a focus on the actors toward connections or associations as social ties. For us, however, it is the discussion of personal and social identity implicit within this that will bring us back to photography and immemory.

The referencing of photography by cinema, as exemplified by *Memento,* always seems bent toward the traumatic experience, as implicitly suggested by Garrett Stewart, and this seems no different from photographs that inhere cinema or video, such as the photo/video work of David Claerbout.[49] Claerbout's work exploits our reliance on the transcriptive role of photography in the creation of visual history and the general "layering of historical time with fleeting human events."[50] Several of his photographic installations have used looping video laid over found photographs to lay the trapped present over the trapped past of the photograph. The clearest example, *Vietnam, 1967—Near Duc Pho (Reconstruction after Hiromichi Mine)* (2001), involved Claerbout revisiting the area of a fatal USAF Caribou C-7 crash depicted in a famous black-and-white photograph by Mine. The digital video that Claerbout shot was superimposed behind a colorized falling airplane to create a looping video that appears to catch the plane in mid-descent. At first sight the work appears to be a traumatic repetition of a catastrophe in which a traumatic past is caught in a perpetual return to the present. The most obvious reference that the work makes, beyond the Duc Pho crash itself, is to the traumatic photojournalism that emerged from Vietnam throughout the war. This is exemplified by the original Mine image, as well as Nick Ut's famous photograph of the child victims of napalm from 1972, in which a naked and screaming Kim Phuc flees, running past soldiers. In an exhaustive close analysis of that photograph's place in photographic and cultural history, Robert Hariman and John Louis Lucaites point to photography's primacy over video or film in corresponding to the "phenomenological structure of trauma: one simultaneously feels stopped in time (or thrown outside of time, temporal movement, history, change) while constantly repeating the actions within that isolated moment."[51] Their study points to the history of public trauma and political accountability with which that photograph has become invested. However, their study better reveals, as does Claerbout's work, how the traumatic exists in the everyday details also picked up by the camera. Kim Phuc's pain, and the culpability of the

viewer, is made all the more excruciating by the sense of the everyday suggested in the pose of the soldiers, who clearly treat this event as just another misdirected attack, in a manner similar to readers treating the photograph as just another image from a far-off war. Despite many attempts to recuperate the event and rehabilitate the culture that created it, *that* photograph from the past will always remain in the present.[52]

In Claerbout's video overlays, the "superimposed time codes" emphasize the gap that we appreciate between past and future, but it takes Claerbout rending them apart to reveal how photography naturally crashes past and future together.[53] New technologies always have the capacity to reveal the unspoken characteristics of old ones. Lev Manovich specifically links the early days of digital film exhibition with early cinema through their shared use of the loop. The loop allowed digital filmmakers to overcome limitations brought about by low

David Claerbout, *Vietnam, 1967—Near Duc Pho (Reconstruction after Hiromichi Mine)* (2001). Copyright David Claerbout. Courtesy of Galerie Yvon Lambert, New York and Paris, and David Claerbout.

computational memory and low Internet bandwidth, where the loop had heightened the sensational effect of early cinema and its spectacular views.[54] Manovich explores how these limitations forced a new direction in narrative, specific to new media. Claerbout's use of the loop, invisible at first glance, reveals instead the relationship that all media have with the ossification of memory into history. For years cinema and video have been seen to reveal the relationship that photography has with memory and death. Yet what the convergence or superimposition of both often reveals is the role of all photographic media in historiography to organize, if we remember Mulvey's suggestion, "the unspeakable and intractable nature of time itself." This is a lesson we need to repeat from very early on. Time is revealed in the unthought details of the photographic image, especially the photograph, since it prevents the forward motion of the filmstrip or video signal from wiping the detail away. Even if, as Mulvey suggests, home video technologies allow slow motion, freeze-frame, or screen grabs to fetishize the image in a manner never before possible with cinema, this has always been the seductive and terrible curse of the photograph: "Digital technology enables a spectator to still a film in a way that evokes the ghostly presence of the individual frame."[55] The trauma or catastrophe that so many have seen in the Photograph, the idea that stands for all photography, is in its glimpse of the future as past, which is also a glimpse of the everyday life that is trapped by the everyday detail. This is why one image of war—such as Ut's photograph of Kim Phuc—can eclipse so many more violent or more wretched images that surround it. Mine's photograph, like Ut's or Eddie Adams's photograph of General Loan shooting a Viet Cong suspect (1968), came to stand for the visual experience of the Vietnam War for so many so far away. As Patrick Hagopian outlines, in reference to these and other iconic images from Vietnam, "unlike a piece of moving film, which viewers process in real time, a photograph allows the viewer to stare, to turn from the picture and then return to it."[56]

The details of the soldier's gestures in the Ut image echo the gestures that surround us as people continue the everyday activities that will continue and be repeated everyday beyond our own organic lives. This is the heart of photography's perceived trauma and why Barthes picked the *punctum* as something that refers to the unthought everyday details of a photograph. This overwhelming nature of photography is

misrecognized as the image of death. Whether the death is in the future of the sitter or a reminder to the viewer of their own mortality, the thought of death evoked by the banal detail of memory is a blind spot that obscures the true ground behind it. This is the shared glimpse of past and future in the captured present. This glimpse is more blinding than any awareness of death, and more overpowering than even the most intrusive of memories, because it is the truth of photography— the photographic idea that pertains to everyone and everything. It is the shared glimpse of our insignificance within the space of the universe and the time of our duration. It is the shared glimpse of immensity that both raises and stifles the cry for identity and individuation in photographs. This is shared by all photographic images and only spotlighted by the family photograph or the traumatic document. Photography at its core always offers a glimpse of immanence. How can something so personal within the photograph, whose very power lies in its ability to connect *personally* with each viewer, be understood as a shared experience? It helps if we understand photography as a practice of *personalization,* and it is within this practice that we will see photography's true relationship with time, the relationship on which all other understandings are based.

The Humanization of Photography

It should come as no surprise that the notion of shared thoughts should resurface in the era of the Internet and digital photography, a new era of shared images. The public life of the digital photograph is characterized by its decentralization. Until this time the photographic image was located in public life in a limited number of focused places—the billboard and magazine, the television and cinema screen, and the album or jumbled shoebox of family photographs. The centralization of exhibition and dissemination was made through controlled broadcast: many television sets carried the same programming, many screens showed the same cinema product, and the printed photograph had a carefully chaperoned public life on the street and on the page. Similarly, the strongest evidence of a shared idea of the family photograph has been the standard kinds of photo albums that can be purchased. The bound vinyl, cloth, and paper albums that are produced embody in style and form the

cultural idea of the family heirloom—albeit in leatherette and fake gold trim—modeled on the leather-bound daguerreotype and *cartes-de-visite* albums of the nineteenth century. Many of these corporeal evidences of photography remain now that the digital image is the dominant mode, offering cost efficiency and ease of image management. Jose van Dijck, for instance, points to new software packages that attempt to mimic the organization of memory that has been passed down as a practice of domestic photography and transferred to searchable computing: Researchers working on AT&T lab's Shoebox software "reduce cultural practices to technical tools" whereby the practice of searching for tags applied to digital images is intended to mimic the cultural practice of sifting through print to elicit reverie and discussion.[57] The denaturalization of public life created by digital storage and the miniature digital camera means that images can now be kept in the pocket or on the computer, but most often are on a server far removed from the user's personal space and time. Digital technology's reliance on centralized servers means that users can gain access to images and files from any location, so the culture now appears decentralized and mobile even while a user's pathway through culture is one of personalization. Added to this is the awareness of a global economy created by the technological weaving of the fabric of civilization, a warp and weave created by the transfer and sharing of digital information. Here again is an apparent shaping of the immanent forces of culture by the very theories of those forces, when awareness itself gathers its own incremental power. The notion of global unification, linked with this growing sense of self-awareness that appears as a new enlightenment, is one such awareness, and rekindled with it are many of the philosophies that have occasionally been drawn upon for ideas of global thought and spiritual development. One of these, embodied in the thought and writing of Pierre Teilhard de Chardin, is the idea of the noosphere.[58] Teilhard's philosophy is unpopular in contemporary culture, mostly because of the Christian dimension to much of his work, written over a series of essays and letters and published after his death, and because he theorized the noosphere as part of a continuing evolution toward a final socialization of love in the Omega point. The Internet revolution and a growing awareness of the environmental precariousness of the global ecology both served to

revivify Teilhard's philosophy in the late 1990s and 2000s. Some scientific scholars have viewed the religious dimension of this Jesuit-turned-paleontologist as an embarrassment when dealing with his "flawed, but invaluable, synthesis."[59] Others more seriously interested in the impact of noospheric thought have measured the teleology in his work against the loosely ethical problems of a practical collectivized consciousness in relation to the biosphere. David Turner remarks that collective human consciousness should not be unquestioningly understood as benign, and if "Earth's biosphere has become a noosphere [it is] a rather dysfunctional one."[60]

Teilhard is in fact useful to us because of the dynamic drive in his teleological view, particularly from the birth of thought (hominization) to the collective understanding of a global society (planetization). It is the dynamic that helps us understand not only the truth of photography's glimpse of pure immanence but the power of this expressed in the digital photographic image. The photographic image is separated from its technological base and rooted as a configuration of time revealed directly or indirectly. Teilhard follows a well-worn trajectory of philosophy in his understanding of noogenesis, where it is significant "no longer merely to know, but to know that one knows."[61] In this hominization is a humanization of time and space, an awareness of environment and duration. We must ask what such an awareness means, or rather we must ask: how does duration reveal itself? This, for Teilhard, is the substantial change marked out as evolution through massive events that propel humanity forward toward a "phosphorescence of thought" that will eventually (if it has not already done so) dominate the future of our biosphere.[62] Reflection, self-consciousness, to "know that one knows" are activities that exist in duration and, although invisible to those who wish to pinpoint "the first," are nonetheless world-changing events. Modernity is, for Teilhard, clearly a taming of the terrors of duration that accompany self-reflection and an inhering of the time of the individual with the time of humanity and beyond:

> Modern man must have tried to reconcile the hopes of an unlimited future with which he could no longer dispense, with the perspective and inevitability of his own unavoidable individual death. . . . No evolutionary future awaits man except in association with all other men.[63]

This is what leads to a fixation on the moment as a glimpse of duration, for it requires the experience of reflection to reveal duration.

This is the desire at work in the contemporary proliferation of our Nokia moments, arranged as they are into personal diaries that appear to reconstruct and particularize the user as an individual. They are Photographic Memories stitched or patched together to create a rounded individual life from the passing of pure time. In Teilhard the *humanization* of time and space is a response to the glimpse of pure duration that is so impossible to bear.[64] After all, what is a photograph but an attempt to capture and tame the terrible abyss of eternity? Thus the photograph will always be connected to the birth of thought and the self-awareness of one's place in time and one's brief stay. For Latour, a similar glimpse is offered of humanity as generic (the "we" of hominization in Teilhard) from which the individual aspires to subjectivity. This terrible awareness of one's lack of individuality is gradually ameliorated by the establishment of a particular identity appreciated as inherently "you," even though it will always be a composite assemblage of traceable gestures and experiences. The social project is thus to "observe empirically how an anonymous and generic body is made to be a person: the more intense the shower of offers of subjectivities, the more interiority you get."[65]

Latour borrows from new media culture the metaphor of plug-ins and patches to describe this process of particularization: the accumulation of special skills seen as natural aptitudes and idiosyncrasies that are the results of long-forgotten memories. Compare this to the creation of personal narratives in moblogs and photo-sharing sites; the urge to pronounce one's own hard-won identity seems irresistible. This correlation of the individual person and the moments of individualization is at the heart of the modern moment that we saw in the period of the earliest cinema. The photograph's collapse of past and present, so often mistaken as morbid, is in fact a glimpse of one's personal relativity to ongoing totality of duration and, at the same time, to the whole of humanity.

It is no accident that such a glimpse should be brought about by history and technology, although the photographic image was eventually to shed its reliance on any essential relation to either. For Teilhard the passage from hominization is made in social leaps or events that in-

here the whole process. One such event is planetization, and Teilhard's historicism of this is disarmingly precise and prescient. Teilhard locates the event of planetization in the unification brought about by the Second World War, the first truly global conflict, and the connections made across the world by communications and news as well as strategy and alliance. Technology and the organization of the State precipitated, on a global scale, a collective memory to become humanity's legacy and its charge to education.[66] This is what lies behind the global reach of David Claerbout's work depicting imperial hubris in Duc Pho, or that of Shimon Attie's work on the pogroms. The Holocaust is no longer related only to those groups who provided the victims and who live with the gaping generational holes created. The "extraordinary network of radio and television communications" were, for Teilhard, the linkages of a "universal consciousness" apparent even in the few years immediately after the end of the war.[67] These linkages give the truth of the Holocaust its universality in the global dissemination of the photographs and newsreels of the liberation of the camps. Thus the Holocaust becomes one of the first memories of the noosphere. Even in 1947 Teilhard saw the "insidious growth of the astonishing electronic computers" as pivotal in the development of noogenesis, an observation that has led to numerous citations of Teilhard as predicting the future emergence of cyberspace and the "blogosphere."[68] The observation refers more to the great leap in reflection offered by the "speed of thought" at which computers run, akin to the great leap in vision from the cellular to the molecular. The observation therefore parallels Benjamin's noting of the optical unconscious, and both affirm, as Teilhard expresses, that "Life . . . compels us increasingly to view it as an underlying current in the flow of which matter tends to order itself upon itself with the emergence of consciousness."[69] In ever smaller glimpses of duration, the dynamic forces of life continue to be revealed. This is Teilhard's contribution to the philosophy of immanence, which is, for Deleuze, at the heart of all philosophical questioning. This is what occupies so much of Deleuze's work, most famously perhaps in his writings on Spinoza. So much could be written on the relationship between immanence, immemory, and their debt to each other that would have to include Deleuze and Spinoza, as well as Deleuze and Nietzsche. At this late stage, it is sufficient to appreciate the importance of immanence

in understanding the globalization or planetization of the thought of photography—the shared glimpse of immanence that photography offers. We must remain sensitive to the problems expressed by Latour of panoramic views such as that of the noosphere. What is at stake here is, as Flora Samuel observes, the "sensation of connection" with the environment that pervades the contemporary readings of the noosphere, whether an appreciation or a yearning. This glimpse of "the global" mirrors in some way the glimpse of immanence afforded by looking at photographs.[70] It is the same immanence that provides the technologies of connection with "raw matter-energy," in Manuel DeLanda's analysis, the "immanent power of morphogenesis."[71]

It is no coincidence that the immanent sensations of connection should be expressed through a sharing of the photographs of the everyday, as happens on the Internet. Immanence, Deleuze and Guattari attest, can only be understood through the everyday, the footprints it leaves behind. Indeed, immanence cannot be brought into the light itself and is visible only by its shadow. This is perhaps the best way of understanding them when they say:

> THE plane of immanence is, at the same time, that which must be thought and that which cannot be thought. . . . Perhaps this is the supreme act of philosophy: not so much to think THE plane of immanence as to show that it is there, unthought in every plane.[72]

This accounts for the slippery nature of the real in photography, the consistency within criticism of the paradox of photography's referential and superficial series, as it was described by de Duve.[73] It is the task of philosophy to reveal immanence, but it is photography that always captures its shadow, that reveals it as always already there in the unthought details of the everyday. The geographer Paul Harrison places the embodiment of the everyday central to Deleuze's unthought "the unseen in the act of seeing," and says that "through the disturbance of habits, sensation becomes the basis of disclosing new worlds, forcing us to think."[74] This is what photographers of the banal, who attempt to stage the everyday, bring to sensation. Photographers such as Jeff Wall, James Coleman, and Hannah Starkey, who take pains to stage the everyday moments that might normally be captured candidly, bring to clarity the hazy peripheries of observation. Coleman, for example,

also works in cinema, but it is the work of Wall, and more interestingly Starkey, in photography that still attracts the description "cinematic." At first glance some of Starkey's images share the contemplation of the moment that is evident in Cindy Sherman's film stills, and like those images, they do so because they seem to propel time forward and backward. Other Starkey photographs suggest the freeze-frame of cinema, calling into question the elevation of this particular instant from all the others flying through the film gate. Finally, the use of mirrors and especially the female subjects in Starkey's images suggest the unfolding crystal nature of time that we found in Goldin and in Manet.

What, then, do Starkey's photographs demonstrate that is different? In this particular case Starkey's images are cinematic because they reveal what photographs have always been able to reveal and what cinema struggles to demonstrate—the underlying empty time of duration,

Hannah Starkey, "Untitled (May 1997)" (1997). Copyright Hannah Starkey. Courtesy of Hannah Starkey and Maureen Paley, London.

the time that Wall's photographs attempt to fill to bursting. Cinema can never leave its staccato representation of time displayed through the passage of discrete images. Even the crystal image relies on the foregrounding of perception to reveal duration. Photography's potential, revealed in Starkey's staging of the banal, is its avoidance of any relation to the catastrophic gaps between frames that so many filmmakers and scholars are obsessed with. The photograph's poverty in representing time is demonstrated through its apparent need to be attached to other frames in the filmstrip, when in fact its abundant richness is from time plunging into the photographic frame.

No images invite this more than the work of Hiroshi Sugimoto. His photographs of picture palaces give the lie to the notion of cinema's flicker and blackness within it, a notion of deceit that has surfaced in so much criticism and even in the reflections of Ingmar Bergman, who re-

Hiroshi Sugimoto, "La Paloma, Encinitas" (1993). Copyright Hiroshi Sugimoto. Courtesy of Sonnabend Gallery.

minds us that almost half of a film screening is total blackness.[75] Sugimoto photographs his cinema interiors illuminated only by the film's ninety-minute or so projection so that the screen appears phosphorescent in the umbra created by the auditorium's deep black. Sugimoto's photographs reverse the eclipse of cinema created by the blackness of the catastrophic gap between frames. Instead, they are a persistence of vision, a real phi effect of the image, as if burned on our retinas so that only the experience of the gaze itself remains. This is a glimpse of immanence whose blinding luminescence is the antithesis of the darkness so evocative of the still frame's resonance of death. Teleologies of cinema that emphasize the gap between frames imagine such a gap drawing or sucking the new frame into the void left by the old: death of the photograph through the birth of the photogram. But, David Green writes, in these images "life is given to the photograph through the death of the film."[76] Here, in the attenuated instant of Sugimoto's photographs, each frame burns through the moment of its presentation into the future yet leaves on the photograph's emulsion a record of its passing. The still image as a record of the past, named as the Memory of cinema's motion, is the blind spot in cinematic thinking on time. Here in Sugimoto's images is the Memory of cinema passing into sensation, through the blinding glimpse of immanence that only the photograph can reveal.

NOTES

1. Cinema and the Event of Photography

1. Jon Silberg, "A Master Sleuth," *American Cinematographer,* April 2002, 49.

2. Oliver Wendell Holmes, "The Stereoscope and the Stereograph," in *Classic Essays on Photography*, ed. Alan Trachtenberg (New Haven, Conn.: Leete's Island, 1980), 74.

3. D. N. Rodowick, *Reading the Figural, or Philosophy after the New Media* (Durham, N.C.: Duke University Press, 2001), 212.

4. D. N. Rodowick, *The Virtual Life of Film* (Cambridge, Mass.: Harvard University Press, 2007), 103.

5. John Belton, "Digital Cinema: A False Revolution," *October* 100 (2002): 114.

6. Lev Manovich, "The Paradoxes of Digital Photography," in *Photography after Photography: Memory and Representation in the Digital Age,* ed. Hubertus von Amelunxen, Stefan Iglhaut, and Florian Rotzer (Munich: G+B Arts International, 1996), 57.

7. Andrew Darley, *Visual Digital Culture: Surface Play and Spectacle in New Media Genres* (London: Routledge, 2000), 13.

8. Lev Manovich, *The Language of New Media* (Cambridge: Massachusetts Institute of Technology, 2001), 308.

9. Alain Badiou, *Infinite Thought: Truth and the Return to Philosophy,* trans. Oliver Feltham and Justin Clemens, 2nd ed. (London: Continuum, 2005), 93–94.

10. Manovich, *The Language of New Media,* 325.

11. Gilles Deleuze, *Cinema 1: The Movement-Image,* trans. Hugh Tomlinson and Barbara Habberjam (Minneapolis: University of Minnesota Press, 1986).

12. Badiou, *Infinite Thought,* 85.

13. Gilles Deleuze, *Cinema 2: The Time-Image,* trans. Hugh Tomlinson and Robert Galeta (Minneapolis: University of Minnesota Press, 1989).

14. David Campany, *Photography and Cinema* (London: Reaktion Books, 2008), 18.

15. Peter Osborne, "Photography in an Expanding Field," in *Where Is the Photograph?,* ed. David Green (Brighton, UK: Photoforum and Photoworks, 2003).

16. Georges Didi-Huberman, *Invention of Hysteria: Charcot and the Photographic Iconography of Saltpêtrière,* trans. Alisa Hartz (Cambridge: Massachusetts Institute of Technology, 2003), 27. Alisa Hartz notes that Didi-Huberman plays on the duality of the French term *pose,* meaning both exposure and "pose" (88). Unless otherwise noted, emphasis in quotations are in the original.

17. Ibid., 108.

18. Kamal A. Munir, "The Social Construction of Events: A Study of Institutional Change in the Photographic Field," *Organization Studies* 26, no. 1 (2005): 94.

19. Ibid., 108.

20. Bruno Latour, *Science in Action: How to Follow Scientists and Engineers through Society* (Cambridge, Mass.: Harvard University Press, 1987), 128.

21. Alain Badiou, *Ethics: An Essay on the Understanding of Evil* (1993), trans. Peter Hallward, 2nd ed. (London: Verso, 2002), 42.

22. I would like to express my great appreciation to Benjamin Noys for helpful comments and suggestions as I try to make clear my reading of Badiou.

23. Alain Badiou, *Saint Paul: The Foundation of Universalism,* trans. Ray Brassier (Stanford, Calif.: Stanford University Press, 2003), 60–61.

24. Peter Hallward, *Badiou: A Subject to Truth* (Minneapolis: University of Minnesota Press, 2003), 111.

25. Badiou, *Ethics,* 69.

26. Jacques Rancière, "Aesthetics, Inaesthetics, Anti-aesthetics," trans. Ray Brassier, in *Think Again: Alain Badiou and the Future of Philosophy,* ed. Peter Hallward (New York: Continuum, 2004), 220.

27. Jacques Aumont, "The Variable Eye, or The Mobilization of the Gaze," in *The Image in Dispute: Art and Cinema in the Age of Photography,* ed. Dudley Andrew (Austin: University of Texas, 1997), 231.

28. William Henry Fox Talbot, introduction to *The Pencil of Nature* (London, 1844), n.p.

29. Larry J. Schaaf, *Out of the Shadows: Herschel, Talbot, and the Invention of Photography* (New Haven, Conn.: Yale University Press, 1992), 36.

30. Talbot, *The Pencil of Nature,* footnote to plate VI, n.p.

31. Didi-Huberman, *Invention of Hysteria,* 61.

32. Badiou, *Ethics,* 42.

33. Lauren Sedofsky, "Being by Numbers: Interview with Alain Badiou," *Artforum,* October 1994, 123.

34. Badiou, *Ethics,* 70.

35. Ibid., 55–56.

36. Didi-Huberman, *Invention of Hysteria,* 48.

37. See *The New Art History,* ed. A. L. Rees and Frances Borzello (London: Camden Press, 1986). See also Jo Spence, *Cultural Sniping: The Art of Transgression,* ed. Jo Stanley and David Hevey (London: Routledge, 1995); *Thinking Photography,* ed. Victor Burgin (London: MacMillan, 1982); Terry Dennett and Jo Spence, *Photography/Politics: One* (London: Photography Workshop, 1979); and *Photography/Politics: Two,* ed. Patricia Holland, Jo Spence, and Simon Watney (London: Comedia, 1986).

38. Allan Sekula, "The Body and the Archive," in *The Contest of Meaning: Critical Histories of Photography,* ed. Richard Bolton (Cambridge: Massachusetts Institute of Photography, 1992); John Tagg, *The Burden of Representation: Essays on Photographies and Histories* (London: MacMillan, 1988).

39. Frank Webster, *The New Photography: Responsibility in Visual Communication* (London: John Calder, 1980), 154.

40. Didi-Huberman, *Invention of Hysteria,* 33.

41. Tagg, *The Burden of Representation,* 76.

42. Didi-Huberman, *Invention of Hysteria,* 17.

43. Sir Arthur Conan Doyle, "The Man with the Twisted Lip" (1892), reprinted in *The Adventures of Sherlock Holmes,* 5th ed. (London: John Murray, 1968).

44. Sekula, "The Body and the Archive," 360.

45. Ibid., 362.

46. Didi-Huberman, *Invention of Hysteria,* 51.

47. Jacques Rancière, *The Politics of Aesthetics: The Distribution of the Sensible,* trans. Gabriel Rockhill (London: Continuum, 2004), 22.

48. Ibid., 24.

49. Badiou, *Ethics,* 50.

50. Ibid., 45.

51. Alain Badiou, *Being and Event,* trans. Oliver Feltham (London: Continuum, 2005), 239.

52. Gilles Deleuze and Félix Guattari, *What Is Philosophy?* (New York: Columbia University Press, 1994), 193. See also chapter 5 of this book.

53. Rancière, *The Politics of Aesthetics,* 63.

54. Ibid., 61.

55. Tagg, *The Burden of Representation,* 93.

56. Deleuze, *The Time-Image,* 280.

57. Gilles Deleuze and Félix Guattari, *A Thousand Plateaus: Capitalism and Schizophrenia,* trans. Brian Massumi (Minneapolis: University of Minnesota Press, 1987), 275–76.

58. Ibid., 261–63.

59. John Pavlus, "Razzle Dazzle," *American Cinematographer Online,* February 2003, http://www.theasc.com/magazine/feb03/razzle/index.html (accessed 7 February 2009).

60. Deleuze, *The Time-Image,* 61.

61. Ibid., 116–17.

62. Dudley Andrew, "*Amélie,* or Le fabulous destin du cinema Français," *Film Quarterly* 57, no. 3 (2004): 34–46.

63. See, for example, D. N. Rodowick, *Gilles Deleuze's Time Machine* (Durham, N.C.: Duke University Press, 1997); and "A Deleuzian Century?" ed. Ian Buchanan, special issue, *South Atlantic Quarterly* 96, no. 3 (1997).

64. Thomas Elsaesser, "Cinephilia, or The Uses of Disenchantment," in *Cinephilia: Movies, Love, and Memory,* ed. Marijke de Valck and Malte Hagener (Amsterdam: Amsterdam University Press, 2005), 35–40.

65. Elsaesser, "Cinephilia," 41.

66. Deleuze, *The Time-Image,* 269–70.

67. Ian Buchanan, *Deleuzism: A Metacommentary* (Edinburgh: Edinburgh University Press, 2000), 86.

68. Deleuze, *The Movement-Image,* 7.

69. William Bogard, "Smoothing Machines and the Constitution of Society," *Cultural Studies* 14, no. 2 (2000): 272–73.

70. Miriam Hansen, "Early Cinema, Late Cinema: Permutations of the Public Sphere," *Screen* 34, no. 3 (1993): 198.

71. Aumont, "The Variable Eye," 243.

72. Chris Rojek and Bryan Turner, "Decorative Sociology: Towards a Critique of the Cultural Turn," *Sociological Review* 48, no. 4 (2000): 629–38.

73. Michael Sprinker, "We Lost It at the Movies," *MLN* 112, no. 3 (1997): 389–92.

74. André Jansson, "The Mediatization of Consumption: Towards an Analytical Framework of Image Culture," *Journal of Consumer Culture* 2, no. 1 (2003): 16.

75. Scott Lash and John Urry, *Economies of Signs and Space,* 3rd ed. (London: Sage, 1999), 60–61, 133.

76. Jürgen Habermas, *The Structural Transformation of the Public Sphere,* trans. Thomas Burger and Frederick Lawrence, 6th ed. (London: Polity, 2003), 246.

77. David Sedman, "Market Parameters, Marketing Hype, and Technical Standards: The Introduction of DVD," *Journal of Media Economics,* 11, no. 1 (1998): 50.

78. Nicholas Negroponte, *Being Digital,* 2nd ed. (London: Hodder and Stoughton, 1995). This argument essentially repeats Negroponte's much-quoted column for *Wired* in which the idea of repurposing was first suggested. See Nicholas Negroponte, "Repurposing the Material Girl," *Wired* 1, no. 5 (1993), http://www.wired.com/wired/archive/1.05/negroponte.html (accessed 7 February 2009).

79. Sedman, "Market Parameters, Marketing Hype and Technical Standards," 55.

80. David Jay Bolter and Richard Grusin, *Remediation,* 4th ed. (Cambridge: Massachusetts Institute of Technology Press, 2001), 45.

81. John Rajchman, *The Deleuze Connections* (Cambridge: Massachusetts Institute of Technology Press, 2000), 137.

82. Dudley Andrew, "*Amélie,* or Le fabulous destin du cinema Français," 34.

83. Ginette Vincendeau, "Café Society," *Sight and Sound* 11, no. 8 (2001): 24–25.

84. Gilles Deleuze, *The Logic of Sense,* trans. Mark Lester and Charles Stivale (London: Athlone, 1990), 165.

85. Frédéric Bonnaud, "The Amélie Effect," *Film Comment* 37, no. 6 (2001): 38. See also Vincendeau, "Café Society," 24–25.

86. John Rajchman, *The Deleuze Connections,* 116.

87. Cinematographer Alwin Kuchler, interviewed in Graham Rae, "A Corpse for Christmas," *American Cinematographer,* September 2002, 76.

88. Deleuze, *The Time-Image,* 267.

89. Peter Hallward, ""Everything Is Real": Gilles Deleuze and Creative Univocity," *New Formations* 49 (2003): 66.

90. Catherine Cullen, "The Films of Lynne Ramsay," *Afterimage* 29, no. 1 (2001): 12.

91. Deleuze, *The Time-Image,* 137–47.

92. Gregg Lambert, *The Non-philosophy of Gilles Deleuze* (London: Continuum, 2002), 91.

93. Rob Marshall interviewed by John Pavlus, "Razzle Dazzle."

94. Deleuze, *The Time-Image,* 60–64.

95. Rancière, "Aesthetics, Inaesthetics, Anti-aesthetics," 229.

2. Photographic Memory, Photographic Time

1. I have explored the possible medical and psychological reasons for Carter's condition previously. It is possible that Powell and Pressburger wished to portray a real medical condition—temporal lobe epilepsy (TLE) brought on by a blow to the head—in order to discuss the traumatic effects of the war on individuals and the public. See Damian Sutton, "Rediagnosing *A Matter of Life and Death,*" *Screen* 46, no. 1 (2005): 51–61.

2. Gilles Deleuze, *Bergsonism,* trans. Hugh Tomlinson and Barbara Habberjam (New York: Zone, 1997), 37.

3. Estelle Jussim, *The Eternal Moment: Essays on the Photographic Image* (New York: Aperture, 1989), 50.

4. Deleuze, *Bergsonism,* 52.

5. Gilles Deleuze, *Cinema 2: The Time-Image,* trans. Hugh Tomlinson and Robert Galeta (Minneapolis: University of Minnesota Press, 1989), 81.

6. Deleuze, *Bergsonism,* 38.

7. Ibid., 57.

8. D. N. Rodowick, *Reading the Figural, or Philosophy after the New Media* (Durham, N.C.: Duke University Press, 2001), 80.

9. Gilles Deleuze, *Cinema 1: The Movement-Image,* trans. Hugh Tomlinson and Barbara Habberjam (Minneapolis: University of Minnesota Press, 1986), 2.

10. Deleuze, *The Time-Image,* 82.

11. André Bazin, "The Ontology of the Photographic Image," in *What Is Cinema?* trans. Hugh Grey (Berkeley: University of California Press, 1967), 14.

12. Gilles Deleuze, *Negotiations, 1972–1990,* trans. Martin Joughin (New York: Columbia University Press, 1995), 46.

13. D. N. Rodowick, *Gilles Deleuze's Time Machine* (Durham, N.C.: Duke University Press, 1997), 86.

14. Jacques Rancière, *Film Fables,* trans. Emiliano Battista (Oxford: Berg, 2006), 122.

15. Jussim, *The Eternal Moment,* 57.

16. Patricia Pisters, *The Matrix of Visual Culture: Working with Deleuze in Film Theory* (Stanford, Calif.: Stanford University Press, 2003), 44.

17. Deleuze, *The Time-Image,* 69.

18. Deleuze, *The Movement-Image,* 1. See also Henri Bergson, *Creative Evolution,* trans. Arthur Mitchell (New York: Macmillan, 1911), 322.

19. Deleuze, *The Movement-Image,* 24.

20. Henri Bergson, *Matter and Memory* (1896), trans. Nancy Margaret Paul and W. Scott Palmer, 5th ed. (New York: Zone, 1996), 39.

21. Deleuze, *The Movement-Image,* 5.

22. Bergson, *Matter and Memory,* 38.

23. "Il y a autant d'yeux que vous voudrez, mais l'œil au sens que vous pouvez lui donner n'est qu'une image-mouvement parmi les autres, donc ne jouit strictement d'aucun privilege. . . . C'est parce que l'œil est dans les choses." Gilles Deleuze, "Image-mouvement, image-temps," lecture at Université Vincennes St. Denis, 1982, http://www.webdeleuze.com/php/texte.php?cle=76&groupe=Image%20Mouvement%20Image%20Temps&langue=1 (accessed 7 February 2009). Author's translation.

See also *The Movement-Image,* 76: "A subjective perception is one in which the images vary in relation to a central and privileged image; an objective perception is one where, as in things, all the images vary in relation to one another, on all their facets and in all their parts."

24. Bergson, *Matter and Memory,* 40.

25. Deleuze, *The Movement-Image,* 72.

26. Beamont Newhall, "The Conquest of Action," in *The History of Photography* (New York: Museum of Modern Art, 1982), 117–41.

27. Walter Benjamin, "Theses on the Philosophy of History," in *Illuminations,* ed. Hannah Arendt, trans. Harry Zohn (London: Fontana, 1973), 247–54.

28. Eduardo Cadava, *Words of Light: Theses on the Photography of History* (Princeton, N.J.: Princeton University Press, 1997), 5.

29. Villiers de l'Isle Adam, *L'ève future* (1886), trans. Robert Martin Adams (Chicago: University of Illinois Press, 2001), 21–22. Interestingly, the subtitle "snapshots" is probably an example of translator's license from the French "photographies"; the term "snapshot" was not used until after the first Kodaks were released in 1888.

30. Roger Brown and James Kulik, "Flashbulb Memories," *Cognition* 5 (1977): 73–99.

31. Robert B. Livingston, "Reinforcement," in *The Neurosciences: A Study Program,* ed. Gardner Quarton, Theodore Melnechek, and Francis O. Schmitt (New York: Rockefeller University Press, 1967), 568–77. The "Now print!" order involves print media and possibly early computer printouts as an analogy of the storage of memory as data. Brown and Kulik suggest that Livingston misses the role that the media has in recording events in his use of the metaphor and go on to propose reasons for this memory to exist before the analogy is used to name it—echoing Deleuze's critique of Bergson.

32. Brown and Kulik, "Flashbulb Memories," 74–75.

33. Lauren R Shapiro, "Remembering September 11th: The Role of Retention Interval and Rehearsal on Flashbulb and Event Memory," *Memory* 14, no. 2 (2006): 144. I survey the various responses to the role of the media in the events of September 11, 2001, in my "September 11th and the Memory of Media," in *Philosophy, Method, and Cultural Criticism,* ed. Charlton McIlwain (Cresskill, N.J.: Hampton Press, forthcoming).

34. Antonietta Curci and Olivier Luminet, "Follow-up of a Cross-national Comparison on Flashbulb and Event Memory for the September 11th Attacks," *Memory* 14, no. 3 (2006): 331.

35. Bazin, *What Is Cinema?*, 14.

36. Christian Metz, "Photography and Fetish," *October* 34 (1985): 83.

37. Deleuze, *Bergsonism*, 32. Compare Bergson, *Creative Evolution*, 10.

38. Deleuze, *The Time-Image*, 17.

39. Roland Barthes, *Camera Lucida: Reflections on Photography*, trans. Richard Howard, 4th ed. (London: Vintage, 1993). See also Roland Barthes, *Image, Music, Text*, trans. Stephen Heath, 3rd ed. (London: Fontana, 1982). Peter Wollen, "Fire and Ice," in *Other Than Itself: Writing Photography*, ed. John X. Berger and Olivier Richon (Manchester, England: Cornerhouse, 1989), n.p. See also Peter Wollen, "Photography and Aesthetics," *Screen* 19, no. 4 (1979): 9–28.

40. Barthes, *Camera Lucida*, 60.

41. Metz, "Photography and Fetish," 82.

42. Wollen, "Fire and Ice."

43. Deleuze, *The Movement-Image*, 24.

44. Kevin MacDonnell, *Eadweard Muybridge: The Man Who Invented the Moving Picture* (London: Weidenfeld and Nicolson, 1972), 132.

45. Rebecca Solnit, *River of Shadows: Eadweard Muybridge and the Technological Wild West* (London: Penguin 2004), 81.

46. Adam D. Weinberg, "Vanishing Presence," in *Vanishing Presence* (Minneapolis: Walker Art Center; New York: Rizzoli, 1989), 63–64.

47. Ibid., 74.

48. Benjamin, "Theses on the Philosophy of History," in *Illuminations*, ed. Hannah Arendt, trans. Harry Zohn (London: Fontana, 1973), 254.

49. The "free-rewriting time." Wollen, "Fire and Ice."

50. Christian Metz, *Psychoanalysis and Cinema: The Imaginary Signifier*, trans. Celia Britton, Annwyl Williams, Ben Brewster, Alfred Guzzetti (London: Macmillan, 1982), 43.

51. Deleuze, *Bergsonism*, 65.

52. Ibid., 57.

53. Ibid., 59. See also Bergson, *Matter and Memory*, 161–63.

54. Deleuze, *The Movement-Image*, 98.

55. Metz, "Photography and Fetish," 83.

56. Deleuze, *The Movement-Image*, 1, 212.

57. Deleuze, *The Time-Image*, 6.

58. Thierry de Duve, "The Photograph as Paradox," *October* 5 (1978): 116–17.

59. Deleuze, *The Movement-Image*, 32.

60. De Duve, "The Photograph as Paradox," 114–15.

61. Mary Ann Doane, "Real Time: Instantaneity and the Photographic Imaginary," in *Stillness and Time: Photography and the Moving Image*, ed. David Green and Joanna Lowry (Brighton, England: Photoforum/Photoworks, 2006), 25.

62. De Duve, "The Photograph as Paradox," 116.

63. Ibid., 123. See also Metz, "Photography and Fetish," 83–84.

64. Doane, "Real Time," 35.

65. De Duve, "The Photograph as Paradox," 115.

66. Rob Kroes, *Photographic Memories: Private Pictures, Public Images, and American History* (Lebanon, N.H.: Dartmouth College Press, 2007), 80.

67. Barthes, *Image, Music, Text,* 44.

68. Deleuze, *The Time-Image,* 81. See also Deleuze's discussion of the crystal image as a "seed image," 74–75.

69. Karen Beckman, "Crash Aesthetics: *Amores Perros* and the Dream of Cinematic Mobility," in *Still Moving: Between Cinema and Photography,* ed. Karen Beckman and Jean Ma (Durham, N.C.: Duke University Press, 2008), 142.

70. Thierry de Duve, "How Manet's *A Bar at the Folies-Bergère* Is Constructed," *Critical Inquiry* 25 (1998): 163.

71. Paul Mantz, Jules-Antoine Castagnary, and Théodore Pelloquet, quoted in ibid., 142.

72. Ibid., 164–67.

3. The Division of Time

1. Gerry Turvey, "Panoramas, Parades, and the Picturesque: The Aesthetics of British Actuality Films, 1895–1901," *Film History* 16, no. 1 (2004): 11.

2. Sean Cubitt, *The Cinema Effect* (Cambridge: Massachusetts Institute of Technology, 2004), 21.

3. Ibid., 35.

4. Mary Ann Doane, *The Emergence of Cinematic Time* (Cambridge, Mass.: Harvard University Press, 2002), 178.

5. Turvey, "Panoramas, Parades, and the Picturesque," 11.

6. Patrick Russell, "Truth at 10 Frames per Second?," in *The Lost World of Mitchell & Kenyon: Edwardian Britain on Film,* ed. Vanessa Toulmin, Simon Popple, and Patrick Russell (London: BFI, 2004), 18.

7. Tom Gunning, "Pictures of Crowd Splendor: The Mitchell and Kenyon Factory Gate Films," in *The Lost World of Mitchell & Kenyon,* ed. Toulmin, Popple, and Russell, 55–56.

8. Cubitt, *The Cinema Effect,* 39.

9. Ibid., 35.

10. Rebecca Solnit, *River of Shadows: Eadweard Muybridge and the Technological Wild West* (London: Penguin, 2004), 13.

11. Henri Bergson, *Creative Evolution,* trans. Arthur Mitchell (New York: Macmillan, 1911), 322–23.

12. Tom Gunning, "The Cinema of Attractions: Early Film, Its Spectator, and the Avant-Garde," in *Early Cinema: Space, Frame, Narrative,* ed. Thomas Elsaesser and Adam Barker, 2nd ed. (London: BFI, 1994), 56–62.

13. Walter Benjamin, "A Short History of Photography," *Screen* 13, no. 1 (1972): 5–27.

14. Ben Singer, *Melodrama and Modernity: Early Sensational Cinema and Its Contexts* (New York: Columbia University Press, 2001), 65.

15. Miriam Hansen, "Benjamin, Cinema, and Experience: 'The Blue Flower in the Land of Technology,'" *New German Critique* 40 (1987): 183.

16. Winsor McCay, *Little Nemo, 1905–1914* (Cologne, Germany: Evergreen, 2000), 7.

17. Tim Blackmore, "McCay's McChanical Muse: Engineering Comic-Strip Dreams," *Journal of Popular Culture* 32, no. 1 (1998): 15–38.

18. Ibid., 21.

19. Martin Barker, *Comics: Ideology, Power, and the Critics* (Manchester, England: Manchester University Press, 1989), 6–7. See also Lawrence L. Abbott, "Comic Art: Characteristics and Potentialities of a Narrative Medium," *Journal of Popular Culture* 19, no. 4 (1986): 155–76.

20. Blackmore, "McCay's McChanical Muse," 24.

21. Gilles Deleuze, *The Logic of Sense*, trans. Mark Lester and Charles Stivale (London: Athlone, 1990).

22. Gilles Deleuze, *Cinema 2: The Time-Image*, trans. Hugh Tomlinson and Robert Galeta (Minneapolis: University of Minnesota Press, 1989), 81.

23. Deleuze, *The Logic of Sense*, 63–64.

24. Ibid., 61. Cf. Deleuze and Guattari's description of Aion and Chronos in *A Thousand Plateaus* (where Aion is Aeon): "Aeon: the indefinite time of the event, the floating line that knows only speeds and continually divides that which transpires into an already-there that is at the same time not-yet-here, a simultaneous too-late and too-early, a something that is both going to happen and has just happened. Chronos: the time of measure that situates things and persons, develops a form, and determines a subject." Gilles Deleuze and Félix Guattari, *A Thousand Plateaus: Capitalism and Schizophrenia* (1980), trans. Brian Massumi (Minneapolis: University of Minnesota Press, 1987).

25. Ibid., 165.

26. Walter Benjamin, "On Some Motifs in Baudelaire," in *Illuminations*, ed. Hannah Arendt, trans. Harry Zohn (London: Fontana, 1973), 171.

27. Ibid., 181.

28. Scott McCloud, *Understanding Comics: The Invisible Art* (New York: Harper Collins, 1993), 97.

29. Deleuze, *The Logic of Sense*, 164.

30. Hansen, "Benjamin, Cinema, and Experience," 184.

31. Leo Charney, "In a Moment: Film and the Philosophy of Modernity," in *Cinema and the Invention of Modern Life*, ed. Leo Charney and Vanesa R Schwartz (Berkeley, Calif.: University of California Press, 1995), 293.

32. Gilles Deleuze, *Cinema 1: The Movement-Image*, trans. Hugh Tomlinson and Barbara Habberjam (Minneapolis: University of Minnesota Press, 1986), 2.

33. Jacques Aumont, "Lumière Revisited," *Film History* 8, no. 4 (1996): 423.

34. Dai Vaughn, "Let There Be Lumière," in *Early Cinema: Space, Frame, Narrative*, ed. Thomas Elsaesser and Adam Barker, 2nd ed. (London: BFI, 1994), 65.

35. Auguste and Louis Lumière, *Letters* (original letters of A. and L. Lumière), ed. Jacques Rittaud-Hutinet, trans. Pierre Hodgson (London: Faber, 1995), 3–117.

36. Ibid., 111.

37. Anthony R. Guneratne, "The Birth of a New Realism: Photography, Painting, and the Advent of Documentary Cinema," *Film History* 10, no. 2 (1998): 170.

38. Naive curiosity was nevertheless just as useful for the success of the process: "What I remember as being typical was some passer-by sticking his head round the door, wanting to know what on earth the words Cinématographe Lumière could possibly mean. Those who took the plunge and entered soon reappeared looking astonished." Clément Maurice, cited in Lumières, *Letters,* 84.

39. Gunning, "The Cinema of Attractions," 58.

40. Aumont, "Lumière Revisited," 425.

41. Bergson, *Creative Evolution,* 323.

42. André Gaudrealt, "Film, Narrative, Narration: The Cinema of the Lumière Brothers," in *Early Cinema: Space, Frame, Narrative,* ed. Elsaesser and Barker, 71–72.

43. Ibid., 74n16.

44. Richard Brown, "New Century Pictures: Regional Enterprise in Early British Film Exhibition," in *The Lost World of Mitchell & Kenyon: Edwardian Britain on Film,* ed. Vanessa Toulmin, Simon Popple, and Patrick Russell (London: BFI, 2004), 74.

45. Hansen, "Benjamin, Cinema, and Experience," 216.

46. Benjamin, "A Short History of Photography," 7.

47. Deleuze, *The Logic of Sense,* 61.

48. Atget's itinerant practice of photography had amassed as many as ten thousand glass-plate images of the city of Paris and its surrounding countryside. He intended his work to be "Documents pour artistes": photographs taken as reference material for archivists, illustrators, and painters. The latter included Man Ray himself and Georges Braque.

49. Rey Chow, "Walter Benjamin's Love Affair with Death," *New German Critique* 48 (1989): 72.

50. Benjamin, "On Some Motifs in Baudelaire," 181.

51. Benjamin, "A Short History of Photography."

52. Walter Benjamin, "The Work of Art in the Age of Mechanical Reproduction," in *Illuminations,* ed. Hannah Arendt, trans. Harry Zohn (London: Fontana, 1973), 219–53.

53. Benjamin, "A Short History of Photography," 20.

54. Mary Price, *The Photograph: A Strange Confined Space* (Stanford, Calif.: Stanford University Press, 1994), 48.

55. Benjamin, "On Some Motifs in Baudelaire," 155–56.

56. Ibid., 171.

57. Benjamin, "A Short History of Photography," 7.

58. Benjamin, "On Some Motifs in Baudelaire," 184.

59. Benjamin, "A Short History of Photography," 20.

60. Alain Buisine, "Une miraculeuse pureté," in *Eugène Atget ou la mélancholie en photographie* (Nimes: Éditions Jacqueline Chambon, 1994), 63.

61. "Fait tout son possible pour contrer l'ardeur at l'allant du siècle, pour contrecarrer son emballement, pour freiner son acceleration cinétique." Buisine, *Eugène Atget,* 112–13; author's translation.

62. Benjamin, "A Short History of Photography," 25. Miriam Hansen has pointed to the possible unreliability of the more widely available translations of Benjamin's most famous essay. See Miriam Hansen, "Benjamin and Cinema: Not a One Way Street," *Critical Inquiry* 25, no. 2 (1999): 306–43.

63. Benjamin, "The Work of Art in the Age of Mechanical Reproduction," 228.

64. Deleuze, *The Time-Image,* 236.

65. Buisine, *Eugène Atget*, 64. See also Christian Metz, "Photography and Fetish," *October* 34 (1985): 87. Metz also connects the off-frame to Benjamin's aura.

66. Benjamin, "A Short History of Photography," 20.

67. Charney, "In a Moment," 283–85.

68. Benjamin, "A Short History of Photography," 7. See also Benjamin, "The Work of Art in the Age of Mechanical Reproduction," 239.

69. Eduardo Cadava, *Words of Light: Theses on the Photography of History* (Princeton, N.J.: Princeton University Press, 1997), 88–89.

70. John Fraser, "Atget and the City," in *The Camera Viewed: Writings on Twentieth-Century Photography—Photography before World War II,* ed. Peninah R. Petruck (New York: Dutton, 1979), 204. See also Berenice Abbott, *The World of Atget* (New York: Paragon, 1964).

71. Deleuze, *The Logic of Sense,* 167.

72. John Fuller, "Atget and Man Ray in the Context of Surrealism," in *The Camera Viewed,* ed. Petruck, 226.

73. Kozloff, *The Privileged Eye,* 288–89. For more depth on Atget's *petits métiers* series, see Jeff Rosen, "Atget's Populism," *History of Photography* 18, no. 1 (1994): 50–63.

74. Benjamin, "On Some Motifs in Baudelaire," 164.

75. Deleuze, *The Logic of Sense,* 62.

76. Kozloff, *The Privileged Eye,* 292.

77. Buisine, "L'affreuse lèpre en train de lui ronger le corps," in *Eugène Atget,* 198; author's translation.

78. Kozloff, *The Privileged Eye,* 291.

79. Roland Barthes, *Image, Music, Text,* trans. Stephen Heath, 3rd ed. (London: Fontana, 1982), 148.

80. Bergson, *Creative Evolution,* 291.

81. Henri Bergson, *Matter and Memory* (1896), trans. Nancy Margaret Paul and W. Scott Palmer, 5th ed. (New York: Zone, 1996), 67.

82. Annette Kuhn, *Family Secrets: Acts of Memory and Imagination* (London: Verso, 1995), 17.

83. Roland Barthes, *Camera Lucida: Reflections on Photography,* trans. Richard Howard, 4th ed. (London: Vintage, 1993), 95–96.

84. The comparison between the Dauthendey photograph and the portrait of Lewis Payne is also noted in Price, *The Photograph,* 96. Kuhn confronts a photograph of her mother, and the auto/biographical urge is very strong in Alain Buisine's work, leading to what he calls a "préface autobiographique," in Buisine, *Eugène Atget,* 13. Indeed, an autobiographic approach has established itself as the most Barthesian of analytical methods in contemporary photography criticism.

85. Deleuze, *The Logic of Sense,* 164.

86. Ibid., 63.

87. Metz, "Photography and Fetish," 84.

88. Jay Prosser, *Light in the Dark Room: Photography and Loss* (Minneapolis: University of Minnesota Press, 2005), 31.

89. Pierre Mac Orlan, "Preface to *Atget, Photographe de Paris,*" in *Photography in the Modern Era: European Documents and Critical Writings, 1913–40,* ed. Christopher Phillips (New York: Metropolitan Museum of Art, 1989), 43–45.

90. Buisine, *Eugène Atget,* 11.

91. Kozloff, *The Privileged Eye,* 299.

92. Abbott, *The World of Atget,* xxvi.

93. John Szarkowski and Maria Morris Hambourg, *The Work of Atget* (London: Gordon Fraser, 1985), 4:9–33.

94. Abigail Solomon-Godeau, *Photography at the Dock: Essays on Photographic History, Institutions, and Practices* (Oxford: Oxford University Press, 1991), 31.

95. Kozloff, *The Privileged Eye,* 301.

96. Mac Orlan, "Preface to *Atget, Photographe de Paris,*" 44.

97. Susan Sontag, *On Photography,* 7th ed. (London: Penguin, 1989), 68.

98. Mac Orlan, "Preface to *Atget, Photographe de Paris,*" 45.

4. Cinema's Photographic View

1. Berenice Abbott, "Photography at the Crossroads," in *Classic Essays on Photography,* ed. Alan Trachtenberg (New Haven, Conn.: Leete's Island Books, 1980), 183.

2. Max Kozloff, *The Privileged Eye: Essays on Photography,* 2nd ed. (Albuquerque: University of New Mexico Press, 1988), 34–38.

3. Sandra S. Phillips and Maria Morris Hambourg, *Helen Levitt* (San Francisco: San Francisco Museum of Modern Art, 1991), 15–46.

4. Gilles Deleuze, *The Fold: Leibniz and the Baroque,* trans. Tom Conley (Minneapolis: University of Minnesota Press, 1993), 24.

5. Ibid., 33.

6. Ibid., 126–27.

7. Phillips and Hambourg, *Helen Levitt,* 58.

8. Ibid., 29. Phillips compares Levitt's work with Weegee, whose photography presented people as the soul of the city, forced out onto the street by murder, fire, and public gatherings.

9. Christian Metz, "Photography and Fetish," *October* 34 (1985): 84.

10. Gilles Deleuze, *Cinema 2: The Time-Image,* trans. Hugh Tomlinson and Robert Galeta (Minneapolis: University of Minnesota Press, 1989), 14.

11. Gottfried Willhelm Leibniz, *Monadology,* ed. Nicholas Rescher (Pittsburgh, Penn.: University of Pittsburgh Press, 1991), 128.

12. Deleuze, *The Fold,* 19.

13. Gilles Deleuze, *Cinema 1: The Movement-Image,* trans. Hugh Tomlinson and Barbara Habberjam (Minneapolis: University of Minnesota Press, 1986), 76.

14. Garrett Stewart, *Between Film and Screen: Modernism's Photo Synthesis* (Chicago: University of Chicago Press, 1999), 10.

15. Raymond Bellour, "The Film Stilled," *Camera Obscura* 24 (1991): 105.

16. W. J. T. Mitchell, *Picture Theory,* 2nd ed. (Chicago: University of Chicago Press, 1995), 288. Mitchell identifies the "photo-essay" as a key form at this time. See also James Agee and Walker Evans, *Let Us Now Praise Famous Men: Three Tenant Families* (Boston: Houghton Mifflin, 1941).

17. Roland Barthes, *Image, Music, Text,* trans. Stephen Heath (London: Fontana, 1982), 15–32.

18. Opening intertitle from *In the Street.*

19. James Agee, "A Way of Seeing," in *A Way of Seeing,* Helen Levitt (New York: Viking Press, 1965), 4.

20. Kozloff, *The Privileged Eye: Essays on Photography,* 30. See also Phillips and Hambourg, *Helen Levitt,* 54. This tension is demonstrated in Levitt's approach. She employed a right-angle finder so that she never appeared to be looking at her subjects when photographing them to make them relax "as if they were inside," an approach she learned from Shahn and Evans. The orthodox viewfinder of Levitt's movie camera meant she looked directly at her subject once more, and no "alibi" is given to the photographer in her act of perceiving.

21. Régis Durand, "How to See (Photographically)," in *Fugitive Images: From Photography to Video,* ed. Patrice Petro (Bloomington: Indiana University Press, 1995), 143.

22. John Mullarkey, "Deleuze and Materialism: One or Several Matters?" *South Atlantic Quarterly* 96, no. 3 (Summer 1997): 455.

23. E. H. Gombrich, "Standards of Truth: The Arrested Image and the Moving Eye," *Critical Inquiry* 8 (Winter 1980): 246.

24. Joel Snyder and Neil Walsh Allen, "Photography, Vision, and Representation," *Critical Inquiry* 2 (Autumn 1975): 148–49.

25. Deleuze, *The Fold,* 22.

26. Ibid., 20–21.

27. Gombrich, "Standards of Truth," 241.

28. Leibniz, *Monadology,* 110–20.

29. John Tagg has written of the development of early portrait photography—particularly daguerreotypy—as inheriting the traditions of portrait painting. See John Tagg, *The Burden of Representation: Essays on Photographies and Histories* (London: MacMillan, 1988).

30. Vilém Flusser, *Towards a Philosophy of Photography,* trans. Anthony Mathews (London: Reaktion, 2000), 71.

31. Ibid., 27–33.

32. Noted by Hubertus von Amelunxen in his afterword to Flusser, *Towards a Philosophy of Photography,* 86.

33. Sarah Kofman, *Camera Obscura: Of Ideology,* trans. Will Straw (Ithaca, N.Y.: Cornell University Press, 1998), 41–43, 52.

34. Ibid., 39.

35. Deleuze, *The Fold,* 22.

36. Ibid., 35, 78.

37. Tom Conley, "From Multiplicities to Folds: On Style and Form in Deleuze," *South Atlantic Quarterly* 96, no. 3 (1997): 642.

38. Deleuze, *The Time-Image,* 130–32.

39. Deleuze, *The Fold,* 62.

40. Mullarkey, "Deleuze and Materialism," 458.

41. Jonathan Crary, *Techniques of the Observer: On Vision and Modernity in the Nineteenth Century* (Cambridge: Massachusetts Institute of Technology, 1990), 39–40.

42. Snyder and Allen, "Photography, Vision, and Representation," 157.

43. Roger Scruton, "Photography and Representation," *Critical Inquiry* 7 (1981): 578–79.

44. Colin MacCabe, "Realism and the Cinema: Notes on Some Brechtian Theses," *Screen* 15, no. 2 (1974): 7–27, 8.

45. Deleuze, *The Time-Image,* 269.

46. Simon Watney, "Making Strange: The Shattered Mirror," in *Thinking Photography,* ed. Victor Burgin (Basingstoke, England: Macmillan, 1882), 171.

47. Kofman, *Camera Obscura,* 46.

48. Amy Taubin, "Chilling and Very Hot," *Sight and Sound* 5, no. 11 (1996): 16.

49. Michael Cohen, "Discussion with Larry Clark," Art Commotion, http://www.artcommotion.com/VisualArts/indexa.html (accessed January 4, 2007).

50. Kendall L. Walton, "Transparent Pictures: On the Nature of Photographic Realism," *Critical Inquiry* 11 (1984): 254.

51. Gilles Deleuze and Félix Guattari, *What Is Philosophy?* (New York: Columbia University Press, 1994), 173.

52. bell hooks, "White Light," *Sight and Sound* 6, no. 5 (1996): 10–12.

53. Gilles Deleuze, *Nietzsche and Philosophy,* trans. Hugh Tomlinson (London: Athlone, 1983), 185–88.

54. Ibid., 188–89.

55. Rose Pfeffer, *Nietzsche: Disciple of Dionysus,* 2nd ed. (Lewisburg, Penn.: Bucknell University Press, 1974), 121–22.

56. Kofman, *Camera Obscura,* 44–45.

57. Ibid., 21–27.

58. Peter Krämer, "'A Cutie with More than Beauty': Audrey Hepburn, the Hollywood Musical, and *Funny Face,*" in *Musicals: Hollywood and Beyond,* ed. Bill Marshall and Robynn Stilwell (London: Intellect, 2000), 62–69. See also Stephen Winer, "Dignity—Always Dignity: Betty Comden and Adolph Green's Musicals," *Velvet Light Trap,* no. 11 (1974): 29–32.

59. Deleuze, *The Time-Image,* 62.

60. If we followed the pattern of Nietzsche's *ressentiment,* each photograph of Jo

would be a little death that signaled her death *as a woman*. However, such a conclusion privileges the tense perceived in photography and not the time that unfolds from the photographic image.

61. Stewart, *Between Film and Screen*, 49–50.

62. Ibid., 321.

63. Ibid., 88.

64. Deleuze, *The Time-Image*, 71–72.

65. Ibid., 76.

66. Jean-Louis Leutrat, *L'année dernière à Marienbad*, trans. Paul Hammond (London: BFI, 2000), 52–61. For different interpretations of *Marienbad*, see Bruce Kawin, *Mindscreen: Bergman, Godard, and First-Person Film* (Princeton, N.J.: Princeton University Press, 1978); Jefferson T. Kline, *Screening the Text* (Baltimore, Md.: Johns Hopkins University Press, 1992); and Beverle Houston and Marsha Kinder, *Self and Cinema: A Transformalist Perspective* (New York: Redgrave, 1980).

67. Georges Sadoul, "Notes on a New Generation," *Sight and Sound,* August 1959, 114–15.

68. Deleuze, *The Time-Image*, 119.

69. Emma Wilson, *Alain Resnais* (Manchester, England: Manchester University Press, 2006), 76.

70. Deleuze, *The Fold,* 14.

71. Beverly Houston and Marsha Kinder, *Self and Cinema: A Transformalist Perspective* (New York: Redgrave, 1980), 254.

72. Scott McCloud, *Understanding Comics: The Invisible Art* (New York: Harper Collins, 1993), 126.

73. Lawrence L Abbott, "Comic Art: Characteristics and Potentialities of a Narrative Medium," *Journal of Popular Culture* 19, no. 4 (1986): 167.

74. Mitchell, *Picture Theory,* 154.

75. Ibid., 104.

76. In 1959, when *Dans le labyrinth* was published, Deleuze had, by coincidence, recently finished his work on Nietzsche and was poised to return to Bergson.

77. Deleuze, *The Time-Image,* 250.

78. Mitchell, *Picture Theory,* 154.

79. Alain Robbe-Grillet, *In the Labyrinth,* trans. Christine Brooke-Rose (London: Calder and Boyars, 1967), 56–57.

80. "Toutes les photographies qu'elle a trouvées tout à l'heure dans le secrétaire sonts étalées autour d'elle: sur le lit, sur la table de nuit, sur le tapis, le tout dans un grand désordre." Alain Robbe-Grillet, *L'année dernière à Marienbad* (Paris: Les Editions de Minuit, 1961), 162; author's translation.

5. How Does a Photograph Work?

1. Laura Mulvey, "Phantasmagoria of the Female Body: The Work of Cindy Sherman," *New Left Review* 188 (1991): 137.

2. "I was certain [a visitor to the gallery's] anger must have come from a sense of his own involvement, the way those images speak not only *to* him, but *from* him—and he kept blaming Sherman herself for it, as if she really was a bit of a whore." Judith Williamson, *Consuming Passions* (London: Marion Boyars, 1983), 91–92.

3. See Rosalind Krauss and Norman Bryson, *Cindy Sherman, 1975–1993* (New York: Rizzoli, 1993); and Jan Avgikos, "Cindy Sherman: Burning Down the House," *Artforum,* January 2000, 74–79.

4. Laura Mulvey, "Visual Pleasure and Narrative Cinema," *Screen* 16, no. 3 (1975): 6–18.

5. Laura Mulvey, *Death 24x a Second: Stillness and the Moving Image* (London: Reaktion, 2006), 191.

6. Williamson, *Consuming Passions,* 95.

7. Lucy Lippard, "Scattering Selves," in *Inverted Odysseys: Claude Cahun, Maya Deren, and Cindy Sherman,* ed. Shelley Rice (Cambridge: Massachusetts Institute of Technology, 1999), 30.

8. Douglas Crimp, "Pictures," *October* 8 (1979): 75–88.

9. Laura Mulvey, *Fetishism and Curiosity* (London: BFI, 1996), 69.

10. Ted Mooney, "Cindy Sherman: An Invention for Two Voices," in *Inverted Odysseys,* ed. Rice, 152.

11. Mulvey, *Fetishism and Curiosity,* 69.

12. Gilles Deleuze and Félix Guattari, *A Thousand Plateaus: Capitalism and Schizophrenia* (1980), trans. Brian Massumi (Minneapolis: University of Minnesota Press, 1987), 291.

13. Ibid., 277.

14. Ibid., 277–78.

15. Rosi Braidotti, *Patterns of Dissonance: A Study of Women in Contemporary Philosophy,* trans. Elizabeth Guild (London: Polity Press, 1991), 122.

16. Ibid., 121.

17. Antonella Russo, "Picture This," *Art Monthly,* no. 181 (1994): 9.

18. Phillip Sturgess, *Narrativity: Theory and Practice* (London: Clarendon, 1992), 13.

19. Gilles Deleuze, *Cinema 1: The Movement-Image,* trans. Hugh Tomlinson and Barbara Habberjam (Minneapolis: University of Minnesota Press, 1986), 10.

20. Robert Scholes, *Semiotics and Interpretation* (New Haven, Conn.: Yale University Press, 1982).

21. Gilles Deleuze, *Bergsonism,* trans. Hugh Tomlinson and Barbara Habberjam (New York: Zone, 1997), 63.

22. Thierry de Duve, "The Photograph as Paradox," *October* 5 (1978): 113–17. See also Roland Barthes, *Image, Music, Text,* trans. Stephen Heat (London: Fontana, 1982), 44.

23. Sturgess, *Narrativity,* 11.

24. Deleuze, *The Movement-Image,* 72.

25. Sergei Eisenstein, "A Dialectical Approach to Film Form," trans. Jay Leyda, in *Film Theory and Criticism,* ed. Gerald Mast, Marshall Cohen, and Leo Braudy, 4th ed. (Oxford: Oxford University Press, 1992), 145.

26. Deleuze, *The Movement-Image,* 32–40.

27. Ibid., 36.

28. Gilles Deleuze and Félix Guattari, *What Is Philosophy?* (New York: Columbia University Press, 1994), 193.

29. Catherine Lupton, *Chris Marker: Memories of the Future* (London: Reaktion, 2005), 91.

30. Garrett Stewart, *Between Film and Screen: Modernism's Photo Synthesis* (Chicago: University of Chicago Press, 1999), 104.

31. Barthes, *Image, Music, Text,* 68.

32. Peter Plagens, "The Odd Allure of Movies Never Made," *Newsweek* 129, no. 26 (1994): 74.

33. Deleuze and Guattari, *What Is Philosophy?,* 193.

34. Deleuze, *Bergsonism,* 17–18.

35. Henri Bergson, *Matter and Memory* (1896), trans. Nancy Margaret Paul and W. Scott Palmer, 5th ed. (New York: Zone, 1996), 10.

36. Deleuze, *Bergsonism,* 38–39.

37. Ibid., 25.

38. Michael Hardt, *Gilles Deleuze: An Apprenticeship in Philosophy* (Minneapolis: University of Minnesota, 1993), 18.

39. Barthes, *Image, Music, Text,* 67.

40. Shelley Rice, "Inverted Odysseys," in *Inverted Odysseys,* ed. Rice, 7–8.

41. Williamson, *Consuming Passions,* 99. Interestingly, all the directors named imply a film experience of a particular level of education, class, and social and political experience—despite the "shlock" to which they also refer. There are no Sirks, Hawks, or TV movies individually remembered, and yet the object of Sherman's perceived criticism is, apparently, Hollywood.

42. Mulvey, *Fetishism and Curiosity,* 68.

43. Gilles Deleuze, *Cinema 2: The Time-Image,* trans. Hugh Tomlinson and Robert Galeta (Minneapolis: University of Minnesota, 1989), 68.

44. Deleuze, *Bergsonism,* 52–53.

45. Deleuze, *The Time-Image,* 81.

46. Ibid., 81, 82.

47. Deleuze, *The Movement-Image,* 205.

48. Peter Wollen, *Readings and Writings* (London: NLB, 1982), 79–91. See also Peter Wollen, *Signs and Meanings in the Cinema* (London: Secker and Warburg/BFI, 1972).

49. Deleuze, *The Time-Image,* 82.

50. Ibid.

51. Ronald Bogue, *Deleuze on Cinema* (London: Routledge, 2003), 126.

52. Deleuze, *The Time-Image,* 73.

53. Ibid., 94.

54. Ibid., 72.

55. David Campany, *Photography and Cinema* (London: Reaktion, 2008), 136.

6. Becoming-Photography

1. Stephen Koch has Ed McDermott credited in the role of the "Sugar Plum fairy," while Tony Rayns has him as Joseph Campbell. Stephen Koch, *Stargazer: Andy Warhol and His Films,* 2nd ed. (London: Marion Boyars, 1985), 81; R. Tony Rayns, "Andy's Handjobs," in *Who Is Andy Warhol?*, ed. Colin MacCabe, Mark Francis, and Peter Wollen (London: BFI, 1997), 85.

2. Gilles Deleuze, *Cinema 2: The Time-Image,* trans. Hugh Tomlinson and Robert Galeta (Minneapolis: University of Minnesota, 1989), 203.

3. Tony Rayns, "Andy's Handjobs," 85. See also Tony Rayns, "Review of *My Hustler,*" *Monthly Film Bulletin* 38, no. 449 (June 1971): 123. "Included within this massive accumulation of physical materials are many detailed clues to Warhol's filmmaking practice [including] unused 33-minute reels shot for films such as *My Hustler* (1965)." Callie Angell, "The Films of Andy Warhol," in *The Andy Warhol Museum,* Callie Angell et al. (Pittsburgh: Carnegie Institute, 1994), 122. This situation parallels the real relationship between Warhol and Paul America. Warhol seldom, if ever, spoke directly to Paul America, and when addressed would reply through an intermediary even when Paul was standing in the room.

4. See John Berger, *Ways of Seeing* (London: Penguin/BBC, 1972), 62–64. Interesting visual comparisons can also be made between the composition of *Odalisque and Slave* and the framing of Genevieve Charbon and Paul America, as well as between the composition of *Déjeuner* and the framing of Paul America and Joe Campbell.

5. R. Bruce Brasell, "*My Hustler:* Gay Spectatorship as Cruising," *Wide Angle: A Film Quarterly of Theory, Criticism, and Practice* 14, no. 2 (1992): 58.

6. Koch, *Stargazer,* 85. See also Brasell, "*My Hustler:* Gay Spectatorship as Cruising," 57.

7. Brasell, "*My Hustler:* Gay Spectatorship as Cruising," 64.

8. Gilles Deleuze and Félix Guattari, *A Thousand Plateaus: Capitalism and Schizophrenia,* trans. Brian Massumi (Minneapolis: University of Minnesota Press, 1996), 168.

9. Ibid.

10. Ibid., 191.

11. Ibid., 243.

12. Deleuze, *The Time-Image,* 72–73.

13. Deleuze and Guattari, *A Thousand Plateaus,* 243.

14. Vilém Flusser, *Towards a Philosophy of Photography,* trans. Anthony Mathews (London: Reaktion, 2000), 37.

15. "The photographic universe is made up of such little pieces, made up of quanta." Ibid., 67.

16. Deleuze and Guattari, *A Thousand Plateaus,* 168.

17. Ibid., 175.

18. Ibid., 190.

19. Ibid.

20. "Becoming is not imitating. . . . One does not imitate, one constitutes a block of becoming." Ibid., 305.

21. Richard Hellinger, "The Archives of the Andy Warhol Museum," in *The Andy Warhol Museum*, Callie Angell et al., 195–203.

22. Roland Barthes, *Mythologies*, 3rd ed. (London: Vintage, 1993), 86–71.

23. Flusser, *Towards a Philosophy of Photography*, 8–10.

24. Diana Crane, *The Transformation of the Avant-garde: The New York Art World, 1940–1985* (Chicago: University of Chicago Press, 1987), 11.

25. Deren Van Coke, *The Painter and the Photograph: From Delacroix to Warhol* (Albuquerque: University of New Mexico Press, 1972), 73.

26. David E. James, "The Producer as Author," *Wide Angle: A Film Quarterly of Theory, Criticism, and Practice* 7, no. 3 (1985): 32.

27. P. Adams Sitney, *Visionary Film: The American Avant-garde* (Oxford: Oxford University Press, 1974), 371.

28. "The wolf is not fundamentally a characteristic or a certain number of characteristics; it is a wolfing." Deleuze and Guattari, *A Thousand Plateaus*, 239.

29. Arthur C. Danto, "The Philosopher as Andy Warhol," in *The Andy Warhol Museum*, Callie Angell et al., 81.

30. Paul Mattick, "The Andy Warhol of Philosophy and the Philosophy of Andy Warhol," *Critical Inquiry* 24, no. 4 (1998): 970.

31. Brasell, "*My Hustler*: Gay Spectatorship as Cruising," 62. See also Annette Michelson, "Gnosis and Iconoclasm: A Case Study of Cinephilia," *October* 83 (1998): 12–13; and Gregory Battcock, "Notes on Empire," *Film Culture*, no. 40 (1966): 39.

32. Sitney, *Visionary Film*, 374.

33. Danto, "The Philosopher as Andy Warhol," 89.

34. James, "The Producer as Author," 26.

35. Benjamin Buchloch, "Conversation with Andy Warhol," *October* 70 (1994): 44–45.

36. See David Hopkins, "Douglas Gordon as Gavin Turk as Andy Warhol as Marcel Duchamp as Sarah Lucas," *twoninetwo*, no. 2 (2001): 93–105.

37. Amy Taubin, "****," in *Who Is Andy Warhol?*, ed. MacCabe, Francis, and Wollen, 29. See also Amy Taubin, "My Time Is Not Your Time," *Sight and Sound* 4, no. 6 (1994): 20–24.

38. Deleuze and Guattari, *A Thousand Plateaus*, 278.

39. Rosi Braidotti, *Patterns of Dissonance: A Study of Women in Contemporary Philosophy*, trans. Elizabeth Guild (London: Polity Press, 1991), 120.

40. Deleuze and Guattari, *A Thousand Plateaus*, 277.

41. Ibid.

42. Matthew Tinkcom, "Warhol's Camp," in *Who Is Andy Warhol?*, ed. MacCabe, Francis, and Wollen, 113.

43. Rayns, "Andy's Handjobs," 84.

44. Richard Dyer, *Stars* (London: BFI, 1979), 24.

45. Jackie Stacey, "Feminine Fascinations," in *Stardom: Industry of Desire*, ed. Christine Gledhill (London: Routledge, 1990), 151.

46. Peter Gidal, *"The Thirteen Most Beautiful Women* and *Kitchen,"* in *Andy Warhol: Film Factory,* ed. Michael O'Pray (London: BFI, 1989), 118.

47. Deleuze and Guattari, *A Thousand Plateaus,* 302.

48. Paul Mattick, "The Andy Warhol of Philosophy and the Philosophy of Andy Warhol," *Critical Inquiry* 24, no. 4 (1998): 978.

49. Ibid., 984–85.

50. Taubin, "****," 25.

51. Gidal, *"The Thirteen Most Beautiful Women* and *Kitchen,"* 118.

52. Callie Angell, *The Films of Andy Warhol: Part II* (New York: Whitney Museum of American Art, 1994), 22.

53. Matthew Fuller, *Media Ecologies: Materialist Energies in Art and Technoculture* (Cambridge: Massachusetts Institute of Technology, 2005), 77.

54. J. Hoberman, "Nobody's Land: Inside *Outer and Inner Space,"* program essay for Andy Warhol and Sound and Vision exhibition, Institute of Contemporary Art, London, July 28 to September 2, 2001.

55. Callie Angell, program notes to *Outer and Inner Space,* Whitney Museum of American Art, October 15 to November 29, 1998.

56. Gilles Deleuze, *Cinema 1: The Movement-Image,* trans. Hugh Tomlinson and Barbara Habberjam (Minneapolis: University of Minnesota, 1986), 215.

57. Gidal, *"The Thirteen Most Beautiful Women* and *Kitchen,"* 120.

58. Deleuze, *The Time-Image,* 191.

59. "This withdrawal of the artist's encouraging presence was crucial to the film's purpose, which was to use the unmitigated scrutiny of the camera to gradually evoke hidden aspects of Geldzahler's personality." Angell, *The Films of Andy Warhol: Part II,* 20.

60. I rely here on conversations with Callie Angell (October 2005) and Charles Silver, associate curator, Department of Film and Media, Museum of Modern Art, New York, (September 2001).

61. Angell, *The Films of Andy Warhol: Part II,* 17.

62. Koch, *Stargazer,* 60. See also Jonas Mekas, "Warhol Shoots Empire," in *The Cinematic,* ed. David Campany (Cambridge: Massachusetts Institute of Technology Press, 2007), 50.

63. Gregory Battcock, "Notes on Empire," *Film Culture,* no. 40 (1966): 39.

64. Deleuze and Guattari, *A Thousand Plateaus,* 168.

65. Angell, *The Films of Andy Warhol: Part II,* 16.

66. Gidal, *"The Thirteen Most Beautiful Women* and *Kitchen,"* 120. It is certain that *Empire*'s absence of sound results from Warhol's choice, since *Empire* was filmed using his new sound-synch Auricon camera; see Koch, *Stargazer,* 60.

67. Malcolm Le Grice, *Abstract Film and Beyond* (London: Studio Vista, 1977), 95.

68. Deleuze and Guattari, *A Thousand Plateaus,* 172.

69. Flusser, *Towards a Philosophy of Photography,* 65.

70. John Palmer quoted in interview, Mekas, "Warhol Shoots Empire," 50.

71. James, "The Producer as Author," 26.

7. The New Uses of Photography

1. Gilles Deleuze, *Pure Immanence: Essays on a Life,* trans. Anne Boyman, 2nd ed. (New York: Zone, 2002), 29.

2. Matthew Fuller, *Media Ecologies: Materialist Energies in Art and Technoculture* (Cambridge: Massachusetts Institute of Technology, 2005), 81. See also Vilém Flusser, *Towards a Philosophy of Photography,* trans. Anthony Mathews (London: Reaktion, 2000).

3. Laura Mulvey, "Passing Time: Reflections on Cinema from a New Technological Age," *Screen* 45, no. 2 (2004): 151.

4. Ibid., 148–49. See also Laura Mulvey, *Death 24x a Second: Stillness and the Moving Image* (London: Reaktion, 2006).

5. Fuller, *Media Ecologies,* 82.

6. Gilles Deleuze, *Cinema 2: The Time-Image,* trans. Hugh Tomlinson and Robert Galeta (Minneapolis: Univerity of Minnesota Press, 1989), 207.

7. Bruno Latour, *Reassembling the Social: An Introduction to Actor-Network-Theory* (Oxford: Oxford University Press, 2005), 189.

8. Ibid., 189–90.

9. Bruno Latour, *Science in Action: How to Follow Scientists and Engineers through Society* (Cambridge, Mass.: Harvard University Press, 1987).

10. Latour, *Reassembling the Social,* 187.

11. Ibid., 181.

12. "It took 38 years for radio to attract 50 million listeners. 13 years for television to attract 50 million viewers. In just 4 years the Internet has attracted 50 million surfers" (source unknown). J. Jonathan Gabay, *Successful Cybermarketing in a Week* (London: Hodder & Stoughton, 2000), cited in Gisle Hannemyr, "The Internet as Hyperbole: A Critical Examination of Adoption Rates," *Information Society* 19, no. 2 (2003): 111.

13. Hannemyr, "The Internet as Hyperbole," 119.

14. Scott Kirsch and Don Mitchell, "The Nature of Things: Dead Labor, Nonhuman Actors, and the Persistence of Marxism," *Antipode* 36, no. 4 (2004): 689.

15. Ibid., 698–99.

16. Latour, *Reassembling the Social,* 201.

17. Interview with the author, December 17, 2005.

18. Gene McSweeney, Lost Films, http://westfordcomp.com/updated/found.htm (accessed 11 February 2009).

19. Gene McSweeney, Ilford Sporti c1959, http://westfordcomp.com/classics/ilfordsporti/index.htm (accessed February 5, 2006).

20. Fuller, *Media Ecologies,* 82.

21. Gilles Deleuze and Félix Guattari, *What Is Philosophy?* (New York: Columbia University Press, 1994), 167.

22. Ibid., 168.

23. John Rajchman, session on "Visual Arts," Immanent Choreographies: Deleuze and Neo-Aesthetics, September 21–22, 2001, Tate Modern, London. Archived at http://www.tate.org.uk/ onlineevents/archive/deleuze.htm (accessed February 5, 2006).

24. Deleuze and Guattari, *What Is Philosophy?*, 168.

25. Gilles Deleuze and Félix Guattari, *A Thousand Plateaus: Capitalism and Schizophrenia* (1980), trans. Brian Massumi (Minneapolis: University of Minnesota Press, 1987), 296.

26. Deleuze and Guattari, *What Is Philosophy?*, 176.

27. Peter Thomas, "Victimage and Violence: Memento and Trauma Theory," *Screen* 44, no. 2 (2003): 205.

28. Ibid., 206.

29. William G. Little, "Surviving *Memento*," *Narrative* 13, no. 1 (2005): 69.

30. Roland Barthes, *Camera Lucida: Reflections on Photography,* trans. Richard Howard, 4th ed. (London: Vintage, 1993), 96.

31. Rosalind Sibielski, "Postmodern Narrative or Narrative of the Postmodern? History, Identity, and the Failure of Rationality as an Ordering Principle in *Memento*," *Literature and Psychology* 49, no. 4 (2004): 97.

32. Rob Content, "Memento," *Film Quarterly* 56, no. 4 (2003): 41.

33. David Martin-Jones, *Deleuze, Cinema, and National Identity: Narrative Time in National Contexts* (Edinburgh: Edinburgh University Press, 2006), 141–47. I am very grateful to David Martin-Jones for providing me with the draft manuscript of *Deleuze, Cinema, and National Identity* in advance of publication.

34. Chris Marker, *Immemory,* CD-ROM (Paris: Centre Georges Pompidou, 1998), cited in Kent Jones, "Time Immemorial," *Film Comment* 39, no. 2 (2003): 46.

35. Catherine Lupton, *Chris Marker: Memories of the Future* (London: Reaktion, 2005), 210. See also Catherine Lupton, "Shock of the Old," *Film Comment* 39, no. 3 (2003): 44.

36. Chris Marker, cited in Lupton, *Chris Marker,* 154. See also Lupton, "Shock of the Old," 42.

37. Jacques Rancière, *Film Fables,* trans. Emiliano Battista (Oxford, England: Berg, 2006), 158.

38. Annette Kuhn, "Heterotopia, Heterochronia: Place and Time in Cinema Memory," *Screen* 45, no. 2 (2004): 113. See also Annette Kuhn and Kirsten Emiko McAlister, eds., *Locating Memory: Photographic Acts* (New York: Berghahn Books, 2006).

39. Deleuze and Guattari, *A Thousand Plateaus,* 294.

40. Chris Norris, "Charlie Kaufman and Michel Gondry's Head Trip," *Film Comment* 40, no. 2 (2004): 21.

41. Nick James, "I Forgot to Remember to Forget," *Sight and Sound* 14, no. 5 (2004): 18; Barry Gibb, "Eternal Sunshine of the Spotless Mind," *Lancet Neurology* 3, no. 7 (2004): 441.

42. Maryanne Garry and Kimberley A. Wade, "Actually, a Picture Is Worth Less than 45 Words: Narratives Produce More False Memories Than Photographs Do," *Psychonomic Bulletin and Review* 12, no. 2 (2005): 364.

43. Rajchman, *Immanent Choreographies: Deleuze and Neo-Aesthetics.*

44. Manuel DeLanda, "Immanence and Transcendence in the Genesis of Form," *South Atlantic Quarterly* 96, no. 3 (1997): 509.

45. Michael Hardt and Antonio Negri, *Empire* (Cambridge, Mass.: Harvard University Press, 2001), 328.

46. Kirsch and Mitchell, "The Nature of Things," 699.

47. Neil McBride, "Actor-Network Theory and the Adoption of Mobile Communications," *Geography* 88, no. 4 (2003): 274.

48. Latour, *Reassembling the Social,* 217.

49. See Garrett Stewart, *Between Film and Screen: Modernism's Photo Synthesis* (Chicago: University of Chicago Press, 1999).

50. Cathryn Drake, "David Claerbout: Akademie der Künste," *Artforum International* 33, no. 9 (2005): 259.

51. Robert Hariman and John Louis Lucaites, *No Caption Needed: Iconic Photographs, Public Culture, and Liberal Democracy* (Chicago: University of Chicago Press, 2007), 182.

52. Ibid., 185.

53. Mark Prince, "Painting and Photography," *Art Monthly,* no. 260 (October 2002): 5.

54. Lev Manovich, *The Language of New Media* (Cambridge: Massachusetts Institute of Technology, 2001), 315–17.

55. Mulvey, *Death 24x a Second,* 26.

56. Patrick Hagopian, "Vietnam War Photography as a Locus of Memory," in *Locating Memory: Photographic Acts,* ed. Annette Kuhn and Kirsten Emiko McAllister (New York: Berghahn Books, 2006), 202.

57. Jose van Dijck, *Mediated Memories in the Digital Age* (Stanford, Calif.: Stanford University Press, 2007), 155.

58. Pierre Teilhard de Chardin, "The Formation of the Noosphere" (1947), reprinted in *The Future of Man,* trans. Norman Denny, 4th ed. (London: Fontana, 1973), 163.

59. Peter L. McDermott, "Pierre Teilhard de Chardin: Being, Critical Thresholds, and Evolutionary Thought," *Perspectives in Biology and Medicine* 40, no. 4 (1997): 1.

60. David P. Turner, "Thinking at the Global Scale," *Global Ecology and Biogeography* 14 (2005): 506.

61. Pierre Teilhard de Chardin, *The Phenomenon of Man,* trans. Bernard Wall (1955), 5th ed. (London: Fontana, 1967), 183.

62. Ibid., 203.

63. Ibid., 271.

64. Ibid., 251.

65. Latour, *Reassembling the Social,* 208.

66. Teilhard, "A Great Event Foreshadowed: The Planetization of Mankind" (1946), in *The Future of Man,* 137.

67. Teilhard, "Formation of the Noosphere," 172–74.

68. Ibid., 174. See, for example, Sherlock Google, "1947 Blogosphere Prediction: Teilhard's 'Noosphere,'" Daily Kos (blog), December 9, 2005, http://www.dailykos.com/storyonly/2005/12/9/112210/131 (accessed April 4, 2006).

69. Teilhard, "Formation of the Noosphere," 180.

70. Flora Samuel, "Le Corbusier, Teilhard de Chardin, and 'The Planetisation of Mankind,'" *Journal of Architecture* 4 (1999): 161.

71. DeLanda, "Immanence and Transcendence in the Genesis of Form," 509.

72. Deleuze and Guattari, *What Is Philosophy?,* 58.

73. Thierry de Duve, "The Photograph as Paradox," *October* 5 (1978): 114–15.

74. Paul Harrison, "Making Sense: Embodiment and the Sensibilities of the Everyday," *Environment and Planning D: Society and Space* 18 (2000): 497–98.

75. Ingmar Bergman, cited in *Ingmar Bergman's Persona,* ed. Lloyd Michaels (Cambridge: Cambridge University Press, 2000), 16.

76. David Green, "Marking Time: Photography, Film, and Temporalities of the Image," in *Stillness and Time: Photography and the Moving Image,* ed. David Green and Joanna Lowry (Brighton, England: Photoforum/Photoworks, 2006), 10.

INDEX

DAMIAN SUTTON is a lecturer in historical and critical studies at the Glasgow School of Art, where he teaches cinema and photography history and theory as well as critical studies in new media. He is the coeditor of *The State of the Real: Aesthetics in the Digital Age* and coauthor of *Deleuze Reframed*.